NOTHING EVER DIES

NOTHING EVER DIES

Vietnam and the Memory of War

VIET THANH NGUYEN

 Harvard University Press

Cambridge, Massachusetts & London, England / 2016

Fourth printing

Library of Congress Cataloging-in-Publication Data

Names: Nguyen, Viet Thanh, 1971- author.
Title: Nothing ever dies : Vietnam and the memory of war / Viet Thanh Nguyen.
Description: Cambridge, Massachusetts : Harvard University Press, 2016. |
 Includes bibliographical references and index.
Identifiers: LCCN 2015037444 | ISBN 9780674660342 (cloth: alk. paper)
Subjects: LCSH: Vietnam War, 1961–1975—Social aspects. | Vietnam War,
 1961–1975—Art and the war. | Memory—Sociological aspects. | War and
 society. | Art and war. | Identity (Psychology) in art.
Classification: LCC DS559.8.S6 N48 2016 | DDC 959.704/31—dc23 LC record
 available at http://lccn.loc.gov/2015037444

For my father and mother

Contents

AESTHETICS

Denver picked at her fingernails. "If it's still there, waiting, that must mean nothing ever dies."

Sethe looked right in Denver's face. "Nothing ever does," she said.

TONI MORRISON, *Beloved*

Prologue

I WAS BORN IN VIETNAM but made in America. I count myself among those Vietnamese dismayed by America's deeds but tempted to believe in its words. I also count myself among those Americans who often do not know what to make of Vietnam and want to know what to make of it. Americans, as well as many people the world over, tend to mistake Vietnam with the war named in its honor, or dishonor as the case may be. This confusion has no doubt led to some of my own uncertainty about what it means to be a man with two countries, as well as the inheritor of two revolutions.

I have spent much of my life sorting through this confusion, both my own and that of the world, and the most succinct explanation that I have found about the meaning of the war, at least for Americans, comes from Martin Luther King Jr. "If America's soul becomes totally poisoned," he said, "part of the autopsy must read 'Vietnam.'"[1] Americans mostly know King for his dream, but this is his prophecy, and it continues in this manner: "The war in Vietnam is but a symptom of a far deeper malady within the American spirit. If we ignore this sobering reality, we will find ourselves organizing 'clergy and laymen concerned' committees for the next generation. They

will be concerned about Guatemala and Peru. They will be concerned about Thailand and Cambodia. They will be concerned about Mozambique and South Africa. We will be marching for these and a dozen other names and attending rallies without end, unless there is a significant and profound change in American life."[2] Exactly one year after uttering these words, he was assassinated.

He did not mention Iraq and Afghanistan, but since his speech, many Americans have raised the relationship between the conflicts there and the war in Vietnam.[3] Even though Vietnam is neither Iraq nor Afghanistan, the analogy keeps returning for Americans. This invocation of Vietnam as quagmire, syndrome, and war speaks neither to Vietnamese reality nor to current difficulties in Iraq and Afghanistan. It speaks to American fear. Americans think defeat in these wars is the worst thing, when winning in Iraq and Afghanistan today only means more of the same tomorrow: Somalia, Pakistan, Yemen, and so on. This is the most important reason for Americans to remember what they call the Vietnam War, the fact that it was one conflict in a long line of horrific wars that came before it and after it. This war's identity—and, indeed, any war's identity—cannot be extricated from the identity of war itself.

For King, "the problem of racism, the problem of economic exploitation, and the problem of war are all tied together."[4] His prophecy does not always roll off the tongue. The language is only occasionally biblical, never uplifting. He asks us not to turn our eyes up to the mountaintop but down to the plain, the factory, the field, the ghetto, the unemployment line, the draft board, the rice paddy, the lotus blossoming in a pond of mud, the Vietnamese landscape that even American soldiers called beautiful, and America, what the Vietnamese call the beautiful country. These are the places where memories of war belong. Most troublesome is the memory of how it was a war that took place not only over there but also over here, because a war is not just about the shooting but about the people who make the bullets and deliver the bullets and, perhaps most importantly,

pay for the bullets, the distracted citizenry complicit in what King calls the "brutal solidarity" of white brother and black.[5]

Although King refers to America, he may as well be gesturing to Vietnam, both revolutionary countries which have not lived up to their revolutions. While the America that was a city upon a hill now exists mostly as a sentimental fantasy, even wartime Vietnam seems far away. This was the country of which the revolutionary Che Guevara could say, "How close and bright would the future appear if two, three, many Vietnams flowered on the face of the globe."[6] He was speaking of the way that the Vietnamese war against American occupation had inspired hope among those who dreamed of liberation and independence in the Americas, Africa, and Asia. Today the Vietnamese and American revolutions manufacture memories only to absolve the hardening of their arteries. For those of us who consider ourselves to be inheritors of one or both of these revolutions, or who have been influenced by them in some way, we have to know how we make memories and how we forget them so that we can beat their hearts back to life. That is the project, or at least the hope, of this book.

Just Memory

THIS IS A BOOK on war, memory, and identity. It proceeds from the idea that all wars are fought twice, the first time on the battlefield, the second time in memory. Any war could prove this claim, but the one that serves personally as a metonym for the problem of war and memory is what some call the Vietnam War and others call the American War. These conflicting names indicate how this war suffers from an identity crisis, by the question of how it shall be known and remembered. The pairing of war and memory is commonplace after the disasters of the twentieth century, with tens of millions of dead who seem to cry out for commemoration, for consecration, and even, if one believes in ghosts, for consolation.[1] The problem of war and memory is therefore first and foremost about how to remember the dead, who cannot speak for themselves. Their unnerving silence compels the living—tainted, perhaps, by a touch or more of survivor's guilt—to speak for them.

Inseparable from this grim and mournful history are more complicated questions. How do we remember the living and what they did during times of war? How do we remember the nation and the people for whom the dead supposedly died? And how do we re-

member war itself, both war in general and the particular war that has shaped us? These questions gesture at how new wars cannot be fought unless a nation has dealt with its old wars, however imperfectly or incompletely. The problem of how to remember war is central to the identity of the nation, itself almost always founded on the violent conquest of territory and the subjugation of people.[2] For citizens, garlands of euphemism and a fog of glorious myth shroud this bloody past. The battles that shaped the nation are most often remembered by the citizenry as defending the country, usually in the service of peace, justice, freedom, or other noble ideas. Dressed in this way, the wars of the past justify the wars of the present for which the citizen is willing to fight or at least pay taxes, wave flags, cast votes, and carry forth all the duties and rituals that affirm her or his identity as being one with the nation's.

There is another identity involved as well, the identity of war, "the genesis of a nation's soul," as novelist Bob Shacochis puts it.[3] Each war has a distinct identity, a face with carefully drawn features, familiar at a glance to the nation's people. The tendency is to remember any given war, to the extent it is remembered at all, for a detail or two. Hence, World War II is the "Good War" for many Americans, while the tragedy in Vietnam is the bad war, a syndrome, a quagmire, a stinging loss in need of healing and recuperation. The inclination is to remember wars like individuals, separate and distinct. Wars become discrete events, clearly demarcated in time and space by declarations of war and ceasefires, by the inscription of dates in history books, news articles, and memorial placards. And yet all wars have murky beginnings and inconclusive endings, oftentimes continuing a preceding war and foreshadowing a later one. These wars often do not take place only in the territories for which they are named, but spill over into neighboring countries; they are also shaped in war rooms and boardrooms distant from the battlefields. Wars are as complex as individuals, but are remembered by names that tell us as little as the names of individuals do. The Philippine-American

War implies symmetry between two nations, yet it was Americans who seized the Philippines and instigated the carnage. The Korean War implies a conflict between Koreans, when China and the United States did more than their fair share of the fighting. In the case of the Vietnam War, Americans invented the name, an odd handcuffing of two nouns that has become normal through constant repetition. So normal, in fact, that even if the name is abbreviated to Vietnam, as it so often is, many people still understand it to mean the war. In response, many have protested that Vietnam is a country, not a war. But long before this cry, some of the Vietnamese (the ones who eventually won) had already begun calling it the American War.[4] Still, if the Vietnam War is an inadequate name in the sense that it misleads us about the war's identity, is the American War any better?

This name excuses the various ways in which Vietnamese of all sides also own the war, from its triumphs and its disasters to its glories and its crimes. Not least the name encourages Vietnamese people to think of themselves as victims of foreign aggression. As victims, they are conveniently stricken with amnesia about what they did to one another and how they extended their war westwards into Cambodia and Laos, countries that a unified Vietnam would strive to influence, dominate, and even invade in the postwar era.[5] These ambivalent meanings of the American War are matched by those found in the Vietnam War. While that name has come to represent American defeat and humiliation, there are also elements of American victory and denial, for the name limits the war's scale in space and time. When it comes to space, either name effaces how more than just Vietnamese or Americans fought this war, and how it was fought both inside and outside of Vietnam. When it comes to time, other American wars preceded it (in the Philippines, the Pacific Islands, and Korea), occurred at the same time (in Cambodia, Laos, and the Dominican Republic), and followed it (in Grenada, Panama, Kuwait, Iraq, and Afghanistan). These wars were part of

a century-long effort by the United States to exert its dominion over the Pacific, Asia, and eventually the Middle East—the Orient, broadly defined.[6] Two landmark years bracketed this century. In 1898, America seized Cuba, the Philippines, Puerto Rico, and Hawaii, inaugurating an overseas expansion of American interests that ran into unexpected resistance in 2001, with 9/11 and the ensuing conflicts in the Middle East. The real American War was this entire American Century, a long and uneven expansion marked by a few periodic high-intensity conflicts, many low-intensity skirmishes, and the steady drone of a war machine's ever-ongoing preparations. The result is that "wartime has become normal time in America."[7]

To argue over the Vietnam War or the American War is thus to argue over false choices. Each name obscures human losses, financial costs, and capital gains, as well as how the war also blazed through Cambodia and Laos, something both the Vietnamese and the Americans wish neither to acknowledge nor remember. The North Vietnamese sent troops and materiel through Cambodia and Laos, and the U.S. bombing of these efforts, as well as the civil wars that flared up in both countries, killed approximately four hundred thousand in Laos and also seven hundred thousand in Cambodia during what the journalist William Shawcross sarcastically called the "sideshow" to the war. If we count what happened in a bomb-wrecked, politically destabilized Cambodia during the Khmer Rouge regime of 1975–1979 as the postscript to the war, the number of dead would be an additional two million, or close to one-third of the population, although some estimates say the count was only 1.7 million, or about a quarter of the population. The body count in Vietnam for all sides was closer to one-tenth of the population, while the American dead amounted to about 0.035 percent of the population.[8]

In tabulating a war's costs and consequences, postscripts should count as well as sideshows, both of which are erased in the names of the Vietnam War or the American War. They contain the damage

to the years 1965–1975, to the country of Vietnam, to a death toll of about three million. Counting the sideshows in Cambodia and Laos would raise that number to around four million, while adding the postscripts would make the total approximately six million. Refusing the war's given names acknowledges that this war, like most wars, was a messy business not easily or neatly contained by dates and borders. To deny it a name, as I will do by sometimes simply calling it the war, clears a space for reimagining and remembering this war differently. Denying this war its name also acknowledges what everyone who has lived through a war already knows: their war needs no name, for it is always simply *the* war. Referring to another war, her own, the writer Natalia Ginzburg says, "We will never be cured of this war. It is useless. We are people who will never feel at ease, never think and plan and order our lives in peace. Look what has been done to our houses. Look what has been done to us. We can never rest easy again."[9]

This war—admittedly, my war—was not even fought only between the two sides in the two names, American and Vietnamese. In reality, these nations were fractured, the United States into its pro- and antiwar factions and the Vietnamese into north and south as well as communist and anticommunist, ideological positions which did not divide neatly with the geography. The war also had other national participants, Cambodians and Laotians bearing the brunt, but also many South Koreans. To see how they remembered their war and have themselves been remembered, as I will do, is not an attempt at total inclusion and total recall, since I pass over other participants in silence (Australians, New Zealanders, Filipinos, Thai, Russians, North Koreans, Chinese . . .).[10] But expanding the story to include people outside of Vietnam and the United States is my gesture at both the need to remember and the impossibility of total memory, since forgetting is inevitable and every book needs its margins. Still, my desire to remember as many as I can is a reaction to the lack of inclusiveness found in many, and perhaps most, memo-

ries of the war, or at least the ones circulating before the public. What these public memories show is that nations and peoples operate, for the most part, through what I call an ethics of remembering one's own. This ethics has national variations, with the Vietnamese more willing to remember women and civilians than the Americans are, the Americans more willing than the Vietnamese to remember the enemy, and neither side showing any inclination for remembering the southern Vietnamese, who stink of loss, melancholy, bitterness, and rage. At least the United States gave the southern Vietnamese who fled as refugees to American shores the limited opportunity of telling their immigrant story and, by so doing, inserting themselves into the American Dream.[11] The Vietnamese government only offered them reeducation camps, new economic zones, and erasure from memory. Little surprise, then, that the exiled southern Vietnamese also insist, for the most part, on remembering their own.

For both nations and their diverse constituents, including the defeated and exiled Vietnamese, an alternative ethics of remembering others is the exception, not the rule. This ethics of remembering others transforms the more conventional ethics of remembering one's own. It expands the definition of who is on one's own side to include ever more others, thereby erasing the distinction between the near and the dear and the far and the feared. Working from both ends of the ethical spectrum, from remembering one's own to remembering others, I thread together the memories of my war's dramatis personae, men and women, young and old, soldiers and civilians, majorities and minorities, and winners and losers, as well as many of those who would fall in between the binaries, the oppositions, and the categories. War involves so many because war is inseparable from the diverse domestic life of the nation. To think of war solely as combat, and its main protagonist as the soldier, who is primarily imagined as male, stunts the understanding of war's identity and works to the advantage of the war machine.

A more inclusive memory of war is also an outcome of the struggle to build what the sociologist Maurice Halbwachs called *collective memory*, where individual memories are made possible by memories already inherited from the communities to which we belong, which is to say that we remember through others.[12] The critic James Young revises this through his model of *collected memories*, where the memories of different groups can be brought together in the reassuring style of American pluralism.[13] Any potential dissent between these groups and their memories is tamed by a "ritual of consensus" that is the mythical American Way, says scholar Sacvan Bercovitch.[14] Whether we speak of collective memory or collected memories, these models are only credible if they are inclusive of the group by which they are defined, however great or small. So it is that a call for war is usually accompanied by a demand that the citizenry remember a limited sense of identity and a narrow sense of the collective that extends only to family, tribe, and nation. Thus, the inclusiveness of the American Way is, by definition, exclusive of anything not American, which is why, even today, American memories of the war usually forget or obscure the Vietnamese, not to mention the Cambodians and Laotians. Those who are against war call for a broader human identity that would include those we had previously forgotten, hoping that such expansiveness will reduce the chances of conflict.

This desire to include more of one's own or even others runs into problems both personal and political, for neither individual nor collective memory can be completely inclusive. Total memory is neither possible nor practical, for something is always forgotten. We forget despite our best efforts, and we also forget because powerful interests often actively suppress memory, creating what Milan Kundera calls "the desert of organized forgetting."[15] In this desert, memory is as important as water, for memory is a strategic resource in the struggle for power. Wars cannot be fought without control over memory and its inherent opposite, forgetting (which, despite

seeming to be an absence, is an actual resource). Nations cultivate and would monopolize, if they could, both memory and forgetting. They urge their citizens to remember their own and to forget others in order to forge the nationalist spirit crucial for war, a self-centered logic that also circulates through communities of race, ethnicity, and religion. This dominant logic of remembering one's own and forgetting others is so strong that even those who have been forgotten will, when given the chance, forget others. The stories of those that lost in this war show that in the conflict over remembrance, no one is innocent of forgetting.

While the fight between the powerful and less powerful over the strategic resources of memory and forgetting can be fevered and even violent, more often it is a low-intensity conflict where the state and its supporters fight with both conventional and unconventional methods. The authorities control the government, the military, the police, and the security apparatus with its surveillance mechanisms and counterinsurgency techniques. These authorities—politicians, oligarchs, corporate and intellectual elites—also influence much of the media directly or indirectly. They possess tremendous persuasive power over academics, universities, pundits, think tanks, and the educational apparatus. In general, these authorities have firm control of the war machine, with the ethics of remembering one's own being the binary code that makes the machine run, dividing the world into us versus them and good versus bad, the more easily to build alliances and target enemies. Meanwhile, through rituals, parades, speeches, memorials, platitudes, and "true war stories," the citizenry is constantly called to remember the nation's own heroes and dead, which is easier to do when the citizenry also forgets the enemy and their dead.

Those who resist war foreground a different ethics of remembering others. They call for remembering enemies and victims, the weak and the forgotten, the marginalized and the minor, the women and the children, the environment and the animals, the distant and

the demonized, all of whom suffer during war and most of whom are usually forgotten in nationalist memories of war. In the struggles that take place within and between nations over the meanings of war and the justifications for them, those who resist war and remember others fight for the imagination, not for a nation. In the imagination new identities can arise, alternatives to national identities and the identities that nations attribute to their wars. But while remembering others may be admirable to some, this mode of memory can also be dangerous or deceptive, for remembering others can simply be a reversal, a mirror, of remembering one's own, where the other is good and virtuous and we are bad and flawed. These competing ethics of remembering one's own or remembering others are simple ethical models of memory. What I look for and argue for in this book is a complex ethics of memory, a just memory that strives both to remember one's own and others, while at the same time drawing attention to the life cycle of memories and their industrial production, how they are fashioned and forgotten, how they evolve and change.[16]

Art is crucial to this ethical work of just memory. The writing, photography, film, memorials, and monuments that I include in this book are all forms of memory and of witnessing, sometimes of the intimate, the domestic, the ephemeral, and the small, and sometimes of the historical, the public, the enduring, and the epochal. I turn to these works of art because after the official memos and speeches are forgotten, the history books ignored, and the powerful are dust, art remains. Art is the artifact of the imagination, and the imagination is the best manifestation of immortality possessed by the human species, a collective tablet recording both human and inhuman deeds and desires. The powerful fear art's potentially enduring quality and its influence on memory, and thus they seek to dismiss, co-opt, or suppress it. They often succeed, for while art is only sometimes explicitly nationalistic and propagandistic, it is often implicitly so. In this book I examine a spectrum of artistic work on war and

memory, from those who endorse the values of the powerful to those who seek to subvert such values. Even given how many artists are complicit with power, I remain optimistic that in the centuries yet to come, what people will remember of this or any other war will most likely be a handful of outstanding works of art that resist power and war (as well as a history book or two).

Both memory and forgetting are subject not only to the fabrications of art, but also to the commodification of industry, which seeks to capture and domesticate art. An entire memory industry exists, ready to capitalize on history by selling memory to consumers hooked on nostalgia.[17] Capitalism can turn anything into a commodity, including memories and amnesia. Thus, memory amateurs fashion souvenirs and memorabilia; nostalgic hobbyists dress up in period costume and reenact battles; tourists visit battlefields, historical sites, and museums; and television channels air documentaries and entertainments that are visually high definition and mnemonically low resolution. Emotion and ethnocentrism are key to the memory industry as it turns wars and experiences into sacred objects and soldiers into untouchable mascots of memory, as found in the American fetish for the so-called Greatest Generation who fought the so-called Good War. Critics have derided this memory industry, seeing it as evidence that societies remember too much, transforming memories into disposable and forgettable products and experiences while ignoring the difficulties of the present and the possibilities of the future.[18] But this argument misunderstands that the so-called memory industry is merely a symptom of something more pervasive: the industrialization of memory. Industrializing memory proceeds in parallel with how warfare is industrialized as part and parcel of capitalist society, where the actual firepower exercised in a war is matched by the firepower of memory that defines and refines that war's identity.

Thus, the Pentagon's war of attrition in Vietnam was matched by Hollywood's *Apocalypse Now* and its entire celluloid campaign to

refight the Vietnam War on global movie screens. This campaign foreshadows how the "shock and awe" of U.S. bombing during the Gulf War was equaled by the spectacular quality of American media coverage with its global saturation. The American wars in Iraq and Afghanistan have begun to receive the same propagandistic treatment, if the success of films such as *Zero Dark Thirty* and *American Sniper* are any indication. *Zero Dark Thirty* views CIA torture and the killing of Osama Bin Laden through the eyes of a CIA agent, encouraging the viewer to empathize with the CIA, while *American Sniper* is about a soldier who killed 160 Iraqis, an experience seen not only through his eyes but through the scope of his rifle. No matter the horrors that Americans may see on their screens—the beheadings, the suicide bombings, the mass executions, the waves of refugees, the drone's eye view of war—the viewers who are not physically present at those events are anesthetized into resignation, into watching the news as an awful form of entertainment. This, too, is the "society of the spectacle" of which theorist Guy Debord spoke, a society in which all horror is revealed and nothing is done on the part of the average citizen to resist it.

If we look at a spectacular war movie such as *American Sniper* in isolation, it appears to be a part of a memory industry, but if we look at that movie as a part of Hollywood, and Hollywood as a component of the military-industrial complex, then we see an industry of memory in operation. The ultimate goal of this industry is to reproduce power and inequality, as well as to fulfill the needs of the war machine.[19] The technologies of warfare and memory depend on the same military-industrial complex, one intent on seizing every advantage against present and future enemies who also seek to control the territory of memory and forgetting. But a military-industrial complex does so not simply or only through a memory industry based on the selling of baubles, vacations, heritages, or entertainment. The memory industry produces kitsch, sentimentality, and spectacle, but industries of memory exploit memory as a

strategic resource. Recognizing that the memory industry is only one aspect of an industry of memory enables us to see that memories are not simply images we experience as individuals, but are mass-produced fantasies we share with one another. Memories are not only collected or collective, they are also corporate and capitalist. Memories are signs and products of power, and in turn, they service power. Furthermore, just as countries and peoples are not economically at the same level, neither are their memories. As Barbie Zelizer notes, "everyone participates in the production of memory, though not equally."[20] One sign of this inequality is that while the United States lost the war in fact, it won the war in memory on most of the world's cultural fronts outside of Vietnam, dominating as it does moviemaking, book publishing, fine art, and the production of historical archives.

But even identifying the sites of industrial memory is not enough to show how the strong industries of strong countries will find more receptive audiences and consumers than the weak industries of weak countries will. Language itself becomes a circuit through which industrial memories circulate, so that English-language products are more accessible than Vietnamese ones, or at least much more likely to be translated, while American memories are varnished with a kind of coolness that Vietnamese memories do not yet possess. Even Korean memories of the war—South Korea having been America's most important ally—travel more fluidly on the international circuitry of commodification and desirability. Vietnam, Laos, and Cambodia are much weaker powers, and as a result, their memories usually have, at best, local and national distribution and impact. When those weaker memories are exported internationally, it is almost always on art circuits that have limited reach, or in the closed worlds of diasporic and exilic communities. Those communities cannot amplify the memories of their homelands, for when they produce memories in their adopted countries, the memories remain mostly invisible, inaudible, and illegible to those outside the

communities. So it is that in a shooting war's mnemonic sequel, smaller nations and weaker peoples are outmatched because the aftermath is not fought only on their territory, where they have some advantages, but throughout the world, where they have many disadvantages.

By drawing attention to how industrial power exploits remembrance, a project such as this does not simply add even more memories to the surfeit of memories. This surfeit occurs often for traumatic events, and it happens not because the past has been worked through too much but because the past has not been worked through enough. A just memory suggests that we must work through the past or else be condemned to act out because of it, as Freud says.[21] But while this is true enough, it is also still not enough. Only sometimes can the past be worked out solely through therapy or individual effort, since the conditions of the past are often beyond the individual, as is the case with war. Given the scale of so many historical traumas, it can only be the case that for many survivors, witnesses, and inheritors, the past can only be worked through together, in collectivity and community, in struggle and solidarity. This effort of a mass approach to memory should involve a confrontation with the present as much as the past, for it is today's material inequalities that help to shape mnemonic inequities.

While revolutions in memory are thus not possible without revolutions in other aspects of social, economic, and political life, and vice versa, some scholars have argued that if we remember too much, we will be mired in the past, unable to move forward. Remembering too much, or remembering the wrong things, is supposedly part of an identity politics, a negative politics motivated by a feeling of victimization, or so the critics claim. For these scholars, identity politics encourages people to believe that they are members of a persecuted group rather than individuals, which incites them to resurrect old histories of grief and resentment that divide a nation from within or separate it from its neighbors. Undermining the na-

tion's identity, identity politics supposedly diverts us from real politics, the kind concerned with economy and class, money and mobility, the things that matter for people, country, and nation.[22] But those who insist that we should forget the past and focus on economic and class inequality do not see that inequality cannot be addressed without a just memory.[23] This kind of memory recognizes that nationalism is the most powerful form of identity politics, armed to the teeth and eager to harness all the nation's resources for war, including memory and the dead.

A just memory opposes this kind of identity politics by recalling the weak, the subjugated, the different, the enemy, and the forgotten. A just memory says that ethically recalling our own is not enough to work through the past, and neither is the less common phenomenon of ethically recalling others. Both ethical approaches are needed, as well as an ethical relationship to forgetting, since forgetting is inevitable. All individuals and groups are invested in strategic forgetting, and we must forget if we are to remember and to live.[24] A just memory constantly tries to recall what might be forgotten, accidentally or deliberately, through self-serving interests, the debilitating effects of trauma, or the distraction offered by excessively remembering something else, such as the heroism of the nation's soldiers. These excessive memories do not point to a just approach to the past, but to an unjust one, defined by what philosopher Paul Ricoeur calls "memory abusively summoned" by those in power.[25]

The response to unjust, repetitive memory is not to cease remembering an event that has been chewed over relentlessly, but to reconsider how we remember that event, who controls the industries of memory, and who abuses memory. A project of just memory indicates two ways of dealing with the problem of excessive memories. The passive route is to recognize that time and mortality offer a solution, for witnesses inevitably pass on. Their hardened memories turn to a handful of dust, fulfilling Nietzsche's claim that "without forgetting, it is quite impossible to *live* at all."[26] The other route to

fulfilling his claim is active, through the struggle to ethically re-member conflicted events. Acts of the imagination, the creation of memory works, and the entire artistic enterprise are crucial to this kind of just memory, but just memory can never be fulfilled solely through them. Art and ethical work are never enough to effect change without power. Just memory is only possible when the weak, the poor, the marginalized, the different, and the demonized, or their advocates, can influence or even seize the industries of memory. This struggle for what Ricoeur calls an *enlightened forgetting*, which leads the way to reconciliation and forgiveness, can only be done through an ethical memory that recalls one's own and others.[27]

This ethical practice inevitably questions identities, for if remem-bering one's own affirms deeply held notions of identity, remem-bering others challenges those notions. In so far as this work of just memory is done about war, it also challenges war's identity. If we no longer accept the identities of our enemies as provided by the au-thorities, we might find it difficult to accept the identities of the wars those same authorities give us. Negotiating between remembering one's own and remembering others does not mean that competing memories can be reconciled, only that submitting to only one eth-ical way of memory, at the exclusion of the other, will never suffice. Still, even a just memory which uses both these ethical approaches will not necessarily make us feel better about ourselves or recon-ciled with our deeds, our omissions, or our enemies. While just memory might lead to an enlightened forgetting of the horrors and conflicts of the past, it can also lead to a tragic awareness of what is irreconcilable within ourselves and within those near and dear to us. When it comes to war, ethical memory illuminates how war nei-ther emerges from alien territory nor is fought by monsters. War grows on intimate soil, nurtured by friends and neighbors, fought by sons, daughters, wives, and fathers. Our ambivalence about war's identity simply expresses ambivalence about our own identities, which are collectively inseparable from the wars our nations have

fought. These are the wars for which we have paid, from which we have benefitted, by which we are traumatized. Whatever may be noble and heroic in war is found in us, and whatever is evil and horrific in war is also found in us.

When it comes to war, the basic dialectic of memory and amnesia is thus not only about remembering and forgetting certain events or people. The basic dialectic of memory and amnesia is instead more fundamentally about remembering our humanity and forgetting our inhumanity, while conversely remembering the inhumanity of others and forgetting their humanity. A just memory demands instead a final step in the dialectics of ethical memory—not just the movement between an ethics of remembering one's own and remembering others, but also a shift toward an ethics of recognition, of seeing and remembering how the inhuman inhabits the human. Any project of the humanities, such as this one, should thus also be a project of the inhumanities, of how civilizations are built on forgotten barbarism toward others, of how the heart of darkness beats within. No wonder, then, that for Jorge Luis Borges, remembering is a *ghostly verb*.[28] Memory is haunted, not just by ghostly others but by the horrors we have done, seen, and condoned, or by the unspeakable things from which we have profited. The troubling weight of the past is especially evident when we speak of war and our limited ability to recall it. Haunted and haunting, human and inhuman, war remains with us and within us, impossible to forget but difficult to remember.

/ ETHICS /

1

On Remembering One's Own

DRIVE ALONG THE HIGHWAYS of Vietnam for any extended distance and you may notice, if you are looking for them, the cemeteries abutting the roads. Marking each one is an obelisk, a monument, or a sculpture, usually of a trio of heroes, sometimes including a heroine, tall enough to be visible from a distance. Draw closer and you will see a stone stela, engraved with the names of the dead. Every town and village has its own necropolis, devoted to the martyrs who died in the twentieth-century wars to unify and liberate the country. These burial grounds exist in America, too, and perhaps if I drove its freeways and thoroughfares looking for them, I would see them and think that America was preoccupied with its sacrificed warriors. This seemed the case in Vietnam, but possibly only because I had tasked myself with looking for these cities of the dead, traveling to find them by motorbike, bus, train, and private car. These cemeteries impact the geography in a way that would not be possible in the United States, for while the country is smaller than California and larger than New Mexico, there were more than a million dead to account for, if you counted only those who fought for the winning side. These dead victors inhabited every neighborhood,

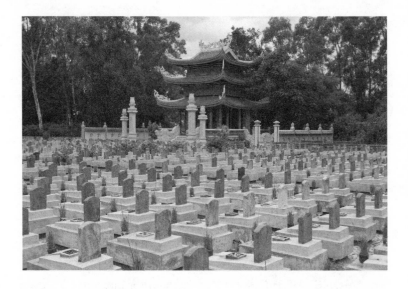

their resting places constituting the most visible and brooding re-
minders in this country of the ethics of remembering one's own.

Among these graveyards, the most spectacular is the Truong Son
Martyrs Cemetery. I think of it as the capital of the dead, a place
where over fifty thousand lay interred, nearly the same number as
those American dead commemorated in Washington, DC, at the
Vietnam Veterans Memorial. This martyrs cemetery is found out-
side the provincial town of Dong Ha in the province of Quang Tri,
its most prominent feature a gigantic white statue of Le Duan, the
man who had taken the leadership of the Communist Party as Ho
Chi Minh's health and influence declined. Some fifty meters tall,
the statue towers over a parade ground in the city center, as does a
similar statue of Ho Chi Minh in the northern city of Vinh, near his
birthplace. Perhaps to the locals these statues inspire awe, as they
seem designed to do. To me and perhaps to other outsiders, their
grandiosity seems so inconsistent with communist principles that
they are absurd. But in the land of democracy and equality for all

there broods a massive Lincoln on his throne, eyes fixed on the Washington monument's white, phallic spire. Regardless of ideology, something in humanity seems to require towering heroes and monuments, as well as the more horizontal affirmations of the masses. Quang Tri, the province where Le Duan was born and the scene of terrible bombardment and warfare, offers those more democratic commemorations. They assume the form of cemeteries for tens of thousands of the war dead, regimented in death as in life. Once they stood tall; now they lay supine.

Quang Tri was home to the demilitarized zone that had divided the country. Nearby is the fabled Truong Son Road, known as the Ho Chi Minh Trail to Americans and much of the world. This is a landscape that remembers war and holds it close. Embedded in the earth are war's explosive remnants, the bombs, shells, and mines that did not detonate as designed. Dormant and deadly, they at times activate and continue fulfilling their fate, ending the lives of over seven thousand provincial residents since the war officially concluded, and mutilating many more. No memorials commemorate these accidental dead, except for the prostheses attached to the citizens of Quang Tri who have lost limbs. In a clean and efficient lab, foreign agencies train local technicians to fabricate these artificial arms and legs. My traveling companion, a professional photographer, tries to take photos of these arms and legs. He cannot find an angle that pleases him. Every war has these human consequences that are not easy to frame in ways that would make them more acceptable, these amputees, these blind, these depressed, these suicidal, these insane, these jobless, these homeless, these side effects and delayed effects whose existence keeps memories of the war alive when most citizens would rather forget, or, at best, remember in circumscribed fashion.[1]

The cities of the dead fulfill this desire for a memory quarantined in both space and time, for the burial of the dead is a burial of contagious memory. As Marc Augé notes of the war cemetery at

Normandy, "nobody could say that this arranged beauty is not moving, but the emotion it arouses is born from the harmony of forms," which "does not evoke raging battles, nor the fear of the men, nothing of what would actually restore some of the past realistically lived by the soldiers buried" there.[2] Beautiful, quiet war cemeteries mask the certainty, recorded in many photographs, that these dead died in heaps, in fragments, in piles, in pieces, their limbs bent at impossible angles and their muddy clothes sometimes ripped from their bodies by the velocity of the manmade force that took their lives. Their gravestones become what Milan Kundera calls "melancholy flowers of forgetting."[3] On memorial days or private anniversaries, families will gather at the gravestones of their dead, who all too often met their fates in their teens or early twenties. But during the rest of the year, the dead are noticed only by their caretakers, who do their work as cows wander among the tombs.

In daylight, the capital of the dead is a peaceful and reverent place, exempt from the crowds and the clamor of the cities of the living. The atmosphere is somber but not gloomy, the red-roofed temples with their ornate eaves serene and the tombs tended and tidy. Many of the capital's features are shared with the smaller cities of the dead, the most important being the Mai Dich Martyrs Cemetery in Hanoi, reserved for the heroes of the Communist Party. Behind gated walls, nineteen luminaries rest on an elite boulevard, prestigious real estate lined with black marble tombs for the likes of Le Duan; To Huu, the party's poet laureate; and Le Duc Tho, winner of the Nobel Peace Prize along with Henry Kissinger for their negotiation of the Paris Peace Accords (Kissinger accepted his award but Le Duc Tho declined, for there was no peace to speak of in 1973). The boulevard leads to the center of the groomed grounds where an obelisk stands, engraved with *To Quoc Ghi Cong*, the Fatherland Remembers Your Sacrifice. This slogan is inscribed in all the places where the honored dead dwell. The Communist Party draws its vitality from the marrow of those bones, most of which

are found in cemeteries far less grand than Mai Dich.[4] In these more proletarian burying grounds, *Vo Danh* marks many of the gravestones—nameless, anonymous, unknown. Most of the dead have died far from home, and while they are not disrespected, they often exist in shabby circumstances, too distant for relatives to visit, looked on askance by those locals who see themselves as having been conquered by these martyrs. Their provincial cemeteries are often dusty and neglected, the grass withered, the tombs arrayed on bare earth, the names on gravestones and shrines faded.

In these cemeteries, the masses of the dead lay as inert as facts, a million of them, not counting the contradictory facts of the losers and bystanders. These facts are not memory but are interpreted, re-vivified, and placed into stories by memory's mechanisms, stories that change from time to time to suit the interests of the living. "Memory fades," the writer Joan Didion says, "memory adjusts, memory conforms to what we think we remember."[5] Mutable and malleable memory calls for an ethical sense, a guide on how to remember in fitting ways. Perhaps this need for a guide is particularly urgent when it comes to remembering the dead, who may have died for us or the community to which we belong, whom we might have killed or whom someone killed in our name. This need to remember the dead properly extends to all those whom we consider kin, by blood, affiliation, identification, community, sympathy, and empathy. These are the near and the dear, as the philosopher Avishai Margalit calls them, people for whom we naturally feel a bond because they belong to us through what he calls the "thick" relations of family, friends, and countrymen.[6]

A sense of natural affinity is what gives the ethics of remembering one's own its tremendous power, its capacity to draw from our emotions and to stimulate feelings that range from heartwarming to blood-boiling. We are in the thick of things when it comes to this kind of ethics, our feelings deep and our reactions quick, whether we speak of love in the private world or patriotism in the public

world. Because these ethics emerge from relationships that we deem natural, they often lead to unquestioning loyalty to those we remember, at least in the heroic version of these ethics. When it comes to war, we usually remember our own as noble, virtuous, suffering, and sacrificial. Uncomfortable questions about these heroes are unthinkable or recede into the background, unless circumstances force us to confront them. If and when we can finally acknowledge that those of our own side committed acts that cannot be reconciled with law and morality, we sometimes excuse those acts and their agents by blaming extenuating circumstances, such as the stress of combat. At worst, we may consider these acts as reactive and justified simply because the enemy acted immorally first. Even so, we continue to think that those of our side are human, demanding understanding and empathy as people endowed with complexities of feeling, experience and perspective. Those of the other side, our enemies, or at least those unfriendly or alien to us, lack those complexities. To appropriate the language of the novelist E. M. Forster, they appear in our perception as "flat" characters.[7] Those of our own side are usually "round," three dimensional, observable from all angles, thick in flesh, bone, feeling, and history. When they feel, and what they feel, so do we.

One exception in the prominence of round characters for this kind of heroic ethics is that those of our own side can also be flat characters, so long as they are positive. After all, there is nothing flatter than the dead in a cemetery, marshaled as characters into a narrative not of their own making. They remain obedient to the generals and statesmen who continue speaking on their behalf, telling the story that the Fatherland remembers their sacrifice. This mournful but triumphant Vietnamese story exemplifies the ethics of remembering one's own, unifying the cemeteries with the monuments, memorials, and museums that commemorate the war, where dead and living appear as both round and flat.[8] The greatest and flattest character in contemporary Vietnamese storytelling and memory is Uncle Ho. While the historical Ho Chi Minh is round and complex,

in life and in his biographies, the fictional Uncle Ho whose image is found everywhere is flat, featured most prominently on the country's paper currency.[9] This Uncle Ho is pure, sincere, and sacrificial, embodying all the ideals of the painful and glorious days of the revolution. So utterly attractive a character is he that even some of those from the losing side acquiesce to calling him Uncle. The persuasive, titanic, and heroic Uncle Ho proves Forster's claim that flat characters are not necessarily worse, aesthetically, than round characters. Flat and round characters simply serve different purposes. This flattened Uncle Ho is the one whom the revolution must remember, his image and icon continuing to urge on the people the heroic version of the ethics of remembering one's own, where their identity is one with that of party, state, and country.

Flat, heroic characters are commonplace, even fashionable, in Vietnam. They star on those billboards all over the country that exhort citizens to behave nobly and work for the nation. These billboards have their stylistic origins in wartime propaganda posters featuring revolutionary heroes and heroines, virtuous and smiling, chiseled and fierce, urging the people to unite and fight. Flat characters also dominate in the museums, from the Fine Arts Museum of Hanoi to the War Remnants Museum of Saigon, where the stories share a numbing sameness. In the common narrative of the country's museums, a foreign invader, French and later American, occupies the land and terrorizes the people. Communist revolutionaries, at great cost to themselves, mobilize and organize the people. Following the guidance of Uncle Ho, the Communist Party leads the people to victory. In the aftermath, with Uncle Ho gone but under his benevolent gaze, the Communist Party moves from total war to collective industry, shaping the country's increasingly prosperous economy. The shabby Museum of the Revolution in Hanoi presents this story for the entire country, beginning with black-and-white documentary photographs of colonial atrocities and legendary revolutionaries, ending with unintentionally pitiful displays of

economic triumph: textiles and sewing machines and rice cookers behind glass.

On a smaller scale and in the middle of the country, the Son My museum that commemorates the My Lai massacre focuses on the singular tragedy of the five hundred people murdered—some raped—by American troops. The aftermath of their story is the same as the common narrative, the triumphant revolution eventually transforming the war-blasted landscape of village and province with verdant fields, new bridges, lively schools, and lovely people. While the photographs that decorate these museums feature real people, the captions underlining them have stamped them flat, as in the Son My museum's display of Ronald Haeberle's most famous photograph, underwritten with this: "The last moment of life for villager women and children under a silk cotton tree before being murdered by the U.S. soldiers." Whoever these civilians and soldiers were in their complex lives and complicated histories, they exist in the caption as victims and villains in a drama that justifies the revolution and the party. The caption as genre echoes the slogan as genre, from Follow Uncle Ho's Shining Example to Nothing Is More Precious than Independence and Freedom. Slogans like these exemplify the Communist Party's story of itself, which has become, for now, the official story of the country and the nation.

Past these captions, slogans, and official commemorations, round characters do exist and are also a part of the ethics of remembering one's own. They walk and breathe in a few works of art that deviated from the dominant story and yet found their way to readers and viewers. Bao Ninh's *The Sorrow of War* was one, a landmark novel that expressed, for the first time, how the noble war to liberate the Fatherland was oftentimes horrific for the soldiers who fought in it. The novel begins in the months following the end of the war, with a team searching for the missing and the dead in the Jungle of Screaming Souls. Kien, the soldier at the novel's center, hears the dead too well. Once an idealistic volunteer and now a col-

lector of corpses, he has been "crushed by the war."[10] The sole survivor of his platoon, he vividly remembers the men and women he killed as well as his dead comrades. Still, he might have been able to bear these horrors but for the gangrenous disillusionment of the postwar years. "This kind of peace?" says the driver of the truck bearing the dead, among whom Kien sleeps. "People have unmasked themselves and revealed their true, horrible selves. So much blood, so many lives were sacrificed—for what?"[11] This is the universal question of the disillusioned soldier.

In an effort to make sense of death and disillusionment, of being surrounded by the dead, Kien becomes a writer. He is intent on imposing a plot on the past, "but relentlessly, his pen disobeyed him. Each page revived one story of death after another and gradually the stories swirled back deep into the primitive jungles of war, quietly restoking his horrible furnace of war memories."[12] Gusts of images swirl from this furnace until they settle near the novel's end, leaving him with two traumatic memories.[13] The first is the fate of Hoa, a female guide who led his men toward the safety of Cambodia. When American troops hunt them, she stays behind as a decoy, killing their tracker dog. After they capture her, the Americans, black and white, take turns raping her. Kien watches from a distance, too afraid to save her. Remembering this horrible scene provokes Kien into recalling another scene that came before it. In the earlier event, a teenage Kien sets off to war, accompanied on the train by his beautiful girlfriend Phuong. He is so devoted to her that he cannot bring himself to make love to her, despite her repeated invitations. This purity is a symptom of weakness rather than strength, at least in terms of how he perceives his masculinity. His weakness is revealed to him on the train, when he cannot protect her from fellow soldiers intent on gang-raping her. Years later, "he suddenly remembered what he thought he had seen in the freight car and what could still be happening there. He was to remember that as his first war wound. . . . It was from that moment, when Phuong was violently

taken from him, that the bloodshed truly began and his life entered into bloody suffering and failure."[14]

Too late and too fearful to save Phuong from the rapes she has already endured, the teenage Kien murders his first man, a sailor who tries to be next in line. Eventually he becomes an able killer, but despite his lethal ability, he will not save Hoa and cannot save Phuong from "what could still be happening there," raped by men driven by the same murderous urges found in Kien. If he gave in to murder, these other men gave in to rape, the erotic indistinguishable, at one extreme, from the homicidal. Rape is the hidden trauma, its climactic revelation destroying the masculine fiction that war is a soldier's adventure and a man's experience, or that war—over there—can be separated from the domestic world of the family, over here. "Can't you see?" Phuong cries after the rape. "It's not a wound! It can't be bandaged!"[15] The disturbing images of sexual violation at the novel's end incinerate the gentler language earlier in the novel, when Kien thinks how "the sorrow of war inside a soldier's heart was in a strange way similar to the sorrow of love. It was a kind of nostalgia, like the immense sadness of a world at dusk. It was a sadness, a missing, a pain which could send one soaring back into the past."[16] The novel traces this journey into the past, where war and love's paper-thin abstractions are fed into memory's hot furnace, the ashes revealing how the heady ideals of romance, purity, and patriotism devolve into rape, slaughter, and trauma.

But what is the relationship of these rounded characters of memorable fiction to the flat characters of the country's cemeteries, museums, and propaganda? While round characters are sometimes antiheroic, and the flat characters of one's own side are usually heroic, both enact the ethics of remembering one's own. Regardless of whether those we remember are saintly or all too human, the ethical force of remembering one's own reinforces the shared identities of family, nation, religion, or race. In the ethics of remembering one's own, remembering those of one's side, even when they

do terrible things, is better than ignoring them altogether. Nothing is worse than being ignored, erased, or effaced, as the losers of any war or conflict can affirm. In memory wars, a victory is had in simply being remembered and being able to remember, even if one's self and one's own appear troubled, tortured, even demonic. The antiheroic version of this kind of ethics dwells in the nebulous world of the chiaroscuro, half-lit, half-obscured. No surprise, then, that by the end, Kien the writer vanishes from his apartment and into the shadows, leaving only his manuscript. The last words of the novel, spoken by the unnamed person who discovers Kien's manuscript, commemorates why the warrior and writer must disappear: "I envied his inspiration, his optimism in focusing back on the painful but glorious days. They were caring days, when we knew what we were living and fighting for and why we needed to suffer and sacrifice. Those were the days when all of us were young, very pure, and very sincere."[17] The war and the Communist Party may be condemned in the pages of the novel, but not the young people and the true patriots who sacrificed themselves. Both an idealist in looking back and a cynic in looking at the present, Kien is not fit to live in a postwar society that only speaks about the glorious brightness of war. He, like many of the war's survivors, men and women both, dwell in the crepuscular margins of melancholy, loss, and sorrow.

At least these veterans of the revolution are remembered by their country in some way, even if inadequately. In contrast, those who fought for the losing side are disremembered. They can be discovered by driving on from the Truong Son Martyrs Cemetery and heading further south on Highway 1A. This is the nation's main artery, a crowded, noisy, and slow two-lane road running the length of the coast and lowland interior. This trans-Vietnamese route eventually reaches the outskirts of Ho Chi Minh City, or what many still prefer to call, for reactionary, sentimental, or simply lyrical reasons, Saigon (itself a name of memory and forgetting, given to a city conquered by the Vietnamese people on their great march south, a

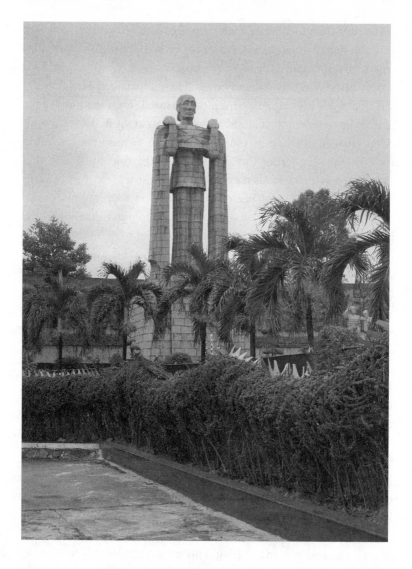

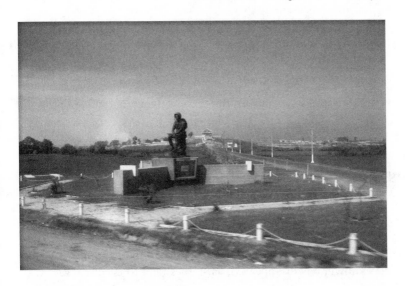

history remembered by the Vietnamese as a feat of nation-building rather than bloody imperialism). Past the industrial zone on Saigon's edge where the sky is always a sheet of smog, one will see, on the border of the highway, a grand martyrs cemetery. A towering statue of a mother grieving for these martyrs gazes across the highway. The crowded landscape of factories, billboards, and roadside homes she sees is unremarkable, unless one knows what was once there. Many years ago, during the war years and before the victors built the martyrs cemetery, there sat on the other side of the highway another statue, a soldier of the Army of the Republic of Vietnam, pensive on a rock as he gazed on the road from his modest six-meter height.[18] Behind him was the vast national cemetery for this southern army.

In the days when the mourning soldier still surveyed the land, it was barren and sparsely populated, and the cemetery and pagoda behind him could be seen from the road. Of this time and this place, journalist Michael Herr noted that

there is a monument to the Vietnamese war dead, and it is one of the few graceful things left in the country. It is a modest pagoda set above the road and approached by long flights of gently rising steps. One Sunday, I saw a bunch of these engineers gunning their Harleys up those steps, laughing and shouting in the afternoon sun. The Vietnamese had a special name for them to distinguish them from all other Americans; it translated out to something like 'The Terrible Ones,' although I'm told that this doesn't even approximate the odium carried in the original.[19]

More than thirty years later, the landscape has changed, but the abuse aimed at the cemetery has not. The mourning soldier, as he was known, has disappeared, as statues tend to do after wars end or regimes collapse. The cemetery itself is not marked by any signs and is invisible from the highway. Drive a hundred meters down a spur from the highway and one will see, at last, the cemetery's entrance, a memorial gate overgrown by green foliage, the lettering on its faded pillars proclaiming the need for sacrifice and struggle. Workers on their noon break sit on the littered steps, smoking cigarettes. At the top of the stairs, another laborer dozes on a hammock strung between a pillar and the faded blue doorframe of the pagoda, its white walls serving as pages for lines of graffiti. Inside, the pagoda is empty except for a makeshift shrine on a wooden table, decorated with flowers in vases and an urn for incense. On my first visit, a corner of the room is charred from a fire where someone has burned something, a fire on a cold night or perhaps paper offerings to the dead. There is nothing else to see.

The actual cemetery lays a few hundred meters further west. No signs mark the route to the cemetery, which turns out to be closed for lunch. Its barred gate is rolled shut, the office is empty, and there is no indication of when anyone will return. I have traveled a long distance on a hot day, I am impatient, and over a lifetime I have

learned lessons from the Vietnamese people about letting nothing get in our way. I crawl under the gate. The cemetery that I discover is the ugly, beaten, closeted cousin of the one celebrating the victors across the highway. There are the same rows of tombs nearly level with the earth, but they lay unloved, unpainted, and untended amid green meadows of uncut grass and groves of shade trees. In the center of the cemetery squats an unfinished gray hulk of a memorial obelisk, resembling an industrial smokestack. Most of the tombs are little more than neglected slabs and headstones, but a handful have been rebuilt recently. Composed of granite and marble, they appear cleanly swept and feature fresh photographs of their inhabitants. The desecrated tombs far outnumber these rehabilitated ones. Someone has vandalized the photographs of the dead on these desecrated tombs, scratching out the eyes and faces. I do not have time to count the numbers of defaced dead. Worried about my illicit entry, I return to the gate, where I find the staff has returned. My presence bemuses this handful of functionaries in sandals and short-sleeved shirts, who record my passport's information in a ledger. When I return to visit the following year, a blue, solid metal gate on rollers has replaced the barred gate with the gap underneath. I cannot slip beneath this time. A brand new sign installed next to the gate proclaims this the People's Cemetery of Binh An, which was not the name it bore during the war, the National Cemetery of the Army of the Republic of Vietnam. Once again I present my passport, and this time one of the staff follows me as I walk from grave to grave, put-putting on his motorbike.

These decaying tombstones and this neglected cemetery evoke in me the same emotion I sometimes felt in libraries of years past, encountering books whose checkout cards recorded last encounters with readers from decades ago. Forgotten people and forgotten books exude the same melancholy, for books, too, live and die. Bao Ninh writes of how Kien's novel has its own autonomy, how it "seemed to have its own logic, its own flow. It seemed from then on

to structure itself, to take its own time, to make its own detours."[20] What alleviates melancholy in both *The Sorrow of War* and this Bien Hoa cemetery is the sense that both books and the dead live in their own ways. "As for Kien, he was just the writer; the novel seemed to be in charge and he meekly accepted that."[21] After the novelist disappears, his book remains. In the cemetery's case, the dead are too dangerous to be unguarded, but also too dangerous to be bulldozed, or at least completely. They remain a precious resource, for the state might one day use them to reconcile with the country's defeated exiles.

They, too, demand their share of memory. They have created plans for renovating this cemetery and display them in the only museum that commemorates their experiences, the Museum of the Boat People and the Republic of Vietnam. It stands in the History Park of San Jose, California, the city where I was raised and home to a Vietnamese community that is the second-largest outside Vietnam. A small, two-story Victorian house, the Viet Museum, as it is also known, is an apt metaphor for exilic memory, overstuffed with amateurish exhibits and historical relics kept in someone else's home. Its hours are so irregular that the first two times I visit, the doors are locked. I peer through the windows to see mannequins outfitted in Republican uniforms and a bronze sculpture of a slightly larger than life southern soldier, all inhabiting what was once a parlor. On my third try, the museum is open, run by husband and wife custodians. The mood in the handful of rooms, denoted in the captions and narratives, is one of sorrowful memory and mourning for dead soldiers, forgotten heroes, and what I think of as oceanic refugees, a term that lends more nobility to the sufferings and heroism of those whom the Western press called the "boat people." The soldier is not in a fighting posture. Instead, he kneels before a comrade's grave, while nearby a small diorama shows a model of the national cemetery, as groomed and as green as it could be if the victorious state would allow it. Until that moment of reconciliation, the state

and party will exclude the exiles and their dead from memory, for part of the ethics of remembering one's own is the exclusion and forgetting of others.

But this forgetting also begets remembering (sometimes thought of as haunting). This is especially the case when forgetting is not accidental but deliberate, strategic, even malicious—in other words, disremembering. Thus, in the aftermath of any war or conflict, the defeated and disremembered will inevitably seek to remember themselves, although not as others. So it is that the refugees from this country and this war have also engaged in an ethics of remembering their own, knowing their country of origin has erased or suppressed their presence. The greatest work of collective memory these defeated people have created is not a museum or a memorial or a work of fiction but is instead their archipelago of overseas communities, the largest and most famous of which is Little Saigon in Orange County, California. Little Saigon and similar communities worldwide are "strategic memory projects," as scholar Karin Aguilar-San Juan calls them.[22] Little Saigon's residents see it as the embodiment of the "American Dream in Vietnamese," where capitalism and free choice reign.[23] Bolsa Avenue in Little Saigon is the most famous thoroughfare in the refugee diaspora, its eight lanes more commodious than Highway 1A, its sidewalks more usable than any in the country of origin, its restaurants cleaner and oftentimes offering better native food than that found at home. For more than a decade after war's end, perhaps two, as the homeland suffered from failed collectivist economic policies, explosive inflation, the rationing of necessities, and an American embargo that was part of a continuing "American war on Vietnam," Little Saigon's malls were more spectacular and its entertainment industry more vibrant than the homeland's.[24] Little Saigon was a triumph of capitalism and a rebuke against communism, and in this way it fulfilled its role as the ultimate, much belated strategic hamlet so desired by the southern government and its American advisors.

The original strategic hamlet program was designed to persuade the peasantry that their best interests lay with the southern government and the Americans, who coerced them into fortified encampments meant to isolate the guerillas from peasant support. In practice, the guerillas infiltrated the hamlets, while the residents often resented the government for forcibly evacuating them from their farms and ancestral homes. While these strategic hamlets were crude, blunt instruments, Little Saigon is an example of American capitalism and democracy operating at a refined level of soft power. If Ho Chi Minh City is now a better place to live than Little Saigon for many of those with privilege, it is because the Communist Party adopted the capitalist practices and consumer ideology of Little Saigon. As strategic hamlet, Little Saigon beckoned for years to the people of the homeland to come to America, as oceanic refugees, as Amerasians, as reeducation camp survivors, as family members reunited through immigration policy, as spouses of citizens. All were marginalized or punished in their homeland under communist rule and chose to flee or migrate to a land that promised wealth and inclusion. But Little Saigon as strategic hamlet is not just physical real estate. It is also mnemonic real estate, for according to the informal terms of the American compact, the more wealth minorities amass, the more property they buy, the more clout they accumulate, and the more visible they become, the more other Americans will positively recognize and remember them. Belonging would substitute for longing; membership would make up for disremembering. This membership in the American body politic would be made possible not only by economic success, but also through winning those political and cultural rights of self-representation denied to the exiles and refugees when they lived under communism. Memory and self-representation are thus inseparable, for those who represent themselves are also saying this: remember us.

The Vietnamese in America understood that strength and profit came in the concentration of their numbers. Thus, like other new

arrivals, they gathered themselves defensively into ethnic enclave, subaltern suburb, and strategic hamlet, those emergent landscapes of the American dream distinct from the sidelined ghetto, barrio, and reservation of the American nightmare. Enclave, suburb, hamlet, ghetto, barrio, and reservation are examples of *lieux de memoire*, the sites of memory that have, in the modern age, substituted for history, or so says scholar Pierre Nora.[25] American society created these particular *lieux de memoire* through centuries of warfare, exploitation, appropriation, and discrimination, practices that tell the inhabitants of these sites to remember their place. These inhabitants also tell themselves to remember their place. They understand that if they have any hope of being remembered by Americans, they must remember themselves first. For Vietnamese refugees, the most important anniversary is April 30, the date of Saigon's fall, which they call Black April (although white is the color of mourning in Vietnamese society, calling this day White April would likely offend, or at least confuse, white Americans, around whom the Vietnamese in America are usually on their best behavior, polite at the least and often solicitous at the most). On Black April, hundreds of veterans of the Republic of Vietnam's military forces gather at the Vietnam War Monument located in Freedom Park on All American Way in Garden Grove, Orange County. A portable memorial showcases photographs of communist atrocities and ragged boat people. Commemorative wreaths decorate a shrine honoring dead soldiers. Speeches are given by local politicians and former generals and admirals, one of whom, during the memorial's dedication in 2003, proclaimed the invasion of Iraq to be an extension of the Vietnam War. Once again, America was defending freedom, a claim with which no one disagreed. The national anthems of both the United States and the Republic of Vietnam play as honor guards march forth with the flags of both countries, parading before veterans displaying themselves in recreations of their old uniforms. The veterans are se-

nior citizens, their supporters numbering in the several thousands at the dedication and in the several hundreds in subsequent years. Theirs is a ferocious display of patriotism, at once spectacular and yet small, inadvertently showing what Vladimir Nabokov calls the "gloom and glory of exile."[26]

This gloom and glory arises from how loss has stung exiles and the related breeds of refugees, immigrants, and minorities. They have lost their countries of origin, either by choice or circumstance, and their hosts often see them as others. This sense of loss and otherness inflects their memories differently from the memories of majorities. For majorities, the ethics of remembering one's own can range from heroic to antiheroic. The power and privilege of being the majority usually provides enough security to allow the antiheroic, although this is not always the case, as in authoritarian societies where the state's near-total grasp of power paradoxically breeds a great insecurity about power. In a related fashion, for those who see themselves as marginalized, dominated, excluded, exploited, or oppressed, the antiheroic takes time to develop. This is because weaker populations can ill afford to seem less than powerful to the powerful. Thus, the ethics of remembering one's own as practiced by the less powerful is usually done first in the heroic mode. Their longing for their past is what scholar Svetlana Boym calls "restorative nostalgia," the desire to reproduce, wholesale, what once was.[27] Only later, when the less powerful feel more secure in their host country, or after they give up on the host country's promises, does the antiheroic mode flourish in stories of the morally flawed or culturally inassimilable. The antiheroic mode has not yet, for the most part, developed among the Vietnamese in America, with one of the most visible exceptions being the writer Linh Dinh, of whose grotesqueries I will say more later. Otherwise, Vietnamese American art, literature, and film, while often depicting the troubles of refugee life and the haunting past, nevertheless prefer the beautiful to the grotesque

and the heroic to the antiheroic. Collectively, Vietnamese American culture, for better and for worse, foregrounds the adaptability of the Vietnamese and the promise of the American dream, albeit with some degree of ambivalence.

For these Vietnamese exiles in America and many of their descendants, remembering one's own takes place in relationship to, and often antagonism with, the national projects of remembering one's own in Vietnam and America. These projects often ignore them and when they do notice them, usually cast them in less than heroic terms. So it is that Vietnamese Americans, for now, insist on the heroic mode in remembering themselves. Since the most heroic are the dead, perhaps the most symbolic way these ethical practices of remembering can be reconciled is over the bodies of the dead. But even in pluralist America, the weak and the defeated find themselves rejected. American veterans have rebuffed the request of Vietnamese veterans to be included in their war memorials in places such as Kansas City, and no mention of Vietnamese veterans exists in the Vietnam Veterans Memorial of Washington, DC.[28] Arlington National Cemetery would also presumably turn these veterans away if they asked to be buried there. This was what happened, after all, to another American ally, General Vang Pao, leader of the Hmong soldiers who fought for the CIA in Laos during the so-called Secret War (which was, of course, not a secret to the Hmong who fought it, just as the Cold War was not cold to the Asians who killed and died for it). Good enough to die for American interests in vast numbers, good enough to lose their home to America's enemies, these Hmong soldiers are not good enough to be buried alongside American soldiers. Their deaths, too, will remain secret to American citizens.

Come home, then. That should be the message that the countries of origin send to their exiles in the future, through the way these countries deal with the dead. At the Bien Hoa cemetery, the dead lay ready to be called on once more to serve a national cause, this

time of reconciliation. Meanwhile, in Quang Tri province, arduous efforts to excavate dormant bombs, mines, and shells have also uncovered the bones of the dead from both sides. In a sunbaked field, a demining squad that has searched meter by meter for this ordnance has also uncovered the remains of six or seven southern soldiers. They were buried in a local cemetery. Not far away, in Dong Ha, the remains of two northern soldiers were also recently found. My guide from the demining organization tells me that national reconciliation means we should not distinguish between northern dead and southern dead. He speaks without bitterness or melancholy, even though the French killed his paternal grandfather and the Americans killed his maternal grandfather. Bespectacled and in jeans and a t-shirt, my guide looks no different than any of the Vietnamese who return from overseas. But my embittered Vietnamese American compatriots, remembering their losses and their own dead, may not so readily bring themselves to share his sentiment. It is difficult for them when stories like this, remembered by refugee Hien Trong Nguyen, interfere:

When [my brother] died in 1974, he was only 22 years old. Five years after my brother's death, the Communists plowed the cemetery for Southern soldiers, where my brother was buried, in order to build a military training center. My mother decided to exhume his body and move him. During the next few days, my parents, uncle, cousins, and I went to remove his body. When I first looked at his body, I was amazed and frightened to see that he looked as if he were only sleeping. His body was wrapped inside a plastic bag, and the coffin had been specially made so that water would not seep in. My family took his body and removed all the skin and flesh so that only bones remained. The skin came off just like a glove. The bones were washed and put in a smaller box.[29]

Generosity comes easier when one has won, and the victorious find it in their best interests to be magnanimous to the defeated. I do not mention this to my guide as we watch the men in khaki probe the earth, their work slow and hot. I think we are both aware that survivors do not so easily forget history. What once happened here could still be happening for many, the past as explosive as any of the remnants buried in this land.

2

On Remembering Others

A BLACK WALL STANDS in the American capital, embedded in the earth. Inscribed on its surfaces are the names of over fifty-eight thousand Americans who fought and died in the war. For many visitors, the power of the wall arises from these names of the dead, which evoke these biblical verses: "There be of them, that have left a name behind them, that their praises might be reported. And some there be, which have no memorial; who are perished, as though they had never been; and are become as though they had never been born; and their children after them."[1] The black wall saves from oblivion the names of those soldiers who had been forgotten or at least ignored by their fellow Americans for a period of time. Although the wall's critics despise its aesthetics, which they see as evoking the darkness of shame, many others see it as the most powerful of American memorials.[2] Designed by the architect Maya Lin, the wall is a geographical site of memory that compels and depends on its verbal, visual pun: the sight of memory. Many things are seen at this site, with the three most important being the names of the dead, the presence of others, and the reflection of oneself as visitor in the wall's dark mirror. The names call forth to visitors,

who themselves, as pilgrims and mourners, call on these names and sometimes call them out. This site, these names, and these visitors create a congregation, a communal experience of memory that is visible and sometimes audible.

Given that the black wall has played an important role in how America remembers its war dead, it would be easy to mistake the black wall and the mourning it conjures as a pure expression of the ethics of remembering one's own. The wall is the centerpiece and symbol of a mass American effort from the 1980s until the present to remember the American dead, a campaign born as a reaction to the civil war in the American soul that was America's experience of the war, its most divisive since the actual Civil War. This division contributed to the decline in esteem of the American military and its soldiers. Many saw these soldiers as losers who fought in a dirty war that took the lives of innocents, civilians, and freedom fighters, and so it was that throughout the 1970s the war was a difficult subject for many to speak of, including veterans.[3] Some of these veterans, inspired, perhaps, by the movements that struggled for civil rights and spoke out against the war, decided that they, too, should speak out for themselves and demand recognition. They led the campaign that created the Vietnam Veterans Memorial, its intention to encourage Americans to remember these soldiers as some of their own, rather than as others who evoked only disgrace and humiliation.

Various surgical procedures of memory have healed the wounded reputation of the American soldier. The black wall is the most symbolic—a cut and a wound in the earth, but also a scar and a suture. Politicians and presidents have visited the wall and praised these soldiers. Filmmakers and novelists fought the war again and again in movies and literature, casting these soldiers as the main characters.[4] Whether they appeared as heroes or antiheroes, as was often the case, they demanded sympathy and empathy for their virtues and their failures. The rise in compassion for the American soldier among the American public helped to create a resurgence of patri-

otic feeling, providing solid evidence of how the arts of memory are shaped by the world and shape it in turn. This patriotic feeling has been fundamental to America's increasingly pugilistic stance since the 1980s, when it began to test its revised, all-volunteer military with small adventures in Grenada and Panama. The early results against vastly outnumbered foes were good, and the American public did not reject these efforts; thus encouraged, the United States struck against Saddam Hussein's forces in Kuwait. This Gulf War was an application of the lessons that some Americans learned from the earlier war: avoid guerrilla conflict and nation-building; refine American technological superiority; and apply overwhelming force in conventional land, sea, and air battles. With Saddam Hussein's forces routed in spectacular fashion, President George H. W. Bush could claim: "By God, we've kicked the Vietnam syndrome once and for all."[5]

Presidents and pundits understand the "Vietnam syndrome" to be the fear of failure and the moral revulsion to war that have plagued Americans since their defeat in Vietnam. The shamed American soldier and the antiwar movement were symptomatic of this syndrome. Both had to be treated in postwar operations of memory, where absences became as telling as presences. Present in the black wall are redeemed American soldiers. Absent from the memorial are the casualties who are easier to forget, the veterans who suffer from trauma, or are homeless, or have committed suicide, as the memorial's most astute critic, Marita Sturken, observes. Collectively, these postwar dead and wounded far outnumber the wartime deaths, but this nation, like other nations, has difficulty acknowledging them and their ills. Nations prefer that wars finish quickly, the wounds cauterized in memory through the conventionally understood "war story" rather than remaining open and infected. One version of the war story is captured in a catchy postwar slogan that might have been written by an advertising firm: Oppose the War but Support the Troops. As the historian Christian Appy notes, the slogan "has often been used as a club to dampen antiwar dissent."[6] The slogan

implicitly evokes the memory among many Americans that they did not support their troops during the war in Vietnam and calls on them now to support the troops fighting in current wars. In doing so, the slogan also suppresses troubling questions. Perhaps one could support the troops if one only opposed the war on issues of foreign policy, or if one simply did not agree with the expenditure of American treasure on military adventurism. But if one opposed a war because it killed innocent people, then how could one support the troops who inflicted the damage? Do they not bear moral responsibility for killing? Might they not bear some political responsibility for a war that they implicitly supported through their votes, their attitudes, and their actions? The question of responsibility is particularly pressing for an all-volunteer army versus an army with many draftees, as was the case in Vietnam. Martin Luther King Jr. judged this draftee army, with its racially diverse soldiers, as one that behaved "in brutal solidarity" against the Vietnamese. Would not a volunteer army be even more prone to such a judgment?

The slogan's refusal to judge soldiers also implies a refusal to judge the civilians. What lies behind the slogan is not only support for the troops but the absolution of the same civilians who utter the slogan. If the hands of the troops are clean, so are the hands of these civilians. As for the American dead, they have not died for nothing after all. This slogan has arisen in their memory, proving once again that the memories the living create of the dead—and the dead themselves—are strategic resources in the campaigns of future wars. Once the dead seemed to cry out against war, but now, just as plausibly, the dead seem to cry out in support of our troops who wage new wars. At least this is what the living say, and it is what the living say that really counts. As the scholar Jan Assman writes, "if 'We Are What We Remember,' the truth of memory lies in the identity that it shapes. . . . If 'We Are What We Remember,' we are the stories that we are able to tell about ourselves."[7] The story of supporting the troops affirms an American identity invested in the justice of Amer-

ican wars and the innocence of American intentions. This identity is the true "Vietnam Syndrome," the selective memory of a country that imagines itself as a perpetual innocent.

Graham Greene both diagnosed and mocked this version of the Vietnam Syndrome in his novel *The Quiet American*, featuring the sober, idealistic, and almost virginal CIA agent Alden Pyle. In the name of supporting an anticommunist "third force," he smuggles explosives into the post-French, pre-American Vietnam of the 1950s. Although it is not Pyle's intention that this third force will kill civilians with these explosives in terrorist bombings, they do. Greene's point is that both innocence and intention are excuses for the inevitably fatal consequences of American intervention. In this version of the Vietnam Syndrome where America is the dangerous naïf, war is something that Americans love rather than fear, despite any denials to the contrary. How else to explain the many wars that America has fought in its American century? What made Vietnam unique for Americans was that this love was unrequited, the war a tragic affair that ended badly, which Greene signaled in casting the fickle and enigmatic Phuong as Pyle's lover. Pyle sincerely loves Phuong and wishes to marry her, but his demise, murdered by agents of the Viet Minh, seems not to bother her very much. While the campaigns in Grenada and Panama and the wars in Kuwait, Iraq, and Afghanistan have not generated these kinds of romantic allegories, they are efforts by American leadership to rebuild the American people's love for war. The American soldiers who fought these wars make the emotional connection between past and present conflicts easily enough, or so argues former Marine Anthony Swofford as he describes the Marines preparing for Kuwait:

For three days we sit in our rec room and drink all of the beer and watch all of these damn movies, and we yell Semper fi and we head-butt and beat the crap out of each other and we get off on the various visions of carnage and violence and deceit,

the raping and killing and pillaging. We concentrate on the Vietnam films because it's the most recent war, and the successes and failures of that war helped write our training manuals.[8]

These soldiers love war, or at least the idea of war, which is no surprise, as war is their calling. In order to love war and love their own side while hating the other side, they remember their own.

The black wall does not engage in such an obvious ethics of memory, although political interests have used it for that purpose. If the black wall engaged directly in this call to remember only one's own, especially in the virile ways that the Marines enjoy, it would not be a very compelling memorial. Many memorials are more transparent and upright about celebrating wars, masculinity, heroism, and sacrifice, and few elicit the depth of attachment from visitors that the dark wall does. The wall's power does not come from its complete commitment to war and soldiers but from its deep ambivalence about war and soldiers, who do not even appear personified as figures, faces, or bodies. The black wall is both mirror and barrier, and this is what shapes and creates the ambivalence. As a mirror, the wall shows the figures, faces, or bodies of its visitors over the names of the dead, while as a barrier, the wall separates the living from the dead. In this way, the wall foregrounds feelings of recognition and alienation, of intimacy and distance, of the relationship between the living and the dead. Both mirror and barrier, both a place that evokes sight and is a site, the wall captures how the dead belong to the living as their own but are also irrevocably other. And yet that otherness—the mystery and terror of death that is embodied by the dead—is one that will inevitably be shared by the living, who sense the otherness of their own inevitable mortality calling to them from behind that black wall. What makes the black wall powerful is its embodiment of remembering oneself as well as its evocation of otherness.

Maya Lin's reflections on the black wall's design suggest that the world around her shaped her aesthetic and the memory of being

both oneself and other. "*To some, I am not really an American,*" she writes with emphasis, reflecting on her childhood in the American Midwest and the controversy around her selection. Lin was a college student when she won the competition for the design of the memorial, and some viewed her selection as an affront. They could not understand how a woman, a youth, and a Chinese American could design a memorial for men, for soldiers, and for Americans. The "feeling of being other . . . has profoundly shaped my way of looking at the world—as if from a distance—a third-person observer."[9] Compare this late-twentieth-century experience with W. E. B. DuBois's claims in *The Souls of Black Folk*, from 1903:

> the Negro is a sort of seventh son, born with a veil, and gifted with second-sight in this American world,—a world which yields him no self-consciousness, but only lets him see himself through the revelation of the other world. It is a peculiar sensation, this double-consciousness, this sense of always looking at one's self through the eyes of others.[10]

Many minorities besides African Americans also claim double consciousness for themselves. They experience this distinction between America's dominant self—the white self—and its darker others not only in a worldly way, as part of a group cast as other, but also in a personal way. "One feels his two-ness,—an American, a Negro; two souls, two thoughts, two unreconciled strivings; two warring ideals in one dark body, whose dogged strength alone keeps it from being torn asunder."[11] The black wall emerges from this divided way of seeing the world for Maya Lin, but what is also powerful about double consciousness is its universal quality, one that paradoxically arises from the particularity of black experience.

While minorities may experience double consciousness regularly, even daily, the power of the black wall is that it conveys that sense to individuals who are not used to experiencing it, and then reconciles that duality. These visitors experience the double consciousness of seeing themselves and being seen by the dead, the ghosts of the

soldiers who together comprise, in the words of classicist James Tatum, "an insurrection of the dead."[12] Perhaps what the visitor who touches the black wall and is touched by it feels is the sense that she, too, is a minority, regardless of race or culture. In this instance, one's minority identity is to belong to the living, outnumbered by the hosts of the dead. But this moment of double consciousness is reconciled for many, if not all, by the commemorative, nationalist calls that have been delivered by presidents, soldiers, and veterans around the black wall. These nationalist calls allow visitors to mourn with and for the dead, and to submerge the potentially troubling manifestation of double consciousness into the singular consciousness of national identity, of the American, the patriot, the good citizen.

Through its design and its effect, the black wall reveals the porousness between the two ethical models of remembering one's own and remembering others. In the crudest version of the ethics of re-

membering one's own, we draw a clear line between us and them, the good and the bad, the here and the there, the living and the dead (for we will smite our enemies if they are not already dead). Such an ethics motivates people to fight wars against their enemies and draws from those "thick" relations of family, friends, and countrymen described by philosopher Avishai Margalit. Thick relations are apparently natural to Margalit, but in actuality these bonds must be made by us with people who are originally other to us. We solidify these bonds over time with the stories we tell ourselves about our love for our family, friends, and countrymen. The idea of family obscures this process of thickening because many people think of family bonds as natural, even though much evidence of alienation within family exists, from murder, abuse, violence and pedophilia to apathy, rivalry, and hatred. The biblical story of Cain and Abel tells us that it is as natural to kill those close to us as it is to love them, while Freud's psychoanalytic story tells us that the gap between self and other begins within oneself soon after birth, at the mirror stage which Maya Lin's reflective wall invokes. But despite this alienation from others and ourselves, the lucky among us discover that our family loves us, and we learn to love them in return. Gradually we extend the circle of the near and dear to those strangers who become our friends and neighbors, then our countrymen, until some of us learn the ultimate lesson, as Bao Ninh writes of Kien: "He would understand true sacrifice: friends who would die to save others."[13] But under the sway of patriotism and nationalism, we forget that we have learned how to remember these others, that our love is acquired rather than spontaneous.

The black wall and the controversies around it both illuminate and obscure how remembering one's own and remembering others are always at play together. For many Americans, the black wall tells the story of how some among us were cast out, how they eventually came back, and how we welcomed them, at last restoring friendship, familial bonds, patriotic feelings, and good relations between citizen

and soldier. Some of the controversies around the black wall arise, however, because some visitors feel that the black wall is not inclusive or reflective enough. This is the paradox of the ethics of remembering one's own, that to be successful, it must convince the right others that they are recognized or should want to be recognized. This is also the problem of the mirror and the sight of memory: does the mirror reflect us, or the image of us that we would like to see? Does the mirror make us feel whole or does it make us feel like an other? Some veterans and their supporters did not see themselves reflected in the black wall's memory; feeling themselves to be excluded, to be other, they demanded better representation. The visitor to the Vietnam Veterans Memorial thus encounters not only the black wall but also two sculptures nearby, one featuring black, white, and Latino GIs, weary and contemplative as they gaze at the wall, the other with three nurses tending to a wounded soldier. These sculpted soldiers and nurses are heroic, human, and embodied, commissioned by the memorial's authorities to address the concern that the wall, without bodies and faces, could neither represent nor recognize the veterans. These sculptures also exist, then, to remember the nation's own.

In order to do so, these sculptures require the nation to remember some of its historical others—minorities and women. Only a decade or two before the creation of the black wall, memorials, movies, or stories of American soldiers would not have featured minorities or women as the equals of white men, in the unlikely chance they were included at all. It would not be natural to include these others in a world where characters such as John Wayne or George Washington embodied the American soldier. In a society oriented around white men in power, women and minorities are what Margalit calls "strangers"[14] and Paul Ricoeur calls "distant others."[15] And yet, thirty years after the black wall's creation, what the sculptures show is that an American military without minorities is unthinkable. This narrative of an America made powerful through its diversity is embodied in America's first black president, Barack Obama, who had this to say about the war:

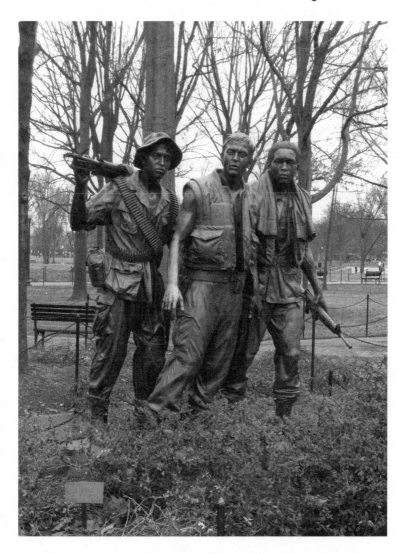

The Vietnam War is a story of service members of different backgrounds, colors, and creeds who came together to complete a daunting mission. It is a story of Americans from every corner of our Nation who left the warmth of family to serve the country they loved. It is a story of patriots who braved the

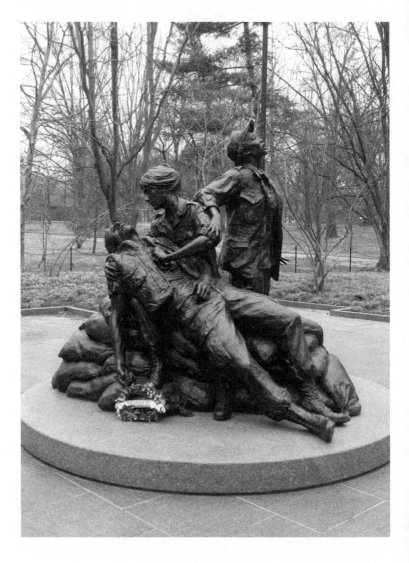

line of fire, who cast themselves into harm's way to save a friend, who fought hour after hour, day after day to preserve the liberties we hold dear.[16]

The recasting of this war as a heroic and patriotic endeavor is thus intertwined with optimism about reconciling the differences within American society and its military. In another thirty years, it is possible that an American military without women, or gays and lesbians, will be unthinkable, even if, for Margalit, these populations would today be strangers and distant others to many of "us." For him, ethics covers the thick relations between the near and the dear, while morality governs the "thin" relations between "us" and our strangers and distant others.[17] If Margalit indeed accepts this distinction between thick and thin as natural, the example of the memorial shows us that this distinction is not inevitable, but acquired. As people able to learn both love and hate, we expand our circle of the near and dear to include others, and formerly thin relations become thicker.

Rather than think of "our" relationship to others as a thin one existing in a moral realm, influenced by religious codes, I think of this relationship as existing in an ethical realm where people can struggle to remember others through secular acts of inclusion, conversation, recognition, and hope. The remoteness of these strangers and distant others is not only a function of geography, as Margalit implies. Sometimes we detest our neighbors and feel more affinity for those far away, as is the case with some Americans' attitudes toward Mexico and, say, England. Those who feel such affinity believe it to be natural, even though it is actually learned. The naturalness arises from our having forgotten how we came by this affinity whereby some Americans think that they share more culturally with the English than the Mexicans. In contrast to psychic intimacy, physical proximity is not a guarantee of creating feelings of nearness and dearness. Americans did not enslave those who lived far from

them, but instead enslaved those who lived with them or next door to them, including their lovers and illegitimate offspring. Men denied the vote to their wives and daughters and constricted their lives. Today, of course, slavery and the denial of political franchise to vast populations no longer seem to exist as realistic options. But there is nothing "natural" about this current state of fragile, partial reconciliation around race and gender relations. Bitter political struggle led Americans to this point. This struggle included a multitude of intimate gestures and relationships between people who chose to learn about and live with others, even to love them. The moral demand to treat our fellow human beings as we wish to be treated becomes, through political effort, the ethics of seeing them as part of our "natural" community, sharers of our national identity.

We learn to develop habits of recognition and to see strangers as kin, oftentimes by creating sites of communal identity where the sight of others, as our own, is affirmed. What makes the ethics of recalling others explicitly political is that it goes against the grain of the natural and by doing so becomes visible. In contrast, the ethics of remembering one's own is implicitly political, for it has the luxury of appearing to be natural and hence invisible. As Ricoeur says with considerable irony, "it is always the other who stoops to ideology," which is the "guardian of identity."[18] He is implying that those with the power to define themselves in relation to others have the privilege of believing that they themselves have neither identities nor ideologies, neither biases nor politics. These worldly matters are left to others, the ones stuck in the muck of their small concerns and their provincial territories, their bodies not inherently dark but rather darkened by the shadow cast by the tower in which the powerful reside. These powerful believe themselves to be impartial, unbiased, fair, objective, and universal, and do not like to be reminded that they are not, or that their power depends on creating and targeting others. So it is that when someone calls on her people to remember

others, she identifies herself—she stands out—by committing a political act. Asking her own side to remember others, she risks being called a traitor. At best, those of her own side may call her a cosmopolitan, with the pejorative connotation that she may be a citizen of the world but not of her own nation.

Not coincidentally, the charge of treachery is often leveled most viciously at women, the ones who are supposed to bear within them both the future and the past of the nation, embodied in its children and its culture.[19] Take, for example, the Vietnamese author Duong Thu Huong, war veteran and one time member of the Communist Party. Her disillusionment with the Communist Party in the years after its revolutionary victory shaped her fiction, beginning with *The Paradise of the Blind*. In this novel, she examined the notorious land reforms of the 1950s, when the party sought to redistribute land from landowners to peasants and encouraged peasants to denounce landowners. The excesses led to the execution of even minor landowners and innocent peasants, targeted by their fellow peasants and zealous cadres. Thousands died and Ho Chi Minh apologized.[20] Huong's denunciation of the party grew more strident and more contemporary in *Novel without a Name*, where she calls the party cadres of the postwar years "little yellow despots."[21] Their "blindness gave them extraordinary energy,"[22] but the "herds of dreamy, militant sheep" that followed them deserved some blame.[23] The novel is also notable for its evocation of Vietnam's imperialist history, its long march south to escape Chinese influence and to occupy the lands of numerous tribes and nations, including Cambodians and Cham. The hero of her novel visits the land of the Cham and dreams of his ancestor who had fled from the "barbarians from the north" who "hunted you down. You bore arms against those who lived in the south. It was an unending circle of crimes . . . history is enmired in crime."[24] The party denounced her, censored her, and placed her under house arrest for committing the crime of remembering those whom the party considered to be others. Even worse, she

remembered people of her own side as having committed crimes. But while the party considered her a traitor, Western publishers and readers considered her to be a dissident who spoke for justice, a heroic author who could not be contained by communism's provincial ideology. Banned at home, her novels were published abroad, for the West likes to translate the enemies of its enemies.

Duong Thu Huong's case exemplifies the troubling, threatening, and seemingly unnatural quality of remembering others. She shows how one can be denounced by one's own while being praised by others for the same exact act of recall. Neither denunciation nor praise is innocent, because both emerge from the ideologies of one side or the other. Both sides—if there happen to be only two—prefer to see themselves as being without ideology, with the other side guilty of playing politics, as if politics was a dirty word. A laundering of these dirty politics occurs in the move from remembering others to remembering others as our own. "We" can be said once again, without remembering that those included in the "we" fought each other at one point. This is the hope expressed in a statue such as that of the three soldiers, with its portrait of benevolent solidarity, a hope already dashed by Martin Luther King Jr. in his demand that Americans recognize the brutal solidarity of these men, arrayed against those Vietnamese others who are invisible at the site of the Vietnam Veterans Memorial. The scholar Paul Fussell also wanted to jar his fellow Americans from the comfort of remembering only their own. As he wrote about the Great War and modern memory, a war sixty years in his past, what he saw was that

> my American readers had also experienced in Vietnam their own terrible and apparently pointless war of attrition, which made body counts a household phrase. . . . I hoped that the effect of the book on such readers might persuade them that even Gooks had feelings, that even they hated to die, and like us called for help or God or Mother when their agony became unbearable.[25]

Was I not one of these others to whom Fussell gives the proper name of the Gook and yet does not name properly? If so, then I can say it is true: Gooks do have feelings.

As a Gook, in the eyes of some, I can testify that being remembered as the other is a dismembering experience, what we can call a disremembering. Disremembering is not simply the failure to remember. Disremembering is the unethical and paradoxical mode of forgetting at the same time as remembering, or, from the perspective of the other who is disremembered, of being simultaneously seen and not seen. Disremembering allows someone to *see right through the other*, an experience rendered so memorably by Ralph Ellison in the opening pages of *Invisible Man*. His narrator, the titular hero, runs into a white man who refuses to see him, and enraged, strikes back to force the white man to see him. Even beaten, however, the white man refuses to see him the way he wishes to be seen. That is because the other's use of physical force may make the other visible, but only to turn him into a target. If the other wishes to transform ways of seeing, then the other must deploy the psychic forces of remembering, imagining, and narrating as well. Not satisfied with being disremembered, we who are others find that it is up to us to remember ourselves. Having carried ourselves over, or been brought over, from the other side—we Gooks, we goo-goos, we slopes, we dinks, we zipperheads, we slant-eyes, we yellow ones, we brown ones, we Japs, we Chinks, we ragheads, we sand niggers, we Orientals, we who cannot be distinguished between ourselves because we all look alike—we know that the condition of our being and our self-representation is that we are both ourselves and others. We are never without identity and never without ideology, whether we like it or not, whether we acknowledge it or not. Those people who believe themselves to be beyond identity and ideology will, sooner or later, charge us with identity and ideology if we dare to commit that most unnatural act of speaking up and out.

Thus, even though no one has called me, to my face, Gook or any of its equivalents, I know that that epithet exists to be aimed at me.

No one had to call me that name, because American culture had already done so through the discourse of the Gook, myself as other struck by the slurs hurled from the airwaves of pop culture. My realization of my racialization, the first sting of a nervous condition untreatable by any type of medicine or surgery, except for the mnemonic kind, arrived early in my adolescence, through jarring encounters with fictions, with other people's memories. At much too young an age, my preteen self read Larry Heinemann's *Close Quarters* (1977) and watched *Apocalypse Now* (1979). I have never forgotten the scene in *Close Quarters* where American soldiers gang rape a toothless Vietnamese prostitute, holding a gun to her head and giving her the choice of either blowing them all or being blown away. "After that, Claymore Face didn't come around much, and nobody much cared."[26] Nor did I ever forget the moment in *Apocalypse Now* when American sailors massacre a sampan full of civilians, the coup de grace delivered by Captain Willard when he executes the sole survivor—also a woman, since the Vietnamese woman is the ultimate Gook, different from the American soldier through race, culture, language, and gender. She is the complete and threatening object of both rapacious desire and murderous fear, the embodiment of the whole mysterious, enticing, forbidding, and dangerous country of Vietnam. These accounts of rape and murder were only stories by an author and artist intent on showing, without compromise, the horror of war, but fictional stories are another set of experiences as valid as historical ones. Stories can obliterate as much as weapons can, as philosopher Jean Baudrillard shows in his estimation of *Apocalypse Now*. Watching the movie, Baudrillard thinks that

the war in Vietnam "in itself" perhaps in fact never happened, it is a dream, a baroque dream of napalm and of the tropics, a psychotropic dream that had the goal neither of a victory nor of a policy at stake, but, rather, the sacrificial, excessive deploy-

ment of a power already filming itself as it unfolded, perhaps waiting for nothing but consecration by a superfilm, which completes the mass-spectacle effect of this war.[27]

Baudrillard is not aesthetically wrong about the power of the story and the spectacle. He is just morally and ethically wrong. The war did in fact happen, and to suggest otherwise as he does only affirms the dread power of Western popular culture, its spectacles not even acknowledging the real bodies of the dead, only the dead extras on the screen.

Toni Morrison's concept of "rememories," from her novel *Beloved*, is useful here not only in clarifying the power of stories to both dismember the living and to bring the dead back to life, but to suggest that something needs to be done about such rememories. A rememory is a memory that inflicts physical and psychic blows; it is a sense that the past has not vanished but is solid as a house, present in all its trauma and malevolence. The most powerful kinds of stories, such as *Close Quarters* and *Apocalypse Now*, are rememories. Every time I thought of them, I experienced my readerly and spectatorial emotions all over again, intense feelings of disgust, horror, shame, and rage brought about by having witnessed what the scholar Sylvia Chong calls "the Oriental obscene."[28] My body trembled and my voice shook, an emotional testament to the aesthetic power of these works as well as to their participation in the discourse of the Gook, herself a rememory. It was not that I was forgotten in these stories or that I did not see my reflection; no, I saw myself, but as the other, the Gook, and that, I knew, was how others might be seeing me, not just the audiences chortling in movie theaters but even thinkers such as Baudrillard, for whom the dead are an abstraction to be dismissed in favor of the more interesting topic, the power of the war machine and its cinematic squadrons.

To be forgotten altogether or to be disremembered—these are the choices left to the Southeast Asians of the former Indochina in

the discourse of the Gook, as well as any other Asians unfortunate enough to be mistaken for such a creature. Even Maya Lin's aesthetic triumph, itself a rememory, speaks in this discourse, despite, or perhaps because, Maya Lin herself can be seen in this racist fashion. When one is in hostile or indifferent country, the safest way to survive is to be silent and invisible, or, in Lin's words, to see things from a distance as a third-person observer, far from the crossfire. If her body is invisible in the memorial, so are all the bodies like it, the ones belonging to those Southeast Asians whose names are nowhere to be found in the memorial. Marita Sturken states the case clearly:

> the Vietnamese become unmentionable; they are conspicuously absent in their roles as collaborators, victims, enemies, or simply the people on whose land and over whom (supposedly) this war was fought. . . . Within the nationalist context of the Washington Mall, the Vietnam Veterans Memorial must necessarily "forget" the Vietnamese and cast the Vietnam veterans as the primary victims of the war.[29]

The memorial shows that "remembering is in itself a form of forgetting,"[30] a mnemonic sleight of hand that many scholars of memory have observed, one that, in this case, substitutes fifty-eight thousand American soldiers for three million Vietnamese. As the photographer Philip Jones Griffiths observes, "Everyone should know one simple statistic: the Washington, D.C., memorial to the American war dead is 150 yards long; if a similar monument were built with the same density of names of the Vietnamese who died in it, [it] would be nine miles long."[31] This mnemonic reality for many Americans, where they and their soldiers are the victims, and not the three million Vietnamese, is nothing less than Orwellian.

But it is not only the Vietnamese who are invisible, forgettable, and unrecognized. The name of the Vietnam War erases other Southeast Asians, even from Sturken's memory and sight (for if one cannot

see people, one cannot remember them, and vice versa). Southeast
Asians from Cambodia and Laos have not forgotten their living and
their dead, as the poet Mai Neng Moua shows in her poem "D.C.":

> I stood my ground
> It's not enough that I am here
> I want the imprints of their names
> Some American proof that they were known
> Their courage recognized
> The sacrifices of their lives acknowledged.

Moua asks for recognition and acknowledgment of the Hmong sol-
dier as a Vietnam veteran, just as South Vietnamese soldiers in the
United States have done.[32]

> I know six who died there
> Grandfather Soob Tseej Vws
> Uncle Txooj Kuam Vws
> Uncle Kim Vws
> Uncle Looj Muas.

These foreign names must be spoken, must be written down, must
be forced into the landscape of American sight, for recognition and
acknowledgment only happen if one is remembered. In the absence
of such recognition and acknowledgment, the forgotten and the dis-
remembered must remember themselves, even if, as Moua concedes,
memorial forms guarantee nothing. Tourists gathered

> Around the memorial as if
> It was an exotic exhibit
> Talking loudly, laughing, downing
> Their Evian in the humid heat
> Disturbing the memories of chaos
> Just another thing you do while you're in D.C.[33]

No aesthetic work is inherently powerful. Foreigners, youth, or
the disinterested who do not carry these memories of the war may
be unaffected, dismissive, blasé, bored, or unnerved. To them, and

perhaps to the majority of future visitors, when living memory of the war is dead, the wall will be simply a wall.

Nevertheless, it is better to have a memorial that can be ignored than no memorial at all. Implicit in Moua's poem is a common conviction among the forgotten and disremembered, which is that being forgotten, or forgetting others, is unjust, particularly if we are talking about a conflict in which it is in the interests of one side to suppress the memories of others. For the forgotten and disremembered, the important question is this: how can we recall the past in a way that does justice to the forgotten, the excluded, the oppressed, the dead, the ghosts? This question is central to an ethics of recalling others. It assumes both the injustice of forgetting others and the justice of remembering others. Ricoeur proposes the outlines for such an ethics of remembering others in his monumental *Memory, History, Forgetting*, where he argues that justice is a virtue always "turned toward others. . . . The duty of memory is the duty to do justice, through memories, to an other than the self." And: "moral priority belongs to the victims. . . . The victim at issue here is the other victim, other than ourselves."[34] In short, justice always resides with remembering the other.

Ricoeur's approach to memory is powerful and persuasive, at least for anyone invested in resistance against forgetting or the demands of subordinated people for justice. In a similar vein, critic Paul Gilroy calls for a "principled exposure to the claims of otherness."[35] Gilroy, like Ricoeur, and myself, too, advocates for the idea that "histories of suffering should not be allocated exclusively to their victims. If they were, the memory of the trauma would disappear as the living memory of it faded away."[36] That is, it should not purely be the burden of victims to remember the injustices done to them. Placing the weight of memory solely on these injured parties would encourage them to see themselves only in terms of victimization. Treated as objects of pity, the temptation for victims is to mistake their otherness as their sole identity—the most visible and

the most disparaged kind of identity politics, although not the only kind. An ethics of recalling others is defined, paradoxically, by acknowledging that those we consider to be others are neither other nor ideal. Instead, in as much as we consider ourselves to be subjects, these others, from their own point of view, are subjects as well.

As a subject, the other will resist being forgotten and will demand inclusion in the annals of memory. Like those who control the already established means of memory and who are content to remember only their own, this other will say *always remember* and *never forget* her experiences, her histories, and her memories. She will demand to have her name on the wall, her face on the sculpture, and the story of her people in the book. As something is always being forgotten and strangers are always appearing, this mode of remembering others is a perpetual motion machine, oriented toward inclusion and reconciliation. The ultimate goal of the most common form of this ethics is for the other to be incorporated in citizenship, commemorated in the nation's rituals, cast in the nation's epics, and blended into the ethical mode of remembering one's own, until there is no meaningful difference between the other and the self. The secondary goal of this ethics, especially for those formerly cast as others, is to be empathetic to the ever-new others on the horizon.

If the ethics of remembering one's own operates in every society, the ethics of remembering others is the refinement of remembering one's own, at work only in those societies that see themselves as more inclusive, open, and tolerant. But as powerful as such an ethical model can be, it possibly can service war. This willingness to remember others and to allow others to remember themselves justifies the campaigns of open and tolerant societies against others not so ethically refined. America is the embodiment of such an ethics of remembering others, used both to call for greater inclusion of minorities within American borders and to justify war against strangers outside of the country. Southeast Asians were once these strangers

and could be again, and those Southeast Asians who made it to America sometimes still feel themselves to be alien in American society. It is not surprising, then, that many Southeast Asian refugees and their descendants, brought to the United States by an American war, have been so willing to join the American military and American society in their War on Terror. As American history has shown, it has been the prospect of newer, more terrifying strangers that has encouraged us to bring familiar others closer, especially through enlisting them on our side in wars against these strangers. Fighting against terrorism and terror, these former others hope to affirm their belonging to America itself, in their own eyes and those of their fellow Americans.

3

On the Inhumanities

WHAT THESE REFUGEES AND THEIR descendants who wish to become American seek is recognition, which is intimately tied to memory. We remember those we recognize, and we recognize those we remember. Some of us, perhaps most of us, yearn to be remembered and recognized, by our intimates and our colleagues, by society and history. We want individuals whose regard we long for to recognize us, and we want to be seen as a part of the place in which we live or call home, where we claim belonging and where we ask for citizenship. Recognition becomes key to the movements for memory that create memorials, museums, and commemorations for victims, veterans, atrocities, battles, wars, and so on, all of which are tied, implicitly or explicitly, to the identities of interest groups and ethnic groups, cultures and races, nations and states. These ethics of recognizing self and others help to build inclusive societies and to heal wounds, but they also encourage us to overlook our ability to hurt others.

The temptation is always present to deny that we can do unjustified harm; it is the other's ability to do damage that we tend to see as being unjustified. "If only it were all so simple!" protests Aleksandr

Solzhenitsyn. "If only there were evil people somewhere insidiously committing evil deeds, and it were necessary only to separate them from the rest of us and destroy them. But the line dividing good and evil cuts through the heart of every human being. And who is willing to destroy a piece of his own heart?"[1] Solzhenitsyn implies that while it is ethical and just to remember others and victims, it is also ethical and just to recognize our potential to harm, damage, and kill others, or to allow those actions to happen through complicity or turning a blind eye. Without such a recognition, we can make peace with old enemies only to continue wars with newer enemies not recognized as friends or even human. Identifying *with* the victim and the other in an act of sympathy, or identifying *as* the victim and the other in an act of empathy, has the unexpected, inhuman side effect of perpetuating the conditions for further victimization.[2]

Recognizing our potential for inhumanity contrasts with how calls for remembering one's own and remembering others are based on the urge to think of one's own as human, and then, ultimately, to think of others as human, too. But even as tolerant, humanistic societies have called for equality and human rights, they have never found a shortage of inhuman others to justify war and violence. Identifying with the human and denying one's inhumanity, and the inhumanity of one's own, is the ultimate kind of identity politics. It circulates through nationalism, capitalism, and racism, as well as through the humanities. Reminding ourselves that being human also means being inhuman is important simply because it is so easy to forget our inhumanity or to displace it onto other humans. The project of just memory is thus a work of the inhumanities rather than the humanities, for if the humanities have a hard time remembering the inhuman at the heart of civilization and culture, the inhumanities must remember the human, which is included in its very name.

If we do not recognize our capacity to victimize, then it would be difficult for us to prevent the victimization carried out on our behalf, or which we do ourselves. Likewise, the slogans to *always remember*

and *never forget*, while seemingly inarguable on the surface, are sometimes, even often, tainted by piousness, sentimentality, or hypocrisy. When we say *always remember* and *never forget*, we usually mean to always remember and never forget what was done to us or to our friends and allies. Of the terrible things that we have done or condoned, the less said and the less remembered the better. More than this, what we really wish to remember and never forget is our humanity and the inhumanity of others. This model easily incorporates an ethics of remembering one's own. As for an ethics of remembering others, it often encourages us to see others as human, which seems inarguably good. In contrast, however, an ethics of recognition says that the other is both human and inhuman, as are we. When we recognize our capacity to do harm, we can reconcile with others who we feel have hurt us. This ethics of recognition might be more of an antidote to war and conflict than remembering others, for if we recognize that we can do damage, then perhaps we would go to war less readily and be more open to reconciliation in its aftermath. Refusing to recognize our capacity to inflict damage does not preclude reconciliation with those who might have injured us, but it does encourage us to seek concessions and confessions from these others, who may themselves want the same from us. So it is that historically intractable conflicts continue, both sides seeing themselves as victims, or refusing to see themselves as potential or actual victimizers.[3]

Ricoeur's ethical model, predicated on always identifying with the other and seeing the other as a victim, is powerful for those who see themselves as victims or sympathize and empathize with them. It urges us to see the other as damaged by injustice and compels us to take up the cause of justice for the other. But this ethical model also tempts us into believing that those we think of as others are always going to be so. This misrecognition stems from our refusal to grant the other the same flawed subjectivity we assume for ourselves. As we are not always just, neither is the other. The other can be unjust

because even he or she can create others. And yet Ricoeur overlooks this by insisting that the other is a victim, or, as he puts it, "the other victim." Ricoeur tends to mistake the other as always and ever the victim, and conversely, the victim as the other. This mistake tempts minorities and the Western Left as a whole and reveals two potential problems with the ethics of recalling others—either mistaking oneself as that idealized, innocent other, or idealizing the other as guilt-free while incriminating oneself. Both of these are variations of identity politics. When Rey Chow calls for an "ethics after idealism," it is this idealization of identity and the other that she rightly speaks of and rejects, although she focuses her criticism on minorities as the ones who engage in identity politics. But nationalism is nothing more than an identity politics so triumphant that it can deny being about identity and politics, as nationalists accept both national identity and national politics as being simply natural.

So far as idealizing the other, the way the global antiwar movement usually saw the Vietnamese—and often still does—is an archetypal case of treating the other as victim and the victim as other, freezing them in perpetual suffering and noble heroism. Thus the antiwar movement elevated Ho Chi Minh to iconic status, waved the flag of the National Liberation Front, praised the communist Vietnamese as heroic revolutionaries defying American imperialism, accepted communist propaganda that the South Vietnamese were traitors or puppets, and was mostly blind to the Stalinist direction of the Vietnamese Communist Party. In the postwar years, the philosophical interventions of Ricoeur and his philosophical allies, Jacques Derrida and Emmanuel Levinas, have not completely persuaded some Western artists, critics, and leftists to avoid idealizing the other. Take, for example, the corollary to the discourse of the Gook, its not-so-distant cousin found in the discourse of the raghead, the hajji, and the sand nigger, epithets for the Muslim, the Arab, and the terrorist as the other. The impulse exists today for some to treat the Muslim and the Arab, and to a

lesser extent the terrorist, in the same idealized fashion as the antiwar movement treated the Vietnamese.

Some of the work of philosopher Judith Butler after 9/11 illustrates this temptation, although she is not alone in succumbing to it. It is not that Butler is an idealist or not aware that terrorists should be held responsible for their actions. In *Precarious Life: The Powers of Mourning and Violence*, she stresses the heinousness of the 9/11 attacks on the United States, as well as the viciousness of the American response in Afghanistan, Iraq, and Guantanamo. But the force of the book is aimed at American accountability and the inability of Americans to grieve for the deaths of others. She demands that we reframe our understanding of war to include the losses of others and to contest the terms of recognition that dictate what we see and whom we recognize. The book concludes with an invocation of Vietnam: "it was the pictures of children burning and dying from napalm that brought the US public to a sense of shock, outrage, remorse, and grief. These were precisely pictures we were not supposed to see." Without such pictures of Afghans, Iraqis, or Guantanamo detainees, "we will not return to a sense of ethical outrage that is, distinctively, for an Other, in the name of an Other."[4] Butler is right in being outraged at the vastly disproportionate death and suffering inflicted on America's others by Americans, from the Vietnam War to the War on Terror. But ethical outrage is not enough, even though it may be more than many can allow themselves. The danger of ethical outrage is that it continues to reassert the centrality of the person feeling that emotion, which justifies viewing the other as a perpetual victim—hence the return to the infamous, horrific images of Vietnam, which remains a war rather than a country, and to the napalmed Tran Thi Kim Phuc, the "girl in the picture" as her biographer has called her, her arms forever extended in a pose somewhat like the crucifixion.[5] For Americans, Iraq and Afghanistan may also, in the future, remain wars rather than countries for the exact same reasons of guilt, denial, and outrage.

In the urgency and the immediacy of her work, responding to American apathy and to an ongoing war, Butler cannot or will not treat the other as much more than a victim, or at best as an agent with vaguely understood motives and histories. As much as I also feel Butler's ethical outrage, it appears to me that seeing the other only as a victim treats the other as an object of sympathy or pity, to be idealized or patronized. Existing as the object of or excuse for one's theory or outrage, the other remains, at worst, unworthy of study, and, at best, beyond criticism. Not criticizing others and theorizing on their behalf further subjugates them by relegating the real work of empathy to ourselves. We are the antiheroes, the guilty ones who deserve criticism, which makes us the center of attention. In the case of Butler, the "we" is the West of which the Western Left is a part of and apart from. While the West may deserve criticism, this judgment need not come at the expense of turning others into (nearly) idealized victims or (almost) unknowable enemies. In her book *Frames of War: When Is Life Grievable?*, which focuses on the war in Iraq, Butler is right in demanding the recognition of Western responsibility and Iraqi victimization. But she does not demand the recognition of Iraqis as political subjects, who not only are others but who themselves make others. Correct in pointing to Iraqi losses as lives that the West will not grieve, she nevertheless draws too clear of an opposition between Americans as killers and torturers and Iraqis as victims. Iraqis killed and tortured one another as well, and regardless of American culpability in creating the conditions for such warfare, the responsibility for such killing and torturing falls on those Iraqis who committed the acts. To be a subject, rather than to be an other, means that one can be guilty, and such guilt can be and should be examined as fully as Western guilt.

The kind of antiwar sentiment that keeps others in their (innocent) place also manages to keep the (guilty) West's upper hand above the (pitiful) Rest. This maneuver toward continued superiority, through being able to feel guilt, and made the center of atten-

tion, is staged through Western dramas of self-flagellation. Thus, much of the American artistic and cultural work about the Vietnam War, even as it engages in anti-American criticism, places Americans firmly and crudely at the story's center. Exhibit one: Brian de Palma's film, *Casualties of War*, which depicts the true story of American soldiers who kidnap, gang rape, and murder a young Vietnamese woman. The result, cinematically, is a horrific rendition of victimization, where both the soldiers and de Palma brutalize the Vietnamese woman and silence her for good. Seen in one way, de Palma's vision of the Vietnamese as victim forces viewers to confront what the journalist Nick Turse argues was standard American policy: "kill anything that moves."[6] But seen another way, de Palma's story is not about the Vietnamese at all; it is about American guilt only, played out over a poor victim. He would go on to make *Redacted*, also based on a true story about American soldiers in Iraq who kidnap, gang rape, and kill an Iraqi girl. The movie not only repeats the graphic victimization, but also implies that the war in Iraq repeats the war in Vietnam. In both movies, the victim elicits pity and sympathy, but is silenced. Her lack of a voice allows Americans to talk on her behalf. She and all the others like her are transformed into perpetual victims interchangeable with their traumas, visible to Americans only when they stimulate American guilt.[7] As victims, or as villains and revolutionary heroes, these others are never granted full subjectivity by the West, unlike those Westerners who hate them or sympathize with them.

An ethics of recognition involves a change in how we see the other, and in how we see ourselves as well, especially in relation to the other. "Ethics is an optics," as Levinas argues, one intimately tied to war, violence, and the perception of the other.[8] For Levinas, the "face of the Other" can either incite us to violence or invoke goodness and the possibility of justice.[9] "Power, by essence murderous of the other, becomes faced with the other and 'against all good sense,' the impossibility of murder, the consideration of the other, or justice

[*sic*]."[10] He implies that the face of the Other—the sign of otherness itself—is found on actual others such as the widow, the stranger, and the orphan; we might say that the face of the other is found also on the slave, the refugee, the guerrilla, the enemy. This distinction between the other, who is a real person, versus the Other—a difficult philosophical concept expressing that which is prior to and beyond our selves—is the distinction Ricoeur glosses over when he says that memory is always for the other, always for justice. When speaking of justice, neither he nor Levinas are much concerned with actual others, despite briefly naming them as categories, in the case of Levinas. To deal with actual others, we would have to confront their lives, their cultures, their particularities, their names, and so on. In doing so, we would see that they are, like ourselves, generally self-interested. Their self-interest brings with it the uneasy, contradictory contaminations of worldly politics and histories.

Thus, while Ricoeur assumes that ethical memory is always oriented toward justice and the other, he avoids the question of what happens when competing claims to justice exist. Competing claims to justice always exist in regard to any contested event, such as war and its aftermath, but Ricoeur is not explicit about adjudicating justice, or at least the dirty, impure, pragmatic justice that actual others may care about. He is also silent on another, related question: if we deem some memories to be ethical, then must conflicting ones be unethical? Many on opposing sides of memory, presumably most, consider themselves ethical in regards to their remembrance of the past, although such subjective feeling does not mean they are indeed ethical. Implied in Ricoeur, and more explicit in Levinas, is the idea that these worldly claims to ethics and justice among actual others belongs in the realm of what Levinas calls "totality." War, violence, and self-interest rule in totality, which is where we struggle for "freedom" at the expense of the other, whom we wish to turn into the "same."[11] For Levinas, the face of the Other belongs to "infinity,"[12] where "the force of the Other is already and henceforth

moral."[13] For Levinas and Ricoeur—and for Butler, too, who draws from Levinas—the ethical orientation and meaning of justice is not in dispute, for ethics and justice are always oriented toward others and an always-vanishing otherness, not toward the self or the same.[14]

The uncompromising, ethical demand for justice is inspiring and points toward the utopian horizon of a time when reconciliation, hospitality, and peace—all without limitations or compromises—is possible. But as Levinas says, and as Derrida says after him, and as so many of Derrida's followers have repeated, that time is a future always yet "to come," arriving under the sign of the Other.[15] What is to be done in the present, with actual others, where the struggle over ethics and justice is often tied to people's deeply rooted sense of past recriminations, where any ethical achievement will be inevitably compromised, where any act of justice has a limit, where small wars and total war continue to be fought? In this worldly realm of totality, many feel that they are the ones for whom justice needs to be done, even if they are the ones who invaded, conquered, or occupied. An ethics of recognition aims not only at the utopian world of infinity but also at this disagreeable and dirty world of totality, toward what the self has done, and the conditions that make those actions possible. Recognition draws on the visual language that Levinas uses when he thinks of ethics as optics, a way of seeing anew—in this case, seeing what we are capable of as individuals and collectives, given our role in creating the conditions for individual action. Without the latter kind of panoramic recognition, what Butler calls a reframing and what one might colloquially call seeing the bigger picture, the danger is that blame and responsibility would fall only on the self and the individual, rather than on societies, cultures, industries, states, and war machines.

Nevertheless, ethical recognition is oftentimes intimate rather than panoramic, explicitly about individuals, beginning from face-to-face confrontation, particularly at the moment of violence. Ethical

recognition's visual dimension is matched by trauma's visual shock, the sight of horrible things leaving trauma "stored there in your eyes," as Michael Herr says.[16] The killer, or even the witness to killing, is traumatized by the act of killing, especially the most intimate kinds where the victim's face can be seen. Long-distance killing by artillery and missiles does not have the commensurate effect on gunners, pilots, and bombardiers as killing someone with a knife, a gun, or perhaps a drone, when the killer can see the face of the one being killed.[17] The face of the other returns to haunt the killer, as in *Novel without a Name*, where Duong Thu Huong describes how the war dead "would never leave us, those faces . . . accusatory, demanding justice."[18] Perhaps that is why, in the republican cemetery outside of Saigon, somebody scratched out the eyes and faces of the South Vietnamese dead.

As for rape, it cannot be conducted except on face-to-face terms, which is one reason why it is traumatic for its victims, and perhaps for its perpetrators; it's hard to say about the latter, since so few admit to rape, while many will admit to killing. The admission to rape is one of the most striking and disturbing parts of Larry Heinemann's *Close Quarters*. Claymore Face's nickname is telling, especially if we think, as Levinas does, that "violence can only aim at a face."[19] Her acne-scarred visage is ruined as if blasted by a claymore mine, an antipersonnel device that spews deadly bursts of pellets. Already defaced by the Marines through the image and language of her nickname, she will be defaced again by their choice to orally rape her. What happens to her, and what the reader feels about her fate, illustrates the claim by Levinas about the face "making murder possible and impossible" (we could substitute rape for murder, since rape is a violent act on a continuum with murder).[20] On the one hand, her name evokes the face of the other as it incites the murderous, sexual, and industrial violence of the American military machine, embodied in the claymore mine and the Marines. On the other hand, her face should make murder or rape impossible, at

least for those readers who feel rage, grief, or at least discomfort at what they have witnessed. That the face of the other makes murder and rape both possible and impossible shows that we who see the other as human or inhuman are ourselves both human and inhuman. We are tempted to identify with the other and also to eliminate the other, the two impulses able to exist in the same person, and certainly in the same culture.

The tendency to remember only the just, ethical part of ourselves that identifies with the other, and forget the unjust, unethical part which would kill the other, can be seen in yet another comforting cliché of memory: "The struggle of man against power is the struggle of memory against forgetting."[21] Milan Kundera's oft-quoted words are a beautiful statement concerning the human will. Everyone who agrees with Kundera identifies with man and memory against power and forgetting. The opposition, however, is false, beginning with its separation of man from power, with man on the side of "memory," while power is interested in "forgetting." Perhaps true power does not reside with any individual, as the philosopher Michel Foucault claims, instead circulating beyond the grasp of any individual, so that "power is everywhere."[22] But even on Foucault's terms, man as a whole is inextricably intertwined with power. Notions of man or humanity are constituted through power, through the ability of some to claim their humanity (while denying the humanity of others). Outside of Foucault's concerns, individuals do commit acts of power, and the state or the group that abuses power and wishes to erase the traces of its abusiveness is composed of individuals. Man, individual or collective, is just as interested in forgetting what he has done as he is in remembering what was done to him. And the powerful are not only interested in forgetting whom they have abused but also in remembering what they have accomplished. Man is ever and always implicated in power, and no one is innocent except the infant and the most abject victim. Power must be used, and the only question is whether it will be used ethically. Kundera's epigram

turns power into something that can only be abused, even as it fore-grounds the struggle against power, which can itself only be a form of power. Rather than retreat from our implication in power, we should consider exercising power as a necessary action in need of ethical principles that look beyond the idealizations of heroes and villains, good and bad, and us and them. With neither ethical prin-ciples nor an awareness of our implication in power, we are tempted, as in Kundera's epigram, to take up the humanist cry of remembering humanity against an inhuman state, conveniently forgetting that an inhuman state would not exist without the inhumanity within man, and vice versa. The state, of course, is us.

If we cannot recognize our ability to use and abuse power, then we make it easier to see ourselves purely as victims. Even more, we are able to justify vengeance against those who we believe have done harm to us. It is no coincidence that Kundera makes his claim in a Cold War environment, where his anticommunist statement cir-culates as cliché in an anticommunist world that cannot see itself as able to abuse power, unlike the communist world. The stereotypical, reassuring dynamic of memory and forgetting, of (free) man against the amnesiac state and its abuse of power, is inseparable from the Cold War climate, where trite claims make us feel warm and fuzzy about how we are on the side of memory and liberation, incapable of victimization. The War on Terror inherits these claims and the as-sociated logic of seeing ourselves only as victims, as Americans did after 9/11. In one frame, it is true that Americans were victims. In another frame, as Butler argues, this point of view isolated 9/11 from the complicated history preceding it and justified unleashing inhuman acts of war by the United States on those deemed as ene-mies. But an ethics of recognition should apply not only to Ameri-cans; it should also apply to America's enemies or perceived enemies, who also see themselves as victims. Any side in a conflict needs the optical character recognition provided by this ethics, the ability to see not only the flaws of our enemies and others but our own fun-

damentally flawed character. Without this mutual recognition, a genuine reconciliation will be difficult to achieve.

Perhaps such an ethics of recognition would lead only to retribution or resignation. Retribution can be seen in how some Americans in the postwar era learned that what they needed to do was to "empathize with the enemy," in the words of former Secretary of Defense Robert McNamara.[23] The implication is that such a mode of empathy helps us understand our other better in order to control him (or kill him). Thus, the counterinsurgency field manual for the wars in Iraq and Afghanistan was written by General David Petraeus, who drew on his experiences from the war in Vietnam to refine military techniques and to encourage greater cultural sensitivity among American forces toward the peoples of the lands they occupied. For Americans, multiculturalism at home finds an overseas corollary via culturally sensitive warfare. In both cases, studying difference and understanding the other are instrumental: they serve the purpose of domesticating others and rendering them harmless. As for resignation, it is the sense that if we are indeed human and inhuman, then nothing can be done about the inhumanities we commit. Resignation takes the form of inaction, which is the most common way by which those who see themselves as human condone inhuman behavior.

Retribution and resignation can be found in the Khmer Rouge era of Cambodia and its aftermath, but we also find here an ethics of recognition and a struggle to see the face of the Other. This ethics is exemplified in the work of filmmaker Rithy Panh, the most important artist to confront the genocide. For him and many others, the policies and horrors of the Khmer Rouge regime are symbolized in S-21, the infamous prison and death camp located in the capital of Phnom Penh.[24] During the Khmer Rouge reign of 1975 to 1979, some seventeen thousand men, women, and children entered S-21, where they were photographed, interrogated, tortured, and killed. Seven survived by one count, a dozen by another, perhaps a couple

hundred at most (as is usually the case in a poor country, the bureaucracy has yet to catch up with the disaster). S-21 was the most extreme manifestation of an extreme regime whose policies of execution and forced labor led to the death, through murder, starvation, and illness, of approximately 1.7 million Cambodians out of a population of about 7 million. During this time, the Khmer Rouge created the faceless Angkar, or Organization, that ruled all of Cambodian society, mandating uniform haircuts and clothing, eliminating family relations and human affections, and transforming the entire population into a compulsory labor force. Khmer Rouge policies were retribution against an entire society and the "new people," a population who embodied Western influence and class inequality (in contrast to the "base people," the peasantry).[25] "Only the deaf, the dumb, and the mute would survive," becoming faceless parts of a revolutionary society, a utopia that would erase the unequal past and begin anew from Year Zero.[26] This was the drive for totality of which Levinas speaks, the impulse to subsume everything, all difference, all others, into the same. Colonialism was also an expression of this drive for totality. What the French did to the Khmer foreshadowed the extermination that the Khmer would do to themselves and any others they found in Cambodia.

The United Nations refuses to use *genocide* to describe what happened to the Cambodian people, reasoning that it was Khmer killing Khmer in most instances, while a genocide is one ethnic group singling out another. Rithy Panh refuses this bureaucratic interpretation when he (along with cowriter Christophe Bataille) says that "the invention of a group within a larger group, of a group of human beings considered different, dangerous, toxic, suitable for destruction—is that not the very definition of genocide?"[27] Panh calls this culling "the elimination," the title of his powerful, spare, unsentimental memoir of having survived the genocide as a teenager and ultimately confronting the only Khmer Rouge official convicted at that time of any crimes against humanity, the commandant of

S-21, Duch. *The Elimination* is a meditation on the effects of the genocide and the psychology of the perpetrators, represented by Duch, who allows Panh to interview him repeatedly, face to face. "He's a man who searches out and seizes upon the weaknesses of others. A man who stalks his humanity. A disturbing man. I don't remember that he ever left me without a laugh or a smile."[28] Duch's defense lawyer, Kar Savuth, himself a genocide survivor, said

> when he first met Duch, the former Khmer Rouge commandant had cried, overwhelmed by guilt, then gathered himself, pointing out that the first commandant of S-21 had been killed and that he knew it was only a matter of time before he himself would have been killed, too. Duch asked Kar Savuth a question: If they told you they were going to kill your family, what would you have done? And Kar Savuth said, "I would have done exactly what you did."[29]

Duch tries to impress on Panh that he, too, would have done the same, an implication that Panh refuses. While Duch says he convinced Kar Savuth that he might have done the same things, Panh tries to convince Duch that he must take responsibility for his actions. Both are versions of this ethical need to recognize the inhuman within the human, and vice versa. "He's human at every instant," Panh says of Duch. "That's the reason why he can be judged and condemned. No one can rightly authorize himself to humanize or dehumanize anyone. But no one can occupy Duch's place in the human community. No one can duplicate his biographical, intellectual, and psychological trajectory."[30] Duch is both man and human and someone outside of the human community. He is an other even as he eliminated others, a creature who can only reclaim his humanity through acknowledging what he has done.

Panh does not urge this recognition only at the level of the individual. Duch is "man, entirely man," but he is also the face of the regime.[31] Duch is a unique perpetrator, and perhaps victim, but the

catalog of horrors he oversaw, exceeding anything dreamed up by Hollywood, are an outcome of history and the species:

> The crimes committed by Democratic Kampuchea, and the intention behind those crimes, were incontrovertibly human; they involved man in his universality, man in his entirety, man in his history and in his politics. No one can consider those crimes as a geographical peculiarity or a historical oddity; on the contrary the twentieth century reached its fulfillment in that place; the crimes in Cambodia can even be taken to represent the whole twentieth century. This formulation is excessive, to be sure, but its very excess reveals a truth: It was in the Enlightenment that those crimes took place. At the same time I don't believe that.[32]

Panh hesitates on whether the genocide is the culmination of Western thinking, but he does not hesitate, in the end, on demanding that we see how "the history of Cambodia is in the deepest sense our history, human history."[33] The genocide, while extreme, was not marginal, provincial, or aberrant, but as fundamental an expression of inhumanity—and therefore of humanity—as a number of horrific events before and since, as universal, in its abomination, as great art is in its beauty. "I believe in the universality of the Khmer Rouge's crime," Panh says, "just as the Khmer Rouge believed in the universality of their utopia."[34]

Confronting this universality of the genocide and the simultaneous inhumanity and humanity of Duch, the Everyman of the Khmer Rouge, Panh does not allow himself either retribution or resignation. If one sign of inhumanity is destruction, then one sign of humanity is creation, something Panh knows well as an artist. Panh creates art to address Duch, the genocide, and his personal experience of survival and witnessing most of his family die from starvation and illness. He recounts the experience through *The Elimination* as well as through his feature film *The Missing Picture*, a moving

and brilliant autobiography and documentary about his family's and country's fates. In an unexpected gesture, Panh recreates the world of the Khmer Rouge era through the use of hand-carved figurines that stand in for himself and the people of whom he talks. The aesthetic decision is as persuasive and satisfying as Art Spiegelman's turn to comics in *Maus* for addressing the Holocaust. He drew Nazis as cats and Jews as mice, and Panh, facing an equally incomprehensible death world, turned to inhuman figurines as one way to approach inhumanity. The immobilized faces of these figurines achieve an expressive, emotional transfiguration when fused with the film's music, narration, and miniature mise-en-scènes, the diorama-like recreations of the labor camps, fields, huts, and hospital where Panh's family worked and died from starvation and illness, as well as the room where Panh, lying under a picture of Sigmund Freud, interrogates his memories as his dead relatives observe him. Immobility is part of the aesthetic, for like characters in photographs, these figurines do not move but are fixed, as memories sometimes are. Unlike photographs, however, these figurines and their settings are three-dimensional, carved into existence by the artist Mang Satire. Artistic efforts such as Panh's and Mang's are the opposite of resignation, and they are not retributions. Instead, these artists seek to return, again and again, to the scene of the crime in an effort to understand it. Their art is one crucial way of seeing the faces of others, possibly even the face of the Other.

Addressing the past and the most horrific of horrors, Panh expresses faith in the power of his art: "My films are oriented toward knowledge; everything is based on reading, reflection, research work. But I also believe in form, in colors, in light, in framing and editing. I believe in poetry. Is that a shocking thought? No. The Khmer Rouge didn't break everything."[35] Form also interested the Khmer Rouge. People needed to behave, dress, and speak in certain ways, on penalty of death. "Control of bodies, control of minds: the program was clear. I was without a place, without a face, without a

name, without a family. I'd been subsumed into the big, black tunic of the organization."[36] Once free from that Organization, Panh would endeavor over decades and multiple works of art to find the form that could speak to the past and to the difficulty of seeing the human in the inhuman, and vice versa. The result, *The Elimination* and *The Missing Picture*, are two of the finest works of art and memory to deal with the genocide, powerful partly because they abolish the sentimentality, the aesthetic weaknesses, and the fear of assigning responsibility to Western countries that limit so many works from other Cambodians about the genocide. He confronts the difficult possibility that

> after thirty years, the Khmer Rouge remain victorious: The dead are dead, and they've been erased from the face of the earth. Their commemorative stele is us. But there's another stele: the work of research, of understanding, of explication. This isn't some sad passion; it's a struggle against elimination. Of course such work doesn't raise the dead. It doesn't seek out bad ground or ashes. And of course this work doesn't bring us rest. Doesn't mellow us. But it gives us back our humanity, our intelligence, our history. Sometime it even ennobles us. It makes us alive.[37]

The elimination was characterized by erasing not only the dead but effacing the living, stripped of their individuality. "I had no family. I had no name. I had no face. And so, because I was nothing anymore, I was still alive," Panh says.[38] "When you don't have a name it's as though you don't have a face; you're easy to forget."[39]

As he works to remember, Panh is concerned with "the faces of the torturers. Obviously I've met a certain number of them. Sometimes they laugh. Sometimes they're arrogant. Sometimes they're agitated. Often they seem insensible. Stubborn. Yes, torturers can be sad too."[40] In his documentary *S-21*, Panh meets several of the prison's guards and torturers and persuades them to recreate and repeat

their daily actions, their acts of interrogation and torture, grown men recalling their lives as teenagers. From Panh's point of view, these men are others, living embodiments of a mystery he seeks to understand—how did this genocide happen? How did people do this? Why is no one held responsible? These questions also interest filmmaker Socheata Poeuv. In her documentary *New Year Baby*, she brings her father from America back to Cambodia and surprises him by arranging a meeting with a former Khmer Rouge cadre. Her father, a survivor of the era, hates the Khmer Rouge and does not want to meet the cadre, but Poeuv says, "I want to see his face." Like many others, "I didn't understand how a whole country could suffer through this and not demand justice." But in a country divided into new people and base people, in which many were the active agents of death but many more were silent witnesses and complicit spectators who did nothing in order to survive, is it a surprise how difficult it is to achieve justice? Who is responsible? While the United Nations and the Cambodian government are jointly involved in prosecuting the five highest-ranking Khmer Rouge leaders (of whom Duch, the lowest-ranking, was the first convicted), the legal effort to bring justice is at best symbolic, since thousands of real murderers will not be prosecuted, and hundreds of thousands of complicit Khmer will not be touched or named.

Like some of the Khmer Rouge who have, more or less, confessed, Duch admits to certain actions (and not others), but deflects his responsibility by pointing to a force beyond him, Angkar, or the Organization, whose faceless presence so terrified the victims of the Khmer Rouge. The Organization spoke through its cadres, but it was unclear to almost everyone, including most of the cadres, who the Organization was. To Cambodians, was the Organization not power itself, separated from any individual man? Is this excision what allows Cambodians who lived through the Khmer Rouge era to deny responsibility, eliminating themselves from power, from being a part of or complicit with the Organization? Even the

most senior Khmer Rouge, the ones on trial, deny knowledge of hundreds of thousands dying (if, they said, hundreds of thousands even died). Would reconciliation be possible between the victims and the victimizers if the victimizers recognized even their complicity, much less their responsibility? The problem is that few are willing to acknowledge themselves as victimizers, even after admitting to performing certain harmful deeds. Can they face their deeds? Can they face their inaction? Can they come face to face with themselves?

At S-21, Panh films the former guards and notes: "The torturer's face: lost amid the images that none of them explicates, as if there were an insuperable boundary. The unnameable."[41] Panh alludes here to both the images of horror that exist in the mind's eye for witnesses and for those who have only heard of the crimes, and also to the faces of all the prisoners, photographed on entry to S-21. Some of those photos are now featured in the museum that S-21 has become. They are victims, but given the lack of captions, names, and identification, most visitors do not know that a good number of these victims were themselves Khmer Rouge cadres who had fallen afoul of the Organization, including former torturers and guards at S-21.[42] The Khmer Rouge used S-21 to torture and kill its own cadres, as well as foreigners, minorities, intellectuals, and so on. The faces of victimizers who became victims are the most visible rendition of the general problem that the Khmer Rouge era and its aftermath represents for a human and inhuman history: the reluctance to recognize and to reconcile with one's capacity to harm others. When we refuse to see victims as capable of violence, we allow ourselves to imagine that we are the same way.

So it is that the rest of the world looks with horror at Cambodia and the Khmer Rouge and wonders how the genocide happened, when the reality is that it could have happened anywhere with the right "inhuman conditions," to steal Pheng Cheah's title. Cheah's

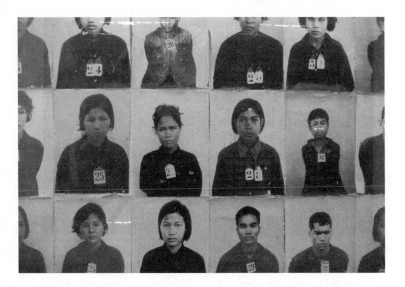

thinking illustrates the poststructuralist tendency in one branch of the humanities, which Panh departs from. Cheah, like his influencer, Foucault, argues that it is a mistake to think of the human and the soul as being divine creations. Instead, they are created by power and should be seen as effects of power. This power is not human in the sense that it is not wielded completely by any individual. Power exceeds individuals, and we are subject to it. This is the inhuman condition, according to Cheah. Derrida also influences Cheah, and in a typically Derridean reversal, Cheah argues that the inhuman precedes the human, not the other way around. In conventional thinking, inhumanity is a deformation of an original humanity, which is what leads to the usual sentimental, humanist hand-wringing over the inhuman behavior of various individuals, tribes, parties, and nations. For Cheah, to insist on the priority of humanity is a fundamental misrecognition, leading to a focus on the inhuman as a moral aberration instead of as a condition for humanity. But while

Cheah is not interested in the more mundane, moral notion of the inhuman, Panh insists that it is impossible to think of the inhuman only on the philosophical terms that Cheah proposes.

While it is critical to recognize inhumanity as an outcome of civilization and its privileging of the human, one must also confront the inhuman in terms of individual culpability and action, as a deformation of the human, as a question of responsibility that cannot be deflected by a turn to the structuring force of power. For Cambodian society in general, horror consists not only of being victimized but also of victimizing others. To speak of Cambodians in this way is not to deny history or power: the responsibility of the French in colonizing Cambodia, the Americans in bombing the country, the North Vietnamese in extending their war through the country, or the Chinese in supporting the Khmer Rouge even with knowledge of their atrocities. To speak of Cambodians as bearing widespread responsibility for the genocide is not to point to them as culturally unique in their ability to commit murder or allow it to happen. As the writer W. G. Sebald points out regarding Germans, "it's the ones who have a conscience who die early, it grinds you down. The fascist supporters live forever. Or the passive resisters. That's what they all are now in their own minds . . . there is no difference between passive resistance and passive collaboration—it's the same thing."[43] What is perhaps unique is that unlike the German or other instances of mass murder, Cambodians of the ethnic majority who killed each other or witnessed each others' deaths wore the same (ethnic) face. So it is that Cambodians cannot solely blame their crimes on the incitement of outsiders or (ethnic) others, which compels them to look at themselves as one reason for what happened, a task they may have a hard time doing.

The Khmer Rouge rendered others inhuman in order to destroy them with inhuman behavior, but in the aftermath of their rule most of those differences disappeared, leaving it clear that those others were not really other, if we speak only of the ethnic majority. For

Panh, Duch is the face of this situation, where the line between human and inhuman has been crossed, as it was for the rest of the former Khmer Rouge, now embedded too deeply in Cambodian society to be extricated easily. But between victim and victimizer exists a population in between—the complicit, the witness, the bystander, the resigned. The Khmer Rouge invoked this population as the reason for their cause—peasants exploited by French colonization and Cambodian hierarchy, then bombed by American planes and misled by the Khmer Rouge. Panh points out that they are still poor. If they were not on the side of justice during the Khmer Rouge era, they are also people for whom justice has not been done in the years afterward. Their situation is absurd, horrible, a low-level and continuous crime that has lasted centuries.

Does Duch laugh because he sees this absurdity? "I could hardly believe it—it was too beautiful, too easy: Laughter bursts out in the midst of mass crime. Duch has a 'full-throated' laugh: I can't think of another way to describe it."[44] Strangely enough, a laughing face stands out amid all the faces of the dead and the soon to be dead at S-21. It seems inexplicable that anyone could laugh in this place, the most disturbing museum or memorial I had ever visited, including the extermination camps of Europe. This is a drawn face, not a human face, the slash through its laughing visage the universal sign of prohibition, here commanding the visitor not to laugh. The sign itself says *Keep silent*. Sign and face testify that someone has laughed here, and not just Duch. While I was there, teenage foreign tourists laughed in the corridor of the isolation cells. Why do some visitors laugh? Out of nervousness, perhaps, for if one is a foreigner visiting this place during one's lunch break or on holiday, what is one supposed to say? Or if one is local, perhaps the laughter covers up the tears or the disbelief, a polite way of hiding how distraught or uncomfortable one may be. Perhaps what the laughter mocks is not the dead, but the authority embodied in memorials. This authority is pedagogical, and who has never wanted to laugh at authority and

pedagogy? This authority trains visitors in the proper etiquette of memory and mourning. This authority says that *this is not a laughing matter* and to *always remember* and *never forget*. This authority wants us to forget its own power, and how the crimes recorded by these memorials were not committed by monsters and enemies of the state. These crimes were committed by humans whose deeds would have been lionized if their state and side had triumphed. Although laughter may not be a polite response, even an inhuman one, it is possibly understandable, aligning the one who laughs with the devil's subversion, as Kundera claims in *The Book of Laughter and Forgetting*. The laughter of angels, he says, is the sound of those in power. But should one always be aligned with the angels? Rather than just believe that devils are fallen angels, might it not be the case that angels are triumphant devils?[45]

In the terms of Levinas, the face of the Other calls out for good-
ness and for justice, demanding that "You shall not commit murder,"
especially against what he calls the Stranger.[46] In his quasi-religious
language—the Other exists on high, in God's realm, in infinity[47]—
Levinas is on the side of the angels, feeling sympathy for the Stranger
rather than the Devil, looking down on an earthbound totality
where warfare and imperialism are the law of the land. He wills
himself to believe in his ethics, in the idea that "to be for the Other
is to be good."[48] But he concedes that "the Other . . . is situated in
the region from which death, possibly murder, comes."[49] When the
Khmer Rouge arrived triumphantly in Phnom Penh on April 17,
1975, they were strangers and others to the city's population. If
everyone on all sides treated their others as if they themselves wore
the face of the Other, then perhaps the ethical and moral goodness
called for by Levinas would be achieved. But the others who were
the Khmer Rouge brought death, and who is to say that the face of
the Other worn by them was not just as real as the one Levinas
longs for? What if the face of the Other heralded not justice but
terror? In our contemporary wars waged for and against radical
Islam, could the masked face of the terrorist be the face of the Other
to the West? What if justice and terror were one and the same? The
Khmer Rouge and the radical Islamists certainly believe that they
are on the side of justice, as do the Western states with their beliefs
in tolerance, free speech, freedom of religion, and airpower.

No wonder that some philosophers, like many other people, turn
away from the possibility of hell and resort to faith in heaven, the
future that is yet to come. The philosophical equivalent of faith is
the secular belief that the Other compels us to justice (which, in
poststructuralist thinking, need never be defined). If we wish to live
as a species, we need to hold on to that faith, but we also need to
confront our doubt. It is possible that the Other is a killer, and that
we ourselves may be killers or complicit in killing. If so—and if
Duch is simply another case of the "banality of evil," the term

Hannah Arendt coined to speak of the Nazi Adolf Eichmann—the lesson to be learned from Duch's example is that the banality of evil has generally been reserved by the West for itself, as a sign of subjectivity, of agency, of centrality, even for the most unimportant of Westerners who functioned as nothing more than cogs in the war machine. Excluding others from the banality of evil denies them that same right to subjectivity found in villianous behavior. In contrast, to make others the subject of the banality of evil is to renounce the patronizing pity of the West, which is tempting for others to themselves assume. Pitying oneself, for others, is always detrimental, for those who believe that they cannot do evil will in the end do evil, which is what happened in Cambodia and in many nations that threw off Western domination.

To put this ethical conundrum of the Other in the most schematic way possible, here is how the various modes of ethical memory work. In the ethics of remembering one's own, the simplest and most explicitly conservative mode, we remember our humanity and the inhumanity of others, while we forget our inhumanity and the humanity of others. This is the ethical mode most conducive to war, patriotism, and jingoism, as it reduces our others to the flattest of enemies. The more complex ethics of remembering others operates in two registers, the liberal one where we remember our humanity and the radical one where we remember our inhumanity. In both registers, we remember the humanity of others and forget their inhumanity. The liberal register where we remember our humanity is also conducive to war, although war usually carried out in humanitarian guises, as rescue operations for the good other (which may require us killing, with great regret, the bad other). The more radical version, where we remember our inhumanity, is the driving force behind antiwar feeling, as we worry about the terrible things we can do. And yet there is a level of deception in this radical register, too, for if we also see only the humanity of others, and not

their inhumanity, we are not seeing them in the same way we see ourselves. So it is that in the name of the other's humanity, we consign the other to subordinate, simplified, and secondary status in contrast to our more complex selves. While we are capable of dying and killing, of tragedy and guilt, of the whole panoply of human and inhuman action and feeling, the other is only capable of being killed, perpetually pegged as an object of our seemingly well-intended pity. To avoid simplifying the other, the ethics of recognition demands that we remember our humanity and inhumanity, and that we remember the humanity and inhumanity of others as well. As for what this ethics of recognition asks us to forget—it is the idea that anyone or any nation or any people has a unique claim to humanity, to suffering, to pain, to being the exceptional victim, a claim that almost certainly will lead us down a road to further vengeance enacted in the name of that victim. The fact of the matter is that however many millions may have died during our particular tragedy, millions more have died in other tragedies no less tragic.

Rithy Panh's memoir and films foreground this ethics of recognition and make a daring claim: Cambodia belongs in the center of world history because of the humanity and the inhumanity of the Khmer. This is an important claim for two reasons. The first and most obvious reason is simply that the claim moves Cambodia and the Khmer people from margin to center. This is also the less interesting reason, given that making the marginalized more visible leaves the periphery intact for new others to inhabit. The more important reason is the assertion of inhumanity, for the other's move from margin to center in Western discourse is most often premised on asserting the other's humanity. By rejecting this sentimental, heart-warming reasoning, Panh's work affirms the importance, and the difficulty, of grappling with inhumanity, both the inhumanity of the West and the inhumanity of its others (which is to say, from the perspectives of those others, us). The face of the Other is thus, even

in its name, a misnomer. It tempts us to pity others, to see only the singular face of their suffering. In reality, the Other always has at least two faces, human and inhuman.

These two faces are both evident in one picture on the walls of S-21, on a second-floor exhibition room, where Duch is shown at trial. There is his face, but it has been defaced. Visitors have scrawled insults and obscenities over it. He is only a man, perhaps one of exceptional ability but not an alien, and they do not like what they see, precisely because he looks no different than us. His resemblance to us and our resemblance to him causes fear, which is why some visitors deface him. An ethics of recognition would prevent us from defacing him, from misrecognizing him as the devil incarnate, for the resemblance to the human is what we must remember if we hope not to repeat atrocities. Ethics is optics, and it demands that we see how Duch is man, human and inhuman. We must continue to look at the horrors done by humans like him if we are to learn anything, if we are to imagine not just a hopeful utopian future but

also an alternate dystopian one where, if the Khmer Rouge had succeeded, Duch would not be a devil but an angel. This would force us to ask whether those we imagine as angels today are not simply triumphant devils who have written their own stories, in the manner of so many bomb-launching bureaucrats and elected officials with ghostwritten memoirs.

For artists, looking, remembering, and creating art are themselves ways of recognizing the ambiguities of the human and inhuman. As Panh says toward the end of *The Missing Picture*, "There are many things that man should not see or know. Should he see them, he'd be better off dying. But should any of us see or know these things, then we must live to tell of them. . . . I make this picture. I look at it. I cherish it. I hold it in my hand like a beloved face. This is the picture I now hand over to you, so that it never ceases to seek us out." Unlike Levinas, who turns the face of the Other into the face of goodness, Panh sees two faces—the beloved face he offers us and the face of Duch, torturer, tormentor, and teacher. Panh neverthe-less follows Levinas when the philosopher calls "justice this face to face approach, in conversation,"[50] which is "an ethical relation."[51] The interviews with Duch are this conversation, this relationship

with the other that aims for justice through dialogue. The relationship with the reader of *The Elimination* and the viewer of *The Missing Picture* are conversations as well; Panh is our other and we are the others to him. Justice is found in this aesthetic relationship, too—justice on the ground of art and in even more worldly terms, on the ground of history and our understanding of humanity and inhumanity. In wanting to recognize Duch as both human and inhuman, Panh enacts an ethics of recognition that both affirms the importance of infinity and justice, the way we want the world to be, and which also demands a confrontation with totality, the way the world was or is. An ethics of recognition that confronts the totality around us and within us reveals the stereoscopic simultaneity of human and inhuman. So it is that Panh turns to figurines to approach the humanity of victims, and the S-21 museum turns to the picture of the laughing face to approach the inhuman response to suffering. Missing in both of these renditions is the actual human face, the photographed face shown in S-21. With this absence comes the suggestion that we need the artist as well as the philosopher to sketch for us an ethics of recognition, to create for us a picture of the inhuman face.

/ INDUSTRIES /

4

On War Machines

FRIEDRICH NIETZSCHE WROTE THAT "if something is to stay in the memory it must be *burned* in: only that which never ceases to hurt stays in the memory."[1] The war has burned itself into many of us, including myself, seared at too young of an age to know exactly where the scar is. Those born too young to remember with clarity, or to remember anything at all, may still see the war's afterimages lingering on their retinas, a result of what W. G. Sebald so memorably called "secondhand memory."[2] A German writer who expatriated himself to England, he spent his life trying to remember a war that ended before he crawled out of the crib. Secondhand memories are part of refugee baggage, too. At times, these memories are intimate legacies bequeathed to us by families and friends who saw the war firsthand; other times, these memories are Hollywood fantasies, the archetype being *Apocalypse Now*, a modern-day Grimm's fairy tale where napalm lights the dark forest. Many Americans, and people the world over, assume they know something of Vietnam from watching movies like *Apocalypse Now*. For having paid the price of a movie ticket, they, too, can say, as Michael Herr did, "Vietnam, we've all been there."[3]

I think this is true even for those with only the faintest of second-hand memories. They have been to Vietnam in the sense that they have seen it burn on screen and in photos, since the war is "the most chronicled, documented, reported, filmed, taped, and—in all likelihood—narrated war in history."[4] My students tell me that they have heard of this war, although they have little sense of what happened and how Americans got there. These students are not a postwar generation but a wartime one, born in the 1980s and 1990s and living through the wars in Iraq and Afghanistan. For an American society that goes to war every couple of decades, the distinction among prewar, wartime, and postwar is blurred. Rather than a discrete event, war is a continuum, an ebb and flow in intensity that occasionally spikes. War has always been a part of our lives, a dull hum of white noise that blends in with the air conditioning, the computers, the hum of traffic. People like my students are accustomed to seeing a burning monk on an album cover or an iconic photo from the war on a rock star's wall.[5] The camera of the show *MTV Cribs* dwells on the photo, blown up to cover the entire wall, as the rock star describes the scene. "This is a famous image from *Life* magazine," he said. "It's obviously a guy getting shot in the head. I had this put here as a reminder of human suffering. I think when I walk out and see this every day, I kind of gain some gratitude for where my life is at." He lives his life in a beautiful Hollywood Hills home with a view of all of Los Angeles. While at a rooftop bar of a chic downtown hotel, I looked at a similar view of Los Angeles and noticed *Apocalypse Now* being projected onto the wall of a neighboring building. The movie played silently as a mud-slick Martin Sheen emerged from swamp water to hack Marlon Brando to death. Nobody on the roof looked twice.

Even if the war no longer burns for many people, its afterimages are unforgettable. Another name for these kinds of glowing afterimages are what Marita Sturken, drawing from Freud, calls "screen memories."[6] These memories both screen out other memories and

serve as the screen for the projection of our private and collective pasts, our own home movies. Although screen memories need not be visual images, most of our vivid screen memories from Vietnam are: Phan Thi Kim Phuc, the naked, napalmed girl running down a road in Nick Ut's 1972 photograph; Thich Quang Duc, the Buddhist monk immolating himself on a Saigon street corner in 1963 to protest President Ngo Dinh Diem's treatment of Buddhists, caught by both still and moving cameras; and the picture on the rock star's wall of Colonel Nguyen Ngoc Loan shooting Viet Cong suspect Nguyen Van Lem in the head during the Tet Offensive of 1968, an act captured by both Eddie Adams' still camera and by a television crew.

These images are evidence not only of Vietnamese suffering, but of the power of the entire apparatus that delivers the images to us. This apparatus extends from the photographer to his equipment to the bureau that pays for his time and his film to the machines that airlift that film from outside the war zone to the homeland offices that copyright, distribute, archive, and circulate in perpetuity those images in which the Vietnamese are burned and scarred by what the filmmaker Harun Farocki called an "inextinguishable fire."[7] Their suffering is forever fixed, their images of pain overshadowing or eradicating memories of other victims of this war. These images, screen memories, and secondhand memories affirm not only what is literally printed on the film, shown on the screen, or indelibly scratched onto the glass of our eyes—they affirm the power of an industry of memory as well. These shots were seen around the world because Western media possessed the apparatus to helicopter journalists into and out of battlefields with endless film rolls, processing their negatives almost immediately, and printing them globally on the same day or the day after the event in question. In contrast, North Vietnamese photographers lived in the jungles, hoarded their handfuls of film rolls, and dispatched their negatives over treacherous land routes to Hanoi via messengers who were often killed by

bombardment.[8] These circumstances limited what North Viet-
namese eyes saw and limited the kinds of Vietnamese that the world
recognized.

Recognizing the individual's face, or even a people's collective
visage, is important, particularly if we speak of faces destroyed by
war machines. But equally important is understanding how recog-
nition is produced, how an industry of memory creates memories.
An "industry of memory" differs from a "memory industry" in the
same way that a "war machine" is not the same as an "arms in-
dustry." At worst, invoking a memory industry brings to mind a cot-
tage industry, a provincial economy geared toward producing some-
thing easily bought and ironically forgettable: key chains, coffee
mugs, t-shirts, animal or human safaris, or, in Vietnam, pens and
necklaces supposedly made from American bullets. At best, a memory
industry calls forth the professionalization of memory through the
creation of museums, archives, festivals, documentaries, history
channels, interviews, and so on. But the work that memory indus-
tries do is only part of an industry of memory. To mistake memory
as just a commodity for sale, or information to be transmitted by
experts, would be like considering a gun and its manufacturer, or
a surveillance system and its designers, to be simply products of
an arms industry. Arms industries are only the most visible parts
of a war machine. In war machines, the bristling armaments are
on display, but more important are the ideas, ideologies, fantasies,
and words that justify war, the sacrifices of our side, and the death
of others.

Likewise, an industry of memory includes the material and ideological forces that determine how and why memories are produced and circulated, and who has access to, and control of, the memory industries. Certain kinds of memories and remembering are possible because an industry of memory depends on, and creates, "structures of feeling." That term by Raymond Williams pulls together both the concrete (a structure) and the immaterial (a feeling).[9] A feeling, no matter how invisible, houses us, shapes us, lets us see the world through its windows. As structures vary from rich to middle class to poor, from wealthy nations and metropolises to colonies and hamlets, so do feelings themselves vary. The world pays attention to the feelings of the wealthy and the powerful, because those feelings matter when the wealthy and the powerful make decisions that can burn. The feelings of the poor and the weak are much less visible, except, of course, to the poor and the weak. As it is with feeling and its structures, so it is with memory and an industry of memory, where the memories of the wealthy and the powerful exert more influence because they own the means of production. As Marx and Engels said, "the ideas of the ruling class are in every epoch the ruling ideas."[10] So, too, are their feelings and memories the most powerful, made, packaged, distributed, and exported in ways that overshadow the feelings and memories of the weak.

While the memories of the weak matter to them, as the individual's memory matters to the individual, they only matter for the world when an industry of memory amplifies them. This industry is more than a set of technologies or cultural forms through which memories are fashioned, like the novels, movies, photographs, museums, memorials, or archives populating this book.[11] This industry is more than the network of professionals who curate, design, and study memories, or the artists, writers, and creators of cultural works of memory. The industry of memory includes these and more, incorporating the processes of individual memory, the collective nature of memory's making, the social contexts of memory's meanings, and,

ultimately, memory's means of production. All these determine how—and whose—memories are made and the reach and impact of their distribution. The blast radius of memory, like the blast radius of weaponry, is determined by industrial power, even if individual will shapes the act of memory itself. So while Thich Quang Duc showed indomitable belief and discipline while fire and smoke consumed his body, the global fallout of his act occurred because Western media seized on it. People have immolated themselves since then, during the war and after, in the country and outside of it, even in America, but those self-sacrifices did not achieve the visibility of the burning monk. Sacrificing one's self in order to be heard is not enough. Until those whose memories are left out not only speak up for themselves but also seize control of the means of memory making, there will be no transformation in memory. Without such control, those who speak up for themselves and others will realize they do not determine the volume of their voice. Those who control the industry of memory, who allow them to speak, set that volume.

Struggles for memory are thus inextricable from other struggles for voice, control, power, self-determination, and the meanings of the dead. Countries with massive war machines not only inflict more damage on weaker countries, they also justify that damage to the world. How America remembers this war and memory is to some extent how the world remembers it. Even if the United States is a reduced industrial base in an age of increasing competition from rising Asia, it is still a superpower in the globalization of its own memories, symbolized in Hollywood and its movies, which feature American memories as well as American armaments. By far the most powerful of its kind, the American industry of memory is on par with the American arms industry, just as Hollywood is the equal of the American armed forces. The global domination of weapons and memories by the United States leads other countries, regardless of their own memories of the war, to confront Hollywood goods and

those instantly infamous snapshots that struck viewers between the eyes. As the essayist Pico Iyer noted, by 1985, "Rambo had conquered Asia . . . every cinema that I visited for ten straight weeks featured a Stallone extravaganza."[12] The technology that makes possible this global distribution and world-class quality of American memories is embedded throughout American society, including at my own University of Southern California. The campus is home to the most advanced cinema school in the world, as well as an army-funded research center that develops high-tech virtual reality simulators for the military. In the same institution where Hollywood's future directors learn their craft and where buildings carry the names of George Lucas and Steven Spielberg, these virtual reality simulators allow soldiers to practice war via cinema or to be treated for trauma from war.[13] The philosopher Henri Bergson implied that memory is a kind of virtual reality, and this simulator demonstrates that virtual reality is also the staging ground for battle and its recuperation.[14] Weaponized memory becomes part of the war machine's arsenal, deployed in the struggle to control reality.

Elsewhere on campus, students learn how to develop software for video games, a genre of weaponized memory not to be ignored when one thinks of the human mind as the most strategic of all battlefields. The mind must be won virtually before a real war can ever be fought. War has long been a subject for video game storytelling, and this war is no exception, as realized in the *Call of Duty* series. More successful than many Hollywood franchises, this $11 billion revenue product belongs to the subgenre of the first person shooter, a name that makes obvious how weapon and narration go hand in hand.[15] In this subgenre's iteration on the Vietnamese landscape, *Black Ops*, the gamer views the chiaroscuro world of heroes and villains through the eyes of an American warrior. The game's trailer evoked movies, the most important one being Michael Cimino's 1978 film *The Deer Hunter*, where Viet Cong torturers force American prisoners of war to play Russian roulette. Although no

historical basis existed for this scene, there might have been an historical inspiration. When actor Christopher Walken presses the barrel of a .38 against his head, it evokes the iconic bullet to the head on the streets of Saigon during the Tet Offensive. Evokes and yet erases, for instead of Vietnamese shooting Vietnamese, the movie centers on an American about to shoot himself. Americans love to imagine the war as a conflict not between Americans and Vietnamese, but between Americans fighting a war for their nation's soul. Russian roulette makes the solipsistic revision of the war a literal one, substituting American pain for Vietnamese pain. *Black Ops* goes further, for while the torturers in *The Deer Hunter* are Vietnamese, the chief villain in the video game trailer is Russian. If the Vietnamese are to be villainous, could they not at least be the chief villains?

But the importance of *Black Ops* is not only the power of its individual fantasy. More than this, *Black Ops* is the entertaining face of the war machine. Young people play games like this the way British lads played in the Boy Scouts, girding themselves to become the guardians of the empire on which the sun never set, except that one day it did. While not all American boys (or girls) will sign up to be tank gunners, drone pilots, or helicopter weapons officers, the ones who do will already know the principles of seeing the enemy through the eyes of a first person shooter. As for the overwhelming majority of Americans who do not join the military, many will enjoy the action and watch it on the screens of their personal devices, where the explosions and the deaths will not seem real but instead be a visual reverberation of the video games they already know. This is how the industry of memory trains people to be part of a war machine, turning war into a game and a game into war through the narration of the first person shooter.

While the novel and the movie are also parts of the industry of memory, the first person shooter outclasses them when it comes to seducing readers or viewers. The first person shooter exploits cinematic technology and changes it from a passive technology to an

active one. A first person shooter combines the duration of *A Re-membrance of Things Past* with the intensity of a movie, each minute more engrossing than reading a novel or watching a movie. The game is not about identifying with the other and feeling for another person, those moments of sympathy and empathy so vital for finding pleasure in the novel and the movie.[16] Instead, the first person shooter is built on the aesthetics of sweat and viscera and is about identifying one's self with the shooter and feeling the joy and excitement of participating in slaughter. The slaughter does not depend on enjoying the pain of the other because the other is so distant that one cannot even conceive of the other as capable of any feelings. The other is simply nonhuman, while the pleasure of the gamer is inhuman, as he or she takes pleasure in destruction.

It is not that we *will* destroy the nonhuman, just as feeling deep empathy for the characters in a novel may not inspire us to save actual human beings. But the novel and the first person shooter lure us, in different ways, to accept their underlying principles of salvation or destruction. A great novel about distant others persuades us of the need to save them, which, in our laziness, apathy, or fear, many of us will likely leave to someone else to do. A great first person shooter heats the blood to the proper temperature for killing others, which, in our attachment to our humanity and instinct for self-preservation, many of us will likely leave to our army to do.[17] We become accustomed to seeing through the rifle scope, then through the crosshairs of a missile with a seeing eye, now through the unblinking gaze of a drone. The first person shooter is the autobiographical point of view of the war machine, a finite view of a society which accepts the necessity of armaments and of killing others as part of daily life, whether it is on the streets and in the schools of one's own city or on the landscapes of others. As novelist Gina Apostol puts it: "The military-industrial complex . . . does it not suggest not only an economic order but also a psychiatric disorder?"[18]

If so, it is a common and pervasive disorder, this complex that refuses to recognize or analyze itself. It is hardly surprising that Americans are then disturbed when they see how others depict them. This is not unique to Americans. All war machines program their passengers to identify with the machinery. They take comfort and pride in their machinery via its ideological software while being fearful of the war machines of others. When they encounter the memories of their others, they, too, are likely to be shocked, suspecting a viral infection from a foreign bug. One can call this either the shock of misrecognition or recognition. One of these two shocks will most likely happen to the tourist when visiting the War Remnants Museum, touted in guidebooks as one of Saigon's top tourist destinations. Of the museum's wide range of exhibits, the one American tourists remember most is the one that greets them on the first floor lobby, titled "Aggression War Crimes" (*tội ác chiến tranh xâm lược*). The average American tourist is turned off by this title. Americans do not appreciate muddled English, even if that English is better than their own grasp of the local language. Even less do Americans like being accused of war crimes, because most Americans believe that it is categorically impossible for an American to commit a war crime. But the museum does primarily feature the war crimes of Americans—massacres, torture, desecration of corpses, the human effects of Agent Orange—captured in black-and-white photos by Western photographers during the war. Suddenly the American tourist becomes a semiotician, aware of how photographs do not simply capture the truth but are framed by their framers. When forced to look at these atrocities, a fairly typical American response is say *we did not do this* or *they did this too*.[19] This is the shock of misrecognition, seeing one's reflection in a cracked mirror and confronting one's disordered self.

Recognition is more likely for American tourists who visit Son My, remembered by Americans as My Lai. The village is located many hundreds of miles north from Saigon and is distant from the

easiest tourist route on Highway 1A, and only the particularly knowledgeable and curious American tourists will visit. A museum is built on the remnants of the village, where trails of footprints in the cement pathways evoke the ghosts of absent villagers. American troops killed more than five hundred of these villagers. An outdoor mosaic shows the villagers under assault from the sky by a science fictional war machine, black and bristling with engines and bombs, an open maw of a furnace in place of its nose. Giant drops of red blood drip from the bottom of the mosaic. In the museum, a diorama shows life-size black and white American soldiers, grimacing in fury as they shoot villagers who look surprisingly peaceful in the moment of death. Americans who make this pilgrimage to Son My already know of the massacre, and rather than being average tourists are more likely mourners come to pay respect.[20] They anticipate the shock of seeing this diorama. *We did this*, they think. *We know we did this.*[21]

In these and other postwar American encounters with Vietnamese memories in Vietnam, Americans find themselves shown in ways that bruise them. They no longer have the comfort of sitting inside their war machine, protected from the recoil of its weaponry by a suspension system of ideology and fantasy. In the Vietnamese landscape, as tourists rather than soldiers protected by armor, artillery, and airpower, they are the disremembered others—murderers, invaders, villains, and air pirates, in the punchy language of the museums and exhibits. Mary McCarthy, visiting Vietnam during the war, calls these names lobbed at Americans "Homeric epithets."[22] Not used to epic poetry in everyday spaces, and not used to being disremembered, many Americans feel that the entire war and their identities cannot be reduced to the atrocities commemorated all over the Vietnamese landscape. These Americans regard the War Remnants Museum and the Son My diorama as propaganda, which they certainly are. Official and unofficial versions of Vietnamese memory show little interest in commemorating others in any way

(note the absence of any outraged dioramas anywhere in the country depicting what the victorious Vietnamese inflicted on the defeated Vietnamese). But these Americans are wrong in denying the truths found in propaganda, specifically that American soldiers committed atrocities in Vietnam and that the rest of America never fully grappled with its complicity in them. The war was not one where "the destruction was mutual," as President Jimmy Carter claimed and as many Americans of all political backgrounds want to believe.[23] In fact—and not as a matter of interpretation—this war's destruction was not mutual in terms of costs and deaths. It is ethical and just to confront those numbers, and the following realities: no massacres committed on American soil, no bombs dropped on American cities, no Americans forced to become sex workers, no Americans turned into refugees, and so on.

It is unethical and unjust to refuse to acknowledge these inequalities in the matters of death and damage, but it is difficult to confront or acknowledge inequalities when the memories of these events are themselves unequal. Exposed only to their own memories, Americans who come across the rememories of others often react with fury, denial, and countercharge. In this, they are not unique. Every nation's people are accustomed to their own memories and will react the same way when confronted with other people's rememories. People protect and justify themselves, and their memories cast themselves in the best possible light. Negative memories are not necessarily forbidden but they are, however, negotiated. Americans may dimly know that some of their soldiers committed terrible acts, but such actions are mitigated by the circumstances that supposedly forced the soldiers into wrongdoing and by the American capacity for honest reflection. Americans may commit crimes, but they do not commit propaganda, or so they believe. No matter what form propaganda takes, it always belongs to someone else, which is not to say that all propaganda is the same. The American version is several grades better than the Vietnamese one, par-

tially because American propaganda is not state-controlled. The industry of memory and the war machine work together, most of the time, to both acknowledge and justify America's mistakes and crimes. The Soviets and the Chinese, for all their authoritarian power and massive war machines, were never as good at packaging their ideology, which came in a one-size-fits-all mode of drab fashion and bad haircuts. Communism's message says to do as the party and the people tell you, while capitalism tells you to do whatever you want, its ideology ready to wear in any size. Everyone can agree to disagree, even if, in the last instance, this may be false. Sometimes the limits to the American belief in "freedom" are nakedly visible, as during McCarthyism, but mostly the limits are visible only out of the corner of one's eye. These limits are found in the requirement to pay one's taxes to fund the war machine and to concede that armed resistance against the war machine is futile.

A key part of American ideology is that all individuals are equal, even if American practice demonstrates that such is not the case, including in the realm of memory. Collective memories are not equal and individual memories are only equal so long as they remain segregated within one's own mind. My memories feel as powerful to me as yours feel to you, regardless of any differences in our places in the world, but if you have access to the megaphones of industrial memory, your memories are more powerful than mine. So it is for Americans and Vietnamese, their memories equally meaningful to each of them but unequal on the global stage. Worldly memory is neither democratic nor fair. Instead, various kinds of power, none of which can be separated from each other, determine memory's influence, reach, and quality. American power means that America can project its memories elsewhere, in the same way that it projects military force to render the lives of others less valuable than American lives. The empire of bases of which the scholar Chalmers Johnson speaks, some seven or eight hundred American military outposts, encampments, airfields, and black sites found all over the world,

manifests this power.[24] And just as many countries let themselves become territories where American soldiers can operate, even more countries have let down their defenses against the intrusion of American memory, the soft power exports of cinema, literature, language, ideas, values, commodities, and lifestyles, the whole Hollywood–Coca Cola–McDonald's network found in many big cities and not a few small ones, including in Vietnam, from its metropolitan centers to its new suburbs with their smooth sidewalks, fast food outlets, and detached single family homes.

Because of the reach of American military and mnemonic power, of the entire American war machine lifestyle and its assumptions, I always run into American memories. No matter where I go outside of Vietnam, if I want to discuss the war, even with intellectuals and academics, I often have to encounter their encounters with American memories. The Ivy League professor of contemporary literature who inquired about Tim O'Brien at my lecture on Vietnamese civilian war memories (because, she asked, what about actual war stories?); the Indian professor of Indian cinema who brought up *Apocalypse Now* when I mentioned Vietnamese cinema about the war; the young Vietnamese filmmaker training at my university who volunteered that he admires *Apocalypse Now*. How I would hate *Apocalypse Now* except for the fact that it is a damn fine movie, besides being the perfect example of the war machine's industrial memory. The Indian professor even quoted from Francis Ford Coppola about the legendary making of the movie: "My film is not a movie. My film is not about Vietnam. It is Vietnam. It's what it was really like. It was crazy. We made it very much like the way the Americans were in Vietnam. We were in the jungle. There were too many of us. We had access to too much money, too much equipment, and little by little, we went insane."[25] I can excuse Coppola for the sentiments. He was young, perhaps megalomaniacal, and certainly caught up in the creative struggle of his life. But was he fundamentally wrong? Jean Baudrillard took him at his word, saying that

"Coppola makes his film like the Americans made war—in this sense, it is the best possible testimonial—with the same immoderation, the same excess of means, the same monstrous candor . . . and the same success."[26] *Apocalypse Now*, nearly a disaster in its making but a box office triumph and a cinematic classic, can be read as an allegory for the fate of America's ambitions in Vietnam: short-term failure during the war but long-term success in containing communism in Southeast Asia.

Movies and wars are related, and the American helicopter symbolizes this relationship. Michael Herr, who also wrote the narration for *Apocalypse Now*, had this to say of those American helicopters known as Loaches: "It was incredible, those little ships were the most beautiful things flying in Vietnam (you had to stop once in a while to admire the machinery), they just hung there above those bunkers like wasps outside a nest. 'That's sex,' the captain said. 'That's pure sex.'"[27] Loaches appear in *Apocalypse Now*, too, a movie that is, cinematically and mnemonically, pure sex, and is unsettling for some as a result. *Apocalypse Now* and Herr's *Dispatches* converge in their honesty about, or perhaps exploitation of, the nitty-gritty core of war, which is the fusion and confusion of lust and killing, sex and death, murder and machinery, resulting in homicides that were illegal at home but encouraged overseas in the war zone. For men and boys of a certain persuasion, "pure sex" is life and death, the mind-blanking climax that eradicates the self and may yet lead to its reproduction. *Apocalypse Now* depicts the desire for pure sex and conveys the lust to its viewer, the emblematic scene being the helicopter assault on a Viet Cong village, set to the diegetic soundtrack of *The Ride of the Valkyries*. Director D. W. Griffiths also used this Wagnerian music in his Civil War and Reconstruction era epic *The Birth of a Nation*, the score accompanying the heroic Ku Klux Klan as they ride to rescue whites besieged by lascivious blacks. Perhaps Coppola was criticizing American culture by comparing American soldiers riding on helicopters to the

Ku Klux Klan on their steeds, but the seductive power of his cinematic, airborne assault makes that critique hard to see.

Just as Coppola quoted from Griffiths, the director Sam Raimi would quote from Coppola in *Jarhead*, the film adaptation of Anthony Swofford's memoir of the Gulf War. Raimi picks up on the author's depiction of young men's erotic infatuation with pure sex and war movies:

> Vietnam war films are all pro-war, no matter what the supposed message, what Kubrick or Coppola or Stone intended. . . . Fight, rape, war, pillage, burn. Filmic images of death and carnage are pornography for the military man; with film you are stroking his cock, tickling his balls with the pink feather of history, getting him ready for his real First Fuck. It doesn't matter how many Mr. and Mrs. Johnsons are antiwar—the actual killers who know to use the weapons are not. . . . The supposedly anti-war films have failed. Now is my time to step into the newest combat zone. And as a young man raised on the films of the Vietnam War, I want ammunition and alcohol and dope. I want to screw some whores and kill some Iraqi motherfuckers.[28]

Politicians, generals, journalists, think tank wise men (and women) do not deploy this language, but writers, artists, and filmmakers do. They recognize what cannot be said in polite company: war is pure sex, in addition to being politics by other means. On screen, Raimi shows an auditorium full of lustful young male Marines watching the helicopter assault from *Apocalypse Now*. Raimi's camera cuts between the screen (which itself shows *Apocalypse Now* cross-cutting between helicopters and villagers) and the faces of Marines howling, cheering, and reaching cinematic orgasm while the air pirates blast the village. Then the lights suddenly come on, *Apocalypse Now* is suspended, and an announcer tells those in the auditorium a real war is about to begin—Desert Storm in Kuwait. It is not coitus in-

terruptus after all, only the realization that the movie was simply foreplay to a war.

Both Swofford and Raimi depict the war machinery's pure sex brilliantly. They recognize that war movies are part of the war machinery, with the helicopter at the center of my war's iconography. Its rotors provided the war's soundtrack, as filmmaker Emile de Antonio understood. In his 1968 cinematic poem *In the Year of the Pig*, the ripple of rockets and the whipping of helicopter blades are repetitious and minimalist. The collective drone is the war machine breathing, insinuating death, industrial production, and orgasm. Coppola popularized part of that drone, making the helicopter concerto of the whipping blades a motif of his movie and ultimately of the war itself for American memory. Material object and (sex) symbol, war machine and a star in the war machinery, bristling with machine guns and rocket pods, the helicopter gunship personifies America, both terrifying and seductive.

The Vietnamese certainly recognized the helicopter's symbolic star power and tried to counter it themselves, most directly in the movie *The Abandoned Field: Free Fire Zone*, released in 1979, one year after *Apocalypse Now*. The screenwriter, Nguyen Quang Sang, survived American helicopter attacks and recounts that he most feared their death-dealing intimacy, "scarier than the B-52 attacks because those bombers flew so high they couldn't see you." Helicopter attacks were "terrifying" because they were so intimate, flying low enough that "I even saw the face of the door gunner."[29] The writer and former helicopter pilot Wayne Karlin imagined the situation in reverse after he met the Vietnamese writer Le Minh Khue, who had fought for the other side: "I pictured myself flying above the jungle canopy, transfixed with fear and hate and searching for her in order to shoot her, while she looked up, in hatred and fear also, searching for me."[30] While the thought of such intimate violence sickens Karlin, *Apocalypse Now* revels in this proximity. The camera looks over the shoulder of a helicopter gunner through his

gun sight, lined up on the back of a Vietnamese woman twenty or thirty feet below. "Look at those savages!" says the pilot. Going out to battle was venturing into "Indian country," an oft-repeated phrase among American soldiers that brought with it all the attendant sense of racial and technological superiority, as well as the mortal fear of being killed by savages.[31] In *Apocalypse Now*, the Vietnamese woman targeted for death had just tossed a hand grenade into a helicopter. In *The Abandoned Field*, the Viet Cong heroine whose husband has been killed by an American helicopter shoots it down with an antique rifle, then walks away from the wreckage with gun in one hand and baby in the other. In these two films, it is intentional that the most dangerous savage and the most heroic hero is a native woman. For a war machine exuding pure sex, she is the collective object of masculine desire, hatred and fear, especially for white men.

People worldwide have watched *Apocalypse Now* and many accept its worldview, which is not merely that the other is a savage. The worldview is also that the self seeing the movie, as well as the self seeing the native in the crosshairs, is savage, and there is not much to be done about it, aside from giving in to the brutality or accepting that others do. So it is that the narrator of *Apocalypse Now* continues his fateful cruise up the river to confront his father figure, Kurtz, the white man who has become king of the savages and who must be killed because he has shown that the white man is no different than the savages. Of course *Apocalypse Now* intends for the images of savages and Indians to be ironic, a knowing commentary on how the white man is also a brute. Such is the white man's burden, turned into a monster himself as he attempts to save the savage from her savagery or kill her in the process. This ethical recognition of the white man's inhumanity gives *Apocalypse Now* its kick as well as its controversy. Enduring works of memory like this movie will force audiences to confront the simultaneity of inhumanity and humanity, rather than just one or the other.

But insofar as an ethical memory calls for remembering one's own and remembering others, we also need to recognize that industries of memory constrain ethical vision. *Apocalypse Now* deploys a limited ethical vision that offers insight into the white man's heart of darkness, where he is both human and inhuman, but at the expense of keeping the other simply inhuman, as either savage threat or faceless victim (as for the movie's stepchild, the first person shooter, it dispenses with any pretense of sympathy for the savage in the crosshairs). Because industries of memory are integrated with their war machines, the war machine's need to subordinate the other affects memory. By definition, the war machine cannot remember the other except in the instrumental ways necessary to kill her or subdue her, and so the other remains other, despite acknowledging one's own savagery. In *Apocalypse Now* the American may know he is a savage, but he takes comfort in being at the center of his story, while the savage is only subject to the American story. The war machinery reveals the savage to be a savage, looked down on from on high. Earthbound, the savage can neither obtain those physical heights nor the moral heights of being a noble victim, because the faceless victim simply is not human. This is the crucial difference between looking through the crosshairs or being caught in the crosshairs, being the first person shooter or being the person shot. The white man perfects the technology that depicts his imperfections and the technology that kills the savage in a spectacle to be enjoyed and regretted simultaneously. The same industrial society produces the American movie and the American helicopter, spectacular machines that hover over alien lands, slaughtering to a haunting soundtrack, eliciting the reaction of pure sex from admirers. In the end, both the movie and the helicopter are more memorable to most of the world than the savages lined up in their sights.

While the American industry of memory is bigger than the movie, the movie is its most visible, spectacular embodiment, industrial

memory par excellence. The American war movie in particular—a depiction of massive firepower and an example itself of massive firepower—shows how cinema has long collaborated with the war machine. As the philosopher Paul Virilio says, "war is cinema and cinema is war."[32] Modern war depends on cinematic technology, and cinematic technology thrives on depicting war. The camera allows mobile vision, especially remotely and on high, which is better for artillery, missiles, smart bombs, surveillance planes, and now drones to see the enemy before killing them. Conversely, the camera records war, depicts war, and documents war's damage. Whether as documentation or entertainment, cinema is critical in disremembering the enemy and remembering war. Another way to say that war and cinema converge is to recognize that Vietnam became a spectacle for Western audiences, the claim of theorist Trinh T. Minh-ha.[33] In real life, Vietnam the country burned, and in photographs, on television, on celluloid, Vietnam the war burned again and again. Vietnam was a shocking spectacle and enjoyable too, eliciting moral repugnance on the part of some and erotic pleasure on the part of others, maybe even the same spectator. The eyeball doesn't just store trauma, as Herr said—the eyeball is also the most erogenous zone of the human body, the distinction between pleasure and pain as thin as the membrane separating sex and rape. The tremor of that membrane is the thrill of watching a machine that embodies pure sex through its promise of high-tech death (for the enemy) and high-tech salvation (for those its own side), of deciding whether to push a button or squeeze a trigger that will tear the veil between life and afterlife. The spectacular war and the cinematic spectacle show how movies love war and how militaries love the visual image. If cinematic and military technology are inseparable, it is because they emerge from the same military-industrial complex, which is the real star of American cinema.

Being only human, celebrities and actors die, but being inhuman, the military-industrial complex lives on. Two examples suffice to

show this, one dumb, one smart. First, the dummy: *Air America*, released in 1990, a cinematic crime about two wild and crazy pilots for the CIA's drug- and gun-smuggling airline, used to supply the Hmong army in Laos. Playing the loveable rogues are a handsome Mel Gibson and a young Robert Downey Jr. The airplane and the airline are the industrial symbols of America, and in the end, Air America—both airline and film—saves the Hmong rather than exploits them. The airplane is used not to smuggle guns and make illicit profits but to rescue Hmong refugees from the Pathet Lao forces attacking their mountaintop base. As explosions and gunfire abound, Gibson and Downey argue over whether to abandon their cargo of contraband weaponry in order to make room for the Hmong. These Hmong say nothing, a crowd in the backdrop standing silent as bullets whiz by and their would-be saviors wrestle with their moral dilemma. In reality, the CIA air-rescued a few hundred of their Hmong allies from their Long Chieng mountain base in the waning days of the war and left thousands more behind. The gap between history and Hollywood is so vast it is hardly necessary to belabor the point that *Air America* is naked propaganda clothed as entertainment, a silly atrocity about how Americans are neither quiet nor ugly but instead decent and good, as well as good-looking.

Now the smart example: *Gran Torino*, a movie about the Hmong that retouches history expertly. This movie also adapts the mechanical motif of *Air America*, named as it is after an American muscle car and set in declining Detroit, aka Motor City, heart and soul of a waning industrial-era America. The legendary Clint Eastwood plays Walt, a gruff, terminally ill Korean War veteran unloved by his own family whose life changes after a Hmong family moves in next door. When the Hmong son tries to steal Walt's Gran Torino with his gangster friends, Walt catches him and whips him into manly shape, in the process befriending the Hmong family. The boy forsakes his Hmong gang, the gangsters rape his sister as punishment, and

Walt takes revenge by going to their lair and provoking them into shooting him dead. The movie enacts the basic ur-myth of European (and American) colonialism, as well as the foundational story of Hollywood, the legend of the white male savior. As the critic Gayatri Spivak put it, this is the tried-and-true epic of the white man saving the brown woman from the brown man (although black or yellow can be substitute colors). But *Gran Torino* twists this epic, for the savior becomes a sacrificial figure. The old white man gives up his own life, but his fate is an example of what Yen Le Espiritu calls the "we win even when we lose" syndrome that characterizes American memory of the war.[34] Walt was already going to die, but now he dies quickly and heroically, bullet-riddled, on his back, his arms spread in crucifixion pose. When a Hmong American policeman arrives to restore order and arrest the gangsters, the moral and geopolitical allegories are clear: America has sacrificed itself to the bad Asians so that good Asians can live and prosper.

More artful than *Air America*, more sympathetic to the Hmong by granting them speaking roles, *Gran Torino* is also the more dangerous film. A low-budget movie that became Eastwood's biggest box-office success before his mega-hit *American Sniper*, it is a small-tonnage smart bomb that hits its target. *Air America* is a big-tonnage dumb bomb that only throws up dust and thunder, leaving the enemy intact, a movie so bad it seems like a parody of a Hollywood blockbuster. In contrast, *Gran Torino* wins the hearts and minds of audiences and critics by allowing the natives to participate in their own subjugation, versus simply turning them into human props, as *Air America* does. *Gran Torino* illustrates the notion of writers Frank Chin and Jeffery Paul Chan that (white) America reserves "racist hate" for uppity blacks and "racist love" for docile Asians.[35] Racist love is what Walt practices, following in a long tradition that includes Kurtz, the king of the natives, as well as his comic relief descendants in *Air America*. Flinging insults at people of every ethnicity, Walt

performs a supposedly endearing and entertaining xenophobia. Walt may be a racist, but he is an honest and paternal racist who loves his little friends so much he will die for them.

Walt embodies (white) America at home and abroad, or at least the way (white) America sees itself after the civil rights era. In this age, (white) Americans may or may not admit their racism, but they will insist that they defend the little guy, especially the poor and tired one from abroad. So it is that Walt wills his beloved Gran Torino not to his inattentive children and spoiled grandchildren but to the Hmong boy whom Walt has taught to be a man. This paternalistic American father figure who saves the Southeast Asian child is a staple of American industrial memory. An early example is Samuel Fuller's film *China Gate* (1957), which opens with a hungry Vietnamese man threatening the puppy of a Vietnamese boy. The boy eventually finds protection with an American serving in the French Foreign Legion, and the film's final frame shows the American walking off with the boy he has saved. John Wayne's *The Green Berets* (1968) echoes this ending when the Duke puts a green beret on a little Vietnamese boy. When the boy asks him what will happen to him, now that the soldier who has worn that beret, his adoptive father figure, has been killed, the Duke tells him, "You let me worry about it, Green Beret. You're what this is all about." John F. Kennedy foreshadowed this Hollywood sentimentalism in 1956:

If we are not the parents of little Vietnam, then surely we are the godparents. We presided at its birth, we gave assistance to its life, we have helped to shape its future. . . . This is our offspring—we cannot abandon it, we cannot ignore its needs. And if it falls victim to any of the perils that threaten its existence—communism, political anarchy, poverty and the rest—then the United States, with some justification, will be held responsible, and our prestige in Asia will sink to a new low.[36]

Like the Vietnamese boy wearing his dead father figure's green beret, the Hmong boy in *Gran Torino* has been gifted with his dead father figure's most important symbolic possession. Clearly now his father figure's son, the boy drives into the Detroit sunset at the wheel of the Gran Torino, the most anomalous and unbelievable image of all, for any self-respecting young Asian American man would much rather drive a Japanese car, preferably with deeply tinted windows, expensive rims, and customized stereos. Likewise, in the unbelievable ending of *The Green Berets*, John Wayne and his charge walk into the sunset off the coast of Vietnam, even though the coast of the country faces east.

That distortion of reality was a laughable mistake, but the setting of *Gran Torino* is a deliberate distortion built into the movie's design, its purpose to advance the American industry of memory. While most of the Hmong refugees ended up in rural California and Wisconsin, in *Gran Torino* they arrive in Detroit, a city nearly dead from a heart attack induced by Japanese competition. This setting allows *Gran Torino* to sketch an outline of history that covers half a century of American involvement in Asia, beginning with Walt's war experience in Korea, continuing through the allegory of the automobile to allude to Japan (whose industry was rebuilt from American bombing with American aid), and gesturing to Southeast Asia with the Hmong.[37] The movie is not really about the Hmong neighbors, for any Asian in need of help would have sufficed. Because of the historical timeline of their devastation, the Hmong were simply good candidates for rescue by the white man. This story of rescue erases American racism and violence by foregrounding Asian violence and American self-sacrifice, a tall tale told as a movie, a product America has perfected in its spectacular form. No kind of exportable entertainment is bigger and more expensive than an American movie, just as nothing is bigger than an American supercarrier or more expensive than an American fighter jet. The pure sex of hard machinery and high technology are part of the sexiness of

superpowers and their memories. Small countries are sexy too, but in predictably exploitable and degrading ways, offering to the more powerful the thrill of employing cheap labor and buying cheap goods, including cheap prostitutes, the "little brown fucking machines" admired so much by Western men that they invented an appellation for them. These machines may be desirable and alluring, but they are no match for a war machine.

None of this surprises, but I am not asking anyone to be surprised. I am not asking Hollywood or the industry of memory to do more or better. They do exactly what they are machined for, exerting dominance for profit and pleasure. I am only asking that their enactment of a joint venture with the war machine be recognized. If Baudrillard understood one thing clearly, it was that a film like *Apocalypse Now* was "cinematographic power equal and superior to that of the industrial and military complexes, equal or superior to that of the Pentagon and of governments."[38] Hollywood's blockbuster strategy is only the cinematic equivalent of American military strategy, a celluloid campaign of shock and awe meant to obliterate all local competition, as American stealth bombers overwhelm enemy air defenses. Shock and awe was born out of the lessons of my war for young American field officers, who ultimately saw the war's strategy of attrition and its escalation of violence as futile. Immediate, overwhelming force was needed to win wars, a lesson these officers, who became generals, applied against Panama, Grenada, and Iraq. Cinema-like technologies filtered shock and awe for the American public and the world, the vividly detailed and highly censored twenty-four–hour news feed that showed little of what happened to the enemy. As cinema conditioned audiences to see onscreen death and understand it as a simulation, so war now depended on audiences feeling that the death of others was neither real nor to be remembered. The industry of memory thus fulfilled its task of supporting the war machine by being its unofficial ministry of misinformation.

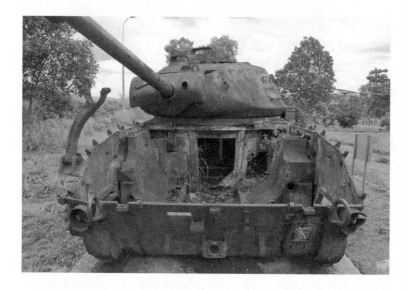

But industries are vulnerable to competition; war machines can be destroyed by asymmetric warfare; both can break down by falling victim to their own excesses of power, money, and greed. This is what one never learns in the war machine's virtual reality world: total domination in industry and war can falter, especially when the others in the crosshairs fight back, oftentimes in unanticipated ways and from unanticipated directions.

5

On Becoming Human

THREE MILLION KOREANS DIED during the Korean War. Much of the country was laid waste by American bombing and by the attack and counterattack of armies from the north and the south, from the United States and from China, and from an array of states in the United Nations.[1] While Cambodians remembered their genocide with the mantra of three years, eight months, twenty days—the finite duration of the Khmer Rouge regime—Koreans point out that their war never officially ended. Korea was divided into the Republic of Korea (the south) and the Democratic People's Republic of Korea (the north), twins facing off for more than half a century in an ongoing Cold War drama. From the capitalist West's perspective, contemporary South Korea is the success story of what capitalism can achieve. Perhaps it is hard to remember, then, that the country was so devastated by the war that in the 1960s it was poorer than South Vietnam. When the United States offered to pay South Korea to use its army in South Vietnam, the impoverished nation agreed. While some Americans call the Korean War the Forgotten War (forgetting that other Forgotten War in the Philippines), from the Korean perspective it is better to say that the Forgotten War was

this one that Korea fought in Vietnam. In South Korea—which many simply call Korea—the Remembered War is the Korean War, which has assumed the status of a nation- and soul-defining event. In its shadow, the other Korean war in Vietnam is poorly remembered by Koreans, which only goes to show that amnesia and selective memory afflicts every nation.

Before I learned of the forgotten Korean war in Vietnam, I knew of Korea through its remembered Korean War. As an adolescent, I read Martin Russ's *The Last Parallel* and watched American war propaganda, Rock Hudson starring in *Battle Hymn* and William Holden in *The Bridges at Toko-Ri*. Both actors played heroic Air Force pilots who helped save the country (the Air Force's mass bombing of all of Korea was conveniently ignored). When I became vaguely aware of Korean students taking to the streets in political riots in the 1980s, Korea was simply another troubled foreign country that appeared briefly in American news broadcasts. During my college years, I along with many Americans had more pleasant encounters with Korea through its cuisine. But the full presence of Korean immigrants in the United States would arrive for the American public in 1991, with the Los Angeles riots, or uprisings, or rebellion. Koreatown was the unlucky star, Seoul USA, home to the largest Korean population outside of Korea and located in the midst of largely black and Latino neighborhoods. The unrest was provoked by two incidents: Los Angeles police officers beating a black man, their assault captured on video, and a Korean shopkeeper fatally shooting a black girl who had shoplifted a bottle of juice. Juries had acquitted both the officers and the shopkeeper. For many African Americans and Latinos, these injustices were the culmination of a history of oppression by the police and economic exploitation by ethnic outsiders. Korean and other shopkeepers became scapegoats for the poor and working class, and Koreatown burned.[2]

A few years later, the reputation of Korea and Korean Americans began to change. Hyundai, Kia, LG, and Samsung stormed the ram-

parts of global capitalism. Millions of consumers owned a bit of Korea in their homes or their pockets, and some began driving Korean cars. Korean capital infused Koreatown and Los Angeles, and some immigrants who had left a poverty-stricken Korea to come to America in the 1960s suddenly found that their relatives in Korea had overtaken them.[3] These immigrants had sacrificed their college degrees to become shopkeepers in ghettoes, all in the name of their American-born children, or so the narrative went in America's model minority myth. In this myth, Asian immigrants and their American-born children appear as superhuman students and workers, with Koreans being the latest Asian immigrant population willing to discipline themselves and to sacrifice their bodies and minds to dream the American Dream. In doing so, they became the model for the rest of America's "unsuccessful" minorities and immigrants, at least in the narratives of the media, the politicians, and the pundits who argue that those who fail to achieve the American Dream have only themselves and the welfare state to blame.

For many conservative commentators, this welfare state is a cousin to the socialist and communist states. The Asian American model minority was important in the antiwelfare narrative not only because of what it said about America domestically, but also because of how it proved to the rest of the world the worth of the American ethos of self-driven capitalist success. Capitalism American-style was imitated and improved upon most successfully by certain countries in Asia, including Korea. In a capitalist worldview, Korea's Asian tiger economy was matched by the Korean diaspora in America as a model minority. Koreatown was not alone in its function as an ethnic enclave that stood in for a poor country. Most ethnic enclaves in the American imagination played that role, including Little Saigon. What made Koreatown unique was being put to the torch, at least in the late twentieth century (the earlier incinerations of ethnic enclaves at the hands of whites having largely been forgotten). In this capitalist way of thinking, the modern-day sacking of

Koreatown by the ungrateful dark masses could be seen as another version of the burning of Korea by the communists. In both cases, lines were drawn to prevent the fires from spreading, by the Los Angeles Police Department in America and by the armed forces of the "free world" and the "free market" in Korea.

Against these legacies of the Cold War and of hot racial relations, the Korean Wave rolled over Asia. *Hallyu* was the phenomenon of Korean soap operas and pop music that infiltrated Asian countries and Asian diasporas. Korean culture became the new cool, climaxing with the global video hit and dance craze of 2013, *Gangnam Style.* Youth all over Asia and Asian youth in America wore Korean fashion and Korean hair. Koreans themselves developed a reputation, fair or not, for reworking themselves with plastic surgery, a practice most visibly performed by the stars of *Hallyu. Hallyu* was the triumph of Korean soft power, enabled by Korea's economic transformation. The rise of Korea impacted even me, for while I was usually mistaken for Japanese in Europe, in some parts of Asia I was mistaken for Korean, most ironically in my own homeland. Compared to my fellow countrymen, at least the ones who had never left, I was too tall and too pale and dressed in Western styles, my hair achieving Korean elevation. Even when I spoke Vietnamese, they routinely said, "Your Vietnamese is so good!" They assumed I was not one of them, which, perhaps, I am not.

In Seoul, no one ever mistook me for Korean. My impression was of a twenty-first–century city coated in a metallic sheen, the reverse of the frightening Pacific Rim metropolis of *Blade Runner.* The international facilities were superb, at least to someone who had agonized through the terminals in Saigon or Hanoi. The plush, air-conditioned limousine taxi that ferried me to my hotel had tinted windows, as did most of the slick cars that sped by. Seoul was clean, efficient, and intense in its display of light and smooth surfaces, its people's designer clothing and handbags and eyeglasses. Traffic was orderly and citizens were courteous, at least to an outsider who did

not speak the language. One need not worry about the water or the food or the air, and the threat of the north was like the threat of an earthquake in my California—everyone was blasé, except for the troops on the Demilitarized Zone, itself a must-see for tourists. I remembered how my first exposure to Korea was through *M*A*S*H*, the 1970s television series about wacky American military doctors in the Korean War, which my young refugee self did not recognize was also an allegory for America's war in Vietnam. America wanted to save both countries but only convinced itself of success in the case of one.

Sixty years after the truce, thirty years after the television show, Korea now jostles with America for cash and coin even as it depends on America for military protection. This history of East and Southeast Asia tempts the counterfactual, presents the lurking possibility of alternative times and universes, of roads and choices not taken, of the different family I could have had and the different self I could have been. How many times have I heard Japanese and Korean businessmen and tourists say that Vietnam reminded them of their country thirty or forty years ago? They visit another country and go back in time to see what might have been: if only the war had not happened, if only the communists had not won, if only the country were still divided, at a stalemate. Isn't division and stalemate what happened to Korea, and for its own good? Korea and Vietnam are both capitalist fables, but with opposing morals. Vietnam lost forty years and fell behind because of the wars against the French and the Americans, and for what? Now a reunified, independent, and communist Vietnam suffers from capitalist jet-lag, behind the times, striving to become China or (South) Korea or perhaps Taiwan or Hong Kong or Singapore, where an authoritarian government at least keeps the country clean and precise, unlike the case in authoritarian Vietnam. Of course my impressions of (South) Korea are faulty and tourist-thin. Turbulence, poverty, and uneven development roil beneath the cosmetic façade, but at least a façade exists.

Vietnam has most of Korea's problems but only a measure of its success, and even to cross the mad streets, one must take one's life into one's hands.

Anyone who remembers America's forgotten war in Korea and Korea's forgotten war in Vietnam must feel the possibility of the counterfactual, the point where the histories of Korea and Vietnam intersected and diverged. If (South) Korea had not gone adventuring in Vietnam, would it be the country it is today? If (South) Korea was not the country it is today, could it rewrite its past as it has? If (South) Korea were not a global powerhouse, would anyone care about its memories? The upshot is that (South) Korea's success in waging a brutal and dehumanizing war in Vietnam helped it to become a capitalist and industrial stronghold that can do more than alter faces. The surgeons of history have been at work in Korea, fashioning war memories that efface brutality and implant humanity. From the remembered war to the forgotten war and on to the present, (South) Koreans have reinvented themselves through developing an industry of weaponized memory. They are no longer ugly and sad objects of pity or subjects of terror that people once saw in the world's newspapers during the years of obliteration. Instead they have become human, unlike those other (North) Koreans. The northerners cannot contest the stories told about them by the West and by the southerners. Thus, for most of the world, they remain alien. The case of the two Koreas shows how soft power cuts, tucks, and transforms memories, as necessary to the hard power of the war machine as the people who run it.

In Seoul, the War Memorial of Korea explicitly shows how hard and soft power work together to tell a story about being human. This gigantic, angular edifice is a perfect example of weaponized memory, resembling an armored bunker or a movie set from Hitler's Germany. Its imposing grandeur is itself a story, a mnemonic fortress symbolizing the military-industrial complex, a creation made possible by military success and industrial triumph. The War Memorial

praises that military success and is silent testimony to that industrial triumph, a behemoth whose massive footprint on the Seoul landscape proves the power of Korea. Arrayed around its walls and in its courtyards is enough weaponry to equip a small army: missiles, airplanes, tanks, cannons, and ships, most of American manufacture. The weaponry itself bears silent witness to American capitalist success, the United States being the world's largest exporter of arms. A psychoanalytic reading of the nationalist, masculine pride and anxiety on exhibition would be overkill because it is obvious: the victorious nation's weapons are polished and ready for visitors to sit on or sit in, triggers and barrels ready for eager hands, while the weapons of the communist enemy, at least in the case of Vietnam and Laos, are often left in states of disrepair and destruction. For Korea, the display of enemy defeat is not necessary outside the bunker's walls because inside the story told is clear enough.

The War Memorial is mostly devoted to the Korean War, with professional-grade videos, dioramas, photos, placards, uniforms, and artifacts curated by a highly competent staff. Their effort shows the war to be a confrontation between a North Korea backed by the communist world and a South Korea backed by the free world of democratic and capitalist societies. The hero of the memorial is the Korean army and what scholar Sheila Miyoshi Jager calls its "martial manhood."[4] In the words of the memorial's promotional brochure, the purpose of the memorial is to "cherish the memory of deceased patriotic forefathers and war heroes" who "devoted and sacrificed their life for the fatherland." The memorial urges the idea that Korea owes a great debt to its army in the country's quest to defend and reunify the homeland against communist threat. A plaque in the courtyard sums up the price of heroism and patriotism that was paid by the army and its men: "Freedom Is Not Free." Human sacrifice is presumably required. While it may be expensive in terms of human life to guard and celebrate freedom, the memorial implies that freedom also rewards its defenders with

material well-being. Freedom's economic charge, both in terms of cost and profit, runs throughout the polished halls of the memorial. As proof, the memorial offers itself, a military-industrial complex if there ever was one.

The bulk of the War Memorial focuses on the south defending itself against the north, but a room after the main exhibits on the Korean War chronicle Korea's "Expeditionary Forces." Here, Vietnam is one of many countries that Korean troops have helped, including Japan, China, Kuwait, Somalia, Western Sahara, Georgia, India, Pakistan, Angola, and East Timor. After exiting the Expeditionary Forces exhibit, I concluded the tour by walking through displays of contemporary Korean weapons and uniforms, while videos celebrated the Korean Army's professionalism and expertise. The memorial's narrative is clear: after a brutal Korean War in which United Nations forces helped Koreans, the Korean Army learned how to defend the freedom of others in Vietnam. By doing so, contemporary Korea becomes a full-fledged member of the world's first-rank nations, enjoying what the scholar Seungsook Moon calls "militarized modernity," or the intertwined ways by which the country's rise to global prominence is tied to its militarization, particularly in the standoff against North Korea.[5] Is this martial modernity not what the war memorial embodies? Those impressive Korean armaments and vehicles, and the video screens that showed them, were manufactured by the Korean megacorporations known as *chaebol*. The cumulative effect was the simultaneous expression of Korean military, capitalist, and memorial power, a fearsome weaponized memory aimed at the tourist, me.

Still, the memorial provides the clues to unravel its own making, like the mysterious tag in one's shirt that says Made in China, or Vietnam, or Cambodia, or Bangladesh. In the case of the memorial, that tag is the Expeditionary Forces room, which obliquely admits that what is commemorated in this room was Made in Korea. Despite its name, the room focuses mostly on the Korean war in

Vietnam, as if the curators of the memorial simply could not excise that memory but had to include it in order to excuse it. One enters through a hallway decorated with jungle foliage, the classic sign of the country and the war. Photographs, dioramas, maps, and mannequins provide a historical account of some of the war's events, its participants, and Korean and National Liberation Front bases of operation. In the background a soundtrack of rotating helicopter blades hums, a motif borrowed from Emile de Antonio and Francis Ford Coppola. In sharp contrast to the Korean War exhibits that revel in human sacrifice, from the struggles of refugees to the heroic soldiers who volunteered for suicide attacks, the Vietnam exhibit is remarkably bloodless. The mannequins dressed in enemy uniforms pose stiffly, the illustrations of booby traps are only technical, and the dioramas of guerilla tunnels present the everyday life of the Viet Cong rather than gut-wrenching combat.

The most dramatic image shows Korean soldiers disembarking from a Huey helicopter, familiar to any viewer of documentaries, movies, or news reports that show American soldiers doing the same. Here, though, the disembarkation happens in a glass-encased diorama with toy-sized figurines, as if created by very talented

children for a school project (in the dioramas devoted to the Korean War, the human figures are life-size). Elsewhere the captions on photographs depicting South Korean soldiers—none in battle—read as public relations statements: "Korean forces in Vietnam also took great pride in improving public services and contributing to developmental projects. They earned a reputation for fairness and kindness among the Vietnamese people." Or:

> Through the dispatch of armed forces to Vietnam, we gained confidence and experience in building a more self-reliant defense force. It also increased the momentum of our economic development, strengthened the US commitment to the defense of the Republic of Korea, and solidified South Korea's politico-military status vis-à-vis the United States. Furthermore, the impressive performance of the Korean forces in Vietnam enhanced our international reputation.

The perfect English of these statements is not to be dismissed. In most museums and memorials in Vietnam, Laos, and Cambodia during the postwar years until recently, the English was comically flawed, as if provided by one of Hollywood's chop suey stereotypes. Precise translation and excellent curatorial work are simply further signs of Korea's modernity. Still, these finely trained translators and curators cannot, or will not, deviate from their country's dominant memory. So it is that the rest of the exhibits devoted to Vietnam recount how, after participating in a number of skirmishes and battles, all described in dry language, the South Korean soldiers "returned home in triumph." This usually happens because soldiers vanquished the enemy, but the exhibit is silent about the heroism of these Korean troops. The exhibit is so reluctant to address Korean participation in combat that it does not even acknowledge the toil and trauma of Korean troops, much less that of Vietnamese enemies or civilians. Bringing up the heroic violence of Korean soldiers might dredge up their other, more embarrassing deeds.[6]

While the United States waged the war to contain communism, this small exhibit contains that war's implications for Korea. The most disturbing of those implications points to what Korean soldiers did during their forgotten war, which played a crucial role in Korea's emergence as a subimperial power, as some scholars put it.[7] Imperial powers conquer large swathes of the globe, while subimperial powers settle for regional domination. But even subimperial power can prove that one's country and one's people are not subhuman, but fully human. The paradoxical evidence of that humanity lies in one's ability to bomb others, as Koreans can do now, versus being bombed by others, which is what happened to Koreans before they became subimperial. Subimperial power makes Korea's War Memorial possible, but benevolent power is what this kind of memorial remembers (although those in power always remember themselves as being benevolent). This benevolent power allows one to defend one's own country and other countries, versus having others defend or invade it. But one cannot own all the tanks, weapons, cannons, missiles, and other fine armaments on display in the War Memorial without using them, and one cannot use them without harming innocents or committing atrocities. Given its role as the bunker of state memory, expensive to build and just as expensive to maintain, the War Memorial will not and cannot acknowledge this reality of inhuman behavior on the part of its heroic soldiers.

If weaponized memory tends to be as costly as the state can afford, antiwar memory is affordable out of necessity. At most it will cost no more than people's time and lives. Time and life, of course, are all that is required to write literature, and so it is no coincidence that two of the most notable efforts to counteract Korea's weaponized memory are found in novels. The first is Hwang Suk-Yong's *The Shadow of Arms*, published in two installments in 1985 and 1988.[8] They appeared during two successive and repressive regimes led by presidents who served as army officers in Vietnam, Chun Doo Hwan and Roh Tae Woo.[9] Given the political climate, the novel

was daring, indicting the American presence in Vietnam as a source of utter corruption for all involved, including Koreans. The novel leaves no doubt that American-style capitalism and racism is at the heart of this war, waged not for a Pax Americana but for the American PX, the post exchange or military shopping mall. "What is a PX?" the novel asks. "A Disneyland in a vast tin warehouse," the novel says. "A place where they sell the commodities used daily by a nation that possesses the skill to shower more than one million steel fragments over an area one mile wide by a quarter mile long with a single CBV." What does the PX do? "The PX brings civilization to the filthy Asian slopeheads."[10] Even more than any tank or plane, the PX "is America's most powerful new weapon."[11] While the PX is the military-industrial complex's legitimate face, the black market is its illegitimate face. The black market welcomes everyone, including the communists and nationalists, and corrupts them with the benefits of a wartime economy inflated by American imports and dollars. The Vietnamese of all sides suffer because they cannot leave, unlike the Americans and the Koreans. These outsiders are what scholar Jinim Park calls "colonized colonizers," the middlemen who help both the Americans and, inadvertently, the Japanese, who supply many of the goods for sale.[12] "In Vietnam everything is Japanese."[13] So it is that Koreans learn a key lesson, which the Japanese, their former colonizers, already know: American wars in Asia can be profitable.

But the profits come with a price, not the least of which is racial inferiority. The American subjugation of the Vietnamese reminds the Koreans of their own past treatment by Americans, one reason why Koreans are both drawn to and repulsed by the Vietnamese.[14] As an American soldier tells Yong Kyu, an enlisted man at the center of the novel, the Vietnamese are Gooks. "They're really filthy. But you're like us. We're the allies."[15] When Yong Kyu recalls how Americans first used "Gook" in Korea, he understands that "it is the Vietnamese that I am like."[16] A fellow Korean even says, "You look fine, black

as any Vietnamese."[17] Perhaps the novel is referring to the popular 1969 Korean song "Sergeant Kim's Return from Vietnam," where the eponymous hero comes back as "black-faced Sergeant Kim." He was the most memorable character from the Korean effort to promote Korean soldiers in Vietnam as heroic and virtuous, but his blackness is an ambiguous sign. He has been exposed not only to tropical sun, but also to violent war and contamination by the anti-Asian racism of Americans.[18] In the case of the My Lai massacre, which the novel recounts in detail, "it is racism, in the end, that makes a person insist that a massacre is justified."[19] The Koreans in the novel do not commit atrocities against the Vietnamese, but Hwang implies they are one step away from doing so, complicit as they are with a racist American military.

What the Koreans definitely do is prostitute themselves, literally or through the black market. While the Vietnamese characters die or are imprisoned, Yong Kyu is alive and free at novel's end, helping the prostitute Hae Jong ship a considerable quantity of illicit goods to her family in Korea, as many Korean soldiers also did.[20] With only minor regret, Yong Kyu obeys the hierarchy that men exploit women, whites subjugate Asians, and Koreans mistreat Vietnamese. "Black" becomes the sign of corruption and inferiority, from the black market to black or blackened people.[21] Blackness is also important to the other major Korean novel about this Korean war, Ahn Junghyo's *White War*, which the author translated himself into English as *White Badge*.[22] But while blackness lurks in the novel, whiteness is the prevalent concern. The narrator, Han Kiju, is an intellectual, unlike Yong Kyu and most of the Korean men who volunteered for Vietnam. He is enthralled with Western, white culture, having read Homer, Remarque, Shakespeare, Hemingway, Montaigne, Dryden, and Coleridge. Befitting an intellectual, he is a man whose masculinity is questioned by himself and others. After the war, he is an "alien" in Korean society, his literary knowledge useless, his career stalled, his adulterous wife having left him because of their

inability to reproduce, eventually revealed as a failure of his virility.[23] A phone call from a veteran comrade, Pyon Chinsu, forces him to remember the war and to realize the cause of his malaise: the "blood money" paid to soldiers who went to Vietnam.[24] Privates who volunteered for Vietnam earned $40 a month when the average family's annual income was $98. The United States paid about $1 billion for these Korean soldiers, or around $6.6 billion today.[25] This money "fueled the modernization and development of the country. And owing to this contribution, the Republic of Korea, or at least a higher echelon of it, made a gigantic stride into the world market. Lives for sale. National mercenaries."[26]

In both these novels, the Koreans sell themselves to the United States, a "swaggering idol, a boastful giant."[27] To Han Kiju's observant eyes, if Americans are giants, then Koreans are dwarves, wearing American uniforms, eating American food, and using American weapons too large for them.[28] The ironies of being a colonized colonizer abound in this white war, certainly for the narrator, who depicts the sole black American in the book as "a Negro soldier with thick, primitive, pinkish lips."[29] Like Americans, some Koreans absorb American racism, calling the Vietnamese "gooks" and a "yellow-skinned, dwarfish race."[30] Like Americans, Korean soldiers cannot tell the difference between friendly Vietnamese and enemy Vietnamese. They pursue the American strategy of punishment and patronization, forcibly removing villagers from their homes to strategic hamlets while also trying to win hearts and minds by building clinics, throwing parties, and distributing rice. But what Koreans do to the Vietnamese is what others did to Koreans: "what did we, or our parents, think when the UN forces, the Americans and the Turks swarmed into our village during the Korean War to liberate us from the Communists and then raped the village women at night."[31] As if to avoid committing the same atrocity, Kiju takes a Vietnamese mistress, a virtuous but compromised woman named Hai. Figures like Hai are staples of foreign literature about Vietnam, the most

famous being Phuong in Graham Greene's *The Quiet American*. With Hai, Kiju can be a man, but the illusion of this masculinity is revealed when she begs him to take her to Korea, which he cannot do.[32] Perhaps he simply will not. As the novel later shows, there are Vietnamese refugees living in poverty in postwar Seoul, including women abandoned by Korean lovers.[33] This history continues today, as poor Vietnamese women come to Korea to be matched with Korean men whom no one else will marry, oftentimes farmers left behind by the modernization and urbanization of their country.

The real drama of *White Badge* is not between Koreans and Vietnamese, but between Koreans. Han Kiju's former comrade, Pyon Chinsu, has contacted him in order to ask a final favor—shoot him and put him out of his postwar misery, which occurs against the backdrop of democratic struggles opposed to the military dictatorship of Chun Doo Hwan. The novel closes with the meeting between Pyon Chinsu, peasant, and Han Kiju, intellectual, without letting us know whether Kiju can pull the trigger. Either way is defeat for soldiers who are neither rewarded nor recognized by their fellow citizens, especially the businessmen that benefited most from the war. Unlike the War Memorial of Korea, *White Badge* shows the costs and myths of martial manhood. Whether this manhood succeeds or fails is due in both cases to its submission to the American giant "who had never learned how to live outside his own world" and who has demanded that Koreans live in his, via his capitalism, his literature, and his (white) war.[34] In return, this giant offers Koreans the opportunity to exploit what historian Bruce Cumings calls "El Dorado," or Vietnam, where Korean engineers from Daewoo rented rooms from my parents in our amiable provincial town.[35]

The disgust with both Americans and Koreans is profound in these antiheroic novels, but there exists a heroic trend in Korean memory about this war found in songs such as "Sergeant Kim's Return from Vietnam." This heroic version of Korean war memory does not circulate outside of Korea, however. Instead, audiences

outside Korea are most likely to know these antiheroic novels and the movie adaptation of *White Badge*. In this way, the Korean case is similar to the American one. Perhaps the global image of the war was so negative that heroic stories did not match the expectations of global audiences. *White Badge*'s 1994 movie adaptation (also called *White War* in Korea) is still perhaps the best-known Korean film about the war, and retains the novel's antiheroic, anti-American qualities.[36] At the same time, the movie signals how Korean memories of the war increasingly emphasized the way that Koreans experienced the war. While the novel is remarkable in the war's global literature for its Vietnamese perspectives, the movie eliminates most of them. Han Kiju's mistress vanishes and the Viet Cong woman whom the soldiers sexually humiliate becomes a suicide bomber. Without sympathetic Vietnamese women, the movie, even more than the novel, becomes a drama about and between Korean men. Their struggle is not so much about their own moral ambiguity in Vietnam but about their postwar relationship to a Korean society poised between dictatorship and democracy in the 1980s.

The movie portrays these struggles and is also an outcome of these struggles. It depicts a war which helps transform Korea into a muscular capitalist society and enables Korea to tell more powerful, more expensive stories. The movie is part of an art form that says as much about its society through its technical achievement, made possible by the development of an industrial complex, as it does by its narrative. As with the War Memorial of Korea, however, the spectacular language of cinema oftentimes comes with more than just a financial cost. Film, as an industrial production, must return profit on investment more so than literature, where the stakes are smaller. While literature can more easily afford to take risky steps such as empathizing with the enemy, film oftentimes lags far behind, as in the big-budget movie *White Badge*. This movie, for all its antiwar qualities, was part of the "New Korean Cinema" that was one more sign of Korea's global competitiveness.[37] New Korean Cinema

has made Korean directors the darlings of the international film circuit and captured the attention of Hollywood. This cinema tells Korean stories and is itself a Korean story. As shiny as the latest line of Hyundai cars, this cinematic soft power is a material artifact of Korean accomplishment and affirms Korea as worthy of inclusion among the world's first rank. Framed in this way, *White Badge* the movie erases Vietnamese characters and by its very presence as a movie about Koreans in Vietnam contributes to the global dominance of the Korean point of view over the Vietnamese, a dominance maintained by Korea's ability to export this and other movies overseas.

Three more Korean movies about the war would follow *White Badge*, together signaling the convergence of memory and power through the industrial art of film: *R-Point* (2004), a horror movie; *Sunny* (2008), a romantic melodrama; and *Ode to My Father* (2014), a historical melodrama and box office hit. These polished, sleek movies, considerably more advanced than anything coming out of Vietnam, are technically on par with Hollywood movies and share a similar theme. As American war movies of the 1980s engaged in what scholar Susan Jeffords called the "remasculinization of America" after the emasculating loss of the Vietnam War, critic Kyung Hyun Kim argues that postwar Korean cinema likewise remasculinized.[38] All three movies show an embattled Korean masculinity in Vietnam and also embody a rising Korea through cinematic flashiness. *R-Point* follows a squad of Korean soldiers searching for a missing squad of their fellow troops. In an abandoned colonial villa, they encounter a ghost who has caused the deaths of those missing soldiers, a Vietnamese woman wearing a white *ao dai* who possesses these soldiers and makes them turn their weapons on each other.[39] As in American war movies, the Vietnamese woman is the most frightening figure of all. The most famous depiction in American film of the threatening woman is *Full Metal Jacket*, where a female sniper decimates an American squad until they capture and kill her. But in *R-Point*, the threatening ghost lives on, destroying all but

one of the Korean soldiers for their sexual and territorial transgressions.[40] Ironically, the death of the Korean soldiers is also an absolution. Victims of their own "friendly fire"—even the last survivor is blinded—they cannot be held responsible in the same way that living American soldiers can.[41]

The theme of absolution is also at the heart of *Sunny*, a strange and entertaining war film about recently married Soon-Yi, whose husband volunteers for the army because he believes his wife doesn't love him (and she believes he has a mistress). Rejected by her in-laws and her family as a result of his abandonment, Soon-Yi travels to Vietnam to get him back. The only route is through becoming an entertainer for Korean and American troops, and she ships out with a bandleader who renames her Sunny, a name more appropriate for the Americans. Their degradation of her, and all Koreans, is driven home when an audience of American soldiers howls and leers at Sunny as she sings "Susie Q." After the delirious GIs shower her with money, Sunny sleeps with their officer in exchange for his help

in saving her husband. Her bandmates acknowledge her literal prostitution and their own figurative prostitution when they burn the dollars with which they have been paid. American villainy is rendered even more vividly when American soldiers shoot a little girl in the back and murder a Viet Cong commander who has spared the band members' lives. In contrast to the evil Americans, Korean soldiers in the movie never commit atrocities. Shot, shelled, and ambushed in several battles, they are almost always on the defensive, terrorized by the enemy until Sunny's husband is the last survivor of his ambushed squad. When Sunny finally meets this traumatized husband on the battlefield, she does not embrace or kiss him; instead, amid gunfire and shelling, she slaps him until he falls to his knees, the final frame of the film. As in *R-Point*, Korean men are the ones to be punished, both by Vietnamese and by women. But unlike *R-Point*, *Sunny* refuses to believe that Korean men did more than fight in self-defense.

Ode to My Father is the story of Duk-soo, a refugee from the north who feels responsible for the loss of his father and sister during their flight. After his family is rescued by American forces, he takes on the responsibility of supporting his mother and siblings. He endures great personal sacrifice as a coal miner in East Germany and as a contractor in wartime Vietnam, but his hard work enables his economic success. His rise from beggar to middle-class patriarch mirrors the rise of South Korea from the 1950s until the present. The Korean war in Vietnam plays a small but crucial role in the transformation of both Korea and Duk-soo. As the war ends, communist forces trap him and other Korean contractors in a Vietnamese village. During a battle where Korean marines fight off the communists and rescue the contractors and friendly Vietnamese, Duk-soo is wounded when he saves a Vietnamese girl from drowning. Although he is permanently disabled, he is now the rescuer rather than the rescued, as is South Korea in relationship to South Vietnam. The story of *Ode to My Father* is harmonious with the story of the

War Memorial of Korea in showing how South Koreans went from being abject and inhuman, in need of help during the Korean War, to human defenders of freedom during the Korean war in Vietnam. While the transformation of Korea is evident to all, Duk-soo's heroism is unknown to his children, who also take for granted their father's labor and suffering for them.

With these portrayals of wounded, victimized Korean masculinity beginning in *White Badge*, Korean cinema functions like American cinema of the war. Even if Americans depict themselves in criminal ways, the depiction is always shown through Hollywood's bright light. Likewise with Korean war movies. As part of a New Korean Cinema that is not reluctant to depict Koreans antiheroically, some of these movies show that self-representation of the darkest kind is better than no representation at all. But viewing these films in sequence, from 1994's *White Badge* to 2014's *Ode to My Father*, what we see is a narrative that decreases darkness and increases revision of the past. Koreans are human in these movies, but more so, they are victims too, proxy warriors who do the bidding of the real villains, the Americans. This cinematic recasting of the other Korean war fits neatly with how Koreans can claim to be a "victim state" of the United States and its Cold War policy.[42]

While Korea of the past may have been a vassal, Korea of the present pushes back, a competitor who demands worldwide recognition, both for its people and its products. In a world of global capitalism, commodities are more important than people and often travel more easily than people do. Like people, commodities are valued in different ways, expensive Korean goods more fashionable than cheap Chinese ones. In the case of Vietnam, one can find both expensive Korean products and expensive Korean people. Koreans have returned in unarmed force, as tourists, business owners, and students. Korea is seen everywhere, in hairstyles, pop music, movies, melodramas, and malls. For most Vietnamese, Korea and Koreans are spectacular images of a beckoning modernity, regardless of the

realities underneath. For both Koreans and Vietnamese, this modernity requires amnesia about their previous shared past. Thus, while Korean commodities can be seen everywhere, memories of the Korean war in Vietnam are still hard to come by, even in their cinematic form.

When Vietnamese do recall Koreans, the memories are negative. At the Museum of the Son My Massacre, better known as the My Lai Massacre, a plaque in English and Vietnamese remembers the "violently atrocious crimes of the American aggressor and the South Korean mercenaries."[43] The South Vietnamese who fought alongside Korean soldiers did not care much for them either. Nguyen Cao Ky, air marshal and vice premier of the Republic of Vietnam, accused them of corruption and black marketeering.[44] Average soldiers resented that American soldiers favored the Korean troops, whom they thought more aggressive. To add insult to injury, the Americans even made the South Vietnamese army buy Korean soy sauce to replace Vietnamese fish sauce.[45] The Vietnamese civilian view of the Korean soldiers was worse, for some of the Vietnamese remembered how, during World War II, when the country was under Japanese occupation, Korean soldiers were in charge of the prison camps.[46] And, according to Le Ly Hayslip, a peasant girl caught in the ground war in central Vietnam:

> More dangerous [than the Americans] were the Koreans who now patrolled the American sector. Because a child from our village once walked into their camp and exploded a Viet Cong bomb wired to his body, the Koreans took terrible retribution against the children themselves (whom they saw simply as little Viet Cong). After the incident, some Korean soldiers went to a school, snatched up some boys, threw them into a well, and tossed a grenade in afterward as an example to the others. To the villagers, these Koreans were like the Moroccans [who helped the French]—tougher and meaner than the white sol-

diers they supported. Like the Japanese of World War II, they seemed to have no conscience and went about their duties as ruthless killing machines. No wonder they found my country a perfect place to ply their terrible trade.[47]

As anthropologist Heonik Kwon notes, this behavior by Korean troops was hardly surprising. Their slogans included "kill clean, burn clean, destroy clean," "children also spy," and "better to make mistakes than to miss."[48]

This litany of memories testifies to the ways that the Vietnamese remember, but mostly forget, Korean soldiers. These fragmentary memories are overwhelmed by the general Vietnamese indifference to the Korean war in Vietnam, and outnumbered by the stories found in Korean novels, films, and even music videos such as that of pop star Jo Sung Mo's 2000 smash "Do You Know?"[49] This epic account of Korean soldiers giving their lives to rescue Vietnamese civilians ends with a Viet Cong firing squad massacring the last living soldier and his Vietnamese lover. "Why is this happening to us?" the soldier cries. The video's postscript renders explicit the sense of Korean victimization: "The Vietnam War was a pure tragedy," it says. "There's no winner or loser." At least when it comes to remembering Koreans, the Vietnamese, for the most part, appear willing to agree.[50] After all, both money and marriages must be made between Korea and Vietnam in the postwar era, and memories of murder only interfere.

Korean stories of the war allow Korea to criticize the United States, acknowledge some degree of Korean complicity, and absolve Koreans of any crimes committed in Vietnam. Cleansed by these narratives, Korea embraces its new role in global capitalism, where money powers memory and memory powers money. As a nation's wealth makes its memories circulate ever wider, weaponized memory in turn justifies how the nation's money was earned, effacing the bloody traces left by those who fought to make those profits possible.

The reach of Korean popular culture, in novels, films, music, and commodities, testifies to an emergent Korea's power. Korea may like to think of itself as a victim—of Japan, of America, of North Korea—but it is also more than that. Koreans may have been cronies, surrogates, or proxies in the Cold War and afterward, but Korea has learned well from its masters. A good student, Korea has graduated from subhuman to subimperial status, and its graduation influences how Korea deals with Vietnam of the present, the Vietnam of its past, and the shadow of its American patron. Once a backwater province humiliated by Japan and subordinated by the United States, Korea has become a chic and sleek global minipower whose projection of itself takes place not only in the factory, the boardroom, the stock market, and the United Nations but also in movie theaters, on televisions, in books, and in architecture signifying might and prowess, intended to intimidate and impress both citizen and tourist.

This weaponized memory foregrounds the humanity of the ones who remember, but inhumanity is in the background of its operations too. The most obvious inhuman acts by Koreans were directed at the Vietnamese people, but becoming subimperial for Koreans also involved absorbing the inhumanity of Korea's imperial patron, the United States. A trace of that inhumanity is found in the words "Freedom is not free," which come from America and are featured on the Korean War Memorial in Washington, DC, dedicated in 1995, a year after the War Memorial of Korea debuted. This slogan has circulated widely, appearing also on the Lao Hmong American War Memorial of Fresno, California, dedicated in 2005 to the American allies who fought in Laos during the "Secret War." One is also likely to hear "freedom is not free" on many American patriotic occasions, although its original context from 1959 is rarely given or remembered: "I am afraid that too many of us want the fruits of integration but are not willing to courageously challenge the roots of segregation. But let me assure you that it does not come this way. Freedom is not free. It is always purchased with the high price of

sacrifice and suffering."[51] Black soldiers fought in American wars, and now, "America, we are simply asking you to guarantee our freedom."[52] Martin Luther King Jr. is saying that America wages wars overseas in the name of protecting the freedom of others, but is reluctant to wage war against racism at home. In the capitals of both the United States and Korea, beneath the stirring calls for freedom, unfreedom echoes.

Koreans became human in the time of global capitalism, but at what cost, and to whom? This is a question not just for Korea. When Koreatown burned in Los Angeles, the question of human life and its value had to be asked, too. Korean businesses suffered hundreds of millions of dollars in losses, and the pain for Korean Americans was real. But while property defined Korean losses, at least Koreans had property to lose. While Latinos lost property too—about 40 percent of the total damages, compared to 50 percent for Koreans—their losses were also measured in terms of crime and life, as was the case for African Americans. Most of those arrested were black and Latino, as were most of those who died. One Korean American died.[53] The body count matters, as it did during the wars in Vietnam and Korea, because that count tells us whose lives were worth more. In the process of serving as foot soldiers on the front lines of a battle fought for capitalism, Korean and Korean Americans became more valuable—more human—than blacks or the blackened, at least in the militarized memories of America and Korea. To be human not only means the capacity to bomb others in long-range wars of pacification, or exercise overwhelming industrial firepower, or profit from capitalism. In America, it also means being remembered as the model minority; in Korea, it means having the capacity to conduct strategic memory campaigns, to exercise surgical memory strikes, to reinvent the past. Korean veterans of that other Korean war can even erect a small memorial in Vietnam, though that country does not have the power to remember itself in Korea. Memory, like war, is often asymmetrical.

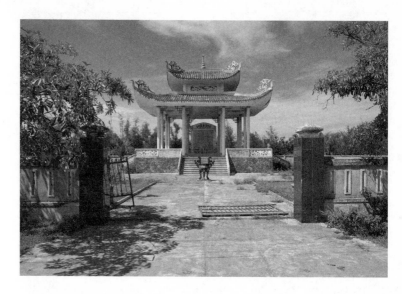

I found that lonely memorial after some effort, on a trail off of a side road from Highway 1A, soon after it passes through Da Nang on the way to scenic, charming Hoi An. Many Korean troops fought near Da Nang, but they might have a hard time recognizing Highway 1A now. Once rural and sparse, the road is now a luxurious stretch of resorts and golf courses, some built by Korean corporations. Few of the tourists who come to these places would want to visit Ha My, if they even knew of it or could find the memorial. Whereas martyrs' cemeteries abut roads, the memorial at Ha My is placed far back, away from sight. My driver drives by twice before I spot its peaked roof. To reach the memorial from the road, I have to dismount and then walk past village homes and across rice paddies. In the summertime, under a hot midday sun, the paddies are dry and brown. As I trudge on a dirt path to a small, ornate temple in a courtyard with yellow walls, only a single farmer is visible in the fields. The blue metal gates have fallen off their hinges, one propped on a wall, the other lying on the courtyard's pave-

ment. An elevated dais occupies the center of the square courtyard, with sixteen pillars holding up two green-shingled roofs. In the middle of the dais, a memorial wall commemorates the victims of January 24, 1968. The oldest victim was a woman born in 1880, and the three youngest died in 1968, perhaps in their mothers' wombs. Vo Danh—without a name—takes the place of their given names. The memorial names 135 people "who were killed" (*bị sát hại*), but on the matter of who killed them, the memorial is silent. The villagers wanted the statement to say that Korean soldiers killed the villagers. Korean veterans, paying for the memorial, did not.[54]

6

On Asymmetry

KILLING IS THE WEAPON OF THE strong. Dying is the weapon of the weak. It is not that the weak cannot kill; it is only that their greatest strength lies in their capacity to die in greater numbers than the strong. Thus, it did not matter, in terms of victory, that the United States only lost fifty-eight thousand or so men, or that Korea only lost five thousand or so men, while the Vietnamese, Laotians, and Cambodians lost approximately four million people during the war's official years (rounding American casualties in this way acknowledges what novelist Karen Tei Yamashita charged when it came to the death statistics for American boys versus everyone else involved in this war, namely that "numbers for Vietnam are rounded off to the nearest thousand. Numbers for the Boys are exact"[1]). Americans could not absorb their losses in the same way that their enemies simply had to do. While the American public would not tolerate a casualty count in the thousands, and knew that the United States could always leave Vietnam, the Vietnamese who opposed the Americans were fighting for their country and had nowhere else to go. The American war machine ran aground on the bodies of its own men as well as the bodies of those it killed, with the specter of

the Vietnamese body count mobilizing global opposition. In the war's mnemonic aftermath, this paradox of the strong and the weak continued. The American industry of memory triumphed in dispatching its machines of memory all over the world, but they could not completely eradicate those bodies that had brought the war machine to a halt, those bodies that turned the name of Vietnam into a symbol of revolutionary victory against empires. Likewise, within Vietnam and Laos, the industrial efforts by the victorious regimes to remember their war as being heroic triumphs against the Americans could not completely erase those same bodies that the American war machine crushed. The bodies lingered, too many of them to be avoided, evoked by both the Americans (who killed them) and the Vietnamese and Laotians (who sacrificed them). Sometimes those bodies appeared in gruesome form as a "legion of angry ghosts," in the words of anthropologist Mai Lan Gustafsson.[2] Sometimes they were resurrected as heroic statues.

Unlike the industries of memory for superpowers or aspiring powers, the industry of memory for a small country does not export its memories on any great scale. This industry's memories appear unpolished on the global market, and its makers recognize that asymmetric memory fights best on its own soil. The small country depends on luring foreigners to its own territory through offering itself cheaply, as a locale for budget tourism that includes the surprise tourist trap, where the tourist is ambushed by history as seen from the local point of view. But like most other industries of memory that turn their attention to war and its afterlife, the smaller one shares a similar emotional register with the more powerful ones, alternating between horror and heroism, with sorrow occupying the middle register. Revolutionary icon Ho Chi Minh, symbol of memory and amnesia, personifies how a small country's industry of memory functions asymmetrically, outmatched as it is by a large country's more powerful memory. His body, or as some rumors suggest perhaps just its replica, can be visited in a mausoleum in Hanoi. There

he is the sole occupant, a luxury in a land where it is common for whole families to live in one room. His body lies encased in what I imagine is a refrigerated crystal sarcophagus, face not quite pressed against glass, unlike those deformed fetuses, victims of Agent Orange, that one encountered in the War Remnants Museum until recently. There is no heat, no smell, and no noise in his mausoleum. The Vietnamese, who never queue for anything, silently and orderly move in single file past the body. No one is allowed to take pictures because photographs take on lives of their own that are separate from the dead.

Is this body a heroic statue or a gruesome zombie, kept alive against its will by a state that defied Ho Chi Minh's wishes that he be cremated, his ashes spread over the country? Both. His body, or its facsimile, is a stage prop for the Communist Party, its war machine, and its industry of memory. His body is either heroic or horrific, neither quite living nor quite dead, a stone-cold, inhuman embodiment of what the scholar Achille Mbembe calls "necropolitics." In necropolitical regimes, states wield the power of life and death by determining who lives and who dies, including those unfortunates caught in between life and death. Think of refugees encamped in the limbo of the stateless, or those targets of drone attacks and supposedly surgical missile strikes, or those populations under authoritarian regimes or occupying powers. The victorious Vietnamese saw the American war machine as the tool of a necropolitical regime, dispensing death, incarcerating prisoners, and creating refugees at will. The defeated Vietnamese saw the Communist Party as the necropolitical power that consigned them to reeducation camps and new economic zones, forced them to flee abroad as refugees, and sometimes caused them to linger for years and decades in camps. To them, Ho Chi Minh symbolizes not heroism but horror. They call him the devil or compare him to Hitler, and displaying his picture to communities of exiles incites rage. To these exiles, his chilled afterlife and the betrayal of his wishes amount to an ironic act of justice, a horror committed on the horrible.

Like every historical artifact, Ho Chi Minh—or his body, or its facsimile—is haunted and animated by its own ghost, which is both inhuman and human, inasmuch as the ghost belongs to us, the living, the issue of our belief, fear, guilt, or paranoia. This blurred line between the inhuman and the human is the place of the inhumanities and the necropolitical. By keeping Ho Chi Minh's body on ice, the triumphant state plays a dangerous game of the inhumanities, gambling that it can tame his ghost and use its human face to pacify a people who may not be satisfied with the regime. In doing so, the regime allows his inhuman face to haunt the land and the memories of the people. When his body is a memorial and his resting place a site of pilgrimage, the people can hardly forget him and everything he lived and died for, mythically or in reality. Powerful symbols have multiple meanings which resist the attempts at complete legislation by critics and apparatchiks. Necropolitical regimes believe or hope that they can control the symbolic meanings of war, subduing the horror and foregrounding the heroic, instilling in the people a sense of sorrow for their dead rather than anger over the fate of those dead. This effort to control symbolism is the reason why the government forbids photographs of the sacred relic that is Ho Chi Minh's body. The spirit of this injunction applies in a peculiar way to his statue in the nearby Ho Chi Minh Museum. This golden, inhuman figure—not lifelike because it is much larger than life—towers over the tourists, who are allowed to photograph it until noon. Then the museum closes for a short time and the cleaners arrive. They extend long-handled mops toward the statue's head, which is the moment when a security guard demands that I put away my camera. It is my greatest missed opportunity, the sight of a custodian running his mop over the great man's forehead.

Heroes are immortal, which is why reminders of their mortality must be censored, from the mundane need to be clean to the pressing need to die. But while Ho Chi Minh in his mausoleum appears to defy death, appearing only to sleep, is there anything more inhuman

than that vampire-like position, shielded from sunlight? And if his nearby statue is larger than life, the gigantic one of him in the city of Vinh is as large as his legend, which is exactly the opposite of how the human man lived, or performed, his humble life. This legend of Ho Chi Minh also pervades the Fine Arts Museum of Hanoi, where he is ubiquitous. He is the subject of statuary, oil paintings, watercolors, and lacquered panels, always heroic, noble, and empathetic. The other major subjects of the museum collection are peasants, workers, women, and soldiers, who work or fight heroically, or else mourn sorrowfully. Their statues appear throughout the landscape, particularly the soldiers, gazing ferociously at the future in front of them. These symbols of the victorious revolution are not human, even though they depict human beings. They are hardened industrial products wearing the guise and shape of softer human beings. As forms of weaponized memory, they condense the heroic and the human, excising any sign of the subhuman, nonhuman, or inhuman. They demand only the ethics of remembering one's own, never the ethics of remembering others (except as inhuman enemies) or the ethics of recognition (of one's own inhumanity), both of which are required, even as shadows, to fully animate the human. These statues represent the most important part of the revolutionary war machine, the collective human being, unified in propaganda posters and in murals like the one at the Cu Chi tunnels that narrates Vietnam's history. That history culminates in revolutionary victory and in the unification of the people in their diversity. Thus we see, besides the typical triumvirate of soldier, worker, and peasant, a range of others: priest and monk, man and woman, old and young, majority and minorities, gathered under Uncle Ho's benevolent gaze. This is the heroic people, the greatest of history's flat characters, an embodiment of the inhumanities told by the revolutionary story, where the spirit of the people live on even if millions died in the flesh.

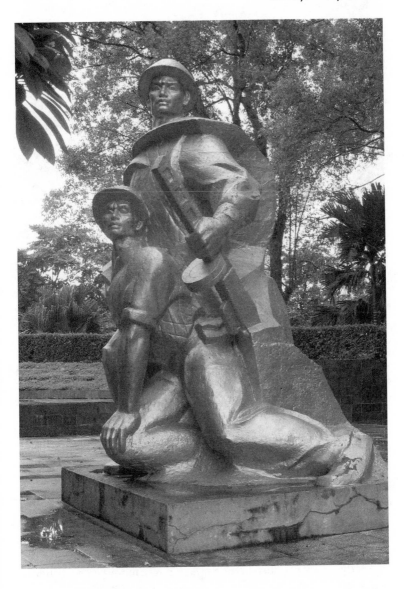

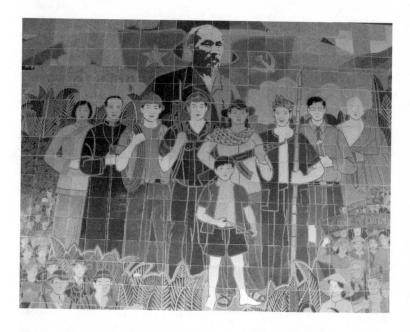

If the heroic people's collective humanity is only a façade, then it is no surprise that the nation's revolutionary industry of memory also gives life to things that are not human. By this I mean the inhuman weapons affixed to the landscape and given central place in many museums, notably cannons, tanks, airplanes, helicopters, and missile launchers. These assembly-line industrial products hint at the economy of scale for weaponized memory. No matter how powerful an individual's memory may be, that memory will not move outside of a small circle unless it enters a mode of mnemonic reproduction. Sometimes that mode is massive and industrial, aimed explicitly at creating stories and memories, as with Hollywood or *hallyu*. Sometimes that industrial mode produces memories inadvertently, as by-product or side effect, a mnemonic halo around a thing. Some of the most memorable characters of the war were thus not people but weapons like the M-16 and the AK-47. Along with the great men, their names are inscribed in history, while the names

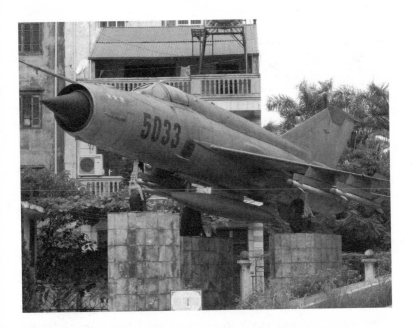

of millions of individuals will be found on a memorial wall, if at all. In the museums of Laos and Vietnam, many of these weapons even have their individual biographies celebrated on placards that detail their great feats and their presence at historical events. The tanks that smashed through the gates of the presidential palace in Saigon on the last day of the war are the most famous examples of weapons with biographies. But the tank that means the most to me is outside the entrance to a wing of Hanoi's Military History Museum. This Soviet-built T-54 fought in the Western Highlands campaign of March 1975, when my birthplace, Ban Me Thuot, was the first town to fall in the final invasion from the north. A vague, blurry image of a tank with soldiers riding on it flickers in my memory, but whether this tank is that tank, or whether this memory is real or a mirage, I do not know. But I remember this tank more than I do any of the people from my infancy, including the (adopted) sister we left behind as we fled the invasion. (Someone once told

me a cruel rumor, that I was adopted. The Vietnamese are good at cruel rumors, which they like to deliver with a smile. "Do you know why you're not adopted?" my older brother said. "Because we didn't leave you behind.")

This tank, these planes, these guns, these inhuman things have more purchase on the collective memory of the human species than 99.9 percent of the human beings who lived through, or died in, the war. These weapons are big things produced by big countries, and as Marx said, things take on lives of their own in capitalism, accruing value even as the workers who make these things lose value in capitalism's race to the bottom. Things become invested with, and animated by, the human labor that went into their making, labor that is invisible to almost all who will encounter them. The thing that is bought, used, cared for, even loved, becomes the medium by which human beings interact. Things exist even when humans die, and thus museums often give more space to things than people. Even in an ostensibly communist society, where machines are celebrated not as products of alienated labor but as products of heroic labor, the practical outcome is that the machinery is oftentimes more important than the humanity. Either in capitalist or communist societies, these things provoke memory and are themselves memories. What else is a land mine in the earth but a bad memory left behind by an industrial mode of production, the seed of a war machine? Or the car in which the monk drove to his final, incendiary destination, appropriated by the revolution for its own purposes? The metallic object is a synecdoche of the war machine, as is the gun, the tank, and the collective human being, whose only hope to defeat the industrial weapon lies in becoming a revolutionary synthesis that is one-dimensionally inhuman and heroic.

If things are industrial products, they also stand in for their industries, both in triumph and defeat. Thus what the local and the tourist often see on the Laotian and Vietnamese landscape are captured weapons and downed airplanes, totems of the industrial

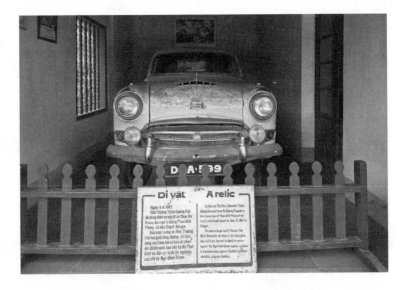

giant brought low. Rusting American and French tanks litter old battlefields and museum grounds, and the bones of American bombers and jets are splayed like the fossils of a vanished species on the neglected property of the Air Defense Museum and the B-52 Victory Museum in Hanoi. The most triumphant display of all is featured in the Military History Museum of Hanoi, where the taxi drivers waiting outside the gates on their motorbikes greet me like a long-lost cousin when they discover that I am an overseas Vietnamese, squeezing my arm and slapping my back with grinning enthusiasm. Inside the gates is an artfully arranged heap of junk, the engines and fuselages of French and American warplanes shot down by antiaircraft fire. If an American museum displayed this heap, it would be called art, as is the case with the assortment of aerial junk arranged by Nancy Rubins at the Museum of Contemporary Art in Los Angeles, the creation of an individual at the service of the Western art industry. The display of destroyed warplanes is the anonymous creation of collective revolutionary struggle, authorized by the state. At the

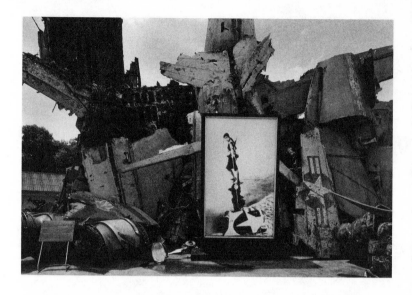

front of the heap is a black-and-white photograph of a young woman
with a rifle slung across her back, hauling a part of an airplane with
American insignia. "When the enemy comes, even the women must
fight," goes the old slogan (like most nationalist slogans, it has an
invisible postscript—when the enemy leaves, the women return
home).[3] The contrast between the woman and the destroyed Amer-
ican machinery reverses the American predilection for seeing young
Vietnamese women, alternately seductive and castrating, as the most
terrible of inhuman enemies. The Vietnamese industry of memory
depicts the Vietnamese as human, humane, and heroic, while showing
Americans to be inhuman, both in behavior and in terms of their
massive, indiscriminating weapons. If Americans want to learn how
much of the world will resent their nation's drone strikes, then they
only need visit the museums of north Vietnam, where the greatest
resentment is reserved for the "air pirates."

But one does have to visit Vietnam to see this other kind of
memory, or else dig for it in books as a specialist or a hobbyist in-

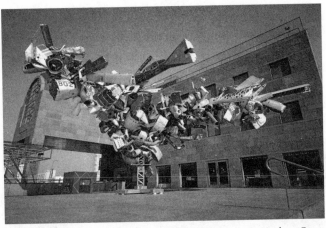

Nancy Rubins, *Chas' Stainless Steel, Mark Thomson's Airplane Parts, about 1,000 lbs. of Stainless Steel Wire & Gagosian's Beverly Hills Space at MOCA*, 2002. ©Nancy Rubins. Photograph by Brian Forrest.

terested in this war. For casual encounters with the war, one is still most likely to see the past through the eyes of the air pirates or their inhuman prostheses, the drone and the satellite. This is the difference between a super-powerful industry of memory with a global reach that exports its products anywhere in the world, versus a middling industry of memory whose products stay within its own borders, or, when exported, are damned by poor reputations. A super-powerful industry of memory makes it easy for people to access its products, delivered to their doors, their televisions, their screens, their shelves, their newspapers, even when they do not want these memories or seek them out. Memory does not work this way for the weaker industrial power, which must either turn itself into a tourist destination to lure the unsuspecting tourist into mnemonic traps or export cheap products that few are likely to encounter or appreciate.

Director Dang Nhat Minh's oeuvre illustrates this distinction between strong and weak industries of memory. He is the most famous

auteur of the revolutionary generation, and his 1984 film *When the Tenth Month Comes* is likely the best-known Vietnamese movie or work on war and memory. Set in the years after American involvement, when Vietnam fought border clashes with Cambodia, and then invaded it, the movie tells the story of a young woman whose husband dies in one of these conflicts. Living with her father-in-law and young son, she keeps his death a secret, unable to break their hearts as her own has been. The movie is intimate, tender, and focused on the consequences of war for a woman and her family. Many Vietnamese war movies, unlike American ones, foreground women and children, although usually to emphasize their heroic, revolutionary spirit, like *The Abandoned Field: Free Fire Zone*. Unlike that film, in which a husband and wife fight off American helicopter attacks, heroism and noble sacrifice are absent in *When the Tenth Month Comes*. The prevalent mood is one of sorrow for the widow and her dead husband, who returns to her one night as a ghost. But no matter how pleasing or moving or full of human feeling, this is a black-and-white movie, the best that Vietnamese cinematic technology could do in 1984, the year when *Beverly Hills Cop*, a black and white buddy comedy shot in full color, topped the American box office. Except for the academic, the movie critic, the art house aficionado, and those with some deep abiding interest in this country, not many outside Vietnam watched *When the Tenth Month Comes*.

In 2009, Dang Nhat Minh made a bid for a larger international audience with the full color *Don't Burn*, an epic film based on the diary of a young North Vietnamese woman, an idealistic doctor who volunteered for war and was killed by American troops. Instead of telling only Dang Thuy Tram's story, Dang Nhat Minh also depicted the story of the American officer who recovered her diary and brought it back to her family more than thirty years later. *Don't Burn* met the ethical demand to recognize both one's own and others, although it was, perhaps, flawed, at least from my inhuman perspective. In standard biopic fashion, the film treated Dang Thuy Tram as a saint

and cast amateurish white American actors, a move typical in Asian movies and television. Nevertheless, the movie deserved wider attention for doing what no other film had ever done, give equal screen time to Americans and Vietnamese. Unfortunately, the movie was released in Vietnam on the same weekend that *Transformers 2* premiered. As the director noted ruefully: "We were crushed like a bicycle."[4] The metaphor is perfect: super-advanced transforming robots, starring in a movie where the human actors are inconsequential, destroy a movie that struggles to foreground the humanity of mutual enemies. Adding insult to injury, this crushing was done on home territory, where Vietnamese audiences prefer watching technically polished inhuman violence imported from abroad than a dramatically imperfect human story from home. These same Vietnamese people would, at the first opportunity, avail themselves of the most advanced mechanical transportation possible. By the millions beginning in the 1990s, they ditched the bicycle for the Honda Dream motorbike and now yearn for the automobiles at the heart of *Transformers 2*. Whether one's fantasy of the good life is the two-wheeled Honda Dream or the four-wheeled American Dream, both are fantasies of consumption, cyborg fantasies of being the human cog in an industrial machine.

The power of industry and the industry of memory may seem overwhelming when one rides a bicycle, dependent on physical strength and muscle memory. The bicycle, however, does not exist only to be crushed. Americans should heed the lessons learned by the French, also convinced of their own technological superiority. French generals amassed an army in the valley of Dien Bien Phu, hoping to tempt their enemies into a battle where they would be destroyed. What the French had not anticipated was the Viet Minh's ability to haul artillery onto the heights of the mountains that surrounded Dien Bien Phu. But, piece by piece, up those mountains on bicycles pushed by human porters, the Viet Minh transported the artillery. This insurgent army, dependent on bicycles (as well as

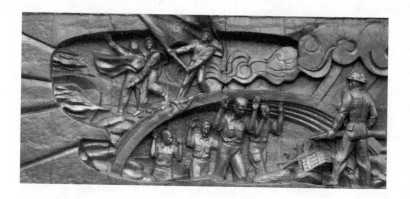

foreign weaponry), bombarded the French war machine into defeat. In the annals of decolonization and national self-determination, this legendary battle was matched only by the myth of David and Goliath, the original example of asymmetric warfare. An army always wants to be Goliath, but the world will often cheer for David.

Thus the defeat of the French and the Americans has managed to stay in many people's memories despite the victors not having access to powerful industries of memory. While the inhuman robots usually crush the human-powered bicycle, sometimes—rarely—the bicycle does win. In the case of the communist Vietnamese, they won partially because they fought the war on their own terrain. So much depends on terrain, including warfare and memory. Against the asymmetric warfare of an industrial giant deploying supersonic fighters, napalm, white phosphorous artillery shells, aircraft carriers, strategic bombers, herbicides, and helicopters equipped with so-called miniguns that could fire six thousand rounds per minute in a blaze of lightning and thunder—almost none of which the communist Vietnamese had, except for some fighters and missiles—the Vietnamese deployed the asymmetric warfare of guerilla insurgency. Asymmetry manifests itself mnemonically as well. Globally, the American industry of memory wins. People the world over may know the Vietnamese won the war, but they are exposed to the tex-

ture of American memory and loss via projected American memories. More importantly, the American industry of memory wins the matter of war memory even when its products do not concern the war. Obliterating most of the cinematic competition it faces, *Transformers 2*—or *1*, or *3*, or *4*—performs crucial mnemonic work for American culture, distracting the world's gaze from actual American wars through its own spectacular existence. *Transformers 2* makes evident the backstory of the war and its aftermath—the triumph of inhuman capitalism, gloriously realized through the spectacle of massive machinery depicted by a cinema-industrial complex in thrall to a military-industrial complex. Together these complexes conquer new territories by inserting themselves into other countries via military bases, trade agreements, and movies, the twin-fisted punch of hard and soft power.

But the Vietnamese have a fighting chance on their own landscape, where they control the memorial apparatus of museums, monuments, schools, cinema, and media. Against foreigners, overseas Vietnamese, and its own people, the state's industry of memory engages in asymmetric war. This is precisely why some visiting Americans feel shock when they encounter themselves as savages. They see themselves as the other, or they see themselves through the eyes of the other, a vertiginous experience. Still, the tourist, like the soldier, comes to this country at significant expense and time, versus the foreign movie-goer who, for the price of a few dollars, is exposed to American culture. Unless he chooses not to be, the Westerner is protected from the memories of others, while those others are periodically, oftentimes regularly, irradiated by Western memories whether they want to be or not.

As for scholars like me, collecting Vietnamese memories means repeated trips to Vietnam, to libraries, and to film festivals such as the one where I saw *Living in Fear*, the 2005 movie by the talented Bui Thac Chuyen. The plot is based on the true story of an unemployed South Vietnamese veteran in the postwar years who defuses

landmines by hand, which echoes the story of Aki Ra in Cambodia. A former Khmer Rouge child soldier who turned himself into an unorthodox, self-taught one-man demining operation, Aki Ra founded the Land Mine Museum in Siem Reap. But whereas Aki Ra only had one wife, the hero of *Living in Fear* must support two, and after his close encounters with death, he is compelled to run home and make love to those wives. The movie combines sex and death with human feeling and drama, but beyond that, it exemplifies the industry of memory and its inequalities through the landmine as synecdoche for memory and industry. One country places landmines in another because it can, and the mined country lives with lethal memories embedded in its earth. Meanwhile, the industrial powerhouse that sows the bad seed can ignore the demand in movies such as *Living in Fear* that attention be paid.

Regardless of American neglect, the mined country must continue its own efforts at rebuilding a war-torn economy, from its industries to its leisure activities, which are sometimes the same, as is the case on the island of Con Son. I caught a plane for a short trip from Saigon to find quiet beaches, green mountains, and tranquil lakes. The landscape is too inviting to believe that the island will not become a tourist haven, where foreigners can snorkel, hike, get drunk, get laid, and pay an obligatory trip to one of the many moss-walled prisons, which, for now, can only be visited with a tour group. The French, who called the island Poulo Condor, originally built these prisons. After the South Vietnamese and their American advisors took over the prisons, they housed Viet Cong prisoners, both men and women. Most of the famous communist revolutionaries spent time here, and thousands of prisoners died within prison walls, including one of the most famous martyrs of all, Vo Thi Sau, the revolution's Joan of Arc, who was executed as a teenager. One can visit her grave and comb one's hair with plastic combs left on her tomb, an allusion to how she loved to brush her long, beautiful hair.

In these prisons, the heroism and sorrow that are fundamental to the revolutionary industry of memory are reconfigured in the pre-

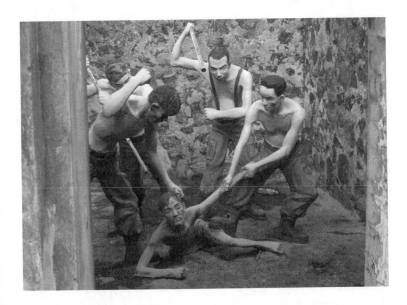

served torture chambers and prison cells. Instead of golden statues of heroic revolutionary soldiers, one sees life-sized wax mannequins of nearly naked Vietnamese prisoners shackled or being beaten. These prisoners, also found in a more accessible place like the Hanoi Hilton, are crude, even cartoonish, which is fair, given that the torture they endured was crude and cartoonish. Americans remember the Hanoi Hilton as the prison where American pilots such as John McCain were kept and tortured, forgetting, or never knowing, that the French imprisoned Vietnamese revolutionaries first. But the Hanoi Hilton was small compared to the system of prisons on this island, which, before the jet age, was a remote island whose name must have struck fear into people's hearts, the kind of place parents warned their disobedient children about. Con Son, the French predecessor to the American Guantanamo, was an island where terrible things happened, now reenacted through the dramatic poses and arrangements of mannequins. While the Hanoi Hilton depicts only the prisoners, here the American and South Vietnamese guards are

also shown, standing aloof in guard posts, watching over prisoners at work, and pouring lime onto prisoners locked into tiger cages.

As I wander out into a prison yard, I see a scene of two men beating another, enacted on gravel. At a barred entrance to a cell, I see four men in fatigues kick and punch a half-naked, bleeding prisoner. I am watching scenes from a horror movie, captured and frozen in dioramas, as if cinema foreshadowed grisly memories of kidnapping, imprisonment, and torture. Of course these things happened first. Torture porn franchises such as *Hostel* and *Saw* and *Texas Chainsaw Massacre* are only stories, but a virulent, contaminated source has nurtured them. The terrors of the past that a war machine created has seeped into and infused the American unconscious. The trauma of war returns through the American industry of memory as horror movies that seem like ghosts themselves. They are bloodied and terrifying, often without history, except in cases such as George Romero's 1968 zombie classic, *Night of the Living Dead*, where a white militia of good old boys wipes out the zombies in what they call a "search and destroy operation," an unambiguous reference to the American strategy of the same name happening exactly at that time during the war. Romero understood necropolitics before Mbembe coined the term. He recognized that America needed zombies of the literal or figurative kind, the living dead whom one could kill or pacify without guilt. They are now everywhere: Hollywood has released an endless stream of zombie movies, and zombies are also the craze of television showrunners and highbrow novelists. These zombies were resurrected, unsurprisingly, in the age of the War on Terror, where they serve the same purpose they did in *Night of the Living Dead*, as allegories of the demonic other against whom Americans are fighting a war. But for the most part, outside of explicit allusions such as Romero's, one has to go to this country, my birthplace, to see the torturous history of the living dead that many first glimpse in the movies, where the horrors of history have been transformed into entertainment.

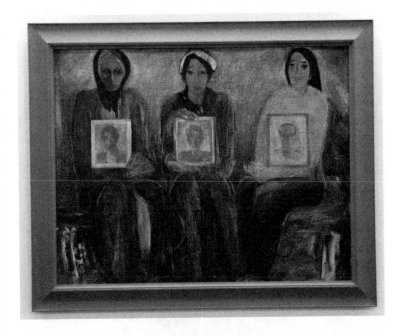

While it is easy to forget foreign wars, it is not so easy to forget wars fought on one's own territory. Reminders are everywhere—those statues, those memorials, those museums, those weapons, those graveyards, those slogans. While one might not remember history, one cannot avoid its reminder. One must willfully turn one's eyes away, or insulate them with filters that the state provides through ready-made stories of heroism and sacrifice. Their message is that the proper position toward the venerable past is to kneel on one knee of sorrow and another of respect. In Hanoi's Fine Arts Museum, the acknowledgment of the dead is expressed through these emotional registers, as in Nguyen Phu Cuong's sculpture *Tuong Niem*, or *Commemoration*, its hooded maternal figure cradling a *bo doi*'s helmet, the mother herself absent, emptied by loss. Dang Duc Sinh's 1984 oil painting, *O moi xom, In Every Neighborhood*, expresses similar sentiments by featuring three women wearing the sorrowful

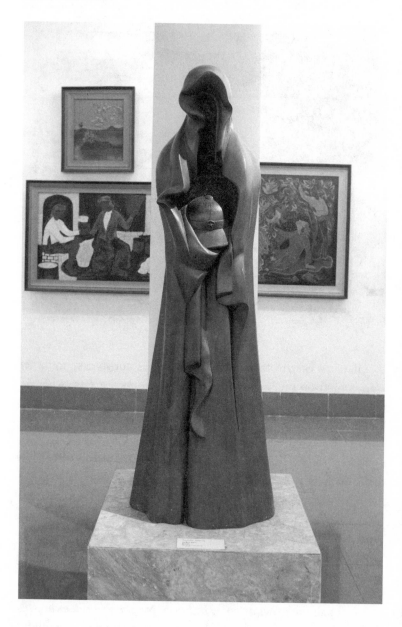

visages of widows or heroic mothers of the dead. While the Fine Arts Museum portrays death in a solemn and respectful fashion, elsewhere the victorious revolutionary regime cannot let go of the horror, or at least not yet. That is why the wax mannequins exist in the prison museums and in the diorama at the Son My Museum commemorating the My Lai massacre, or why photos of atrocities continue to be exhibited in numerous museums, most notoriously at the War Remnants Museum in Saigon. The state demands that its citizens remember the dead and how they died.

It is always a little disorienting, then, to leave these exhibitions of horror or even sorrow and enter the gift shop. Almost always there is a gift shop, selling the usual tourist trinkets that embody some supposed essence of the country, from lacquered paintings of young women in *ao dai* to dinner plates, chopsticks, opium pipes, and so on. One is also likely to encounter war memorabilia, American airplane and helicopter models sculpted from recycled Coke and beer cans, in the poor old days, or now, in the somewhat better days, made from brass. There are bullets and dog tags, advertised as the real things from the real war. These are small memories, produced on a lesser scale than what comes forth from the massive industrial production lines of nations and corporations. This is what we might think of when the term *memory industry* comes up—the cottage industry, the arts and crafts of the mnemonic world.

The best-known of these small memories are the ubiquitous Zippo lighters supposedly handled by a real American GI and imprinted with real GI slogans such as "Yea Though I Walk through the Valley of the Shadow of Death I Will Fear No Evil Because I Am the Evilest Son of a Bitch in the Valley."[5] The tourist who buys this kind of war remnant is presumably looking for a shred of the war's aura. Whoever made these know that they are trading on a certain kind of authenticity when they take leftover Zippos, etch them with (in)famous GI slogans, and rough them up to give them the bruises of war and age. Cheap, mass produced, easily portable, the Zippo's

uses ranged from lighting cigarettes to torching huts to serving as the template for the American soldier's imagination. These uses are not the only reason that the Zippo became one of the most popular symbols of the American occupation. The Zippo's symbolic power comes from its mass-produced nature. While Ho Chi Minh is one of a kind, the Zippo is one of tens of thousands, its owner long forgotten. Its aura arises not just from the individuality of its purported owner but also from his being a member of the military's rank and file, just like the consumer is a member of the tourist masses. Like the M-16, the Zippo is an industrial product with a memorable name, imbued with the antiheroism of slogans such as "When I Die, I Will Go to Heaven Because I Have Already Spent My Time in Hell."

For the local craftsperson, however, the Zippo is just one more piece of American hardware to be recycled and sold to foreign tourists who deserve no better. Squeezing profits from tourists is another weapon of the weak in this asymmetric war, a sneaky tactic from a present scene that is a dark and comic repetition of the American war itself, when the grunt first faced off against the native. The native won that struggle by using the popular warfare of people's struggle and, oftentimes, stealing the grunt's own weapons. In the the war's aftermath, the native faces off against the soldier's descendant, the tourist, in an environment where a memory industry built on tourism replaces the war machine.[6] My visit to the Plain of Jars in Laos was marked by the juncture between this memory industry and the war machine's detritus. I flew into the small airport on a propeller-driven passenger plane carrying a multicultural contingent of U.S.

Air Force medical volunteers on a humanitarian mission, clad in mufti rather than military gear. Male and female, they were mostly young, lean, pleasant, and fit, the older ones among them resembling suburban American fathers on vacation, pleasantly padded. Their forebears bombed this country, and the Plain of Jars in particular, with apocalyptic force. The enlisted man I mentioned this to did not want to talk about this history, while the clean-cut Air Force Academy graduate knew only some vague details. I wonder if they noticed the poster in the airport terminal, which advertised bracelets for peace, small things made from the metal of munitions. Is there anything more asymmetrical than air war waged against those without an air force, or a people forced to make a living by selling the fragments of bombs to those who bombed them?

A memory industry built on war might, in general, be called ironic, although greed or survival would be the more important elements. On Phonsavan's single street, for example, there was a bar named Craters where the airmen gathered for a drink. The bar was not unique in turning the memory of massive carpet-bombing into the name for a site of rest and relaxation. This was small-scale memory work, pitching the past to those passing through, the way street vendors sold pirated copies of English-language classics about the war and these countries to tourists who wanted some education with their entertainment. At least the entrepreneurs in Saigon had been wittier and postmodern, naming their raucous, crowded, sweaty, and admittedly fun bars Apocalypse Now and Heart of Darkness, which the police occasionally raided to show that they were cracking down on what the government called the "social evils" of prostitution and drug use (I haunted these bars enough to witness each one being shut down by the police, who, clad in chartreuse green, win my award for the ugliest uniforms in the world). Turning horror into entertainment is a signature feature of the American industry of memory, as can be seen and heard in the "me so horny" line of dialogue from Stanley Kubrick's jagged masterpiece *Full Metal Jacket*. This line inspired 2 Live Crew's lewd, memorable

rap smash "Me So Horny," prosecuted for obscenity by Florida authorities, the irony of ironies, given how no one was prosecuted for obscenity for anything that happened during the war. Perhaps inspired by these examples, Southeast Asians have done their best to apply principles of capitalist exploitation to even the most dreadful past.

Some of the most memorable and remarked upon ways that these Southeast Asians mine the past are the tunnels and caves from where the war was fought or where civilians sought refuge from the bombing. As Mbembe says of the wars waged by necropolitical regimes, "the battlegrounds are not located solely at the surface of the earth. The underground as well as the airspace are transformed into conflict zones."[7] From the perspective of the emperors of the air, the subterranean is the retreat of the inhuman, where American soldiers called "tunnel rats" hunted for the human rats who lived in the tunnels, waiting to pop up from their spider holes to ambush American troops. But even the Americans grudgingly acknowledged that what they found were veritable cities, an underworld that was an uncanny reflection of the American camps above them, replete with kitchens, hospitals, bunkrooms, granaries, and the like. Perhaps these tunnels or others before them in the history of war influenced the philosophers Deleuze and Guattari when they came up with their notion of the "rhizome" to describe resistant social structures that were horizontal and root-like versus the arboreal, top-down, vertical structures of authority. War machines dislike tunnels, which literally undermine them, taking away their advantages and their pretense to humanity. The tunnel encounter, for the tunnel rat, inverts what Levinas asks for in seeing the other's face. Instead of seeking conversation, an elaboration of shared humanity, the tunnel rat comes to kill, and comes face-to-face not only with the inhuman enemy but with his own inhumanity. Hence the terror of the tunnel for those who must go hunting in them, that they will be pried away from the armored protection of the war machines that

provide an illusion of technological superiority, and through it, humanity.

For those who call the tunnels home, the experience is not necessarily inhuman or subhuman. Tunnel life becomes heroic in memory for both soldiers and civilians. The Vinh Moc tunnels near the demilitarized zone celebrates the endurance of the local civilians who hid there and rebuilt their lives underground, complete with schools and exits to the nearby beach. The most famous of the tunnel networks, at Cu Chi, two hours from Saigon by bus, were built for war and had armories and command bunkers. In the war's aftermath, they, as well as the Vinh Moc tunnels, have become tourist attractions for both locals and foreigners. On my first visit to Cu Chi, I traveled with a popular company whose tour guide gave a rousing rendition of the heroic revolutionary struggle of the tunnel fighters. "We were victorious!" he proclaimed on the bus, fist pumping in the air. (During a rest stop, he lit a cigarette, ordered a coffee, and told me that he was a helicopter pilot for the southern army who trained in Texas). At Cu Chi, gunfire echoed through the groves above the tunnels. At a nearby shooting range, tourists were firing weapons from the war at a dollar a bullet. Another guide in green fatigues led our tour group of mostly Westerners and some locals to a spider hole from where the guerillas had once emerged to ambush Americans. One of the American tourists actually fit into the hole. Perhaps it had been widened for the American butt, like the tunnels, which, our tour guide said, had been both widened and heightened for visiting foreigners. The foreigners laughed. When the guide invited us to descend into a tunnel, the locals, although they did not laugh, declined. Only the Westerners eased down into the dank, steamy recesses, where all that could be seen were earthen walls and the sweaty buttocks of the tourist in front of you.

Crouched in that hot tunnel, amused by the experience but annoyed by the heat, I did not appreciate that the soldiers who fought here crawled in a much more claustrophobic space, without the

benefit of the light bulbs illuminating my way. The earth was musty but the reek of terror had been ventilated, the darkness dispelled, the boredom forgotten. And to what end? "They shout that they want to shape a better future, but it's not true," Milan Kundera says of those in power. "The future is only an indifferent void no one cares about but the past is filled with life, and its countenance is irritating, repellent, wounding, to the point that we want to destroy it or repaint it. We want to be masters of the future only for the power to change the past. We fight for access to the labs where we can retouch photos and rewrite biographies and history."[8] In the present case, the retouched tunnels lead toward a future—there really is a light at the end, when one emerges into fresh air—and close off the past, for one cannot feel the ghosts, chased off by the electrical lighting and the curious tourists. The industry of memory's labs dispel the ghosts of the past or tame them, as the black wall in that other nation's white capital arguably does. The more powerful the industry of memory, the more capacity it has to amplify light and chase away shadows, to foreground the human face

of the ghost and forget its inhuman face. The smaller industries of memory will try to do the same, for the weaker will also try to be more powerful than someone else, even if it is only the dead.

And yet . . . against the industrial memories of the great and small powers, something survives. The reason Dang Nhat Minh made his movie was that Dang Thuy Tram's words lived in spite of the American bullet that killed her. The South Vietnamese soldier who first read her diary told his American superior, "Don't burn it. It's already on fire." Every writer wants to write the book that cannot be burned, the book that is a palimpsest underneath which can be seen the shadow of a ghost. Or take the case of North Vietnamese photographer The Dinh, whose picture concludes the book *Requiem*, edited by Horst Faas and Tim Page to commemorate the photographers of all sides killed in the war. A howitzer intrudes on the left and points toward a jumble of crates and equipment. The barrel of the howitzer is parallel to a dead soldier, his body difficult to distinguish from the ruins, his face hidden or destroyed, one of his legs bent at the knee while the other is partially buried in the dirt. The fabric of his pants is darker than the fabric of the rest of his uniform. Over the landscape The Dinh's shadow hovers. On the back of the only torn print of the photograph is this pencil-written obituary: "The Dinh was killed."[9]

As Roland Barthes and Susan Sontag have observed, photographs are recordings of the dead—not the actual dead, in most cases, but the living who will eventually be dead, and who are dead for many of the photograph's viewers. The Dinh's photograph is haunting because it fulfills the fatal prophecy found in the photographic genre, and because it foreshadows fatality through the self-portrait of the shadow, grafted into a picture with the obscured body of the dead. During wartime, photography's mortal power is realized most graphically because it deals with the dead and because its artists risk death. He was only one of the 135 photographers on all sides killed during the war. *Requiem* acknowledges that although seventy-two

of the dead photographers were North Vietnamese, it is mostly the photographs of the Western and Japanese photographers that survive. The inequities of industrial memory are evident in both death and art. Westerners and Japanese could airlift their film to labs on the same day it was shot, but the film of the North Vietnamese photographers was often lost along with their lives. In The Dinh's case, this self-portrait of a shadow, this premonition of his own ghost, is his only surviving work. The ghostly absence of the Asian photographers is even more visible in their biographies, one of the most poignant sections of the book. While substantial obituaries are devoted to the Western photographers, the words given to the South Vietnamese, North Vietnamese, and especially the twenty Cambodian photographers are so brief they often amount to no more than epitaphs. One Cambodian named Leng is not unusual in having no birth or death date, his entire career described thus: "A freelancer with AP, Leng left no trace."[10]

Except for the trace of his absence. One encounters the haunting absence again in a window looking down on a stairway of the Vietnamese Women's Museum of Hanoi. In the tinted glass stands a blank space in the shape of a woman from a famous photograph, Nguyen Thi Hien, nineteen years old. The militia fighter walks away from Mai Nam's camera, looking over a shoulder on which is slung a rifle, her hair under a conical hat. The photograph became an emblem in the world imagination of 1966 for how "even the women must fight." But in the museum, her photo, marked by her presence, has become an absence in the form of the blank space. That absence inadvertently symbolizes how the Vietnamese Women's Museum, crowded with words and images of the heroic lives of Vietnamese women, cannot help but be a reminder of how that heroism is far in the past. The girl in the photograph has vanished, as has the revolution itself, now only a memory, a cutout, an empty tracing in a communist state running a capitalist economy. The museum proves what Paul Ricoeur argues, that memory is presence that evokes absence. While a memory is present in our minds, it inevitably points to what is no longer there but in the past.[11] Industries of memory seek to turn this absent presence of memory, always and forever elusive, ghostly, invisible, and shadowy, into what one could call the present absence of characters, stories, movies, monuments, memorials. These icons assume the comforting stability of flesh, stone, metal, and image, animated by our knowledge of the absence toward which their comforting presence gestures.

The relationship of absence to presence is the invisible dimension of the asymmetry of memory, existing beside the visible dimension of great powers dominating smaller ones. Whether a country is great or small, each one's war machine and industry of memory seeks to establish control over memory itself. But what is stronger in this asymmetrical relationship, industrial memory or the absent presence of the past? The war machine or the ghost? The war machine

seeks to banish ghosts or tame them, but unruly specters abound, if one looks carefully, if one recognizes that spirits exist to be seen by some and not by others. I encountered them in Laos, a country whose mere mention brought light to the eyes of the many Vietnamese who spoke of it as a paradise, so peaceful and calm. In some ways Laos appears to be a satellite of Vietnam, at least in the official Laotian industry of memory, which commemorates Vietnam as the country's greatest ally. Prominent place is given to the Vietnamese flag and Ho Chi Minh in Vientiane's museums, which follow much the same narrative as Vietnamese ones. Under the bright lights of industrial memory found in museums such as the Lao People's Army History Museum, all white walls and chrome handrails, the presence of ghosts is weak. Their presence was likewise vague in the far caves of Vieng Xai in northwest Laos, at least in the daytime hours when I visited. The Pathet Lao took shelter here in a vast and impressive cave complex, greater than anything found in Vietnam, a subterranean metropolis replete with a massive amphitheater carved from rock. Under American bombardment, with the smells of humanity and fear, with the dust and earth falling on one's head, with electricity faltering, the caves must have been much less tranquil than they are for the tourist whose greatest challenge is adjusting his camera for dim lighting.

Hewn from rock and fashioned into a tourist site, the Vieng Xai caves are industrial memory on a grand scale, a successful attempt to conquer the past, to banish the ghosts. Standing on the amphitheater's quiet stage, it seemed to me that we did build these memorials to forget, as scholar James Young would have it.[12] Many of us want to forget the complexities of the past, as well as its horrors. We prefer a clean, well-lit place that features the orderly kinds of memory offered in the temples of the state, where the line between good and evil is clear, where stories have discernible morals, and where we stand on humanity's side, the caves within us brightly lit.

But even as we memorialize the dead, perhaps what we want to forget most of all is death. We want to forget the ghosts we will become, we want to forget that the hosts of the dead outnumber the ranks of the living, we want to forget that it was the living, just like us, who killed the dead.[13] Against this asymmetry of the dead and the living, the industries of memory of countries large and small, of powers great and weak, strive against ghosts. These industries render them meaningful and understandable when possible through stories, eliminating them when necessary. In most cases, though, the industries of memory avoid them. The number of places where the living remember the dead must surely be outnumbered by the places where the dead are forgotten, where not even a stone marks history's horrors, where there are, Ricoeur says, "witnesses who never encounter an audience capable of listening to them or hearing what they have to say."[14] But what draws our attention are those memorials and monuments, those obelisks and stelae, those parade grounds and battlefields, those movies and fictions, those anniversary days and moments of silence, those outnumbered spaces where the living can command the dead.

Sometimes the ghosts assert their authority, in consecrated spaces of memory yet to be fully industrialized. I did not feel ghosts at Vieng Xai but I did on my way to those caves, on the journey from Phonsavan, when my driver told me I should stop at Tham Phiu. Here, in another mountain cave, an American rocket strike had killed dozens of civilians. This much I knew from my guidebook. I had not intended to stop here, for I was not moved by the prospect of yet another cave of horrors, after the many caves and tunnels that I had already seen. But it was on the way, so why not? There was an exhibition hall, but fortunately I did not see it on my way to the cave. Missing the exhibit meant that I missed the official narrative that would try to tell me what to feel, and what it told me was not surprising, about the innocent civilians and the heartless Americans.

The stairs and the handrail were signs enough that the cave had been prepared for tourists, though I was the only one of that kind at the moment. The four schoolgirls I encountered on the way up the mountain were not tourists but locals, making their way leisurely, giggling and snapping pictures of themselves with their phones. I made it to the cave before them, a black mouth through which a truck could be driven. Daylight threw itself a few dozen feet into the recesses, where there was no artificial lighting. There were no steps, no rails, no ropes to guide me over rough ground, unlike the killing caves of Battambang, in Cambodia. Nor, as in Battambang, was there a memorial or a shrine; nor pictures, photographs, placards, or memorials; nor a hungry boy asking to be a tour guide. At Tham Phiu, I was alone in a cave where the local industry of memory, already fragile, stopped at the threshold. I made my way to where light met its opposite and I looked into the darkness. What had it been like with hundreds of people, the noise and the stench, the dimness and the terror? What was in the void now? I stood on the

side of presence, facing an absence where the past lived, populated with ghosts, real or imagined, and in that moment I was afraid.

Then I heard the laughter. The girls stood at the cave's mouth, profiles outlined by sunlight, making sure the shadows did not touch even their toes. Turning my back on all that remained unseen behind me, I walked toward their silhouettes.

/ AESTHETICS /

7

On Victims and Voices

AS A CHILD, I WAS ALWAYS AWARE of the presence of the dead.[1] Although my Catholic father and mother did not practice ancestor worship, they kept black-and-white photographs of their fathers and their mothers on the mantel and prayed to God before them every evening. I knew the fathers and mothers of my father and mother only through their photographs, in which they never smiled and posed stiffly. In the 1980s, news of my grandparents' passing into another world arrived one after the other, accompanied by more black-and-white photographs of rural funeral processions marching through a bleak northern landscape, of mourners dressed in simple country clothes and white headbands, of wooden coffins lowered into narrow graves. Visiting the homes of other Vietnamese friends, I paused to study the photographs of their relatives, invariably captured in black-and-white. Every household had these photographs, hallowed signs of our haunting by the past that were emblematic of a lost time, a lost place, and, in many cases, of lost people. For many refugees, the clothes on their backs and a wallet full of photographs were the only things they carried with them on their flight,

"the family photograph clutched tight to a chest / When all the rest of the world burns."[2]

In the strange new land in which they found themselves, these photographs transubstantiated into symbols of the missing themselves. Photographs are the secular imprints of ghosts, the most visible sign of their aura, the closest way many in the world of refugees live with those left behind. In le thi diem thuy's *The Gangster We Are All Looking For*, the narrator's mother keeps the only treasured photograph of her own mother and father safe in the attic. When their home is demolished to pave the way for gentrification, the mother forgets to take the photograph with her in the family's frantic attempt to rescue their belongings. Watching the destruction of her home, the mother calls out to her lost parents, "Ma/Ba." The narrator, a child, listens to her mother's cry and thinks of the world as "two butterfly wings rubbing against my ear. Listen . . . they are sitting in the attic, sitting like royalty. Shining in the dark, buried by a wrecking ball. Paper fragments floating across the surface of the sea. There is not a trace of blood anywhere except here, in my throat, where I am telling you all this."[3]

thuy's book, like much of the writing, art, and politics dealing with the war, focuses on the problem of mourning the dead, remembering the missing, and considering the place of the survivors. This problem is endemic to refugees, for whom separation from family and homeland is a universal experience. Common among refugees are memories and stories of the dead, the missing, and the ones left behind, those relatives, friends, and countrymen facing the consequences escaped by the refugee. In some cases, the refugee may even benefit from telling about those consequences and the ghosts of their past. Remembering becomes imbued with the dead, freighted with their weight, a risky and burdened act. As Nguyen-Vo Thu-Huong says, "how shall we remember rather than just appropriate the dead for our own agendas, precluding what the dead can tell us?"[4] In a parallel case, Maxine Hong Kingston captures the ethical

challenge for writers who speak about terrible events when she opens *The Woman Warrior* with her mother telling her, "You must not tell anyone what I am about to tell you," a command broken in the very act of repeating it.[5] The writer and the witness face the ethical demand to speak of things that others would rather not speak of, or hear about, or pass on into memory, even if in doing so they may perpetuate the haunting rather than quell it. Reflecting upon an anonymous aunt whose suicide was the consequence of family neglect and neighborly abuse, Kingston says, "I do not think she always means me well. I am telling on her, and she was a spite suicide, drowning herself in the drinking water. The Chinese are always very frightened of the drowned one, whose weeping ghost, wet hair hanging and skin bloated, waits silently by the water to pull down a substitute."[6] As do all writers who speak of ghosts, Kingston inhabits the fraught territory of the substitute.

For Southeast Asians who lived through the war, ghost stories were easy to come by, as memoirist Le Ly Hayslip recounts:

> We found ourselves praying more often, trying to calm the outraged spirits of all the slain people around us. . . . Slain soldiers used to parade around the cemetery too, but whenever we kids got close, they evaporated into the mist. At night, my family would sit around and the fire and tell stories about the dead. . . . Consequently I began to think of the supernatural—of the spirit world and the habits of ghosts—the way others might think of life in distant cities or in exotic lands across the sea. In this discovery, I would later find I was not alone.[7]

The appearance of ghosts like these becomes a matter of justice, according to the sociologist Avery Gordon. Their haunting demands that "we be accountable to people who seemingly have not counted in the historical and public record."[8] This demand weighs heavily on those investigating the war's aftermath, like Gordon's fellow sociologist, Yen Le Espiritu, who declares that we must "become tellers

of ghost stories."[9] But speaking of ghosts is a dangerous act, for the storyteller must confront these ghosts, or exploit them, or return to the fatal circumstances that made them. In doing so, the storyteller must take responsibility for her tale when she invokes the dead, instead of merely claiming artistic license.

The ethical considerations for storytellers who speak of the dead and ghosts are particularly burdensome for minorities, those smaller in numbers or power. Thinking of themselves as weak or weaker, minorities may also be tempted to see themselves as victims, explicitly or implicitly. The majority may view the minority or the other as a victim, too, for that keeps the minority and the other in their places, their role to suffer and then to be saved by the powerful majority. Being a victim is a masked power that compels guilt on the part of the rescuer or the one who feels pity, but it is also a trick played on the victim for the victim's supposed benefit. To see oneself only as a victim simplifies power and excuses the victim from the obligations of ethical behavior in politics, warfare, love, and art. Being a victim also forecloses the chance to wield real power, which the majority is not inclined to grant the minority and the other, offering them instead victimization and voice, two doors into the same trap. Ethics forces us to examine the power that we wield and the harm we ourselves can do, the dilemma that when one acts or speaks, even in the service of ghosts, one can be victimizer and victim, guilty and innocent.

Writers, artists, and critics can inflict various kinds of harm with the symbolic power they wield; so can minorities and their advocates do damage. Harm is a consequence of holding power, and even minorities and artists have some measure of power. Raising the issue of how a minority can inflict harm acknowledges that a minority is a human and inhuman agent, not merely a powerless victim, a passive subject in history, or a romanticized hero. Thinking of minorities as being human and inhuman complicates the usual stances of a patronizing, guilt-ridden majority as well as many advocates for

minorities, both of which prefer to see the minority as human. So it is that when advocates for minorities speak of them taking up power, they often mean power being used as resistance against abusive power, an act with greatly reduced moral and ethical complication. The possibility of the minority possessing power with all of its confusing and contradictory implications, including the negative and the damaging, may be forgotten or overlooked in the temptation to see the minority as the victim of abusive power. While a minority's power is not equal to the majority's power, the minority must claim responsibility for the power it does possess, the power it must have if it can resist and, ultimately, liberate itself. In the recent past, the Western Left, so keen on the cry for resistance and liberation, has had the luxury of not actually accomplishing revolution and therefore suspending the confrontation with what it means for the wretched of the Earth to have power. Thus, if there is one thing that the revolutions in Indochina can teach the West, it is that resistance and liberation have unforeseen consequences. Those who have been damaged can, when they come into power, damage others and make ghosts.

Vietnamese Americans offer a paradigmatic example of the problems of telling on and about ghosts. Of all the Southeast Asians in America, they have written the most literature and have the longest literary tradition. French colonial policies encouraged this tradition, with the French favoring the Vietnamese over Cambodians and Laotians for the colonial bureaucracy, a practice that inevitably cultivated a literary class. The Vietnamese also benefitted from a more intense extraction of their frightened population at the end of the war, vastly outnumbering Cambodian and Laotian refugees. Both in terms of the superiority of numbers and literary education, the Vietnamese in America are a politically engineered demographic who possess much greater cultural capital than Cambodian and Laotian refugees. Their literary output can and should be judged, then, by the highest standards of ethics, politics, and aesthetics, for they have

had some advantages to balance their war-born disadvantages. Thus their literature serves as an ideal test case for how the use of victimization and voice has come to dominate the aesthetics of minority literature in America. By aesthetics, I mean the process by which beauty is created and studied, which, in the case of victimization and voice, is difficult to separate from the issue of ethical responsibility. In the realm of ethnic storytelling, the ethical and aesthetic reluctance to confront one's power is manifested through not telling on one's own side while reporting on the crimes of others and the crimes done to one's own people. But only through telling on how one's own side has made ghosts can one stop being a victim and assume the full weight of humanity, which includes the burden of inhumanity.

Telling on others and ourselves is perilous, not least of all for the artists who confront the victimization that would silence them and the lure of having a voice that promises to liberate them. Claiming a voice—that is to say, speaking up and speaking out—are fundamental to the American character, or so Americans like to believe. The immigrant, the refugee, the exile, and the stranger who comes to these new shores may already have a voice, but usually it speaks in a different language than the American lingua franca, English. While those who live in what the scholar Werner Sollors calls a "multilingual America" speak and write many languages, America as a whole, the America that rules, prides itself on trenchant monolingualism.[10] As a result, the immigrant, the refugee, the exile, and the stranger can be heard in high volume only in their own homes and in the enclaves they carve out for themselves. Outside those ethnic walls, facing an indifferent America, the other struggles to speak. She clears her throat, hesitates and, most often, waits for the next generation raised or born on American soil to speak for them. Vietnamese American literature written in English follows this ethnic cycle of silence to speech. In that way, Vietnamese American literature fulfills ethnic writing's most basic function: to serve as

proof that regardless of what brought these others to America, they or their children have become accepted, even if grudgingly, by other Americans. This move from silence to speech is the form of ethnic literature in America, the box that contains all sorts of troubling content. After all, what brought these so-called ethnics to America are usually difficult experiences, and more often than not terrible and traumatizing ones.

We might say that the form or the box is ethnic, and its contents are racial.[11] The ethnic is what America can assimilate, while the racial is what America cannot digest. In American mythology, one ethnic is the same, eventually, as any other ethnic: the Irish, the Chinese, the Mexican, and, eventually, hopefully, the black, who remains at the outer edge as the defining limit and the colored line of ethnic hope in America. But the racial continues to roil and disturb the American Dream, diverting the American Way from its road of progress. If form is ethnic and content is racial, then the box one opens in the hopes of finding something savory may yet contain that strange thing, foreign by way of sight and smell, which refuses to be consumed so easily: slavery, exploitation, and expropriation, as well as poverty, starvation, and persecution. In the case of Vietnamese American literature, the form has become aesthetically refined over the past fifty years, but the content—war—remains potentially troublesome and volatile. Race mattered in this war, but to what extent it mattered continues to cause disagreement among Americans and Vietnamese. One can draw a distinction here between the two faces of one country, the United States and America. If the United States is the reality and the infrastructure, then America is the mythology and the façade. Even the Vietnamese who fought against the Americans drew this line, appealing to the hearts and minds of the American people to oppose the policies of the United States and its un-American war. As for Americans, they, too, see this line, although what it means exactly is a subject of intense debate. Many Americans experienced and remember the war as an unjust, cruel one that betrayed the

American character. Many other Americans view the war less as a betrayal and more as a failure of the American character. But the number of Americans who think the war expressed a fundamental flaw in the American character, as a gut-level expression of genocidal white supremacy, is a minority.

Vietnamese American literature is thus published in a country with no consensus on what to make of this war. Was the war a mistake and a failure? A noble but flawed endeavor, carried out with the best of intentions? The naked throbbing of the heart of darkness?[12] If Vietnamese American literature could avoid the war, then it could avoid this challenge of confronting the mythology and the contradictions of America. But the literature cannot avoid the war, because the literature is inseparable from the Vietnamese American population itself, which exists only because of the war. For the Vietnamese American writer as a racially bound ethnic writer, the necessity of speaking up, speaking out, and speaking for remains tied to the name of the ethnic population. As much as this person might want to forget his or her racial past, America will not let this ethnic other forget. This is the history that critic Isabelle Thuy Pelaud speaks of when she characterizes Vietnamese American literature as being located between the poles of history and hybridity.[13] America promises hybridity to its newcomers, the dream of becoming something different on American soil. But Americans cannot awaken from this war's history, which Americans continue to evoke whenever the United States again ventures abroad.[14]

Each racially defined ethnic group in the United States gets its own notable history for which it is remembered by Americans. Blacks get slavery and the plantation, and the legacies they leave in blackness and the ghetto. Latinos are of the Americas but are neither North American nor white (at least the Latinos that come first to the American mind), their lives supposedly marked by barrios and the border. Native Americans get genocide, dispossession, and the reservation. Vietnamese Americans get the war. Any ethnically

defined literature is bound up with that ethnic group's history in America because so-called ethnic literatures are forms of memory, saturated by ethical problems around the remembering of selves and others.[15] Again race is key. For ethnic groups that can shed racial difference, such as the Irish who were once depicted in American media as being inassimilable, or the Jews once seen as beyond the pale, ethnicity becomes, as the sociologist Mary Waters says, an option, a choice.[16] Those ethnic groups that remain marked, or stained, by race, have choices, too, but they also have no control about how others thrust their ethnicity on them. The choices made by racially defined people always conflict with the hard expectations of other Americans, which is also a reality of the literary world. There, the box of form assumes the name of the ethnic group, such as Vietnamese American literature. In contrast, Irish American literature or Jewish American literature has less visibility, with John O'Hara, Mary McCarthy, Saul Bellow, and Philip Roth being American writers first and ethnic writers second, if at all. They have the choice to be white that racial minorities do not.

Minority writers know they are most easily heard in America when they speak about the historical events that defined their populations. These writers can speak of something else, but they are rewarded for speaking about their history and their race. For some, the history of their racial difference instills in them the desire to speak about their past. Nam Le captures the dynamic of silence and speech in his story "Love and Honor and Pity and Pride and Compassion and Sacrifice."[17] A writer named Nam is studying at the fabled University of Iowa writing program. He does not want to write about Vietnamese experiences, but when his father visits, he decides to write the ethnic story, based on his father's harrowing war experience. The father survived a massacre, and not just any massacre, but the most horrible event of the war for the American conscience—the My Lai massacre. Nam knows he can make a literary reputation for himself out of this story, but when he proudly

shows it to his father, his father burns the manuscript. Ironically, this story brought Nam Le to visibility. Writing the ethnic story made his name in the literary scene, and yet the lure of history and race trouble both he and his character Nam. If the literary world allows ethnic authors inside, even if only to one corner, then surely this proves that the larger world also accommodates them and the people they speak of and for. This is perhaps the most troubling tension running throughout Vietnamese American literature. On the one hand, when the literature speaks of the war and the harm done to the Vietnamese, the Vietnamese are victims. On the other hand, the existence of the literature seems to prove that America ultimately fulfilled its promise of freedom, giving the Vietnamese a voice. These problematic scenarios of being a victim or having a voice place the ethnic author into an impossible situation.

Le's story posits that being an ethnic author writing ethnic stories is not really liberatory, for while a pigeonhole can be home, it is a very small one. But it is not only the confinement of the author by the literary and larger world that the story questions. The father's reaction illustrates another danger, that the ethnic author may betray those for whom he speaks, and may therefore deserve not the spotlight but the bonfire. The literary world hungers for secrets and calls on the ethnic author to work as tour guide, ambassador, translator, and insider, the all-purpose literary fixer who will hand over the exotic or mysterious unknown. But the ethnic population may want to keep its secrets or feel that its stories and its lives are being misused for the benefit of an author who is a thief and a traitor.[18] The tension between the ethnic writer and the ethnic population is also a legacy of race and subjugation, for it is an inequity of stories that compels the writer and the population to be at odds. White Americans experience this inequity from the side of the narratively wealthy, for they control the production of stories, with literature as one key industry of memory. The airwaves and the pages are full of stories about Americans of the dominant class, discussed in all

their Whitmanian diversity and individuality. And when these Americans want to know about their others, they can usually find the stories they want to consume, written to cater to their expectations. But while dominant Americans exist in an economy of narrative plenitude with a surfeit of stories, their ethnic and racial others live in an economy of narrative scarcity. Fewer stories exist about them, at least ones that leave their enclaves. Not surprisingly, both the larger American public and the ethnic community then place great pressure on those few stories and those few writers who emerge to stand on the American stage.

This force shapes ethnic literature in general and Vietnamese American literature in particular, providing them with some common generic features. One is the sign of translation within the story, when the author or the narrator explains some feature of the ethnic community, such as its language, food, customs, or history. Since the insiders of an ethnic community obviously do not need these things explained or translated to them, the explanation or the translation implies an audience of outsiders, as critic Sau-ling C. Wong argues in the case of bestselling writer Amy Tan.[19] Sometimes the address to an outside audience is explicit, as in Le Ly Hayslip's *When Heaven and Earth Changed Places*, where she speaks directly at the beginning and end to Americans, especially veterans, absolving them of any guilt they may feel about the war. Sometimes the address is implicit, as in Lan Cao's *The Lotus and the Storm*. In just one example, the character Mai recounts an episode from the classic *The Tale of Kieu* and says that "Every child in our country grows up with this story."[20] One does not have to explain such a fact to one's countrymen, only to those who did not grow up with it. In translating like this, authors can speak for the community to those not of the community, a power that can be rewarded greatly, with publication, sales, prizes, and accolades. But in an economy of narrative scarcity and inequity, the ones with real power are the outsiders (to the ethnic literature) who are the insiders of the literary industry:

agents, editors, publishers, reviewers, critics, and readers who demand that things be translated to them. The ethnic writer is the literary industry's employee, a status shared with most American writers. To be an employee does not say everything about the writer but it says a great deal, most importantly about the choice that all writers face: to see themselves as individuals working privately for art (even as that art becomes a commodity), or to see themselves as part of a larger community, imagining in solidarity even if writing alone.

Related to translation, another generic feature of ethnic literature is affirmation. Translators affirm those whom they serve, for while translators serve both sides of the translating relationship, the most important side is the one that pays. How much, exactly, does the person asking for the translation really want to know? Does the translator soften the blow of the translation? Does the translator silence what does not pay? The most subtle and excellent kinds of affirmation are invisible, so ingrained that both the person affirming and the person affirmed simply take for granted what is being said. This implicit version of affirmation in ethnic literature endorses the American Dream, the American Way, and American exceptionalism, the belief that no matter how bad it was over there, things are better here. But that endorsement takes place in stories that also criticize those mythological American ideas. Vietnamese American literature will often bring up the failure of American ideals during the war, while simultaneously affirming how America rescued refugees from that war. Historian Phuong Nguyen calls this maneuver "refugee nationalism," where the refugee feels bound to America in both resentment for being betrayed and gratitude for being saved.[21] Failure and idealism are part and parcel of the ideological power of the American Dream, the American Way, and American exceptionalism, all of which profess that while Americans may falter, they always strive, with the ultimate proof evident in how Americans allow others to speak.

It is arguably the case that the majority of Vietnamese American literature engages in endorsing this kind of American self-regard, partially through what it depicts and more so through what it does not mention or criticize. The philosopher Ludwig Wittgenstein wrote that "what we cannot speak about we must pass over in silence," and the silence in Vietnamese American literature is about revolution.[22] While some Vietnamese American literature reminds Americans that the Vietnamese have been victims, most of it has given up on revolution, which is one of the most important ways of transcending victimization. Most of the literature settles for having a voice, which allows the authors to criticize America, to a degree. But the very existence of that criticism proves that American society allows them to speak, so long as they pass over certain things in silence. Emphasizing the claiming of voice over the act of revolt, the literature inoculates itself against being a radical threat to American mythology. Communism tainted revolution for most Vietnamese Americans, and revolution is already a difficult topic for them to raise in America, which accepts only one revolution, its own, now safely fossilized. Revolution exists as the horizon for most Vietnamese American literature, forbidden in the United States, foreclosed in Vietnam. What remains is either a resentment that returns to the bitter past, more likely to be spoken of in the kind of literature that Americans cannot read, written in Vietnamese, or the desire for reconciliation and closure. Reconciliation and closure are foregrounded in the endings of Hayslip's and Cao's books and in the literature that is explicit in its affirmation, as in Andrew Lam's collection of essays, *Perfume Dreams: Reflections on the Vietnamese Diaspora*. Here the Viet Kieu—the overseas Vietnamese—embody American possibility, a successful model minority who returns to Vietnam as a kind of Superman, flaunting the American wealth that the Vietnamese could have had, if not for communism.

Vietnamese American literature's political position on the American landscape as a literature of translation and affirmation might

best be described as anticommunist liberalism. As Yen Le Espiritu says, "Otherwise absent in U.S. public discussions on Vietnam, Vietnamese refugees become most visible and intelligible to Americans as anticommunist witnesses, testifying to the communist Vietnamese government's atrocities and failings."[23] In the literature of these refugees or their descendants, there is faith in America as well as awareness that America needs protection from its worst instincts. There is sympathy for others, bred from the experience of being others. There is an awareness of history, because these authors are shaped by a history they cannot forget. There is an investment in the individual, in education, in free speech, and in the marketplace. All of these liberal gestures take place against the backdrop of anticommunism, not of the rabid, demagogic kind found on the streets of Little Saigon, but the reasonable, intellectual kind that allows for conversation with former enemies, for returns to the homeland, and, most importantly for American readers, the possibility of a reconciliation that will put their war to rest.

The movement from the homeland to the adopted land, as refugees and exiles, and finally the return and the reconciliation, marks much of the literature.[24] This is the case in Andrew X. Pham's *Catfish and Mandala* (2000), about a Viet Kieu who returns to the homeland during the early, difficult years of economic reform in the 1990s, or Monique Truong's *The Book of Salt* (2003), which follows the story of a young peasant in French colonial Vietnam who migrates to France to become the cook for Gertrude Stein and Alice B. Toklas. Or the literature is set in ethnic enclaves such as Little Saigon, as in Aimee Phan's *We Should Never Meet* (2005), about orphans who have no choice in being moved to America. The literature overall is marked by the powerful stamp that says to America "we are here because you were there." This stamp's implications are not to be disregarded, but anticommunist liberalism contains them by holding communism responsible first for bringing America to Vietnam. Education also plays an important role in subduing

these implications, particularly as it comes to represent the promise of the American Dream. Education is the invisible infrastructure of Vietnamese American literature, integrating it into the literary industry and the military-industrial complex, with authorial credentials being the baseline BA and the preferable MFA. In the common instance, the workshop model reinforces an averageness of taste, with a master of the craft leading students as they read and comment on each other's work in a democratic appropriation of the communist self-criticism session. As writer Flannery O'Connor puts it, "so many people can now write competent stories that the short story as a medium is in danger of dying of competence. We want competence, but competence by itself is deadly. What is needed is the vision to go with it, and you do not get this from a writing class."[25] This competence or averageness reflects the mainstream values of the literary industry, the educational system, and American society, while reinforcing the literary world's hierarchical nature. The MFA cultivates a standard of aesthetic excellence, and the literature produced from it is, as a result, competent in meeting that standard, which, almost by definition, cannot threaten the literary industry.

As Vietnamese American literature in English developed to meet this industrial standard, only one author emerged who was not college-educated or from the political or military elites, Le Ly Hayslip. Her two memoirs are also cowritten, which is as good as to be damned in the literary world. Her work may lack "competence" as defined by the literary industrial standard, but it possesses great vision—whether or not one agrees with that vision of humanity and reconciliation—which so many literary works lack. Outside of oral histories and besides *The Book of Salt*, her book is also the only major work that focuses on the life of a peasant. Most of the literature centers on those from the political, merchant, military, mandarin, elite, or middle classes, which all imply an elevated educational background in Vietnam for the protagonists or their parents. This elevated status shapes the worldviews of the protagonists—their

vision, so to speak—and the settings of the stories, as well as their amenability to an anticommunist liberalism once they move to the United States (or once the American-born or raised protagonists come to consciousness). Given that the overwhelming majority of the Vietnamese are peasants, it is ironic that almost all the literature focuses on the classes above them. This irony is especially evident when American readers rely on a Vietnamese American literature produced by an urban, educated class to tell them something about the history and culture of the agrarian country and peasant people for which the war was fought.

While Vietnamese Americans are socioeconomically diverse, Vietnamese American authors are not, at least in terms of their education. This is especially evident with the wave of Vietnamese American literature that commenced in the 1990s with *Catfish and Mandala* and in 2003 gained momentum with *The Book of Salt* and *The Gangster We Are All Looking For*. Hayslip was the most visible Vietnamese American author until the arrival of this younger generation who, unlike her, could claim auteur status. They won major prizes and received wide recognition from the literary industry, their works considered "literary" in a way that Hayslip's was not. While none of these authors had MFAs in creative writing, those that followed would, such as Aimee Phan and Nam Le. As Mark McGurl argues, the MFA program helped shape post–World War II American literature.[26] Vietnamese American literature is no exception, being the expression not of Vietnamese Americans in general but of their most educated class. If using literature gives the Vietnamese American author a voice, it does not give a voice to the people for whom the author speaks, or is perceived to speak.

Class markers are evident in what Vietnamese American literature does not often address (the peasantry), as well as in an array of stylistic features that mark an authorial anxiety about being the educated elite of a racial minority, both resentful of and dependent on the literary industry. The most significant anxiety has to do with voice.

College-educated writers, especially the American-raised ones, are aware of their status as the people who have the voice to speak of and speak for Vietnamese and/or Vietnamese Americans. This call to be both one's self (which is how one becomes American) and to write about others (who, even if they are other, look like one's self) is both a responsibility and a burden, as Monique Truong shows in her essay on "The Emergence of Vietnamese American Literature." Truong's essay takes place against two notable acts of speaking of and for Vietnamese Americans. In 1991, Robert Olen Butler won the Pulitzer Prize for his collection of short stories written from the perspective of Vietnamese Americans, *A Good Scent from a Strange Mountain*. Earlier in 1986, Wendy Wilder Larsen cowrote a collection of poetry with Tran Thi Nga, *Shallow Graves: Two Women and Vietnam*. For Truong, both of these books are problematic. The acclaim given to Butler's work raises the issue of whether American audiences prefer hearing an American speaking for the Vietnamese rather than the Vietnamese themselves (Truong does not consider whether Vietnamese American writers simply were not good enough at the time to interest American audiences). In Larsen and Nga's case, Truong uses the metaphor of the bow and the violin to describe their creative relationship, where Larsen is the "active, narrative-generating bow" while Nga is the "passive instrument."[27] Against these American literary acts that appropriate or subordinate Vietnamese voices, Truong makes a persuasive call for a Vietnamese American literature written by Vietnamese Americans.

This urge for self-representation and self-determination is deeply embedded in ethnic literature in general. If "ethnic" means anything in relation to literature, it is the sign of the ethnic speaking of and for the ethnic population. But the issues Truong raises in terms of appropriation and subordination are important for both outsiders and insiders. The ethnic author as an insider is not immune to the risks found in speaking for and speaking of others, even the others of one's own community. Truong's *The Book of Salt* dramatizes

these risks and embodies them. In the novel, the peasant cook for Stein and Toklas—Binh—discovers that Stein has secretly written about him. Spoken for and about, he steals the book in revenge. In depicting these acts of mutual theft, Truong depends on speaking for and of Binh. The relationship of author to fictional character here parallels the relationship of author to a real community. Do Vietnamese American authors also run the risk of ventriloquizing through the creation of fictional characters that are also rather distant to them? If Larsen's bow plays on Nga's violin, does Truong do the same to Binh? No, because Nga is a real person while Binh is a character of Truong's imagination. But the risks in speaking for and of others are not erased because the other is fictional.

In the case of ethnic literature, the "ethnic" label collapses the distinction between author and character, so that an ethnic author using ethnic characters somehow appears more "authentic" than a nonethnic author doing the same. This implies the reverse: that an ethnic writer writing about her ethnic people is "natural" but also limited, whereas a writer writing about a population he or she does not belong to may be appropriating but is also being artistic in a way that the ethnic writer is not—hence the regard that Butler received. Despite the risks of authenticity, there is good reason to think that ethnic authors are more sensitive in depicting characters of their own ethnicity, and that they should have the opportunity to do so. In an economy of narrative scarcity where literary representation cannot be separated from larger social issues of equity and justice, ethnic authors should have equal opportunity to represent both themselves and ethnic characters. The drawbacks to this necessary move are twofold. One is the reinforcement of authenticity, the belief that authors who share a background with who they represent will tell a more truthful story. Authenticity, however, does not eliminate ventriloquism. If Butler's short stories had appeared with a Vietnamese name on them, few would question their authenticity. A blind taste test of literature with authorial names

stripped from book covers would probably prove that the author's ethnicity cannot be determined from the content. But the author's identity and body is relevant because art exists in a social world where readers and writers bring their prejudices to the act of reading. Ethnic authors need to speak for and of ethnic characters, but they must do so aware of the fact that all literature is an act of ventriloquism, depending, as the critic David Palumbo-Liu puts it, on the "deliverance of others," of otherness itself, to readers.[28] It is risky to claim an authenticity that is fictional at best and illusory at worst, but since race is forced on ethnic authors, ethnic authors are necessary to address the preexisting condition, or affliction, of race.

Another drawback to ethnic authorship concerns betrayal. In the fictional world, Binh steals the book about him and Nam's father burns his story. They resent their depictions by the authors within these stories. This implies that the authors of books take the chance of exploiting people through telling their stories, both in relationship to their characters and their communities. Betrayal is hence an omnipresent theme in Vietnamese American literature, although for more than formal and racial reasons. Betrayal is a part of Vietnamese history as well, particularly in the twentieth-century era of war and revolution, when politics encouraged partisans to betray each other, or to betray family members of different political stripes, or to betray certain sides or the entire nation. But as Lan Duong says, betrayal in Vietnamese culture is the other side of collaboration. The positive aspect of collaboration, or working together, is fundamental to artistic work and to building the nation. The negative dimension of collaboration is found in its being seen as an act of treachery, of working with foreigners to betray the nation, an especially volatile charge when applied to women, as it so often is.[29] Likewise, authorial depiction of others is an act of collaboration—explicitly so when those are "real" others, people like Nga, and implicitly so with fictional others, as in the cases of Truong and Le. Their fiction shows what can happen when the others who are

spoken for do not desire this collaboration. Throughout Vietnamese American literature, however, collaboration's positive aspect is also present. Nguyen Qui Duc wrote his memoir *Where the Ashes Are* partially as a story about his father, turning a self-oriented genre into one about others. Andrew X. Pham goes a step further in *The Eaves of Heaven*, writing in his father's voice to depict a man rarely seen in American literature, the southern Vietnamese soldier of a lost regime. He and his father also collaborated on the translation of Dang Thuy Tram's diary into *Last Night I Dreamed of Peace*. Even the self can be the site of collaboration, as Lan Cao shows in *The Lotus and the Storm*. One of the central characters has multiple personalities, caused by terrible trauma, but even they eventually move from conflict to cooperation.

The ambivalence between collaboration and betrayal in Vietnamese American literature signals ambivalence in the literature itself. Vietnamese American literature is collaborative in its relationship to American culture. The literature engages in tactics of translation and affirmation, fulfilling a role it shares with ethnic literature in general, that of America's loyal opposition, bringing up the past in order to lay it to rest, or attempt to do so. As such, the literature can raise the troublesome past of war and even the difficult present of racial inequality, so long as it also promises or hopes for reconciliation and refuge. But signs of betrayal are scattered throughout the literature of loyal opposition, criticisms so serious that they threaten the ways that Americans like to see themselves. At times, the same work exhibits impulses toward both collaboration and betrayal, like *The Lotus and the Storm* does. The novel ends on reconciliation between Vietnamese and Americans, but it also indicts America for not learning from its war with Vietnam as it fights new wars in the Middle East. At other times, the betrayal is hinted at obliquely, through ruptures where the past cannot be forgotten, as in GB Tran's graphic novel *Vietnamerica*. The frenetic, color-saturated narrative ends in the blackness of an airplane hold

as the cargo doors shut on frightened refugees fleeing the fall of Saigon. *Vietnamerica*'s timeline does continue past this point in the plot of the book, with the refugees fleeing to America and then eventually returning to Vietnam, but the book's ending on this note of claustrophobic blackness suggests that the loss of their nation and American betrayal will always entrap Vietnamese refugees.

While Vietnamese American literature that avoids the war is developing slowly, as might be found in Bich Minh Nguyen's writing, the refusal to discuss the war can still be seen in light of the war itself.[30] Somewhere the corpse continues to burn, as poet Galway Kinnell says, and even if we avert our eyes and pretend we cannot smell it, the odor lingers, its flickering shadow occasionally leaping into our peripheral vision.[31] The odor and the flickering shadow of war's burning corpse still haunts Vietnamese American literature, as *The Gangster We Are All Looking For* makes evident. The narrator flees by boat from Vietnam and survives, but her brother does not. His ghost shadows her, becoming one sign of the past that will not go away. The author's postscript to the 2004 paperback edition

makes haunting even more explicit, recounting that her name is not her own but her older sister's. The author and her father had fled on a separate boat than the mother and older sister did, and, after being rescued by an American ship, her father had mistakenly identified her with her sister's name when filling out paperwork. When the family is reunited, the mother reveals that the older sister drowned at a refugee camp, and asks that the younger sister—the author— keep her older sister's name. "My mother saw my father's mistake as propitious; it allowed a part of my older sister to come to this country with us. And so I kept my sister's name and wore it like a borrowed garment, one in which my mother crowded two daughters, one dead and one living."[32] Ghosts like this that tie Vietnam to America must be honored if Vietnamese American literature is to stop being an ethnic literature that ultimately affirms America.

How can ghosts be called on not to propitiate them and send them back to the otherworld, leaving us to our human existence, but to live in the present and to animate our memories with an inhumanity that reminds us of our own? Unsurprisingly, the authors that eschew implicit affirmations of America write from the margins of the literary industry, published by university or small presses rather than major trade houses. Feminist theorist and filmmaker Trinh T. Minh-ha, for example, has focused relentlessly on foregrounding the illusory power in having a voice. Her best-known work, the documentary *Surname Viet, Given Name Nam*, features the words of Vietnamese women who were interviewed about their wartime and postwar experiences. In the first half of the documentary, actresses perform those words in the guise of those women, while the second half focuses on the actresses in their lives off camera. The documentary shows that these women are actresses and not the actual women in order to demonstrate that the stories of Vietnamese women are performances, not historical fact. Trinh's book *Woman Native Other* elaborates her suspicion about the seductiveness of authentic voices. She points out how, for women of color, writing is an act of

privilege tainted by the guilt of being dependent on other women's labor, or speaking for other women.[33] Writing should be a form of liberation for the writer and for all women, instead of only a form that seizes the stories of women who cannot tell their own. To enact this liberation, Trinh does not rely on singular notions of ethnic identity in service of a literary industry, in being only Vietnamese, but instead reaches for solidarity with women of color, drawing on their writings and emphasizing how there is a "Third World in the first, and vice versa."[34]

Following that insight, Linh Dinh's *Love like Hate* is raw, sometimes rough, always impolite, as he depicts, satirizes, and criticizes both Vietnam and America unrelentingly. "Saigon is often squalid but it is never desolate," he writes. "Vietnam is a disaster, agreed, but it is a socialized disaster, whereas America is—for many people, natives or not—a solitary nightmare."[35] This double-edged writing cuts both ways in order to slice open the ethnic box, refusing to affirm either of the nations or their platitudes, as a more radical Vietnamese American or ethnic literature should. The poet Cathy Park Hong points to how minority poetry faces the exact same problems outlined here for Vietnamese American writers, caught between the mainstream and the avant-garde:

> Mainstream poetry is rather pernicious in awarding quietist minority poets who assuage quasi-white liberal guilt rather than challenge it. They prefer their poets to praise rather than excoriate, to write sanitized, easily understood personal lyrics on family and ancestry rather than make sweeping institutional critiques. But the avant-gardists prefer their poets of color to be quietest as well, paying attention to poems where race—through subject and form—is incidental, preferably invisible, or at the very least, buried.[36]

Hong insists on the inescapable importance of race in poetry. How can an author address that importance? Instead of simply being

caught between two worlds, or reveling in the wondrous fusion of two cultures, as the literary industry typically expects of ethnic literature, what can a more radical literature do?

One way to dispense with the ethnic is to engage in comparison and contrast across borders, illuminating the cross-border operations of power and its abuse, greed and its operations. Another way is to reveal the disturbing universality of a shared inhumanity, rather than only the heartwarming cliché of a shared humanity. Dinh's writing carries out both of these strategies. His voice is abrasive and caustic, and his stereoscopic vision of his two countries is sordid, sad, and suicidal. While ethnic literature often turns to digestible metaphors of food and hybrid cuisine, and if reviewers of ethnic literature often do the same, a reader of Dinh's writing would benefit more from the dirty metaphors of parallel roads—the raucous, lawless streets of Saigon, or the underpasses and sidewalks of America. This is where he finds evidence of the inhumanity of humanity, as recorded in his blog, *Postcards from the End of Amer-*

ica, devoted in his words and photographs to the mundane horror of the American present: the wretched and the poor, the ugly with their bad teeth and unkempt hair, reeking of failure and ignominy, ghost-like because we are both afraid of them and refuse to see them at the same time.[37]

A radical literature that strives against the ethnic can also turn with great passion and righteous indignation to American landscapes populated by refugees and ghosts, where "riot is the language of the unheard," the threatening voice that ethnic literature so often softens.[38] This threatening voice is heard loudly in poet Bao Phi's *Sông I Sing*, where he mixes lyricism with obscenity. His subjects of war, racism, and poverty are obscene, but his other subjects of refugees, people of color, and the working class are deserving of lyrical treatment. In his "refugeography," war delivers the refugee to America, where the refugee will encounter another, if subdued, war on the poor in the inner cities and dead zones of a necropolitical regime.[39] Of Vietnamese refugees rendered homeless once again by Hurricane Katrina, he writes that "It's like this country only allows us one grief at a time. Your people, you had that war thing. That's all you get. Shut. The fuck. Up."[40] His grief and rage are aimed not only outward toward America but inward toward those who have absorbed the racism and class warfare directed at them, internalizing it and siding with the powerful. What happens, then,

When you can no longer tell
if you're liberating yourself through expression
or selling your oppression.[41]

This challenge can be leveled at any ethnic author in America. This author should be rightfully paranoid about being caught in so-called ethnic literature's defining dilemma, which is to talk about only one thing, the one grief that can be possessed, worn, and hawked. While the literary industry sees the ability to tell one's story with one's own voice as a sign of humanity, it is also the mark of inhumanity, as

both the ethnic author and the ethnic story become commodities, sold and sold out.

Can a writer do more than intuit the problems in having a voice and speaking of one's victimization? Trinh T. Minh-ha shows us one way, gesturing at the importance of suspicion (toward authenticity and voice) and solidarity (between women, natives, and others). Linh Dinh and Bao Phi show us another, pointing toward the simultaneity of the human and inhuman. Some other writers who are not Vietnamese provide a third way, invoking Vietnam and sharing their grief and rage, which helps to overcome the oppressor's divide-and-conquer strategy. Here James Baldwin speaks of the Black Panthers, the Viet Cong, and America:

> Nothing more thoroughly reveals the actual intentions of this country, domestically and globally, than the ferocity of the repression, the storm of fire and blood which the Panthers have been forced to undergo merely for declaring themselves as men—men who want 'land, bread, housing, education, clothing, justice, and peace.' The Panthers thus became the native Vietcong, the ghetto became the village in which the Vietcong were hidden, and in the ensuing search and destroy operations, everyone in the village became suspect.[42]

Baldwin neither denies nor bemoans the histories of war and slavery that define the Vietnamese and African Americans in American eyes. He does not simply inhabit the history given to him as a black man. He connects those histories, bringing two different spaces together so that the exercise of American power over there becomes the logical extension of American power over here—the Third World within the First, and vice versa. Victimization is not a lonely experience but is shared, which is a point that Susan Sontag also makes when she criticizes how many victims privilege their suffering: "victims are interested in the representation of their own sufferings. But they want the suffering to be seen as unique."[43] Even more, "it is

intolerable to have one's own suffering twinned with anybody else's."[44] Sontag and Baldwin agree that victimization must be seen as more than an isolated or unique experience. Suffering can become solidarity through political consciousness and simultaneous revolution, the only ways for the natives over there and over here to confront the global force of the American war machine. First the natives of a particular place must learn that they are not the only ones victimized, that there are others who share their grief; then they have to stop identifying themselves as only victims.

So it is that Baldwin insists that war occurs not only on foreign soil, waged by soldiers against the enemy or villagers, but also on American soil, carried out by the police against blacks. Oscar Zeta Acosta makes the same charge on behalf of Chicanos when he says that "We are the Viet Cong of America. Tooner Flats is Mylai.... The Poverty Program of Johnson, the Welfare of Roosevelt, Truman, Eisenhower and Kennedy, the New Deal and the Old Deal, the New Frontier as well as Nixon's American Revolution ... these are further embellishments of the government's pacification program."[45] To be poor and black or Chicano was to suffer from a low-intensity counterinsurgency that occasionally erupted into all-out assault, as happened to the Panthers, who the state needed to put down because the Panthers had ceased to see themselves as only being victims and began to see themselves as revolutionaries. Writer Junot Díaz agrees that war, and the interpenetration of foreign wars and domestic tragedies, is central to American life:

Where in coñazo do you think the so-called Curse of the Kennedys comes from? How about Vietnam? Why to think the greatest power in the world lost its first war to a Third World country like Vietnam? It might interest you that just as the U.S. was ramping up its involvement in Vietnam, LBJ launched an illegal invasion of the Dominican Republic (April 28, 1965). (Santo Domingo was Iraq before Iraq was Iraq). A smashing

military success for the U.S., and many of the same units and intelligence teams that took part in the 'democratization' of Santo Domingo were immediately shipped off to Saigon.[46]

In this footnote from his novel *The Brief Wondrous Life of Oscar Wao*, Díaz tells us that Americans have a bad habit of invading other countries. American memory may forget the invasion of his country, but that should not prevent us from seeing that the invasion of Vietnam (as some Vietnamese see it) was not an aberration. At least the Vietnam War has a name, an identity; confronted with how the invasion of the Dominican Republic has no proper name, Díaz, like all artists who look at war, engages in memorialization. He tells his readers that his Dominican characters live on American soil because war brought them here, the human blowback of American intervention. When we remember the wars that forced people to flee, oftentimes into the embrace of their colonizer or invader, then we can see that the immigrant story, staple of American culture, must actually be understood, in many cases, as a war story.

What the immigrant story supposedly registers is the difficult but ultimately rewarding struggle to become American, a transformation from wretchedness to righteousness, from victimization to voice. The mythical power of the immigrant story intoxicates. Even when the immigrant speaks explicitly of war as the origin of their Americanization, like Díaz and many others, many Americans hear them as speaking about the travails of being a new American and the horrors of the Old World. While not all war stories involve immigrants, and while war stories do not scar all immigrants, a vast territory exists where war story and immigrant story overlap. Segregating immigrant story from war story cools the seething histories of strangers who carry troubling memories of American wars, creating in their place narratives filled with damage, wound, and identity. Readers and writers often imagine damage, wound, and identity as the results of cultural conflict, being torn between two

worlds, rather than what they often are, the calamitous consequences of war, colonization, and exploitation, conducted by foreign forces and domestic tyrants. The conventional immigrant story warms the heart, but the story of the immigrant as the collateral damage of American warfare warrants anger as much as tears.

The writer who is marked as ethnic or racial, who is categorized and looked down on for engaging in "identity politics," must not simply accept or deny that pejorative. To do so is to be forced into accepting the impossible choice that a dominant society built on whiteness gives to its minorities: be a victim or have a voice, accept one's lesser identity or strive to have no identity. To have no identity at all is the privilege of whiteness, which is the identity that pretends not to have an identity, that denies how it is tied to capitalism, to race, and to war. Inasmuch as victimization and voice are the particular and inevitable forms of alienation for minorities, so is whiteness the form of alienation for white people. Victimization and voice become the markers of difference and identity for minorities, while whiteness becomes unmarked alienation, manifest in the supposedly universal experiences of loneliness, divorce, ennui, and anomie, all of which are the cancerous costs of living in a capitalist society whose profits also accrue to whiteness. If it is true that identity politics is navel-gazing, then so is the whiteness of white people and the self-absorption of those in power. This whiteness and this power remains unchallenged by the kind of minority identity politics that does not call out the identity politics of whites or speak truth to the power of the war machine. Minorities must dissent from the terms that a regime of whiteness offers. They must call forth anger and rage, demand solidarity and revolution, critique whiteness, domination, power, and all the faces of the war machine. Southeast Asians must insist that the war that defines them in America is not only their war, but a war made by white people, a war that is not an aberration but a manifestation of a war machine that would prefer refugees to think of their stories as immigrant stories.

Even as a child, I always knew, however dimly, that the stories of my parents were not just immigrant stories but war stories. Some soldiers suffered more than my parents did, but my parents suffered more than many soldiers who served at the rear. These rear-echelon soldiers were never shot at or actually shot, threatened with a grenade, forced to flee, losing nearly everything, separated from their loved ones for decades, as happened to my parents and so many other refugees and civilians. Their stories needed to be told, but I always hesitated about telling them. "Terrible, terrible things," my mother said, having told me some things, refusing to tell me others. "Haven't you said enough?" my father said to her. I always wondered what was passed over in silence. I want to know and I also do not want to know, but the absent presence of the secret is enough, the secret that is theirs, not mine. Neither do I know the worlds evoked in those black-and-white photographs that arrived in the mail and sat on the mantel of my childhood home. These are the worlds where victims can be victimizers, where ghosts can be guilty, and where survivors can be inhuman. I could steal the stories of those victims, ghosts, and survivors, or make them up. But speaking for others is a simple and insufficient notion. Voice and humanity and victimization are not enough to fully comprehend what happened back then, over there. The aporia of the past always remains, the absence that I can neither know nor share, the silence that resists my speech, the ghosts who refuse resurrection. I would risk the substitute's fate if I told only the part of the ghost's story that humanizes its inhumanity. Ghosts are both inhuman and human and their appearance tells us that we are, too. To understand our fate and theirs, we must do more than tell ghost stories. We must also tell the war stories that made ghosts and made us ghosts, the war stories that brought us here.

8

On True War Stories

WHAT IS A WAR STORY, AND WHAT makes a good one? The question concerns both the content of a war story and how it is told, the former easier to address than the latter. Both comprise what we think of as aesthetics, or the problem of beauty and its interpretation, which is rendered even more challenging when considered in relation to war. On the one hand, the artist must convey both war's seductions, the beauty to be found in parades, uniforms, medals, explosions, and glory, all the makeup painted on the face of nationalism, which is one of the primary justifications for war in our day. On the other hand, the artist must also address the evisceration of cities, bodies, and ideals, the waste left behind in war's wake. Art's relationship to war is not unique, just extreme, for even the most mundane aspects of life are marked by the simultaneity of beauty and horror, where the intimacies of love and betrayal are observed at close range. To do justice to both the beauty and the horror of war is difficult at the level of both content and form, and yet necessary. It is easier to retreat to the comfort of addressing the content of war stories, and yet if one speaks of doing justice in

remembering war, one might also agree that such justice is found in the form of the artwork as well.

To begin with content, many people in many places think of soldiers and shooting when they think of war stories, but that is too narrow a definition. "Good" war stories that pump us up, get the blood going, that tell the "truth" about war through spectacular battles and sacrificial soldiers, also affirm the necessity of war. This limited way of thinking about war stories is one of the reasons why antiwar movies are often not actually against war. They continually place at their center the soldier, and her or his validation, as hero or as antihero, persuades even some reluctant viewers to be resigned to war. They submit to the passive-aggressive demand to "support our troops" if they oppose the war, for what ingrate would not affirm these patriots? But in providing solace to the soldier, we give license to the politicians, the generals, and the weapons-makers to continue their deceptive and cynical rhetoric of supporting the troops. This rhetoric is deceptive because what it really permits is continual war-making. It is cynical because the troops often are not supported when they come home, unprotected or inadequately protected from depression, trauma, homelessness, illness, or suicide. A true war story should tell not only of the soldier but also what happened to her or him after war's end. A true war story should also tell of the civilian, the refugee, the enemy, and, most importantly, the war machine that encompasses them all. But when war stories deal with the mundane aspects of war, some may see them as "boring" or simply not even about "war." These conventional perceptions of war stories blind us to war's extensive nature, for these perceptions divide the heroic soldiers who seem to be the primary agents of war from the citizens who actually make war happen and who suffer its consequences.

Exposing the war machine fundamentally challenges these identities of soldiers, citizens, and wars. This kind of war story acknowl-

edges how war exercises the entire body politic, the squeezing of the trigger hardly possible if the rest of the body was not involved, all of its organs and parts working in conjunction with mind, memory, imagination, and fantasy. Maxine Hong Kingston renders vividly the reality that the soldier cannot fight without the support of the entire nation in her story "The Brother in Vietnam," from her book *China Men*:

> Whenever we ate a candy bar, when we drank grape juice, bought bread (ITT makes Wonder bread), wrapped food in plastic, made a phone call, put money in the bank, cleaned the oven, washed with soap, turned on the electricity, refrigerated food, cooked it, ran a computer, drove a car, rode an airplane, sprayed with insecticide, we were supporting the corporations that made tanks and bombers, napalm, defoliants, and bombs. For the carpet bombing.[1]

From carpets to carpet bombing, war is woven into society's fabric. It is almost impossible for a citizen not to be complicit, not to find war underfoot at home or hidden behind the curtains, as artist Martha Rosler showed in her photomontage of an American housewife pulling back the drapes to reveal the war happening right outside her window, the one that she sees and yet refuses to see while she vacuums her curtains. Thinking of war as an isolated action carried out by soldiers transforms the soldier into the face and body of war, when in truth he is only its appendage. If we do not recognize the reality of war, we are as blind to it as the housewife.

Imagining war only through the soldier's point of view paradoxically may not lead to a true war story, despite what author Tim O'Brien argues in "How to Tell a True War Story," a chapter from *The Things They Carried*, one of the war's literary classics. The narrator of this book of fiction, also called Tim O'Brien, outlines the features of the true war story:

War is hell, but that's not the half of it, because war is mystery and terror and adventure and courage and discovery and holiness and pity and despair and longing and love. War is nasty; war is fun. War is thrilling; war is drudgery. War makes you a man; war makes you dead. The truths are contradictory.[2]

O'Brien does not mention that war is profitable, even if it is also costly. This is one of the truest things that a war story can tell, since profit is one of the most important reasons humanity keeps fighting inhuman wars. To understand this aspect of war, one must look at it from the highest vantage point possible, as the superpowers well understand with their desire to conquer air and space. One must see with satellite vision that can show the operation of massive war machines, not just the limited vision of a grunt for whom the tank may be the biggest war machine. That grunt can tell a good story, and it may be a true war story, but it is a story that could be limited. He or she might see as far as the horizon, but war machines can see

beyond the horizon, and so must anyone who wants to tell a true war story. Ethics is optics, Levinas says, but war is optics, too, as Virilio argued. Telling a true war story requires the right kind of panoramic optics, an ethical one and an aesthetic one that allows us to see everyone and everything involved in war.

While much of what O'Brien describes is also true for some civilian experiences of war, we generally do not associate civilians with war stories. There is not much fun or thrill in being a civilian involuntarily caught in war (although if one is a civilian who volunteers for war, as diplomat, journalist, contractor, aid worker, and so on, then that is a different story that can be akin to the soldier's war story). For many spectators and readers, war stories must at least be fun and thrilling, even as they try to communicate the obligatory sentiment that war is hell. These good war stories lead boys and girls to dream of being soldiers, but no one dreams of war's costs, or of being a civilian caught in a war, an orphan, a widow, or a refugee. Children playing soldier may fantasize about glorious death, but probably not dismemberment, amputation, shellshock, inexplicable and debilitating illness, homelessness, psychosis, or suicide, all of which are not unusual experiences for soldiers and veterans. And does anyone fantasize about being raped by marauding soldiers, which is an inevitable consequence of war? If war makes you a man, does rape make you a woman?

Rape is another horizon of war memory for many, even if it is one of the truest war stories ever. The first time one human tribe inflicted murder on another human tribe, rape very likely accompanied it. Rape is an inevitable expression of the collective masculine desire that drives men to war, for while not all soldiers are rapists every army rapes. Despite the endemic nature of rape in war, few would enshrine rape in those many sterile memorials dedicated to victorious war. There is no honor to being a rapist and there is neither glory nor fun to being raped, and so memorials to rape victims are rare. (Nanjing's memorial to the rape of the city and its women by

the Japanese army in World War II stands out as an exceptional example.) Nations are more likely to acknowledge the murders their soldiers commit than the rapes soldiers have done. Rape is embarrassing, the most extreme revelation of war as an erotic experience, a turn on, a way of getting off, nasty and fun. Rape is one of war's most unspeakable consequences, denied in the heartwarming images of soldiers being sent to war or greeted on their return by faithful wives and adorable children.

As the scholar Judith Herman notes, rape and sexual trauma are as damaging to its victims as the experiences of combat, but while soldiers are at least honored for their sacrifice, no such succor is granted to the women these husbands, brothers, and sons raped. The experiences of men raped by men are even more invisible and inaudible, anomalous to the entire notion of war as a rite of heterosexual passage. Rape destroys any lingering ideas of heroism, masculinity, and patriotism, those oily notions that keep the gears of the war machine running smoothly. Phung Thi Le Ly narrates this true war story from the perspective of a girl recruited at a young age to work for the Viet Cong, unjustly convicted of betraying them, and then raped by two of them as punishment. "The war—these men—had finally ground me down to oneness with the soil, from which I could no longer be distinguished."[3] At this point, she had already been imprisoned and tortured by her rapists' enemies, the South Vietnamese and Americans. Caught in between these opposing forces, she realizes that soldiers and men of all sides "had finally found the perfect enemy: a terrified peasant girl who would endlessly and stupidly consent to be their victim as all Vietnam's peasants had consented to be victims, from creation to the end of time!"[4] To make sense of what happens to her, she cowrites her memoir under the name Le Ly Hayslip. Her kind of true war story, focused on women, children, peasants, and victims, as well as the unraveling trauma of rape, is the exceptional true war story that forces readers to contemplate the scenario of being raped and living to tell about it.

In the more typical true war story, the reader does not see himself as enduring being killed or raped, only being the witness to such acts, which itself may be an awful experience. Tim O'Brien's stories are closer to this rule, an antiwar true war story that nevertheless can be assimilated into a reader's patriotic, masculine imagination. A scene is repeated again and again: a mine blows a soldier into a tree, leaving his guts hanging from the branches for his comrades to retrieve—horrible, but expected, for this is war. In returning to this scene, O'Brien follows the logic of the ghost story laid down by Hayslip. She writes that "the teller must always specify how the victim died, usually in great detail. . . . Because the manner of death influences each person's life among the spirits, the teller cannot leave out any detail, especially if the death had been sudden and violent."[5] The reader sees herself or himself as the soldier watching this happen, the survivor, not as the soldier who has been dismembered, liquefied, and turned into a ghost, if the writer or the reader believes in ghosts. The reader does not identify with those who die, the ghosts, because then the story would end, unless one tells ghost stories. In the type of true war story that is not a ghost story, the soldier who tells the story lives on, perhaps to suffer, but still alive to bear witness. This type of war story, the most common one in America and elsewhere, is bracketed by the extremes of rape versus banality, the erotic drive of the war machine versus its bland ideological face.

Both exist at the fringes of war memory, for as difficult as rape is to imagine or remember, banality is too boring to be recalled. Most Americans who served in the military during the war never saw combat, serving on ships, guarding bases, delivering supplies, pushing paper, condemned as "rear echelon motherfuckers" in the rich lingo of the combat troops. The epithet is meant to satirize their cowardice and privilege, and perhaps the envy of the combat troops, but something else lurks in the obscenity—the dim realization that contemporary war is a bureaucratic and capitalistic enterprise that

requires its bored clerks, soulless administrators, ignorant taxpayers, contradictory priests, and encouraging families. If we understood that a war machine is a pervasive system of complicity that requires not only its front line troops but also its extensive network of logistical, emotional, and ideological support, then we would understand that all the politicians and civilians who cheer the war effort or simply go along with it are, one and all, rear echelon motherfuckers, including, perhaps, myself.

The obsidian myth of the heroic warrior allows rear echelon motherfuckers to see themselves as red-blooded patriots from the heartland. That myth took a near-fatal wound during the war for Americans, who tried to repair it by turning soldiers who were not seen as heroic warriors into wounded warriors. But soldiers are not warriors in the mythic sense, where every able-bodied man had a spear or battle-axe in his home, ready for the call to arms. Instead the rank-and-file soldier is a manifestation of the modern era, faceless, anonymous, at once an individual and a part of a mass, representing the entire nation. A true war story must not be only about what happens to combat soldiers and their guts, but also about the nation and its guts, about running one's refrigerator, which might use a refrigerant made by Dow Chemical, the company that manufactured Agent Orange. This herbicide debilitated thousands of American soldiers and their progeny, as the U.S. government admitted, and also thousands of Vietnamese and their offspring, as the U.S. government will not admit. The quotidian story about opening one's refrigerator and peering into its guts, stuffed with the plastic-packaged wonders of capitalist life, is just as true as and arguably more unsettling than the blood and guts story of throbbing disembowelment. The quotidian reminds us that war's obscenity lies not only in broken bodies but also in the complicity of the citizenry. Under what might be called compulsory militarism, even those who oppose war still end up paying its costs, for while everyone can intellectually understand that war is hell, few can resist owning the

refrigerator. This complete domestication of war is part of war's identity, in the same way that some family, somewhere, has nurtured every rapist. We are all witnesses to banality and complicity, which is why we do not wish to recall them.

I am most interested in the kinds of true war stories and war memories capacious enough to include the blood and guts as well as the boring and the quotidian. True war stories acknowledge war's true identity, which is that while war is hell, war is normal, too. War is both inhuman and human, as are its participants. Photographer Tod Papageorge's *American Sports, 1970: Or How We Spent the War in Vietnam* portrays war in exactly this fashion. The book features seventy photographs, all but one capturing American sporting events: the players and the fans, the press conferences and the team buses, the dugouts and the locker rooms, with the participants being men, women, young, old, black, white, ugly, beautiful. The last photograph is the one that does not depict a sporting event or its participants. It is of the War Memorial in Indianapolis, with these

words on the facing page: "In 1970, 4,221 American troops were killed in Vietnam." This is horror as an appendix to the banal, which is how many civilians experience war. Papageorge suggests that even as American soldiers die abroad, life continues at home, an experience repeated decades later with America's wars in the Middle East, which often hardly feel like wars at all in the United States. While O'Brien's stories may be true war stories from a sol-dier's point of view, Papageorge's photos are true war stories from a civilian's point of view. The spectacular gore of a certain kind of true war story distracts us from the dull hum of the war machine in which we live, a massive mechanism greased with banalities, bolted together by triviality, and enabled by passive consent. To tell and hear these kinds of banal and boring true war stories is necessary for what philosopher William James called "the war against war."[6] So far as we imagine wars to be dangerous (but thrilling), wars will not end. Perhaps when we see how boring wars actually are, how war seeps into everyday life, then we might want to imagine stop-ping wars. The citizenry can end war at any time by refusing to go along with it, which is no easy matter—perhaps even utopia itself, versus the passive consent to the contemporary global dystopia of perpetual war.

If American war stories favor frontline vividness, for many South-east Asians, wherever they happen to be, true war stories are both vivid and banal, since the war was fought on their territory, in their cities, on their farms, within their own families. For some readers or viewers, these kinds of true war stories are not "good" war sto-ries because they lack the vicarious thrill found in stories about soldiers killing and being killed. Simply by their content, true war stories about civilians and banalities are, for some, boring and hence forgettable. This is true for large numbers of Southeast Asians, many of whom were born after war's end and are impatient with their elders' stories. But for many who lived through the war, its memory remains as bright as a magnesium flare, illuminating darkness and

signaling danger. For those Southeast Asians cast overseas as losers, the need to remember their war stories is even more urgent. They sense that the war may be forgotten, or narrated differently than the way they remember. The genre of the true war story as told by (white) Americans frustrates them. Artist Dinh Q. Lê speaks eloquently of this frustration when he discusses his series *From Vietnam to Hollywood*, which

> is drawn from the merging of my personal memories, media-influenced memories, and Hollywood-fabricated memories to create a surreal landscape memory that is neither fact nor fiction. At the same time I want the series to talk about the struggle for control of meaning and memories of the Vietnam War between these three different sources of memories. I think my concepts of what constitutes memory have changed over the years, from thinking of memory as something concrete to something so malleable. But the one concept I still hold on to is that, because Hollywood and the U.S. media are constantly trying to displace and destroy our memories about the Vietnam War to replace it with their versions, I must keep fighting to keep the meanings of these memories alive.[7]

These memories range from the horrific to the reassuring, the aesthetic spectrum for the war stories of Southeast Asians whether in their countries of origin or in their adopted countries. On the horrific end, the most powerful scene from Ham Tran's epic film *Journey from the Fall* illustrates something that O'Brien gestures at. In O'Brien's stories, the job of the living—at least the living writer—is this: "We kept the dead alive with stories."[8] But what if the living are already dead, and the dead are somehow alive? *Journey from the Fall* examines this convergence of living and dead through the war's impact on one family after the fall of Saigon. After the husband is sent to reeducation for having been a soldier in the southern army, his mother, wife, and son flee as boat people. In a marginal

American neighborhood, they suffer their losses in isolation from Americans and from each other, traumatized by the loss of country and patriarch, as well as the sufferings endured on the boat, which include rape. When the young son accuses his mother of forgetting the father, treating him as if he were dead, she says

> Do you know what I've been through to be with this family today? Do you think your mother is still alive? She's dead already. Dead already! I died the day they took your father. I died again out on that ocean, Lai. This person you call your mother is nothing but a corpse, living only to take care of you. But your real mother is already dead, son. I hope you know. She's dead, son.

Tears do not come to my eyes often, but they did for this scene, the mother weeping at her confession, the son weeping at the revelation. This domestic scene set in a prosaic living room dramatizes war's dreadful cost for civilians, women, refugees, children, and, ultimately, all those people in living rooms who think they are not at war when their country is at war.

The mother's speech reveals that beneath the façade of the human lurks the inhuman, the undead among us and within us, which Westerners typically only confront through watching stories of the undead in zombie movies and television shows. As philosopher Slavoj Žižek says, "the 'undead' are neither alive nor dead, they are precisely the monstrous 'living dead.'"[9] Among the refugees, some are the living dead. If one wants sociological evidence, look at how 62 to 92 percent of Cambodian refugees in America endure post-traumatic stress disorder, or how some of them suffer from a science fictional illness called hysterical blindness, where, for no apparent medical reason, those afflicted cannot see, or how some Hmong refugees, healthy by all appearances, and of youthful age, go to sleep and never wake up, their black hair turned white overnight.[10] What has traumatized, blinded, or killed these people? Memories.

What turns people into zombies? Memories. Because these people might be infectious and threatening, Americans may wish to quarantine their memories and war stories, their tales of being the living dead, which remind us that the inhuman is present within us. As Žižek tells us, there is a difference between not being human, which is "external to humanity, animal or divine," and being inhuman, "which, although it negates what we understand as humanity, is inherent to being human."[11] Riffing on Žižek's insights, critic Juliana Chang says inhuman "implies dread and horror not only because we find it strange but also because we find it overly proximate . . . the inhuman is the alien that permeates the human, and the human that finds itself alien."[12] This human, xenophobic fear of the alien and the refugee is based not on how they are unlike us, but on how they are too much like us. Not only is their condition something for which we might have some responsibility, but their wretchedness might become ours if something catastrophic happens to us. Even more, as Papageorge's photos imply, isn't there something inhuman and monstrous about carrying on our daily business—indeed, in enjoying ourselves—while people die because of our war machine? Do we look that different from zombies in our pursuit of oblivious pleasure? If the victims of a war machine made zombie movies, wouldn't they cast themselves as the humans and the war machine's soldiers and citizens as the zombies? Can the war machine's soldiers and citizens see themselves as zombies, as inhuman? In short, do we who think we are human know that we are also inhuman?

At least some refugees know they are inhuman, the living dead, and perhaps some soldiers do as well, like novelist Larry Heinemann, the war veteran whose novel *Close Quarters* scarred me at so young an age. He wrote the even more troubling *Paco's Story* about a disabled veteran who is the burned, scarred, sole survivor of a company that is wiped out in a massive battle with the Viet Cong. Paco is a drifter who comes into a typical American small town whose citizens look down on him. These are the same people

who shouted their support for their troops. The reader's sympathies are with Paco until near the end, when he remembers the brutal gang-rape his company inflicted on a captured Viet Cong sniper, a girl of fourteen or sixteen years, who killed two Americans. Each of the soldiers line up for their turn to rape her, and when they are done, one of them executes the girl with a bullet to her head. Shortly after the gang-rape, Paco wounds another Viet Cong with a grenade, and then finishes the kill with a knife. The soldier pleads with Paco not to kill him, to no avail. "I am dead already," the man says, right before he dies.[13] Heinemann describes both scenes in excruciating detail, setting the stage for what happens next, Paco reading the diary of a young woman, his neighbor. She has written down her fantasies about making love to Paco, until the moment she imagines his scars touching her. "And then I woke up. I just shuddered. . . . It made my skin crawl."[14] By the next page, the novel is over. Paco leaves this typical American town to drift again. He cannot stand what we witnessed, his forced recognition of his inhumanity, his skin-crawling monstrosity, himself as alien. He removes himself but small town America has already cast him out, sensing the dis-ease he carries after having fought a dirty war in small town America's clean name.

True war stories insist on this dreadful knowledge of the inhumanity that exists within the human, and the humanity of those who appear inhuman. But this is a hard tale to recount, especially for tellers of true war stories dealing with women, children, refugees, and banalities, in particular the banality of inhumanity. Unlike soldiers turned artists, these tellers have a heavy burden to bear in challenging the identity of the conventional war story and insisting that a war story is about many different things and people, not solely soldiers. Recasting war's dramatis personae faces resistance from audiences who believe that war stories are about soldiers, men, machines, and killing. These tellers also struggle, like all other artists, with the judgment of their critics. These criticisms, while sub-

jective, are often pronounced in objective ways, as when the glossy magazine *Entertainment Weekly* gave a B+ to Kao Kalia Yang's *The Latehomecomer*. This is a good grade, but neither great nor perfect, two rungs below the top grade of an A in the American system.[15] At an artist's talk, the author brought up this matter of grading and I made a note of it, for the judgment clearly bothered her.[16] I sympathize, and yet this is how aesthetic judgment often works, albeit not usually in such a blunt way that reveals how aesthetic judgment is similar to the classroom judgment that many artists also exercise in their function as teachers. Ironically, the professor and authority figure who objectively grades her or his students with blithe confidence may suddenly feel, on being evaluated in less than stellar ways by students, deans, peers, and critics, that these assessments are rather subjective.

Suddenly the person who professionally judges becomes aware that a grade brings with it unknown prejudices of personal and aesthetic kinds on the part of the critic. But writers and artists always render judgment, ruthlessly, on their own work as well as on the work of others, if not always in public. How else does one improve one's art if one cannot judge in the most basic ways, especially in comparison to what one wishes to achieve in one's own creation? What is crucial to admit is that this aesthetic judgment is an expression of identity, deeply subjective and perhaps flawed, yet always necessary. Recognizing this, some critics shy away from judging a work's beauty in favor of considering how a work functions in certain contexts. Context is especially important when it comes to looking at minorities, women, the poor, the working class, the colonized, anyone whose art has often been deemed as inferior by authority figures, who in the West are usually white and usually men, but also sometimes women. These authority figures favor the stories of soldiers and men over those who seem only to be war's bystanders. Because they are powerful, these critics can deny how their identities shape their judgments, even as they insist that the less

powerful usually do not transcend their identities. These critics practice the unacknowledged identity politics of their profession when their judgments are delivered as objective, rather than being what they are: subjective expressions of institutionalized power, with the critic being a part of an entire system of art- and taste-making that begins in the schools, extends into the professionalized worlds of art, and incorporates both artist and critic.

Those critics who do not admit to their biases, to the way their tastes have been shaped by their worlds and their aesthetic industries, are being unethical. A stinging rebuke to unethical criticism is given by, not surprisingly, a writer, Nguyen Huy Thiep, the foremost short story writer in Vietnam of the 1980s and 1990s. His short story, "Cun," from his classic collection *The General Retires*, features a writer and his good friend, the literary critic K. The writer tells us that K. "demands high standards in what he calls the character of a person. Hard work, sacrifice, dedication, sincerity, and, of course, good grammar are the qualities he requires"; "he understands our literary debates well (which I must confess I don't)."[17] K. tells the writer that K.'s father, the Cun of the story's title, only wanted to be a human being throughout his short life, but failed. Intrigued by this cryptic fragment, the writer weaves a grotesque story, set during the Japanese-induced famine of 1944 that killed about one million people in the north, a time, my mother tells me, when she found people dead of starvation on her childhood doorstep. This story concerns the child beggar Cun, cursed by a "hydrocephalic head and soft, seemingly boneless limbs."[18] He drags himself on the ground everywhere, but his beautiful face makes him a compelling beggar. Despite his body's inhuman ugliness, Cun is the only human person on his street of able-bodied people, all of whom behave inhumanely. Then Cun becomes wealthy through a windfall inheritance. A beautiful but destitute neighbor persuades Cun to give her his wealth in exchange for one sexual encounter, which is the only happy moment of his life. An illness kills Cun, but he lives just long enough to

see her birth his child. This child is the literary critic K.,
course, appalled by the writer's story, which he considers a
tion. To prove what really happened, the critic shows a photo o
father, "a big fat man wearing a black silk shirt with a starched
collar. He also wore a neatly trimmed moustache and was smiling
at me."[19]

The critic is the authority figure, the comfortable representative
of the literary establishment, which is also, in Vietnam, part of the
political establishment. His judgments on literature cannot be sepa-
rated from his identity as a functionary of a regime that views
literature as potentially dangerous to its own authority. More than
that, he is a bad critic because he cannot bear to be confronted with
criticism, especially criticism that questions his identity. In response
to the story that mocks his heritage, the critic naively turns to a
photograph to show that his father was in fact human, not inhuman,
though this contradicts what he himself suggested previously.[20] But
as Papageorge's photos show, realistic photographs of human beings
doing banal acts can just as readily be evidence of their inhumanity,
their indifference to the things done in their name. The critic's reac-
tion is not just a breakdown of ethical standards but the fullest
expression of his hypocritical aesthetic of propriety. He is so fo-
cused on his father's humanity, and hence his own, that he cannot
even discuss the child beggar, the main character of the story. The
child beggar might be an embodiment of the dehumanized poor, or
perhaps a reference to the inhuman horrors that Agent Orange cre-
ated, or more simply one person whose tragedy is overlooked by the
humans who see him and yet do not see him, including the critic.

It is fairly easy to imagine Western critics in a parallel vein, seeing
through their own supposedly objective, humanistic standards and
yet subjectively blind to the inhumanity in front of them. A verti-
cally integrated system of aesthetic education and reward reinforces
their standards, beginning in the earliest years of schooling and
ending at the rarefied heights of universities, academies, organs of

g bodies. In America, this world typically
st, consumerist, and alienated values and
iety. Capitalism privileges the individual
wield her or his art in ways considered
the tastemakers, those people who, like
ely question how their identities as critics
eauty, and goodness are intertwined with
their dominant class. They do not see that
their aesthetic values, which they understand to be evidence of their humanity, are tainted and shaped by the inhumanity of the capitalist system and the war machine within which they live and whose profits and costs they take for granted.

As critic Pankaj Mishra says, Westerners, including Western writers, routinely expect non-Western writers to decry the oppressive regimes under which they suffer. Not to protest seems like moral failure to Western writers. These same writers often do not work up the same aesthetic outrage toward their own society's crimes via a "selective humanism—blind to the everyday violence of one's own side, and denying full humanity to its victims."[21] These Western writers lack the imagination to see how their drab stories of unhappiness, divorce, cancer, etc.—the very stuff of award-winning realism and the bad outcomes of white privilege *over here*—might be connected to, and made possible by, their society's wars and capitalist exploitation *over there*. Culture, as Edward Said explains, is inseparable from imperialism, which can be read as humanity being inseparable from inhumanity.[22] This selective humanism is, of course, not purely Western but universal, as Mishra is careful to note: "most novelists, in the West as well as the non-West, avoid direct confrontation with powerful institutions and individuals, especially those that not only promise fame and glory to writers but also, crucially, make it possible for them to stay at home and write."[23]

The same charge of selective humanism and complicity with power can be laid against most critics. This is part of the brilliance

of Thiep's story, his insinuation that the punctilious critic's heritage may be inhuman, which is utterly shocking to the critic if not to his Western readers. As outsiders to communism, Westerners can easily see its hypocrisies and blind spots, the inhumanity at the heart of its ideology. The rebellious writer in Vietnam faces a system of power, prestige, and taste that defines what is acceptable and what is human or inhuman. The Westerner demands a heroic response! But what is obvious about Western values, when seen from the outside, is that they too reinforce propriety. This propriety prefers to deny the inhuman, the colonialism, imperialism, domination, warfare, and savagery found in the heart of whiteness. When this inhumanity is acknowledged, its connection to, and contamination of, Western humanity is often suppressed or disavowed by artists, readers, and critics who are blind to their own hypocrisies and contradictions, their participation in inhumanity, their own lack of heroism when confronted with the lures of institutional reward.

Writers new to the West or who are minorities enter a world where their audience is not likely to be aware of its own inhumanity. At the same time these writers may feel the need to prove their own humanity, given that it will be questionable under Western eyes. The *Entertainment Weekly* review of *The Latehomecomer* inadvertently shows this dilemma. Given its emphasis on celebrities and entertainment, this magazine may not be the best venue for literary discussion, but its déclassé nature allows it to display Western values about writing rather bluntly. The entirety of the review is this:

> When your grandmother once outran a tiger, you know perseverance is in your blood. Meet the Yangs, a Hmong family who evaded Pathet Lao soldiers after the Vietnam War by crossing the Mekong River into Thailand, only to float between refugee camps for eight years. They found asylum in Minnesota, but lived on welfare. The toll all of this takes on readers is lightened by Kao Kalia Yang's tranquil descriptions of the cultural

divide—e.g., the smell of green parrot soap compared with Head & Shoulders shampoo—in *The Latehomecomers* [*sic*], a narrative packed with the stuff of life.

Why the book warrants a B+ is never explained, except in the mention of "the toll all of this takes on readers," evidently alleviated by the "stuff of life." The somewhat cryptic comments that accompany the grade are similar to what a college student might get on a midterm paper from an overworked professor. And while a B+ is a good grade, it is little comfort to those clamoring to get into medical or law school, or those striving to enter the MFA program, publish a book, win prizes, and earn recognition. The demands placed on artists by their aesthetic industries differ little from those placed on students. Once graduated, having learned by heart what it means to be graded, artists still strive for perfect grades, manifest in laudatory reviews, rich grants, dazzling awards, and so on. Aesthetic success as being akin to educational success—with the artist as a good student—is shown explicitly in the *Entertainment Weekly* review, as well as in the story *The Latehomecomer* tells. In both cases, making the grade covers up the opposite, the haunting possibility or even past reality of being degraded.

While *The Latehomecomer* is a history of Yang's family and the Hmong people who sided with the United States, it is also a story of how a refugee became a writer. Yang, born in the Ban Vinai refugee camp in Thailand, begins by tracing the history of her family and their struggle to reach a refugee camp across the border of Laos into Thailand. The exodus, by foot, takes four years. Once in the refugee camp, the Yangs are assigned numbers by the United Nations, which requires them to have birthdays. Since these are unknown for some, the Yangs make up dates. "For many of the Hmong," Yang writes, "their lives on paper began on the day the UN registered them as refugees of war."[24] Yang alludes here to how the Hmong did not even have a written language until the 1950s. They were indeed un-

documented, and paperless, until they entered Western bureaucracy. For Yang to write the first book in English by a Hmong author continues the transformation of Hmong people's lives on paper. Her memoir signals that the Hmong have a representative who can speak for them, in all the complicated ways we have already seen:

> For many years, the Hmong inside the little girl fell into silence . . . all the words had been stored inside her. . . . In the books on the American shelves, the young woman noticed how Hmong was not a footnote in the history of the world. . . . The young woman slowly unleashed the flood of Hmong into language, seeking refuge not for a name or a gender, but a people.[25]

The memoir is the documentary evidence of these Hmong refugees being transformed into ambivalent Westerners, of entering into a system that assesses both the weary, terrified refugee who supposedly has no voice and the writer who gives voice to the refugee in a language understood by the West.

Being a writer is one way the refugee sheds her inhumanity—the degraded "toll"—and becomes human, the higher-graded "stuff of life." But this refugee who becomes a writer, who wishes to take the true war story away from those who insist that it belongs to men and soldiers, leaves one fraught territory to enter another one nearly as perilous. In the first instance, as a refugee, what Yang encounters in Ban Vinai is this: "the dominant feature of the camp was the stench of feces. There were toilets, but they were all flooded."[26] Seven years later, the Yang family is finally sent to the Phanat Nikhom Transition Camp to the United States. "The building we were assigned smelled like the toilets that I had dreaded back in Ban Vinai Refugee Camp," Yang recalls. "In fact, it had been used as a bathroom. There was always human waste between the buildings and amid the cement blocks and large rocks throughout the camp."[27] Filth, especially the untreated waste of human excrement, haunts other Hmong accounts of life in the camps, and many stories of other Southeast Asians in

other camps.[28] This is no surprise, since refugees are what philosopher Giorgio Agamben calls "bare life" or "naked life," just alive enough to know they are human, close enough to death to know they are less than human. Confronting one's own waste and the waste of others, living among it, smelling it, stepping in it, confirms for these refugees their inadequate humanity under bureaucratic eyes. Living in shit is a true war story and a traumatizing one. O'Brien conveys some sense of this when he writes about how the soldiers of *The Things They Carried* are ambushed in a "shit field," used by villagers as a toilet. The Indian named Kiowa is killed, or, in GI slang, wasted.[29] Kiowa sinks beneath the shit, waste beneath waste. But awful as it is, the field is a temporary stop for American soldiers who can go home after a year, if they live. For Yang's refugees, the pervasive presence of shit is a part of everyday life that can go on for many years, even decades. That is one crucial difference between a soldier's war story of his terminal tour of duty and a refugee's war story of a possible life sentence.

One difficulty in writing a true war story is the aesthetic challenge of dealing with shit and waste, the unpleasant facts of death, neglect and inhumanity for both soldiers and civilians. One must write about the shit even as one wipes it off one's shoes or feet, making the story aesthetically decent enough to be brought into someone's house. Writing, or spilling one's guts, is thus the second dangerous territory encountered by the refugee who wants to tell a true war story. Writers have to deal with shit if they spill their guts, which includes the figurative shit thrown their way by readers and critics such as myself. By learning to write at all, by learning to write in English, by earning degrees, by publishing, Yang and other Hmong American writers are judged by both the minority community they come from and by their national audience. Ha Jin, a Chinese writer living in America, describes this dilemma as the tension between "the spokesman and the tribe."[30] As Mai Neng Moua, editor of the first Hmong American literary collection, says of the Hmong in the

United States, "this is a community that is very private . . . and may very well be threatened by the writings of its young people."[31] To tell a true war story is thus a risky enterprise, not least of all because it is inevitably a story not only about war and memory but also about identity. This is as true for soldiers as it is for refugees.

A true war story ultimately challenges identity because war radically challenges identity, from the soldier who must confront himself as well as the enemy on the battlefield to the civilian who discovers she is less than human when she becomes a refugee. Blown up, dismembered, wasted bodies on the battlefield also fundamentally disturb human identity for those who killed them, witnessed their demise, or buried them. Those bodies also unsettle national identity when a country divides itself over a controversial war, or when the body politic persuades soldiers to kill others even if in so doing they bring their own humanity into question. The false war story ignores this challenge to humanity by owing its allegiance to war and national identity. The false war story affirms in sentimental, selective, and dishonest ways the idea that "we"—its protagonists and its audience—are human, even though we might be more like chickens clucking our heads over the oh-so-sad loss of life we have just witnessed. A good or great true war story forcefully articulates war's challenge to identity and humanity in content and form, balancing the tension between war's degrading nature and the need to make the grade as a war story.

Perhaps one reason why *The Latehomecomer* might get a good but not great grade is that it does not fully recognize the challenge to identity that it poses. This challenge is found in the transformation from being degraded—of living in shit—to being able to earn a grade, to foreground "the stuff of life." Yang exhibits faith in the power of her story to represent herself and her people, but she does not see the pitfalls of victimization and voice. The refugee who speaks in a language that her adopted national audience can hear faces a dilemma: she is no longer a refugee even as she speaks for

the refugee, and no longer a victim even as she speaks of victimization. Her ability to tell the story to an audience not made of refugees has changed the author's identity. This is why the refugee community may turn against its writers, because it knows its identity is no longer the same as that of the writers. In the West, the refugee writer is an auteur, whereas the community he or she supposedly speaks for is a collective, their condition enforced on them by a general public that cannot hear them even when they do speak.

Since Yang has chosen the form of the written memoir, her identity has been alchemically altered. In leaving the inhuman, degraded world of the refugee camp and its fields of waste behind her, she enters a hallowed world of higher grades where no one says shit, where waste is flushed away behind closed doors, where the aesthetic achieves a certain level of odorless, porcelain refinement. Likewise, a Southeast Asian academic colleague of mine who facetiously (I think) proclaims of having gone from "refugee to bourgeoisie" laughed when I said that I, too, was a refugee. "You don't look like a refugee," my colleague said, no longer joking. And my colleague is right. I no longer have refugee hair or refugee clothing; I no longer have a refugee accent or refugee grammar, if I ever did; I no longer smell like a refugee; and I know better than to do refugee things like talk about money, except in private. I am a Westernized critic, as Yang is Westernized writer, both of us subject to Western standards while also being subject to the standards of our original communities. Like every such writer, she may be unhappy about judgments rendered on her, but the only solution offered from within a world that privileges authorship and the auteur, the accomplishment of the individual in a capitalist society, is to achieve the perfect grade, the A. If one stays within this world, how does one achieve this? What are the standards? Or, as many students have asked their professors: What are you looking for? As a professor, I give the student a rubric by which he or she will be graded. But critics do not provide

checklists of aesthetic criteria by which an artwork is to be assessed, like a car at a tune-up. The critic supposedly knows what is (good and bad) art, just like the judge knows what an obscenity is—when he (or she) sees it. So I refrain from providing criteria for how an artwork gets a perfect grade, since any such criteria are as subjective and mutable as identity itself.

What concerns me is how the experience of an artist who works on a true war story, and who aspires to the perfect grade, itself constitutes another kind of true war story. As O'Brien understands very well in *The Things They Carried*, a true war story is not only about the story itself but is also about how the story is told, heard, and passed on. This is why he creates a character in his book called Tim O'Brien, who shares his name and his occupation as the writer of the book's stories, but who is not the same as the Tim O'Brien in the world. The struggles of the character Tim O'Brien express in a perhaps filtered way the struggles of his creator in both war and storytelling. Self-reflexivity is partly what gives this true war story its kick, its recoil. In a parallel fashion, Kao Kalia Yang's encounter with being graded like a student is as much a true war story as the story in her book. As the soldier faces two rites as ancient as those depicted in *The Iliad* and *The Odyssey*, war and then the journey home, the refugee also goes through those rites, except in an inverted manner. If war makes the surviving soldier a man, a privileged member of his society, it makes some civilians into refugees, the trash of nation-states and war. If the soldier struggles to go home both literally and figuratively, battling external and internal demons, the refugee struggles to find a new home. The soldier typically achieves validation in the epic form of the novel, the memoir, the movie blockbuster, the grandiloquent speeches of kings and presidents. The refugee rarely merits such validation. Hence the burden on Yang's memoir, the grade she has to make, where good is not enough. Good enough is how men or the majority often grudgingly assess women

and minorities, or how the colonizer judges the colonized to be "almost the same but not quite," "almost the same but not white," as the theorist Homi Bhabha says.[32]

Not all soldiers who write make the grade, but soldiers who write can make the grade, as O'Brien does, because the war story belongs to them. The difficult transformation from soldier to writer is not a change in her or his already granted humanity. But for a refugee to become a writer is for the refugee to go from being inhuman to human. While the refugee who becomes a writer is given the license to tell a refugee story, he or she is not seen as writing an actual war story, at least not one that is given the same weight as a soldier's. To get a good or great grade in either respect, as a storyteller of the refugee experience or the true war story, is considerably more difficult for the refugee turned writer. This difficulty is inseparable from the war that created the refugee in the first place and hence created the conditions for grading the refugee turned writer.

The refugee shares this plight of being graded with many of those classified as other: women, minorities, and the colonized. These others may believe in the grading system so much that they grade themselves and find themselves wanting. The specter of the slightly less than perfect grade is particularly haunting and daunting for them. A failing grade might signal rebellion and an alternate world of possibility, of badness, of rejecting the terms forced on a student by the authorities. But a slightly less than perfect grade is the true failure for those who have genuinely tried, for it affirms that they are slightly less than human, slightly less than those doing the grading. So it is that at the beginning of Chang-Rae Lee's first novel *Native Speaker*, a well-known work of (Asian) American literature that foregrounds in its title the role of speech and belonging, the protagonist Henry Park receives a letter from his alienated white wife that calls him a "B+ student of life." This grade is meant to sting. While Henry Park, the son of Korean immigrants, struggles with this grade, I can't help but feel that Lee the novelist also worries about being

given the same grade. In a career marked by deep concerns about war, memory, and identity, Lee has tried mightily to be the perfect student and has garnered his fair share of great grades, including being named a finalist for the Pulitzer Prize for *The Surrendered*, his novel of the Korean War. And yet, as beautifully written as his novels are, there is something of the anxious student in them, the longing for belonging, the evident desire never to write a bad sentence, and indeed always to write the perfect sentence, which sometimes leads to overwritten sentences and lyrical conclusions that may not be earned, as the creative writers say.

But that is just my feeling about Lee's writing. The same things I say of Lee could be said of me as a novelist. Who am I but one of those who may be slightly less than human in the eyes of some, the equally anxious student who cannot help but see himself through the eyes of others, my perception and taste clouded by my own desire for approval? Lee, like Yang and myself, is caught in the struggle to tell the true war story and is in the middle of a true war story: the one about how writers and critics who inherit the legacies of wars find themselves caught between being degraded and given the perfect grade, judged by an aesthetic system implicated in the war machine. This does not mean that artists who struggle to tell true war stories cannot speak or cannot strive for a perfect grade; it does mean that they should question their own identities as artists as well as the identities of the forms they choose, since both these kinds of identities are part and parcel of the triad of war, memory, and identity.

The struggle over how to tell true war stories is about both remembering wars fought elsewhere and conflicts fought here, at home. In communist countries, one usually has to go to war against the state to tell true war stories, since the state is only interested in bad war stories, the dishonest kind that justify war and glorify the state. In America's case, culture wars divided America throughout the twentieth century, their momentum building through the rise

of civil rights, workers' struggles, feminism, gay rights, and queer empowerment, surges of restlessness that came together with the antiwar movement to gain explosive force in the 1960s. These culture wars subsided in the 1970s but returned with ferocity in the 1980s, when defenders of a homogenous America cried out against the barbarians at the gate, those colored hordes who had climbed their way up the hill of civilization to the city of shining light. Kao Kalia Yang and Chang-Rae Lee are among these barbarians, whether they want to be or not, as am I. Reluctantly or fervently, we, the barbarians, are also cultural warriors, demanding to be let in to civilization, haunted by the inhuman wars of that civilization. We, too, wish to tell true war stories, which are impossible to disentangle from the battles we fight to tell those stories.

9

On Powerful Memory

IN AN 1899 ILLUSTRATION OF Rudyard Kipling's poem "The White Man's Burden," Uncle Sam and his British counterpart John Bull climb up a mountain "towards the light" of civilization, each carrying a basket on his back full of "your new-caught sullen peoples / Half devil and half child." Kipling's proimperial paean about the tragic necessity of waging "savage wars of peace" was addressed to Americans, then waging war to subdue the Filipino rebels who thought at first that the United States had come to liberate the Philippines from Spain. Kipling warns Americans of "the hate of those ye guard." And for all the blood and treasure that Americans would expend, he cautions that they will "Watch Sloth and heathen folly / Bring all your hopes to nought."[1] This characterization of the natives certainly describes how many Americans view the people they are supposedly trying to help. A century later, his poem may as well describe my war and its aftermath in our current American wars in the Middle East. All a reader need do is replace the light of civilization with the promise of democracy and freedom, the one that Americans offered to the people of the Middle East after offering it to us. As for those people being carried ever upward, among whom

"THE WHITE MAN'S BURDEN."

I count myself, we remain half devil and half child in much of the American and Western imagination.

If Kipling proved prescient in implying the need for civilizing warfare, at least from the perspective of the civilized, so did his illustrator, Victor Gillam. What he depicts is that we do not descend toward enlightenment, civilization, or God, for that is too easy. We must carry our burden upward, toward peaks rather than valleys, closer to the eternal heavens, the ultimate high ground, which of course we can never reach in this life. I understand this impulse, as well as Kipling's tone of self-satisfied suffering and resignation in describing the savior's pain in saving an ungrateful people. Although I may be half devil and half child, forever ready to nip at the hand of my benefactor and to reject any piety, I have also been baptized and dressed in the clothes of civilization. I know what it means to aspire, to climb, to carry, and to speak and write in the language of my masters. This entire book is an exercise of labor to reach the moment of revelation and inspiration, and ultimately of pub-

lication, which takes place not in the depths where a text cannot be seen but in the bright heights, where God also delivered to Moses the commandments. Perhaps unsurprisingly, I turn to high-minded ideas about ethics to challenge the idea that we need to burden ourselves with war, that war must always be a part of our identity.

But writing this book also involved excavation. My insights, so far as they exist, come not only from achieving some airy plain, or finding respite in a clean, well-lit, and air-conditioned archive, or thinking enlightened thoughts, but from walking and crawling through caves and tunnels where ghosts dwell, or sweating in museums with peeling walls and barred windows, or swearing at the heat and the grime and the vomit and the nauseating toilets and the rough roads and the swindlers and the cheats and the broken finger incurred in Vientiane, which led to infection and two surgeries in two countries. All of this is to say that the high ground, as desirable as it may be to some of us, including myself, is also compromised. From the high ground, we cannot see into the caves and tunnels where the ungrateful and unrepentant and uncivilized hide from our gaze, our armed force, our moral authority. They live to subvert, and to curse. I am not immune, either as the one who curses and who is cursed, or as the one who takes on the authority of calling for ethical behavior. I am among that group of "committed writers," as the critic Trinh T. Minh-ha calls us, "the ones who write both to awaken to the consciousness of their guilt and to give their readers a guilty conscience . . . such a definition naturally places the committed writer on the side of Power."[2] And power, even when carried out with the elevated intention of justice, incites rebellion from those below and suppression from those above.

With this warning about the danger of power and commitment—after all, taken to the extreme, power and commitment justify the greatest of excess, regardless of ideology, from death camps to atom bombs—this final chapter is on the need for a powerful memory to

fight war and find peace. As fraught as engaging with power may be, one must confront it and hope that one can manage it, and oneself, ethically. Our use of power must be done with the full awareness of our own humanity and inhumanity, our capacity for both good and bad. Even those who seek to withdraw from power, to some kind of hermetic or monastic life, must emerge if they seek to change more than themselves. One might be able to climb the mountain toward enlightenment individually, but one cannot change the world without touching on, or being touched by, power. Struggling with power, one might be tempted to see oneself as someone carrying a burden up that mountain. So it is that the story of heading upward as a sign of progress seeps into my narrative as I begin from the low ground and work my way to the high ground.

Both territories are crucial for powerful memory: the low ground forces us to confront our persistent inhumanity, the high ground reminds us of our potential for humanity. Under the cone of utopian light by which this book is written, the high ground is where we need to be, but in the dystopian shadows that surround this light, the low ground is where many of us are now. The power of the low ground was most evident to me on my first visit to the museum of Tuol Sleng, formerly the Khmer Rouge political prison S-21, in the summer of 2010. On the same day, I also made my pilgrimage to the killing fields of Choeung Ek, on the outskirts of Phnom Penh, a typical foreigner's itinerary for a day in the city (most Khmer tourists prefer to visit the beautiful Royal Palace, and who can blame them?).[3] I must specify the time, for the museums and memorials of Southeast Asia transform over the years, much as memory and forgetting themselves do. Museums, memorials, and memories change because their countries change. What is suitable at one moment in time becomes a hindrance, or out of fashion, in another moment. As for me, I too changed, so that my second visit a few years later to Tuol Sleng and Choeung Ek did not impact me as much. I was a

little more hardened, as I was on my second and third trips to the War Remnants Museum in Saigon. My eyes, now habituated, were mostly concerned with taking good photographs. Looking at the same thing twice—even an atrocity—can have that effect.

But that first time, I was still left numb even though I had read about Tuol Sleng and Choeung Ek before visiting, and so knew what to expect. Archivists are sorting through the documents that the security apparatus maintained at S-21, which include the photographs taken of all the inmates on their entry, and other photographs taken of some after death. Many of those black-and-white photographs are arranged in display cases in neat geometrical rows that resemble the layout of photos in American high school yearbooks, except that almost none of these prisoners are smiling, and none are named. A visitor cannot help but look at these faces with knowledge of their doom, and many of those photographed probably had a sense of what was to come. Foreboding thickens the air, but at least the museum is mercifully quiet, most of the time. The tourists speak in low, sometimes nervous voices, for what should one say, exactly, as one walks through interrogation rooms where shackles and bloodstains remain, preserved as visceral proof of the tortures inflicted on so many by teenage guards, some of whom were also fated to have their photograph taken.

And what does one say if one confronts an actual survivor of the prison. Chum Mey emerged from a room in one of the wings and looked exactly as he did in Rithy Panh's disturbing documentary *S-21*, where Mey and the painter Vann Nath, another survivor, returned to the high school that had been turned into a prison. Under the punishing gaze of Panh's camera, Nath confronted several of the prison guards in a dialogue about what they did and who bore responsibility, but Mey was too overcome with emotion to participate. His family died here, and he survived by mere chance. What the scholar Khatharya Um says is true: "The feeling conveyed by

survivors is one of living with 'one body, two lives'—one before, and one after Pol Pot."[4] He wore a short-sleeved red shirt and gray slacks in the film, the same ones he wore when I saw him. His white hair was trimmed short in the same manner. He took me to a narrow brick cell like the one where he had been imprisoned and reenacted how he was shackled and made to use a rusty American ammunition box for a latrine. As my interpreter translated, he described the torture done to him, and he wept as I saw him weep in the film and in the testimony that he offered at the trial of the prison commandant, Duch. Does he weep every time he tells his story to someone like me? I cannot remember now whether I asked for a picture, or whether he offered, but we stood side by side and he embraced my sweaty back with his arm and pulled me tightly to him. I think I smiled—it is not a photograph I care to look at again—because that is what one is supposed to do.

My interpreter drove me on her motorbike to Choeung Ek, where the S-21 guards took prisoners at night, by truck. As one enters the park-like grounds with its green lawns, a majestic stupa is the focal point. Drawing closer to the stupa, one sees behind its glass windows racks and racks of bones and skulls. The empty sockets return one's gaze. These remains serve as both the guardians of this site and its prisoners. If there are ghosts, are they angry that so many strangers trespass on the place of their demise, or are they pleased to be remembered? As for the green lawns, which dip and swell gently, handwritten signs indicate the locations of mass graves, point to the tree where the killers bashed the heads of babies, and inform visitors that bones still emerge from the soil after it rains. Thousands died here, clubbed over the head as they knelt before the open graves, the sounds masked by the hum of a generator. This was not a place I would ever visit at night, without lights. I prefer to take my photos during daylight, as does the monk in the saffron robe who stands at the edge of a swell, framing the scene in his digital camera. The heat

is oppressive. When I return to my hotel, the first thing I do is shower. Then I lay down and the numbness seeped down deep into my mind and body.

I had visited the Dachau concentration camp outside Munich, and while it was a solemn experience, I had not felt as immobilized, exhausted, and shocked, emotionally and physically, as I did in my boutique Phnom Penh hotel. Was it because this history seemed closer to me, in time, in history and in culture? Or was it because by the time I visited Dachau in 1998 the veil of memorialization had already been lowered? The horrors of that place could no longer be seen so immediately, but were instead filtered through a gauze created by the erasure of the visceral, through years of exposure to other people's memories of the Holocaust and its transformation into a mnemonic relic, like Christ's body hanging on a cross in every Catholic church, bloody but remote. It was not that historical detail was absent in Dachau. The degree of detail, and its polish, was much more evident there than at either Tuol Sleng or Choeung Ek. The Germans had processed their history over decades, and with the resources of a wealthy country had built the finest of memorials and museums dedicated to the Holocaust, attuned to Western standards of aesthetics that had become universal by dint of Western power. The archives of photos, from the victims in happier days to the victims in their skeletal phase, were rich in extent, presentation, and captioning. Victims' mementoes, from personal belongings and clothing to even things like locks of hair, were artfully exhibited. The grounds of the concentration camps were manicured, belying the corpses that were once strewn there. This is the work of memory conducted from the higher ground, erected with the power of industrial memory. This work calls for sobriety, contemplation, reflection, for respect and reverence for the dead. It urges us to further our resolve never to allow this atrocity to be forgotten or repeated. But what I also took away from my visits to Germany's memorial network was how horror can be framed in beautiful ways. For many of us, even horror

must be rendered artfully, lest one disrespect the dead or discomfort the living.

What I saw in Tuol Sleng and Choeung Ek; in the killing caves of Battambang; in the small stupas full of skulls and bones that rose here and there on the Cambodian landscape; in the unlit cavern of Tham Phiu in Laos; in the homes near the Plain of Jars that used the casings of American bombs and shells for décor; in the neglected village cemeteries of martyrs and unknown soldiers throughout Vietnam; in the 2003 iteration of Saigon's War Remnants Museum housed in a handful of small buildings and which featured the bottled, deformed fetuses of Agent Orange victims—what I saw was far from beautiful. I saw the poverty of memory found in poor countries, in small places. The typical signs of wealthy memory were absent. There were no vast expanses of marble and granite, no imposing sheets of glass, no precision-cut etchings, no grammatically perfect captions and commentaries in any language. Absent were extensive historical documentation, perfectly shaded lighting, a modulated ambiance of sound, sight, smell, and temperature cossetting one's body and senses. Also missing were fellow well-trained visitors who had already been socialized, like returning churchgoers, into the customs and rituals of silent mnemonic worship. In poor countries, these characteristics of wealthy memory are reversed. As a curator at the Documentation Center of Cambodia told me, referring to the state of affairs at Tuol Sleng and future plans for its renovation, "It could be more beautiful."

If one compares houses of remembrance, from the mansions to the shacks, one gets the sense that the physical environment shapes memory and our feeling of it. Usually, in mnemonic places of poverty, the mood is not one of horror, but of shabbiness and sadness, at least for someone like me, because of what is shown and how. But sometimes one does confront the horror fully, as in the photographs of the dead with their eyes open at Tuol Sleng, or the thankfully blurry photograph of a grisly corpse on a torture bed exhibited in

the same torture chamber where the prison's Vietnamese liberators found it. It is sobering to realize that as horrific as these images are, there was a time when they were not the most graphic. Once there had been a map of Cambodia composed of human skulls—imagine seeing that in person—but now only a picture of the map remains. Just three of the skulls are still displayed, in glass cases, an echo or a foreshadowing of multimillionaire artist Damien Hirst's work of "art" that consists of a platinum skull encrusted with diamonds and real human teeth. Which skull is more profane? Which one more obscene? Which one more unforgettable? Which one more revolting? My answers are predictable. Profligate and obnoxious displays of wealth and consumption, underneath their shiny veneer, are more disgusting than raw and disturbing displays of poverty, even if society as a whole values the glitter more. In a world where the rich buy this kind of art and the poor starve, the diamond-encrusted skull encourages us to forget our complicity. In the most generous reading, however, the very excess of the work of "art" may be nudging us to remember that complicity. Likewise, the sight of people in their death throes, or in rigor mortis, may be unforgettable, or so we hope.

The depressing evidence indicates that we do indeed forget these images, or expect them to come from certain places and to depict certain people whose fate some may feel to be inevitable, marked as they are for death and suffering by dint of their origin. Nevertheless, I defend this shadowy sublime that occurs in small places, in poor countries, on the low ground. These rough, crude, unfinished, imperfect, disturbing examples of a wretched aesthetics will change over time as poor places and poor people become wealthier and less wretched. This can be seen in the Vietnamese Women's Museum of Hanoi, transformed from a provincial space of simply mounted exhibits during my first visit in 2003 into one of the most polished museums in the country by 2013, with the help of French curatorial collaborators who put into place many of the features of wealthy memory. Tuol Sleng, too, is changing, with the assistance of cura-

tors from the stunning Okinawa Prefectural Peace Museum, where Cambodian curators have trained. The museum is one of those very rare places that remembers the dead of all sides, military and civilian, in vast hallways and exhibition rooms and on memorial grounds at the edge of a cliff where the names of all those gone—some two hundred thousand in the battle for Okinawa during World War II, or the Pacific War—are engraved on massive blocks of stone that face the sometimes calm, sometimes turbulent sea, the natural sublime. Who would not want to be remembered in such a way?

Memory in Southeast Asia will change, and people should not be denied their right to the trappings of wealthy memory, just as they should not be denied their right to own cars, refrigerators, luxury handbags, and all those other features of a consumer lifestyle that the wealthy already own, whose price tag is the destruction of the environment, the alienation of human beings from one another, and the perpetuation of a system of global inequality. These seem to be the true cost of producing our goods and desires. But although the poor should not be denied what the wealthy possess, including their industries of memory, we should also be cognizant of what the costs are of the poor repeating the behavior of the rich, no matter where that occurs, including in the realm of memory. For while Tuol Sleng, Choeung Ek, and all the other places of the shadowy sublime disturbed me, they also imprinted themselves on me in ways physical, mental, and spiritual. These places were unrelenting in reminding me, and anyone else who stumbled across them, of inhumanity. They do so not just by telling horrible stories, but also by showing that horror, through the very roughness and bluntness of their wretched aesthetics of memory. This is memory that confronts and exhausts. It is a slap in the face rather than a sermon from the mount.

From low to high, from profane to divine, we need both kinds of memory work. But when do we need each, and in what proportion to the other? Let's turn to some examples of powerful memory

conducted from the high ground to try and answer that question. Le Ly Hayslip stakes her memoir on the moral high ground, speaking from what Paul Ricoeur calls "the height of forgiveness."[5] In her prologue, she condemns the war machine but forgives its soldiers: "If you were an American GI, it was not your fault."[6] Her memoir is framed by this "Dedication to Peace" and an epilogue, the "Song of Enlightenment," whose purpose is "to break the chain of vengeance forever."[7] The memoir offers conciliatory gestures to American soldiers and to the American nation, as when she says that she is "very honored to live in the United States and proud to be a U.S. citizen." But the memoir resolutely places Vietnamese peasants at the center of their own story.[8] "We were what the war was all about,"[9] she writes. "We peasants survived—and still survive today—as both makers and victims of our war."[10] As the filmmaker Rithy Panh does, she claims this war for her people, a direct rebuttal to the persistent American belief that this war was all about Americans. As the people who helped make the war and became its victims, the peasants earned both moral responsibility and the right to forgive. Part of Hayslip's appeal comes from the way she extends forgiveness to everyone in her memoir, which was not something guilty Americans could extend to themselves. While some American veterans, peace activists, and concerned civilians have visited Vietnam to attempt reconciliation with the Vietnamese people or their own pasts, few have used the language of forgiveness to address the Vietnamese. Perhaps they knew they had no standing on the moral high ground to forgive. But as one of the "displaced persons of the American conscience,"[11] Hayslip offers the hope of humanity after recounting many episodes of inhumanity.

Photographer An-My Lê offers another take from the high ground, more clinical than spiritual. The MacArthur Foundation awarded her a grant that carries a prize of over half a million dollars, an amount for one individual that outstrips the budget of many a small museum in a small country. In her series *29 Palms,* she em-

beds herself, in the Orwellian language of the American military and media, with U.S. Marines as they train at a desert base in California. One of the most striking shots, taken at night, shows a squadron of armored vehicles firing their weapons, the barrage of tracers an intense web of lightning and glare through the darkness. Photographed from on high, the armored vehicles assume the size of toy trucks and cars. Lê does not have Hayslip's moral weight of being a victim, of surviving intimate encounters with combat, rape, and torture. Lê cannot forgive, but through her lens, her aesthetic, she assumes another high ground, the related one of vision. Optics concern both war and ethics, and Lê's camera shows both the soldiers and a glimpse of the war machine. While Tod Papageorge shoots the war machine from the civilian's point of view, Lê shoots it from the military's point of view. The individual soldier and his feelings matter less in this photograph and others in Lê's series than the ensemble and the equipment, the war machinery's

collective presence and force. Depersonalized through uniforms, weapons, and armor, these individual humans transform into an inhuman mass seen from on high, the viewpoint of aerial reconnaissance, drones, satellites, and strategic vision. Generals and presidents make decisions based on the movement and placement of these mass units, to which the individual, the human, must be sacrificed. In her photograph, Lê captures the essentially inhuman face of the war machine, which transcends human beings and human bodies into something sublime, something seductive, in its man-made beauty and horror.

To confront the war machine and to tell the true war story, the artist, the activist, and the concerned citizen, or resident, or alien, or victim, must climb to the high ground. This is an ethical and aesthetic move, a double gesture that involves both moral standing and strategic vision. Morally, one must be above the fray in order to renounce and to forgive the bloodletting, as well as to see the (potential) culpability of oneself and one's allies in past, present, and future conflicts. Strategically, one must be able to see a vast landscape if one wants to comprehend the war machine in its totality and its mobility, as well as the war machine's other, the movement for peace. "War can teach us peace," says Hayslip.[12] This task requires, among others, the artist. To imagine and dream beyond being the citizen of a nation, to articulate the yearning for a citizenship of the imagination—that is the artist's calling. To imagine and dream in this manner, one must work for peace as well as confront the war machine. Whereas the war machine wants acts of imagination to focus only on the human face of the soldier, the artist needs to imagine the war machine's totality, collectivity, enormousness, sublimity, and inhumanity. The artist must refuse the identity that the war machine offers through the human soldier, whose dead, sacrificed body, scholar Elaine Scarry argues, persuades the patriotic citizen to identify with the nation.[13] The artist must instead show how the in-

human identity of the war machine incorporates the patriotic citizen and renders her or him inhuman as well.

This is where art plays a crucial role in both antiwar movements and movements for peace, which are not the same. Antiwar movements oppose and react. They can repeat the logic of the war machine, when, for example, antiwar activists treat victims of the war machine solely as victims, taking away the full complexity of their flawed (in)humanity in the name of saving them. When a particular war ends, so may the antiwar movement opposed to it. Understanding that war is not a singular event but a perpetual one mobilizes a peace movement. This movement looks beyond reacting to the war machine's binary logic of us versus them, victim versus victimizer, good versus bad, and even winning versus losing. Perpetual war no longer requires victory in warfare, as what happened in Korea, Vietnam, and now the Middle East shows. Stalemates or outright losses—if not too damaging—can be overcome. The war machine can convert stalemates or losses into lessons for future wars and reasons for further paranoia by the citizenry, both of which justify continuing psychological, cultural, and economic investment in the war machine. While victories would certainly be wonderful, the war machine's primary interest is to justify its existence and growth, which perpetual war serves nicely. An endless war built on a series of proxy wars, small wars, distant wars, drone strikes, covert operations, and the like, means that the war machine need never go out of business or reduce its budget, as even some conservatives admit.[14]

A peace movement is required to confront this inhuman reality. This peace movement is based not on a sentimental, utopian vision of everyone getting along because everyone is human, but on a sober, simultaneous vision that recognizes everyone's unrealized humanity and latent inhumanity. Powerful memory from the low ground presses our noses against this inhumanity in a negative reminder of our capacity for brutality. This memory activates our disgust and

revulsion. Powerful memory from the high ground reminds us positively of a more transcendent humanity that can emerge from looking at our inhuman tendencies. It does so through promoting empathy and compassion, as well as a cosmopolitan orientation toward the world that places imagination above the nation. Empathy, compassion, and cosmopolitanism guarantee nothing, but all are necessary to break the connection between our identity and the war machine. Both Hayslip and Lê value empathy and compassion over politics and ideology. Hayslip empathizes not only with those like her, but extends compassion toward her enemies and her torturers of all sides. She imagines herself as a cosmopolitan citizen of the world, living beyond all artificial boundaries of border and race. Lê immerses herself in the war machine, from those who rehearse and drill for war to those who reenact battles. In a striking photograph from her *Small Wars* series, Lê inserts herself into a scene of American civilians who reenact my war, dressing up with uniforms and weapons from that time. She takes the role of reenactor herself,

playing a Viet Cong sniper aiming her rifle at American soldiers. If one knows the shooter herself is being shot, the picture amuses. But the photograph also reenacts something never recorded by an American camera, an ambush from a Viet Cong perspective. Empathy marks this act of imagination, as Lê sees through the viewpoint of the other to both Americans and to herself, a refugee from the Viet Cong. This empathy underlies the ethics of remembering oneself and others.

In contrast, the war machine requires that one limit empathy and compassion to those just like us, on our side. Those who call themselves political know that the most effective way to mobilize their adherents quickly is to terminate that empathy and compassion for others. The artist who submits to this kind of political demand may create interesting art, but it will be art hampered by an inability to imagine those others that may be most troubling to the artist. For the artist, "politics" may mean choosing a side in life and art, but it also must eventually mean more than choosing a side. The good artist must expand her scope of empathy and compassion to embrace as many and as much as she can, including even the war machine's participants. The genuinely political artist can see across all kinds of borders, beginning with those that separate selves from others. For the artist, politics should ultimately be about abolishing sides, venturing into the no man's land between trenches, borders, and camps. We need an art that celebrates the humanity of all sides and acknowledges the inhumanity of all sides, including our own. We need an art that enacts powerful memory, an art that speaks truth to power even when our side exercises and abuses that power.

For this purpose, the problem is that empathy and compassion are tools, not solutions. They lead to no political, or even moral, certainty, as is the case with empathy's weaker cousin, sympathy. The criticism against sympathy is that it may only compel pity for someone. But it may also breed a sense of shared suffering, and this

fellow feeling may urge us toward action, an urge that empathy may also encourage in its ability to make us identify with, or even as, an other. This empathetic identification may take place through our relationship to works of art, particularly those that explicitly stage or narrate compassion. But while these narratives ask readers to witness scenes of suffering, they may purge readers of the need to take political action.[15] This is why "compassion is an unstable emotion," according to Susan Sontag. "It needs to be translated into action, or it withers."[16] If this is the case, what good is compassion or its related emotions of sympathy and empathy? I advocate for them because they point the way to the high ground, no matter how they might mask more troubling things. The identification with others that arises from compassion often conflicts with our self-interest or instinct for self-preservation, as when the other threatens our survival. Or we carry out our feelings for others from a distance, seeing the other's suffering but doing absolutely nothing. At most we might offer charity that only alleviates rather than solves problems. But while compassion may allow us to disavow our complicity, without compassion we could never move the far and the feared closer to our circle of the near and the dear. Such a move is crucial to art and is fundamental to forgiveness and reconciliation, without which war will never cease.

The artist Dinh Q. Lê, born in Vietnam but raised in the United States, exemplifies how compassion produces powerful, moving, and vulnerable art. His best-known work, his series *From Vietnam to Hollywood*, grapples with what Marianne Hirsch calls postmemory, a recollection passed along from someone else, "transmitted to them so deeply and affectively as to *seem* to constitute memories in their own right."[17] The problem with postmemory, as with memory, is that it might lead one to be concerned only with the suffering of one's own. Lê works against that solipsism in his series *Cambodia: Splendor and Darkness*, where he draws attention to Cambodian suffering. In the late 1970s, Khmer Rouge attacks on Vietnamese

border towns drove Lê's family from their home, but instead of regarding himself only as a victim, he reaches out to see another people's pain. "Untitled Cambodia #4" features his trademark technique of cutting images and weaving them together in order to fuse the "splendor" (of Cambodia's past) with the "darkness" (of Cambodia's genocide). One image is the photograph of a Khmer Rouge victim at Tuol Sleng prison. The man emerges from, and merges with, the stone carving of a temple at Angkor Wat, and as in the rest of Dinh's weaving work, "one image relinquishes itself to another. Faces and figures coalesce, then dissolve again into pure pattern in a continuous rhythm of revelation and concealment."[18] Here the work reveals and conceals the monumental past, embodied in Angkor Wat, and the countless dead. But while remembering that past as splendorous is tempting, critic Holland Cotter points out how darkness overshadows its beauty, since Angkor Wat was built by the labor of many as a tribute to kings: "The message is clear: art has always been as much an accomplice as a deterrent to human brutality."[19]

By turning the dead into a work of art, perhaps Lê runs the risk of being an accomplice, grave-robbing the dead and stealing their images. As Sontag points out, "the more remote or exotic the place, the more likely we are to have full frontal views of the dead and dying."[20] The living can take the images of the dead because they are strong and the dead are weak. In so doing, the living also may allow themselves to forget the ugliness of the dead's passing, which is the danger of powerful memory done from the high ground. The benefit with such risk comes from the sense that the splendor of these lost lives cannot be terminated because of the way they died. Lê urges us to look at the dead again, past their victimization.[21] Resurrected through art, the dead touch us, warning us against our latent inhumanity and telling us that the past can repeat if, paradoxically, we do not remember. This art also shows us, in the words of Toni Morrison, that "nothing ever dies," an insight both terrifying and hopeful.[22]

This is one of the ways that art resists the war machine. But the war machine finds ways to counter art, most seductively through rewarding it, particularly art of the cosmopolitan kind. Dinh Q. Lê and An-My Lê can both be characterized as cosmopolitan artists whose globally appealing work stands above and in stark contrast

to the straightforward, even brutal art of the dead found in the Tuol Sleng museum. Cosmopolitan artists are valued by the people and the institutions in power, such as galleries, museums, festivals, foundations, and trade publishers with prestigious literary traditions. At the same time, cosmopolitan art, as well as cosmopolitan literature, may not do much to help the poor or exotic populations whom it speaks of and for. Given this vulnerability, can cosmopolitanism resist the war machine? Even if cosmopolitanism can cultivate within us a greater compassion for others and strangers, can it compel us to action in meaningful ways beyond the individual? Will cosmopolitanism and compassion lead us toward what Immanuel Kant calls "perpetual peace," the antidote to perpetual war?

The skeptics say that cosmopolitanism imagines a world citizen who is impossible without a world state. If such a world state existed, it would be a totalitarian order, as no competing power will exist to check it. Cosmopolitanism also underestimates how many of us remain viscerally attached to our nations or cultures, which compel real love and passion in a way that cosmopolitanism does not. To some, cosmopolitans seem to be rootless people without loyalty, more inclined to love humanity in the abstract than people in the concrete. Dependent on a vision of the individual as a citizen of the world, particularly of the jet-setting, capitalist kind, cosmopolitanism may not be good at mobilizing masses of people, particularly the noncitizens such as refugees. At the same time, cosmopolitanism's Western origins, arising from the Greeks, may mean it is unattractive to non-Western societies opposed to cosmopolitanism's global ambitions and belief in individual rights and liberties.[23] Cosmopolitanism may also be just as useful for war as for peace, as the philosopher Kwame Anthony Appiah implies. Echoing the claim of Levinas that justice requires a face-to-face dialogue, he endorses the cosmopolitan urge to converse with strangers, where conversation is "a metaphor for engagement with the experience and the ideas of others."[24] But "there are limits to cosmopolitan

tolerance . . . we will not stop with conversation. Toleration requires a concept of the intolerable."[25] Appiah does not mention how tolerant cosmopolitans will deal with the intolerable, although scholar Paul Gilroy provides a name for this: "armored cosmopolitanism."[26]

As Levinas said, the face of the Other can elicit both justice and violence. The terrorist who does not want to talk with us tempts us to take up arms ourselves, even preemptively. Armored cosmopolitanism is the new spin on the white man's burden, where the quaint idea of civilizing the world becomes retailored for culturally sensitive capitalists in the service of the United States, the World Trade Organization, and the International Monetary Fund. The idea and the imagination of being a citizen of the world, driven by compassion, may seem fairly anemic in a world dominated by such entities, to whom we could add the G8, the World Bank, Google, the Hollywood film industry, and so on, most of them staffed by fairly cosmopolitan people. This is why Elaine Scarry argues that we should not simply accept a "pleasurable feeling of cosmopolitan largesse" as the best measure for "imaginative consciousness." Instead, such a consciousness must result in a "concrete willingness to change constitutions and laws."[27]

Still, because "the human capacity to injure other people is very great precisely because our capacity to imagine other people is very small," Scarry says that imaginative works are important in expanding human consciousness.[28] Without cosmopolitanism's call for an unbounded empathy that extends to all, including others, we are left with a dangerously small circle of the near and the dear. Literature and art play an important role not only in expanding our compassion, but in circumscribing and compelling it, too. Our community exerts implicit and explicit pressure to empathize with our own, first by offering only stories about people like us. The absence of stories featuring others, or the presence of stories that render them as demons, stunts our moral imagination. We may not even think of others at all, or when we do we might wish them harm. And

when we think of others generously, our community may penalize and threaten us, as happened to the novelist Barbara Kingsolver for what she wrote only days after 9/11. She mourned the victims but reminded her fellow Americans that bombings of that scale were hardly unusual and that Americans often carried them out. "Yes, it was the worst thing that's happened, but only this week," she wrote. "Surely, the whole world grieves for us right now. And surely it also hopes we might have learned, from the taste of our own blood . . . that no kind of bomb ever built will extinguish hatred."[29]

Kingsolver's refusal to feel only for America's own recalls Martin Luther King Jr.'s speech opposing the war in Vietnam:

here is the true meaning and value of compassion and nonvio-lence, when it helps us to see the enemy's point of view, to hear his questions, to know his assessment of ourselves. For from his view we may indeed see the basic weaknesses of our own condition, and if we are mature, we may learn and grow and profit from the wisdom of the brothers who are called the opposition.[30]

King labels the other not as a stranger or a foreigner but as the enemy, countering the sentimental inclination to say that we are all human. Acknowledging the other as the enemy, as the face of terror, as the inhuman, reminds us that the other is also not likely to see us from a generously compassionate point of view. Indeed, the other is also subject to low feelings, to the compulsory empathy demanded for and limited to the other's own side. The other is as inhuman, and human, as we ourselves are. Appiah's gesture at the intolerable shows how difficult it can be to achieve a conversation when two mutual enemies feel equally aggrieved, equally mired on the low ground, equally hateful of each other. While women, the colonized, and the minority can speak, their speech is often not heard by more powerful others unless it is on terms dictated by those others. Shut out from these conversations, or muted in them, these populations may resort

to violence as a form of speech. Appiah calls this violence intolerant, and in some cases it is. But in other cases some may feel that violence is the only alternative when confronted by an unjust power that refuses to listen, to converse, and to change.

Understanding that the violent ones, our enemies, are motivated not only by hatred but also by compassion and empathy—in other words, by love—gives us a mirror to recognize that our own compulsory emotions are just as partial, prejudiced, and powerful. Understanding this, we can see that we, too, inhabit the low ground, ready to exert violence despite any heady ambitions for transcendence. Powerful memory from the low ground provides this kind of reflection, although we can identify with or reject that image. I conclude with an example of a mirror image that shows how the enemy feels as viscerally as we do, if we are Americans: *Nhat Ky Dang Thuy Tram (The Diary of Dang Thuy Tram)*. Dang Thuy Tram was a twenty-seven-year-old North Vietnamese doctor serving in the south when U.S. troops killed her in 1970. The American officer who recovered her diary kept it for decades before returning it to Tram's family in 2005. Published in Vietnam later that year, the diary sold some 430,000 copies.[31] For the English version, Tram's family and the publisher selected the title *Last Night I Dreamed of Peace*, a sentiment extracted from two occasions in the diary.[32] Mostly the diary is marked by its "hatred" as "hot as the summer sun" for the U.S. and South Vietnamese militaries.[33] The emotion she offers differs little from the patriotism that Kingsolver criticizes, a patriotism shored up by deep feeling for one's own and fear of the other. As Tram says, this diary "must also record the lives of my people and their innumerable sufferings, these folks of steel from this Southern land."[34]

The diary's power for American readers arises from Tram's love for her own comrades and her anger against Americans, not so much from the gestures at peace. She dreams of a peace that arises after the defeat of the enemy, the "vicious dogs" and "bloodthirsty

devils" against whom she yearns for revenge.[35] "It's not my love for a certain young man that makes me feel and act the way I do," she writes. "This is something immense and vibrant within me. My longings extend to many people. . . . What am I? I am a girl with a heart brimming with emotions."[36] Her diary makes clear that romantic love, revolutionary love, and compassion for one's comrades and for the nation all share the same roots. Of a soldier who has just died, she writes that "your heart has stopped so that the heart of the nation can beat forever."[37] She describes feeling that she and her adopted brothers share "a miraculous love, a love that makes people forget themselves and think only of their dear ones."[38] But while being "profoundly compassionate" toward her wounded comrades, she also decries "American bandits."[39]

Ironically, Americans who patriotically hate others can understand Tram's patriotic hatred for them. The compassion that American audiences can now feel for Tram and their former Vietnamese enemies comes from this shared patriotism and the kind of low feeling that originates in the gut. And while this compassion is belated, it emerges in a present indelibly shaped by the wars in Iraq and Afghanistan. In reading Tram's diary at the time of its publication, the English title may evoke a cosmopolitan feeling on the part of readers, a sense that we should reconcile with our current enemies if we can make peace with our former enemies. So while "Last Night I Dreamed of Peace" is inaccurate in foregrounding a relatively insignificant theme in Tram's writing, it nevertheless signals a hope for a broader peace than the one Tram imagined.

Cosmopolitanism and compassion magnify these glimmers of peace. Just as warfare needs patriotism, the struggle for peace needs cosmopolitanism to imagine the utopian future. Without such an imagination and without the expansion of compassion beyond the borders of our own kin, we resign ourselves to the world we inherit. Art, particularly narrative art, makes possible a "cosmopolitan education," the philosopher Martha Nussbaum says, where we see

others empathetically and see ourselves from the perspective of the other.[40] Cosmopolitan education seeps into our minds and emotions through assumptions that our cultures create about the humanity or inhumanity of other cultures. An average American need never have gone to England or to a university to know Shakespeare's name and hence feel, however dimly, a human connection with English culture. Even American tendencies against intellectuals, the elites, and the French would not prevent an average American from feeling that the French have done something worth being saved (or so I hope). This cosmopolitan education about certain others is enacted environmentally, through schools, encounters with works of art, and mass culture. Cosmopolitan education helps limit the violence we inflict on those we see as closer to us on the human scale, but cosmopolitan education also justifies us pouring ever-greater torrents of violence on those not included in our curriculum, on those we see as further away on the animal horizon.

We can measure the degree to which we have been educated about others via our approach to bombing. How many bombs are we willing to drop? What kinds of bombs? Where, and on whom? The indiscriminate, massive American bombing of Southeast Asia was possible because Americans already considered its residents inhuman or less than human. The nuclear bomb is another bomb test. In *The English Patient*, the novelist Michael Ondaatje depicts the atomic bombing of Hiroshima from the perspective the Indian sapper Kip, a soldier in the British Army. When he hears of the atomic bomb's detonation, Kip has a flash of understanding: white people would never drop the bomb on a white country. For Kip, the harsh illumination provided by the bomb begins his decolonization, his recognition of the racism in Western civilization that allows Western technology to be used against non-Western people. As a novel, *The English Patient* both depicts what happens when one culture does not recognize another culture as equally human and is itself evidence against the racist belief that only whites can write. Against the terror

of the bomb, *The English Patient* proves Maxine Hong Kingston's claim in *The Fifth Book of Peace* that "war causes peace" through producing revulsion on the part of war's witnesses.[41]

Some might regard this as an overstatement, since writing back against racism, empire, and war, as Ondaatje does, takes place not on the universal scale but on the intimate scale of the individual artist and work. Scarry points to the inadequacy of individual works of art to enact significant change, with rare exceptions such as *Uncle Tom's Cabin* or E. M. Forster's *A Passage to India*. Many people likely share Scarry's view about art, although with a less generous spirit. Those suspicious people who do not read literature or look at art may be skeptical about their purpose or use, questions not normally directed toward law, business, or government. But does the average lawyer or businessperson or bureaucrat make more difference, inflict more damage, or do more good than the average writer or artist? The average writer and artist, and the average book and work of art, need to be measured against their equivalents: average people in average jobs. Individual works of art should not be measured against daunting standards of making a universal difference or changing the world. Against such high standards, most of us count as failures, not just the average work of art or the average obscure writer. So compare the midlist novelist to the vice president of a regional bank; compare Shakespeare to Bill Gates; compare the novel to the computer; compare cosmopolitan education to war. Only with the appropriate comparisons can we say whether art, and the cosmopolitan impulse to see art as a means to peace, makes a difference.[42]

Kingston goes on to say that "peace has to be supposed, imagined, divined, dreamed."[43] This kind of dreaming will not happen without cosmopolitanism and compassion and their persistent, irritating reminder that waging war is easier than fighting for peace. If peace begins with the individual, it is realized collectively with peace movements, for peace is not simply a matter of praying or hoping, although

they, like dreaming, do not hurt. Instead, peace happens through confronting the war machine and taking over the industries that make it possible, which include the industries of memory. It is no surprise, then, that peace seems so much harder to achieve than war, which offers us an immediate profit. Exploiting our fear and our greed, the cynical supporters of war can convert even powerful memory to weaponized memory. This is the kind that encourages patriotism, nationalism, and the heroic sacrifice of soldiers for the country. The strength of weaponized memory is why appeals from the high ground alone cannot stop war or realize peace. Calls to our humanity have often turned into justifications for war. This is why a need remains for memory that forces us to look at our inhumanity, which we might wish to deny. Recognizing our inhumanity, we begin remaking our own identity so that it does not belong to the war machine, which tells us that we are always and only human, and our enemies less so.

Just Forgetting

WE MUST REMEMBER in order to live, but we must also forget. Too much remembering and too much forgetting are both fatal, certainly to ourselves, perhaps to others. This is why demands to always remember and never forget eventually face calls to reconcile and forgive. The cycle works in reverse as well, when we respond to amnesia by calling for history. But when can we forget? As Paul Ricoeur argues, there are unjust and just ways of forgetting, as there are unjust and just ways of remembering. Unjust ways of forgetting are much more common than just ones. They involve leaving behind a past that we have not dealt with in adequate ways. We ignore that past, we pretend it did not exist, or we write its history to serve a prejudicial agenda. Sometimes we conduct these actions under the guise of reconciliation, as when former enemies agree on treaties that allow them to be friends, without addressing the history of violence that binds them. In regard to my war, all of these modes of unjust forgetting have happened or are happening.

Whether we are winners or losers when it comes to war, the challenge of forgetting is inextricably tied to the question of forgiving. Winners may find it somewhat easier to be magnanimous and

forgiving, while losers are perhaps easier to forgive, given their suffering. But most types of forgiveness are compromised, and a just forgetting will not happen unless we meet the conditions of just memory or until we extend genuine forgiveness. Forgetting can be difficult when both war's winners and losers attempt to portray themselves virtuously, as they usually do. They see themselves as victims, never victimizers. Defeat aggravates this sentiment, as is the case in the community in which I was raised, the Vietnamese refugees in America who lost everything except their memories. They have valid reasons to remember their past, but they also tend to forget, particularly in public commemoration, the venality of the southern Vietnamese regime, the violence committed by their own soldiers—who happen to be their fathers, brothers, and sons—and how their sentiments may be viewed from elsewhere. Hence the bracing quality of Nguyen Huy Thiep's short story, "Khong Khoc O California," or "Don't Cry in California." The story's narrator writes from Vietnam to his brethren in exile and says, *"Vietnamese people, don't cry in California,"* which is *"perhaps the most beautiful place on earth."*[1] He also calls out to all the outposts of Vietnamese exile: Louisiana, the thirteenth district of Paris, Berlin, Sidney, and Tokyo. He enjoins the diaspora to *"Remember me, remember your homeland," "the place you long to see."*[2] The narrator, something of a mess after his lover abandoned him for California, believes these Vietnamese exiles and refugees, steeping in their melancholy, loss, and rage, should recognize what they have gained as much as what they have lost. While they might justify crying for themselves, perhaps they would stop crying if they recognized others, namely their own people who had stayed in the land that they left behind. Otherwise, they suffer the fate of all exiles, who, to borrow from Baudelaire, are "relentlessly gnawed by longing."

One way to overcome one's own grief and to haul oneself out of the morass of memory is to remember others, to see oneself in re-

lationship to others, and to look at oneself with detachment. Or, as spiritual guide Thich Nhat Hanh puts it, "People have a hard time letting go of their suffering. Out of a fear of the unknown, they prefer suffering that is familiar."[3] In not so spiritual a fashion, Thiep's narrator struggles to see his own suffering in relation to the suffering of others. Recognizing that he is a "bum" with "decaying teeth" who "deals heroin," he reaches out to his lost love and all those like her in exile. The story reaches the level of allegory when the narrator comes to stand in for Vietnam, describing himself as afflicted with "inflation," someone "retarded" and "backwards." This story of two lovers lost is really a tragic love story of abandonment and misunderstanding between homeland and diaspora. They are each stuck in the past, struggling to move forward and trying to forgive one another. As always, remembering and forgetting are in a seesaw relationship, never, perhaps, to achieve equilibrium.

Given this, how can the difficult operation of just forgetting be done? Can one just forget when one "feels the tremors of war transferred across generations," as Mai Der Vang says? A writer of the second generation, raised in America, she speaks of another population of the war's losers, the exiled Hmong who fled from Laos and came to an America intent on ignoring their existence, their hurt, and their sacrifice. "While a person can be evacuated from his war-torn country, he can never be evacuated from the trauma," she writes. "Many of us are innately tied to this trauma as if it were strung into our DNA. . . . This war is my inheritance." The demand for memory remains strong for her, but so is the need to turn to the future: "We must build a fortress of Hmong identity that can withstand the effects of exile and diaspora; one that won't mourn what could have been, but instead, transforms the trauma into what we can fully be."[4]

Chue and Nhia Thao Cha realize Vang's understanding of refugee history and memory in their story cloth, a unique art form born from the Hmong refugee experience.[5] Created on a double bed–sized

piece of commercial cloth in a refugee camp, this story cloth narrates an epic history of the Hmong people, from their origins in China; to their settlement in the mountains of Burma, Thailand, and Laos; to their refugee odyssey on foot and across the Mekong River; to their life in Thai refugee camps and their embarkation, in the bottom left hand corner, onto an airplane bound for the west. The story cloth puts Hmong people on the map, their country scattered across many nations.[6] The story cloth is itself a map that contradicts how Western maps of foreign worlds are usually empty of people. Western accounts of new lands often describe them as wildernesses, with the people already there not existing under Western eyes. Those Western maps serve, eventually, as the guide to aerial bombardment. But this story cloth insists that there were people under the bombs, and that their memory and history persists, although not in the linear fashion favored by the West. Instead, the story cloth, by being about both space and time, shows what Vang claims: history and trauma are always present at every moment in Hmong refugee

identity.[7] For the Chas and for Vang, war, memory, and identity are inextricable because Hmong identity in the United States does not exist without war. As for the transformation of trauma, as with the possibility of just forgetting, neither is possible without just memory. Vang's words, and the Chas' story cloth, take us toward that just memory.

As I have argued throughout this book, just memory proceeds from three things. First, an ethical awareness of our simultaneous humanity and inhumanity, which leads to a more complex understanding of our identity, of what it means to be human and to be complicit in the deeds that our side, our kin, and even we ourselves commit. Second, equal access to the industries of memory, both within countries and among countries, which will not be possible without a radical transformation, even a revolution, in the distribution of wealth and power. And third, the ability to imagine a world where no one will be exiled from what we think of as the near and the dear to those distant realms of the far and the feared. I have foregrounded an imagination that thinks and sees beyond the nation because the nation dominates how we carry out our struggles over culture and race, over economy and territory, over power and religion. As the poet Derek Walcott says of the stakes involved—"Either I'm nobody, or I'm a nation."[8] The nation seduces us, particularly if we happen to be cast out of it as refugees, a population that now numbers at least sixty million, a floating, global archipelago of human dispossession.[9] But as powerful as Walcott's line is, I prefer another, more hopeful line by him from the same poem: "I had no nation now but the imagination."[10] Here the poet rejects the fiction that the only alternative to the nation is one's negation and corrects cosmopolitanism's idea of a citizen of the world. Since such a stance might overlook the citizen's other, the refugee forced to flee, the artist turns from claiming the world or a nation to claiming the imagination. In this act, we have one way toward both just memory and just forgetting.

This kind of forgetting is rare and much more difficult to accomplish than the kind of unjust forgetting occasioned by accident, time, amnesia, or death, which are normal and require no effort. The sign of unjust forgetting is repetition. If we repeat a history of violence, then we have not addressed the root causes of that violence. Hence our current predicament in America: we are caught in a time warp of perpetual violence. America's wars have seemed to go on forever, at least for Americans, who live eternally in the present. That is why the journalist Dexter Filkins, in writing of the wars in the Middle East, collectively calls them "The Forever War" in his book of the same title. He borrowed it from the novelist Joe Haldeman, who wrote the science fiction classic *The Forever War*. Haldeman was an American combat veteran of my war who dealt with its absurdity by writing a science fiction allegory. In his fictional war, Earth's best and brightest are drafted to battle bug-like aliens on foreign planets. The military desensitizes the soldiers to killing and programs them to hate and destroy the aliens in a war that turns out to have occurred from miscommunication. Traveling by spaceship and subject to the laws of relativity, the soldiers return to Earth to discover that while they have aged only months, Earth has aged decades. Unable to readjust, the soldiers volunteer for more missions, knowing they will return only after their relatives are dead. For the soldiers, war goes on forever. War also goes on forever for the civilians on the home front, desensitized as they are to the perpetual war that is part of their everyday routine. Theirs is an eternity, but not one of the divine kind.

This is science fiction, but it is also the present, a time when humans live intimately with their inhumanity, accepting it to be normal and eternal. Fiction, and storytelling and art in general, is one way to show us the absurdity of this normality. If the first time we fight a war is tragedy, and the second time a farce, then what do we call the third time, much less the fourth time and the fifth, ad nauseam?

Perpetual war, eternal war, Forever War, in which my war was only an episode, an interruption, an aberration in the chronology that America sees for itself.

That chronology centralizes the triumph of the American way of life, marked by the conflation of democracy and freedom with capitalism and the profit motive. This is a timeline in which democracy is unimaginable without capitalism, and vice versa. A deep investment in this timeline compels many Americans who visit my country of origin to resort to a comforting story about progress and the inevitability of the American way of life: even though Americans lost the war, capitalism has won in the end. The recurrent motifs in foreign reportage about the country of my birth is that the majority of the people are born after war's end, have little desire to remember it, and are instead focused on the same materialism that motivates their communist leaders.[11] The revolution has died. The dollar has triumphed. Long live capitalism! (The situation is similar in Laos and Cambodia.) Despite all the remembering that occurs in both America and Vietnam, an unjust forgetting is winning. This is the case because Vietnamese official memory is unjust, unable to confront the failure of the revolution in bringing freedom and independence to all of the people. American official memory is unjust, too, for it learns no lessons from my war except the lesson to fight the Forever War more efficiently.[12] The reconciliation between Vietnam and America, so far as it has happened, is the reconciliation of two forms of unjust memory and unjust forgetting.

If the precondition for just forgetting is just memory, perhaps it is an impossible forgetting. When, exactly, will we have a time of ethical awareness of our inhumanity, where the industries of memory are available to all, where the artistic will to claim the imagination is norm rather than exception? This is utopian. Yet, at one point, the human imagination had difficulty thinking beyond the light cast by the fire, then of the distance that the tribe could walk, then the

walls of the city-state. So why can we not imagine a future where nations at war seem absurd? Novelist Doris Lessing puts it this way:

> I've lived through Hitler, ranting and raving; Mussolini too; the Soviet Union, which we thought would last for all time; the British Empire, which seemed impregnable; the color bar in Rhodesia and elsewhere; the heyday of European empires. It was inconceivable to think these would disappear. They seemed permanent. Now not one of them remains—and I think that is a recipe for optimism.[13]

The impossible might yet be possible at some point in the future, which is again where art, among other agents, plays a guiding role. Sometimes art does so by imagining utopia, or, through negative lessons, dystopia. Sometimes it does so by offering us models for how to be more human or more ethical in our behavior to one another, or by demanding that we see how inhuman and unethical we can be. And sometimes art, simply by being art, by calling us into a relationship with it, is the template for reflective, contemplative, meditative thinking and feeling that might allow us to become citizens of the imagination. This is an individual, mysterious realm where art and imagination offer some hope and salve to the harsh histories of war, violence, bloodshed, hatred, and terror that continue to affect us. But while art can provoke an ethical awareness of our inhumanity that is necessary for just memory, it cannot achieve just memory alone, not while the industries of memory remain unequal.

Still, art's potential for the individual points toward one way that solace can be achieved during times of unjust memory and unjust forgetting, during our times today. That solace is also found in forgiveness of the most genuine kind, what the philosopher Jacques Derrida called "pure" forgiveness, an "exceptional" and "extraordinary" forgiveness.[14] For Derrida, pure forgiveness is distinct from the kinds of forgiveness tainted by political, legal, or economic con-

siderations, found in acts of amnesty, excuse, regret, reparation, apology, therapy, and so on.[15] Pure forgiveness arises from the paradox of forgiving the unforgivable. All other forms of forgiveness are conditional—I will forgive, if you give me something. The act of forgiving is compromised, as it is between Vietnam and America. Vietnam will forgive America, so long as America invests in it and offers protection against China. America will forgive Vietnam, so long as Vietnam allows itself to be invested in and permits the use of its territory—land, sea, or air—for America's fight against China. Americans who return to Vietnam and feel wonderstruck by how the Vietnamese seem to forgive them do not understand that such forgiveness is conditional. While the Vietnamese surely extend some generosity of spirit to Americans, an undertone of profit exists, for Americans are walking wallets. Such forgiveness is also made possible by the deeper animosity the Vietnamese at home hold against the Vietnamese overseas, whose returns to the homeland can be ambivalent or even fraught. And the reconciliation between the Vietnamese and their French or American invaders must be measured against the hostility the Vietnamese hold against the Chinese. The Vietnamese and the Chinese have their own version of the Forever War, which began when China colonized Vietnam for a thousand years. Neither the Chinese nor the Vietnamese have forgotten that history of conflict, which is why they still repeat it.

Faced with how individuals and states compromise, abuse, and exploit forgiveness and reconciliation, its related term, Derrida argues that forgiveness "is not, it should not be, normal."[16] Rather, "forgiveness must announce itself as impossibility itself," something not dependent on the repentance of the person or entity one might forgive.[17] I must admit that on first encountering Derrida's notion of forgiveness, I struggled with it, for it was, in his own words, "excessive, hyperbolic, mad."[18] If something is unforgivable, how can it be forgiven? Mass bombing, massacres, death camps, genocide,

not to speak of the loss of an individual life—can any of these be forgiven? Not having experienced any of these myself, I cannot say. What I lost was a homeland that I sometimes do not even enjoy visiting; a relationship with an adopted, left-behind sister whom I have seen once in forty years; perhaps a happier childhood; and perhaps happier, healthier parents. But then again, if the war had not been fought and I had not lost these things, I would not be writing these words. I might not be a writer at all to whom the question of forgiveness never occurred until I wrote this paragraph. Now I think, yes, I can forgive, in the abstract, America and Vietnam—in all their factions and variations—for what they have done in the past. But I cannot forgive them for what they do in the present because the present is not yet finished. The present, perhaps, is always unforgivable.

What about pragmatic moments of forgiveness that allow things such as reparations, returns, or recognitions to happen? Are they inconsequential? In the case of my war, even these pragmatic acts are rare. The United States pays a pittance to remove the tons of unexploded ordnance that it dropped in Vietnam, Laos, and Cambodia. It refuses to admit that Agent Orange damaged and damages human beings and the land in Southeast Asia. Many Southeast Asian exiles and refugees continue to hate their communist enemies, do not recognize the communist government, and are afraid or unwilling to return. The communists in Vietnam and Laos have never apologized for reeducation camps and the persecution of people who turned into refugees. The Cambodian government is reluctant to acknowledge the widespread complicity of many people, including its own politicians and leaders, in the Khmer Rouge. A list of sensible things that people and governments could do to admit to the errors and horrors of the past include: truth and reconciliation commissions to encourage face to face dialogue between enemies; trials of war criminals, or at least offers of amnesty which acknowledge that certain people committed criminal acts; returning the homes

and property of refugees, which may now be owned by other histor-
ical victims; erecting memorials to dead refugees and dead soldiers
of the other side; constructing a curriculum that acknowledges all
sides; allowing a civil society that can dissent and discuss the past
freely; and staging dramas of genuine and mutual apology, instead
of the more typical dramas of grief and resentment. Any of these
would be enormously difficult but would help to heal the wounds
of the past and encourage people and governments to move for-
ward without denying the past.

Instead, we have well-intentioned if flawed efforts such as the
United Nations–sponsored Extraordinary Chambers of the Courts
of Cambodia, its mandate to prosecute only five high-ranking indi-
viduals for the crimes of the Khmer Rouge. The trial has gone on
for years and will go on for years, at least until all the aging defen-
dants are dead, or, in the case of one, demented and beyond prose-
cution. This is literally political theater, one with the duration of a
hit Broadway musical and much more expensive to produce. In a
country where the average salary is hundreds of dollars per year, the
cost of the trials runs into the tens of millions of dollars. In order to
visit this theater outside of Phnom Penh, one must make reserva-
tions and arrive early. No pictures are allowed, as is the case with
any theater. On the morning I visited, high school students occupied
most of the seats. This drama was pedagogical, for the Cambodian
people receive little education in regard to the genocide. While the
court will mete out some kind of justice, this is also a show meant
to assure Cambodians that their government is addressing the past,
even when its efforts are weak. And it is a show meant to assure the
world that the United Nations carries out its mission of staunching
the bleeding of the world's injuries, even when it cannot do so.

The trial is set on a stage in front of the auditorium, reinforcing
the theatrical quality. A wall of glass, and behind that glass, a curtain,
separates the audience from the participants—judges, lawyers, de-
fendants, witnesses, translators, stenographers, and guards. When

the audience files in and sits down in the air-conditioned auditorium, the curtain is drawn. The show begins, the curtain opens, and the actors arrive on stage to assume their places in this pseudo-trial. The guaranteed convictions that will result from this trial, while worthwhile, will only lead to a pseudo-reconciliation with the past. The inequality and injustice that led to the rise of the Khmer Rouge still remain, and the unforgivable will not be forgiven. Even the one who asked for forgiveness, Duch, the commandant of S-21, the first one convicted and sent to prison, will not be forgiven. As for the thousands of other Khmer Rouge still alive, many in power or at least in relative peace, and the governments of Vietnam, China, and the United States—none of them will ask for forgiveness, even if they were on trial, which they are not.

But Derrida does not deny pseudo-forgiveness and pseudo-reconciliation a role to play in dealing with the past. It is only that the peace they realize is temporary, an absence of war and violence rather than their negation. Instead of compromise, he only insists on the impossible standard of a pure forgiveness. As unreasonable as it may sound, pure forgiveness is commensurate with the unbearable weight of history's accumulated horrors and our own individual responsibilities. Why is it possible to murder millions and yet impossible to imagine pure forgiveness or just forgetting? Shouldn't mass murder be impossible? The fault is our own. There is no one else to blame for the limits of our spirit and our imagination. We submit to the pragmatists, the profiteers, and the paranoiacs who insist that war is part of humanity, our identity. They are half-right but all wrong in believing that we cannot convert the recognition of our inevitable inhumanity into a different kind of realism, a realism that believes we must imagine peace, no matter how impossible it may seem. It is perpetual war that is unrealistic. Perpetual war is madness, engineered in the rational language of bureaucracy and the high-flown rhetoric of nationalism and sacrifice, operating through campaigns that could lead to human extermination. This

madness can only be matched by the logic of perpetual peace and the excessive, utopian commitment to a pure forgiveness, which the species needs to survive. If we wish to live, we need a realism of the impossible.

Thich Nhat Hanh, who inspired Martin Luther King Jr., provides another perspective on "the situation of a country suffering war or any other situation of injustice." Rather than laying the blame on one side or another, he says, "every person involved in the conflict is a victim." This is obviously a difficult perspective to adopt for those who consider themselves to be victims or the descendants of victims. Nevertheless, "see that no person, including all those in warring parties or in what appear to be opposing sides, desires the suffering to continue. See that it is not only one or a few persons who are to blame for the situation." But in saying that no one single agent is to blame, he does not absolve us of blame. "See that the situation is possible because of the clinging to ideologies and to an unjust world economic system which is upheld by every person through ignorance or through lack of resolve to change it." Even more, the duality of conflict itself, the either-or of war and hatred, is illusory: "See that two sides in a conflict are not really opposing, but two aspects of the same reality." Increasingly, Vietnam and America appear to be part of the same reality. Once symbolic of Cold War division, these two countries now participate in the onward march of global capitalism, military-industrial complexes, the dominance of self-interested political parties, the survival of nation-states, and the perpetuation of power for the sake of power. What, then, was the war good for, if in the end all that will happen is yet another war? "See that the most essential thing is life and that killing or oppressing one another will not solve anything."[19]

What Jacques Derrida and Thich Nhat Hanh ask for, what Immanuel Kant and Martin Luther King Jr. call for, is both simple and difficult, the need to challenge the story about war and violence that so many find easy to accept. This story says that we must resign

ourselves to the necessity and even nobility of war. By now war and violence are certainly a part of human identity, but identity is not natural. It can change, if we tell another kind of story and seize the means of production to circulate such a story. This story foresees a just rather than unjust forgetting, pivoting on just memory and pure forgiveness. As philosopher Charles Griswold says, "resentment is a story-telling passion," which can be addressed through another kind of storytelling driven by forgiveness, "which requires changes in resentment's tale."[20] Griswold, like Thich Nhat Hanh, argues that "unchecked, resentment consumes everything and everyone, including its possessor."[21] Forgiving others and letting go of resentment is an act both for others and for oneself. As Avishai Margalit says, "the decision to forgive makes one stop brooding on the past wrong, stop telling it to other people."[22] Only through forgiveness of the pure kind, extended to others and ourselves, can we actually have a just forgetting and a hope for a new kind of story where we do not constantly turn to the unjust past.

This is why storytelling specifically and art in general inhabit such an important place in this book. Storytelling allows us to tell a different story about war and its relationship to our identity. In this way, storytelling changes how we remember and forget war. The moving documentary *The Betrayal* (*Nerakhoon*) makes explicit how storytelling addresses betrayal and resentment. Betrayal happens at least twice in this film about a Laotian family whose father fought with the royalists and the Americans during the war. First, the Americans betrayed their Laotian allies and abandoned them to the communists. The father is sent to reeducation and his family become refugees, forced to flee to a ghetto of New York. Second, the father betrays his family when, after being released from reeducation, he finds another wife. The dual betrayals nearly destroy his first wife and children emotionally, sending them into poverty and tearing apart the family. But the eldest son, Thavisouk Phrasavath, is befriended by a young filmmaker, Ellen Kuras, and together they film

the family's story. The ending of the story is not exactly happy. After Laotian gang members murder Thavisouk's half-brother, the son of his father and his other wife—the killing one of the war's long-term repercussions, as Lao turn against Lao with violence—Thavisouk and his father begin a fragile reconciliation. The father acknowledges his culpability in the war, when his job was to call for American bombings. "Indeed, I regret what I have done," the father says. "I collaborated with the Americans to bomb my own country to save it. I was part of great destruction of my country with foreigners. Indescribable destruction." Thavisouk gets married, becomes a father, and returns to visit Laos, where he reunites tearfully with two sisters left behind—"the heaviest sorrow" for his mother—but who he cannot take with him to America. "I run between what I remember and what is forgotten, searching for the story of our people whose truth has not been told," says Thavisouk. "As we move further from the Laos of our past, we are travelers moving in and out of dreams and nightmares. What happens to people in our land, a place we call home?"

The Betrayal (Nerakhoon) does not heal all the wounds inflicted on the family because of the war, but the story gestures toward just memory and toward forgiveness between family members. Just as importantly, *The Betrayal (Nerakhoon)* refuses the lure of the Hollywood spectacular or the vanity of auteurship. Instead, it is filmed over decades, a long and patient collaboration. The relationship between Phrasavath and Kuras requires trust and giving, which, lest we forget, is a part of forgiving. The film and its makers work actively to prevent the betrayal of memory, and this film is their gift to those who have seen it. Each time I encounter a meaningful work of art, I feel like I have received an unexpected gift, something to cherish. While storytelling and art are not the only ways we can give and receive gifts, they are one form of the ultimate gift, the one that comes without expectation of reciprocity. This idea of gift giving prevails among the spiritual and religious, especially those we perceive to be

martyrs who have given their lives, from Jesus Christ to Thich Quang Duc to Martin Luther King Jr. But gifts can be secular as well, and small, and this book has explored a myriad of such small gifts, each one a step toward just memory and just forgetting.

At least in English, the meaning of "to forgive" once included giving or granting. In contemporary meanings of forgiving, the idea of giving lingers, when "to forgive" means to give up and cease to harbor resentment or wrath. Implicit in this definition is the idea of surrendering, not as defeat but as a kind of victory over war in that one refuses to fight further. "To forgive" is also to pardon an offense, to give up a claim to requital, to abandon one's claim against a debtor, or to forgive a debt.[23] These definitions of giving and forgiving include not only the personal, emotional, and spiritual meanings of such acts, but have material and economic implications as well. One can forgive a debt, but in giving, one can also accrue a debt. The recipient may feel the need to return the favor, or may understand that accepting the gift is a form of submission. The gift can then be mired in the expectation of exchange or reciprocity.

Going back to the white man's burden, when the West assumes the burden of the Rest, it expects indebtedness, gratitude, and obligation from those to whom it gives the gift of civilization. To forgive that debt, as the West occasionally does, is not to forget that debt. Debt is premised on economic exchange, which in a capitalist system is based on unjust forgetting.[24] As Marx argued, the commodity we love so much—the *thing*—depends on our forgetting the human beings who worked to create it. So it is that the inhuman thing becomes more real to us than the human worker. This is why the West often forgets the Rest, while loving the things that the Rest makes.

For Ricoeur, the way out of this inhuman cycle of giving and indebtedness is to give without expecting reciprocity. Citing Luke 6:32–35, Ricoeur says, "you must love your enemies and do good; and lend without expecting any return." The Christian gift of love and forgiveness serves as a model for the personal act of just forget-

ting, where one lets go of the past, of resentment, of hatred without the expectation of any profit other than that one's enemies will return one's love.[25] Forgiveness is also at the heart of the Buddhist practice offered by Thich Nhat Hanh and, intriguingly, in the secular, artistic work offered by some war veterans. They visit their former enemy's land or commune with those enemies through their writing, as is the case with American writers such as John Balaban (*Remembering Heaven's Face*), W. D. Ehrhart (*Going Back*), Larry Heinemann (*Black Virgin Mountain*), Wayne Karlin (*Wandering Souls*), or Bruce Weigl (*The Circle of Hanh*). Forgiveness on the part of these veterans also involves letting go of the need to be remembered on the terms of nationalism, which is implicitly built on an antagonism toward others. This is the hidden price of the memorials and the monuments erected toward a nation's veterans. This is why Ehrhart writes, "I didn't want a monument. . . . What I wanted was an end to monuments."[26]

Evident in this model of giving and forgiving, of letting go and surrendering, is the gratifying picture of two enemies making peace, acting out the binary of giver and receiver. The model is laudable but vulnerable because it can encourage us to overlook what does not fit this dualistic scheme. So, when it comes to my war, its complicated history is often reduced to a conflict between Vietnam and America. What happens to Laos and Cambodia, the South Vietnamese, the diversity within all of these countries? For many, it is easier to overlook these and other differences in favor of the image of (victorious) Vietnamese and (defeated) Americans reconciling. The model of two enemies making peace is also vulnerable because the reciprocity of gift giving still implies indebtedness, the expectation of getting something in return for a gift, even if it is love and friendship. Thus, the reconciliation of Vietnam and America has not actually led to peace, unless one defines peace as the lack of war. Reconciliation has led to the return of business as usual, two countries negotiating for power and profit in the former Indochina

and the South China Sea region. Those invested in capitalism and militarism steer this corrupted reconciliation, which masks the self-interested exchange between the two countries. In this exchange, gifts turn into commodities and peace turns into alliances for present profit and potential war. If we wish for true peace, pure forgiveness, and just forgetting, we must remember the labor that makes commodities, we must remember the history of war that lurks behind the façade of peace.

Giving without hope of reciprocity, including the gift of art, is one model for pure forgiveness and just forgetting. Rather than think of giving as involving only two people or entities, imagine giving as part of a chain in which the gift circulates among many. The one who receives a gift need not return it but can instead give a gift to another, with the giving itself a gift. In this manner, the giver eliminates the problem of reciprocity and expectation. Critic Lewis Hyde proposes this when he discusses the work of art as a gift that the artist sends out into the world, to be passed along to others. For Hyde,

> art does not organize parties, nor is it the servant or colleague of power. Rather, the work of art becomes a political force simply through the faithful representation of the spirit. It is a political act to create an image of the self or of the collective. . . . So long as the artist speaks the truth, he will, whenever the government is lying or has betrayed the people, become a political force whether he intends to or not.[27]

Giving in its pure form is a way of forgiving the world, the one that accepts the inevitability of warfare and capitalism, blood and debt. Is not such a world unforgivable to those who wish only to give? Giving without expectation of return is a way of working toward a time when just forgetting and actual justice exist in all ways of life, including in memory. The work of art crafted in the spirit of truth is a sign of justice and points toward justice, even if it cannot com-

pletely escape the material and unjust world that can turn the gift into a thing to be bought and sold. Still, the artist who gives her gift to others remembers the gift of art given to her by other artists. She gives and forgets about any debt owed to her. This true artist hopes for an era when all people can be artists if they wish, to give if they wish, to live in a time when the just forgetting of the unjust past has happened.

To all those who demand that we must forget even without justice if we wish to move on—forgetting at all costs will one day cost you or your descendants. The violence and injustice you wish to leave in the past will return, perhaps in the old guise or perhaps in a new and deceptive one that will only be another face of perpetual war. Yes, you can forget, but you will not move on. Just forgetting only happens as a consequence of just memory. Remembering in this manner remains a task that seems impossible, given the irony that many of us prefer to carry the burden of injustice instead of putting it down, a reluctance that makes us bound to our past and present. Until that impossible moment of just memory occurs for everyone, some can undertake the task of just forgetting by giving and forgiving, working alone or, preferably, in solidarity with others.

Meanwhile, the future of memory remains unknown. On my last trip to Southeast Asia, I visit the far reaches of Cambodia to catch a glimpse of that future, to the border town of Anlong Veng, thirteen kilometers from Thailand and in a district that was the Khmer Rouge's last bastion. It takes two hours by private car from Siem Reap, and we drive up mountain roads past an old monument to the Khmer Rouge, carved from a boulder. Someone has beheaded the statues of the Khmer Rouge soldiers who once proudly stood there. Driving past the monument and Anlong Veng, we continue to the border crossing with Thailand, where we have no difficulty finding what I am looking for. On the side of the road, a blue sign that says

"Pol Pot Creamation" points to the grave. It is twenty meters away amid a camp of shacks and tarps where people live in poverty, with the ones doing well selling things like gasoline in old Johnny Walker bottles. What remains of Pol Pot lies in a small and barren dirt lot. A rope keeps out visitors, but the guard lowers it for a dollar. The dusty and neglected tomb is a knee-high, rusty tin roof over a low, rectangular mound of earth, fenced off and decorated with a few sad flowers. Here rests someone who embodied the human and the inhuman in the extreme, an idealist who learned his ideas about taking Cambodia to Year Zero in Paris, City of Light.[28] The anti-memorial he has at present suits him perfectly, its form as ugly as his legacy, but I can only hope that it stays that way. After all, his tomb exists almost literally in the shadow of a casino under construction a hundred meters away, across the highway. By the time I write these words, the casino should be finished, and its proximity to Pol Pot's tomb can only lead to more tourism for both. There will be no giving here, much less forgiving.

A few kilometers away down a badly cratered red earth road stands the tourist future, "Ta Mok's House Historical Attractive

Site," marking the residence of Pol Pot's last ally and possible murderer, nicknamed the Butcher. Hidden behind a screen of weeds and saplings is the decrepit shell of the home, its walls marked with insults against Ta Mok. In a clearing nearby, restaurants and bungalows invite people to eat, drink, and relax. A young couple cuddles in one of the bungalows as they gaze at the view of the plains beneath the mountains. Perhaps one day Pol Pot's grave will be ringed with bars. Why not, if money is to be made from people like myself. In the small town of Anlong Veng itself there is another Ta Mok tourist attraction, a compound where he once lived. A few vanloads of Khmer tourists wander around the barren houses of the compound, devoid of furniture but still decorated with wall paintings of Angkor Wat. Children lounge on the balcony of an open-air room facing fields where the homes of other Khmer Rouge senior leaders—Pol Pot, Khieu Samphan, Ieng Sary—once stood. The homes have disappeared. A demolished truck that was Pol Pot's mobile radio station crouches in the front yard. Under the shade of a pavilion, on cement, stand two gigantic wire chicken coops that once caged prisoners. In Ta Mok's day, he kept the cages and the prisoners under the sun. A woman fingers a cage door and smiles, half-laughing. I doubt she finds this place funny, but as the journalist Nic Dunlop has written in regard to the genocide, "Confronted with the enormity of what had happened, how was one to react?"[29] I take her picture.

Perhaps tears and sorrow are not enough. Perhaps one should smile and laugh when confronting these places, not because they are humorous but because they are strange, these rememories where despair mixes with hope. In these places, we cannot separate the absurd from the tragic. Here are two men who died for a revolution that sought to murder a country in order to save it, a lesson learned from the French and Americans. Now, as ghosts, they inhabit a poor, traumatized country where the forces of unjust memory and unjust forgetting outnumber the forces for just memory. An unpredictable

future waits to be built on the literal bones of the past. Will these bones serve only as a lesson against madness, if even that? Will they also speak against the deprivations that led to that madness, the myriad injustices of the past that survive to this day? Will the past be just forgotten, or will there be a just forgetting of the past?

Epilogue

IN WRITING THIS BOOK, I returned again and again to what people call my homeland, where my parents were born, as was I. But for the Vietnamese, the homeland is not simply the country of origin. It is the village where one's father was born and where one's father was buried. My father's father died where he was supposed to, as my father will not and as I will not, in the province of his birth, his mausoleum thirty minutes from Ho Chi Minh's birthplace. The region is famous for producing hardcore revolutionaries and hardcore Catholics. My parents were among the latter. The geographical proximity of revolutionaries to the religious often makes me wonder what a different direction my life might have taken, what a different war I might have inherited.

I went to my father's homeland to pay my respects, only to discover that my father's father was not buried in his mausoleum. Soil and the smoke of incense smudged the mausoleum, which stood near the compound built by my father's father, where my uncles and most of my cousins still lived. The date of my father's father's death was inscribed at the mausoleum's peak, and beneath it lay two tombs. My paternal aunt and the wives of my uncles pulled weeds,

swept away the dust, and lit incense. Above the tomb of my father's mother was a black-and-white photograph of a sad face that had also peered at me from the mantel of my childhood home. But next to her the tomb of my father's father was empty, no stone slab to seal it, no name above it, no body inside. What remained of my father's father was buried kilometers away, in a muddy field near the railroad tracks, far from the living, laid to rest ten years ago.

I lit incense at his tomb. Later my uncles did the same in their father's compound, in front of his photograph. I knew this man only by his title, my father's father. I would never be expected to call him by his name even if I had known him. Only when I was home in California did it strike me that I did not know the name of my father's father. But I remembered his face vividly from the photograph on my parents' mantel. Some years after my visit, this image, his image, was placed next to that of his wife, above his tomb.

That picture will become the kind of memory that the filmmaker Chris Marker talked about, the kind that fascinate me the most, "those memories whose only function had been to leave behind nothing but memories."[1] I have inherited many of these memories, from the refugees among whom I grew up, from the Americans whose manners and customs I took as my own, and from my mother and father. They rarely discussed the war that had shaped them indelibly, but their lives exuded the force of memories of which they rarely spoke.

I remember what happened a few times after my mother came home from a twelve-hour workday, with even more work yet to do at home. They labored like this every day of the year except for Christmas, Easter, and New Year. Having lost almost everything, they nearly killed themselves to earn it back. She asked me if I wanted to go for a drive with her, without my father. Perhaps I was eleven or twelve, maybe younger. We drove silently in the night, the windows rolled down for the cool breeze. The radio was off. My parents never listened to the radio in the car. She would not speak

to me, or perhaps she did and I did not listen or do not recall. Even if she did speak to me, I do not know what I would have said. We drove into the hills in silence and then we returned home. Perhaps this was her way of reaching out to me, the boy who had lost his mother tongue, or who had cut it off in favor of his adopted tongue. Perhaps she simply needed a few minutes away from work and my father, whom she saw every minute of the day. What did she think of, what did she remember. Now I cannot ask. Her memories are vanishing and her body is slow to obey her. She will not be counted as one of war's casualties, but what else do you call someone who lost her country, her wealth, her family, her parents, her daughter, and her peace of mind because of the war.

I recall what Marker also said about "the function of remembering, which is not the opposite of forgetting, but rather its lining."[2] Yes, remembering and forgetting entwine together, a double helix making us who we are, one never without the other. I want to remember, but so much has been forgotten or silenced. My own personal memory is faulty. Through my youth, I had a memory of soldiers firing from our boat onto another boat as we floated on the South China Sea. I was four. My brother, seven years older, says the shooting never happened. As an adult, I remembered my mother being hospitalized when I was a child. A few years ago, when I discovered a memoir that I had written in college, I read in my own words that she was in the hospital at that time, not years before. Her illness and that strange ward with its mumbling patients had made me feel like I was a frightened child. That feeling was what I remembered.

As for my father, it is pointless to ask him about the past. His relationship to the past is to muffle it, at least in my presence. Although I have visited his homeland, I have never visited my own origin, the town where I was born, because he has forbidden it. More than once he has said to me, "You can never go back there!" Too many people will remember him and persecute me, or so he

believes. I think of what the cartoonist Art Spiegelman said of his father, who survived the Holocaust: "I hadn't a clue as to how to find the places my father had been telling me he grew up in, and he wasn't of much help except to tell us not to go at all because they kill Jews there. Using the present tense: 'They kill Jews there. Don't go!' He was afraid for us."[3] Like Spiegelman's father, my own must believe in rememories that do not die, those mnemonic menaces that retain their fatal force. And while I have disobeyed my father in many things, I cannot in this one thing. The paternal injunction is too strong, the specter of the unknown past too unsettling. What is it that he remembers of this place, what will he not tell me, what if he is right? This absence as a forbidding presence is the opposite of memory. Perhaps some things will never be remembered, and yet also never forgotten. Perhaps some things will remain unspoken, and yet always heard. Perhaps I will only visit where I was born after my father has passed on. Then it will be too late to see what it is he remembers, the rememory having at last expired. This is the paradox of the past, of trauma, of loss, of war, a true war story where there is no ending but the unknown, no conversation except that which cannot be finished.

I think back to my father's father and what happened to his remains. The Vietnamese believe a person should be buried twice. The first time, in a field removed from home and village, the earth eats the flesh. The second time, the survivors must disinter what remains. If they have timed it correctly, there will only be bones. If they have timed it wrong, there will still be flesh. Regardless of what they find, they must wash the bones with their own hands. Then they bury the bones once more, this time closer to the living.[4]

Notes

PROLOGUE

1. King, "Beyond Vietnam," 144.
2. Ibid., 156.
3. For an overview of the connections that Americans have made between the wars in Vietnam and Iraq, see Gardner and Young's edited collection *Iraq and the Lessons of Vietnam*, and Dumbrell and Ryan's edited collection *Vietnam in Iraq*.
4. King, 194–95.
5. Ibid., 143. For more on the controversial nature of King's speech at the time of its delivery in 1967, and the tradition of antiwar protest among black intellectuals such as Frederick Douglass and W. E. B. DuBois, see Aptheker, *Dr. Martin Luther King, Vietnam, and Civil Rights*.
6. Guevara, *On Vietnam and World Revolution*, 15. He was not the only Latin American to have this sentiment, as Macarena Gómez-Barris shows in her interview with the Chilean political prisoner Carmen Rojas. According to Rojas, she was "part of a generation that felt, in their own bodies, the struggle of Vietnam, and that vibrated during the anti-imperialist marches" (*Where Memory Dwells*, 99).

JUST MEMORY

1. The literary and academic body of work on war and memory is substantial. While much of that work will be cited throughout the book and in subsequent endnotes, I will mention here a number of other works that I found helpful: Ashplant, Dawson, and Roper, "The Politics of War Memory and Commemoration"; Winter, "From *Remembering War*"; and the following essays from *War and Remembrance in the Twentieth Century*, edited by Winter and Sivan: Merridale, "War, Death, and Remembrance in Soviet Russia," Winter, "Forms of Kinship and Remembrance in the Aftermath of the Great War," Winter and Sivan, "Introduction," Winter and Sivan, "Setting the Framework."

2. On violence and the founding of nations, see Renan, "What Is a Nation?"

3. Shacochis, *The Woman Who Lost Her Soul*, Kindle edition, 196.

4. Two useful, concise overviews of the history of the war from both American and Vietnamese perspectives are Bradley's *Vietnam at War* and Lawrence's *The Vietnam War*. In writing this book, I also drew on longer histories by Young (*The Vietnam Wars*) and Logevall (*Embers of War*).

5. Um raises similar issues about the way the name of the war contains its meaning in her article "The 'Vietnam War'": What's in a Name?"

6. In *America's Shadow* and *American Exceptionalism in the Age of Globalization*, scholar William Spanos has placed the Vietnam War at the center of his critique of American empire in the twentieth century. Edward Said's landmark *Orientalism* connects the European imagination of the "Near East" and "Middle East" with the American imagination of the "Far East." For Said, the Oriental includes not just America's enemies in the Pacific during the mid-twentieth century but its new enemies in the Middle East during the late twentieth century and beyond.

7. Dudziak, *War Time: An Idea, Its History, Its Consequences*, 8.

8. These percentages are based on my own calculations of Vietnamese casualties in relationship to census counts for northern and southern populations. For a more detailed exploration of casualties for Americans, Vietnamese, Laotians, and Cambodians, see Turley, *The Second Indochina War*, 255–58.

9. Ginzburg, *A Place to Live*, 58.
10. For an account of the United States' allied troops from Korea, Thailand, Australia, the Philippines and New Zealand, see Blackburn. For a discussion of the war's international dimension, see Bradley and Young's *Making Sense of the Vietnam Wars*.
11. For an account of how spaces of memory are limited for immigrants to the United States, see Behdad, *A Forgetful Nation*.
12. For additional important works on collective memory, see Olick, *The Politics of Regret*, and Lipsitz, *Time Passages*.
13. Young, *The Texture of Memory*, xi.
14. Bercovitch, *Rites of Assent*, 1–67, particularly 19–22.
15. Kundera, *The Book of Laughter and Forgetting*, 218.
16. These ideas about the ethics of remembering one's own and others appeared in an early form in my essay "Just Memory: War and the Ethics of Remembrance."
17. For an illuminating exploration of the nuances of nostalgia, see Boym, *The Future of Nostalgia*.
18. For surveys of the idea of a memory industry and a memory "boom" that has exploded since the 1970s, see the following essays from *The Collective Memory Reader*, edited by Olick, Vinitzky-Seroussi, and Levy: Rosenfeld, "A Looming Crash or a Soft Landing? Forecasting the Future of the Memory 'Industry'"; Nora, "From 'Reasons for the Current Upsurge in Memory'"; and Olick, Vinitzky-Seroussi, and Levy, "Introduction."
19. On the memory industry and its relationship to power, see Sturken, *Tourists of History*.
20. Zelizer, *Remembering to Forget*, 4.
21. Freud, "Remembering, Repeating, and Working-Through."
22. For some of these critiques of identity, see Michaels, *The Trouble with Diversity* and Schlesinger, *The Disuniting of America*.
23. Charles Maier, for example, in his article "A Surfeit of Memory?," blames fragmentation and grievance—the telltale signs of identity politics, or "narrow ethnicity" (444)—for preventing an orientation toward the future and transformative politics. But perhaps it is these movements for transformative politics that have not adequately dealt with the wounds of the past, or which have not been inclusive enough, which would limit their transformative ability for those afflicted with "narrow ethnicity."

24. Many scholars of memory have made the case for the mutually constitutive relationship of memory and forgetting. To name just two: Connerton, "Seven Types of Forgetting," and Schacter, *The Seven Sins of Memory*.
25. Ricoeur, *Memory, History, Forgetting*, 57.
26. Nietzsche, *On the Advantage and Disadvantage of History for Life*, 10, italics in original.
27. Ricoeur, *Memory, History, Forgetting*, 68.
28. Borges, "Funes the Memorious," in *Ficciones*, 107.

1. ON REMEMBERING ONE'S OWN

1. For an overview of how Vietnam has dealt with its war memories, see Tai's edited collection *The Country of Memory*.
2. Augé, "From *Oblivion*," 473–74.
3. Kundera, *The Book of Laughter and Forgetting*, 217.
4. For more on the mourning practices for dead revolutionary soldiers, see Malarney, "The Fatherland Remembers Your Sacrifice" and *Culture, Ritual and Revolution in Vietnam*.
5. Didion, *Blue Nights*, 13.
6. Margalit, *The Ethics of Memory*, 8.
7. Forster, *Aspects of the Novel*, Kindle edition, loc. 735–850.
8. For a more detailed study of Vietnamese practices of remembering the American war, see Schwenkel's *The American War in Contemporary Vietnam*.
9. For a detailed account of "Uncle Ho," see Duiker's *Ho Chi Minh*.
10. Ninh, *The Sorrow of War*, 232.
11. Ibid., 42.
12. Ibid., 57.
13. On trauma and its repetitive remembering, see Caruth, *Unclaimed Experience*.
14. Ninh, *The Sorrow of War*, 180. On trauma and the possibilities of a victim repeating the violence, which might explain Kien's violent behavior, see Leys, *Trauma*.
15. Ninh, *The Sorrow of War*, 204. On the prevalence and traumatic impact of rape, see Herman, *Trauma and Recovery*; on the shame of sexual stigmatization, and the haunting legacies of sexually trauma-

tized women in the parallel case of war-torn Korea, see Cho, *Haunting the Korean Diaspora*; on rape in the Vietnam War, see Weaver, *Ideologies of Forgetting*.

16. Ninh, *The Sorrow of War*, 94.
17. Ibid., 233.
18. Vo's *The Bamboo Gulag*, 209, provides more information on the statue's sculptor Nguyen Thanh Thu.
19. Herr, *Dispatches*, 330.
20. Ninh, *The Sorrow of War*, 88.
21. Ibid.
22. Aguilar-San Juan, *Little Saigons*, 64.
23. Nhi Lieu, *The American Dream in Vietnamese*.
24. On postwar American policies in regard to Vietnam, see Martini, *Invisible Enemies*.
25. Nora, "Between Memory and History."
26. Quoted in Ch'ien, *Weird English*, Kindle edition, loc. 819.
27. Boym, *The Future of Nostalgia*, viii, 41–48.
28. Davey, "In Kansas, Proposed Monument to a Wartime Friendship Tests the Bond."
29. Cargill and Huynh, *Voices of Vietnamese Boat People*, 151–52.

2. ON REMEMBERING OTHERS

1. Ecclesiasticus 44:8–9, King James Bible. On the relationship of religion to memory and this war, see Tran, *The Vietnam War and Theologies of Memory*, particularly the section on the Vietnam Veterans Memorial (212–35).
2. Some useful accounts of the making of Maya Lin's memorial, the controversies around it, and the power of its aesthetic, can be found in Ashabranner, *Always to Remember*; Edkins, *Trauma and the Memory of Politics*; Griswold, *Forgiveness*; Hagopian, *The Vietnam War in American Memory*; Hass, *Carried to the Wall*; Huyssen, *Present Pasts*; Lin, *Boundaries*; Marling and Silberman, "The Statue at the Wall"; Menand, *American Studies*; Shan, "Trauma, Re(-)membering, and Reconciliation"; Sturken, *Tangled Memories*; and Wagner-Pacifici and Schwartz, "The Vietnam Veterans Memorial."

3. Isaacs's *Vietnam Shadows* is an informative account of this postwar period and the impact of the war on American memory and life.

4. See McMahon's "Contested Memory" for a pithy summary of how the war's memory was transformed politically and culturally.

5. Dowd, "After the War."

6. Appy, *American Reckoning*, Kindle edition, loc. 3689.

7. Assman, "From *Moses the Egyptian*," 211.

8. Swofford, *Jarhead*, 5–6.

9. Lin, *Boundaries*, 5:06.

10. DuBois, *The Souls of Black Folk*, 5.

11. Ibid.

12. Tatum, *The Mourner's Song*, 9.

13. Ninh, *The Sorrow of War*, 180.

14. Margalit, *The Ethics of Memory*, 87.

15. Ricoeur, *Memory, History, Forgetting*, 496.

16. President Obama proclaiming March 29, 2012, as Vietnam Veterans Day, commemorating fifty years since American involvement began in Vietnam, in "Presidential Proclamation."

17. For a critique of Margalit's distinction between ethics and morals when it comes to memory, see Blustein, *The Moral Demands of Memory*.

18. Ricoeur, *Memory, History, Forgetting*, 82–83.

19. Duong, in *Treacherous Subjects*, shows how Vietnamese patriarchy of all ideological persuasions has often aimed its ire at women.

20. Young, *The Vietnam Wars*, 50.

21. Duong, *Novel without a Name*, 138.

22. Ibid., 84.

23. Ibid., 62.

24. Ibid., 256.

25. Fussell, *The Great War and Modern Memory*, 341.

26. Heinemann, *Close Quarters*, 261.

27. Baudrillard, *Simulacra and Simulation*, 59.

28. Chong, *The Oriental Obscene*.

29. Sturken, *Tangled Memories*, 62–63.

30. Ibid., 82.

31. Lesser, "Presence of Mind."

32. For a critique of how the United States has remembered Hmong soldiers, see Vang, "The Refugee Soldier."

33. Moua, *Bamboo among the Oaks*, 61–62.

34. Ricoeur, *Memory, History, Forgetting*, 89.
35. Gilroy, *Against Race*, 115.
36. Ibid., 114.

3. ON THE INHUMANITIES

1. Solzhenitsyn, *The Gulag Archipelago 1918–1956*, 168
2. Some of the scholars who have worked on the distinction between sympathy and empathy, or on the power or problems of one or both of those two feelings, include: Bennet, *Empathic Vision*; Berlant, "Introduction: Compassion (and Withholding)"; Garber, "Compassion"; and Woodward, "Calculating Compassion."
3. For a compelling study of another case where war survivors were reluctant to see themselves as victimizers, turning instead to being only victims, see Yoneyama, *Hiroshima Traces*.
4. Butler, *Precarious Life*, 150.
5. Chong, *The Girl in the Picture*.
6. Turse, *Kill Anything That Moves*.
7. For an account of how South Vietnamese women functioned in the American imagination, see Stur, *Beyond Combat*, 17–63. For memories of Vietnamese women themselves, see Nguyen, *Memory Is Another Country*.
8. Levinas, *Totality and Infinity*, 23.
9. Ibid., 51.
10. Ibid., 47.
11. Levinas says that "freedom comes from an obedience to Being; it is not man who possesses freedom; it is freedom that possesses man" with "the primacy of the same, which marks the direction of and defines the whole of Western philosophy" (45); "such is the definition of freedom: to maintain oneself against the other" (46). Such philosophy does not question injustice and leads to "power, to imperialist domination, to tyranny" (47).
12. Ibid., see 26–27 for a discussion of infinity and the relation of same to other.
13. Ibid., 225.
14. See Parikh's *An Ethics of Betrayal* for another reading and application of Levinas to the place of minorities and others. In *Totality and*

Infinity, Levinas has this to say about justice and its alignment with the Other: "justice consists in recognizing in the Other my master. Equality among persons means nothing of itself; it has an economic meaning and presupposes money, and already rests on justice—which, when well-ordered, begins with the Other" (72); "justice is a right to speak" (298); "the goodness of being for the Other, in justice" (302).

15. From the film *Derrida*, Derrida says: "In general, I try and distinguish between what one calls the Future and "l'avenir" [the 'to come']. The future is that which—tomorrow, later, next century—will be. There is a future which is predictable, programmed, scheduled, foreseeable. But there is a future, l'avenir (to come) which refers to someone who comes whose arrival is totally unexpected. For me, that is the real future. That which is totally unpredictable. The Other who comes without my being able to anticipate their arrival. So if there is a real future, beyond the other known future, it is l'avenir in that it is the coming of the Other when I am completely unable to foresee their arrival." But as I argue elsewhere in this book, the Other is not only possibly a sign of justice but of terror.

16. Herr, *Dispatches*, 20.

17. See Grossman's *On Killing* for an examination of how distance to the target affects the killer.

18. Duong, *Novel without a Name*, 237.

19. Levinas, *Totality and Infinity*, 225.

20. Ibid., 262.

21. Kundera, *The Book of Laughter and Forgetting*, 4.

22. Foucault, *The History of Sexuality*, 93.

23. This is the first lesson that McNamara offers in Morris's film *The Fog of War*.

24. Chandler's *Voices from S-21* is a powerful account of the prison and its victims, as is Maguire's *Facing Death in Cambodia*.

25. Becker's *When the War Was Over* was helpful in understanding this history.

26. Ratner, *In the Shadow of the Banyan*, 277.

27. Panh and Bataille, *The Elimination*, Kindle edition, loc. 2110.

28. Ibid., loc. 418.

29. Michael Paterniti, "Never Forget," 9.

30. Panh and Bataille, *The Elimination*, Kindle edition, loc. 678.

31. Ibid., loc. 3098.

32. Ibid., loc. 1298.
33. Ibid., loc. 2998.
34. Ibid., loc. 3004.
35. Ibid., loc. 2866.
36. Ibid., loc. 2164.
37. Ibid., loc. 1881.
38. Ibid., loc. 928.
39. Ibid., loc. 1736.
40. Ibid., loc. 2195.
41. Ibid., loc. 2202.
42. Dunlop, *The Lost Executioner*, 23.
43. Sebald quoted in Schwartz, *The Emergence of Memory*, loc. 591–93.
44. Panh and Bataille, *The Elimination*, Kindle edition, loc. 1547.
45. Kundera, *The Book of Laughter and Forgetting*, 85–87.
46. Levinas, *Totality and Infinity*, 303.
47. Ibid., "the Other is not the incarnation of God, but precisely by his face, in which he is disincarnate, is the manifestation of the height in which God is revealed" (79).
48. Ibid., 261.
49. Ibid., 233.
50. Ibid., 71.
51. Ibid., 51.

4. ON WAR MACHINES

1. Nietzsche, *On the Genealogy of Morals*, 497.
2. Sebald, *On the Natural History of Destruction*, 89.
3. Herr, *Dispatches*, 260.
4. Rowe, "'Bringing It All Back Home,'" 197.
5. The album is Rage Against the Machine's self-titled debut album. The rock star is Dave Navarro of Jane's Addiction and the Red Hot Chili Peppers. A video of the MTV Cribs episode can be seen on YouTube: https://www.youtube.com/watch?v=OXJVxwAdOUg.
6. Sturken, *Tangled Memories*, 8.
7. Farocki, *Inextinguishable Fire*.
8. An account of the work of and difficulties faced by North Vietnamese photographers can be found in *Requiem*, edited by Faas and Page.

9. Williams, *Marxism and Literature*, 131–32.

10. Marx and Engels, *The German Ideology*, 64.

11. On technologies of memory and this war, see Sturken, *Tangled Memories*, 9–10.

12. Iyer, *Video Night in Kathmandu*, 3.

13. See "Virtual Reality Exposure Therapy" (no author) and Calverley, "Next Generation War Games."

14. Bergson, in *Matter and Memory*, speaks of how "representation is there, but always virtual" (28), while our perceptions are "interlaced with memories" whose existence is implied as virtual, for "a memory . . . only becomes actual borrowing the body of some perception into which it slips" (72).

15. Makuch, "Destiny Reaches 16 Million Registered Users, Call of Duty Franchise Hits $11 Billion."

16. See Keen, *Empathy and the Novel*.

17. Grossman in *On Killing* lays particular blame on video games for desensitizing children toward violence. His stance of moral outrage at video games obscures the more disturbing reality that it is the war machine that produces video games and which encourages violence in children through a lifetime barrage of messages concerning patriotism, nationalism, the evil of unknowable others, the holiness of the Second Amendment, and so on.

18. Apostol, *The Gun Dealers' Daughter*, 122.

19. The evidence of American and other tourist reactions is found in the guest books available in many museums, which invite visitors to record their reactions and sentiments. See Laderman's *Tours of Vietnam* for a look at some of these American tourist reactions to the War Remnants Museum.

20. See Becker, "Pilgrimage to My Lai," for one account of this kind of journey.

21. For accounts of American veterans and their returns to Vietnam, including their encounters with Vietnamese memorials and memories, see Bleakney, *Revisiting Vietnam*.

22. McCarthy, *The Seventeenth Degree*, 268.

23. Irwin, "Viet Reparations Ruled Out."

24. Johnson uses the phrase "empire of bases" several times, as a core concept of his argument, throughout *The Sorrows of Empire*.

25. Coppola delivered these lines at the Cannes Film Festival in 1979, a moment recorded in his wife Eleanor Coppola's documentary *Hearts of Darkness*.
26. Baudrillard, *Simulacra and Simulation*, 59.
27. Herr, *Dispatches*, 160
28. Swofford, *Jarhead*, 6–7.
29. Appy, *Patriots*, 216.
30. Karlin, Khuê, and Vu, eds., *The Other Side of Heaven*, 11.
31. Fitzgerald in *Fire in the Lake* discusses the American military's use of "Indian country" to describe areas outside of their control, 368.
32. Virilio, *War and Cinema*, 26.
33. Trinh, "All-Owning Spectatorship."
34. Espiritu, *Body Counts*, 83.
35. Chin and Chan, "Racist Love."
36. "Remarks of Senator John F. Kennedy at the Conference on Vietnam Luncheon in the Hotel Willard, Washington, D.C."
37. See Kim's *Ends of Empire* for an accounting of how Asia and Asian Americans have been shaped by American Cold War conflicts and policies.
38. Baudrillard, *Simulacra and Simulation*, 60.

5. ON BECOMING HUMAN

1. Cumings's *The Korean War* provides the historical information on the war for this chapter.
2. See Gooding-Williams's edited volume *Reading Rodney King, Reading Urban Uprising* for more on the events in Los Angeles.
3. For an account of Korean immigrants in Los Angeles, see Abelmann and Lie, *Blue Dreams*.
4. Jager, "Monumental Histories," 390.
5. Moon describes militarized modernity thus in relation to South Korea: "The core elements of militarized modernity involved the construction of the Korean nation as the anticommunist self at war with the communist other, the constitution of members of the anticommunist body politic through discipline and physical force, and the intertwining of the industrializing economy with military service. The

militarization of national identity as such revolved around the ideologies of anticommunism and national security. In other words, South Korea was founded as an anticommunist nation against the 'archenemy,' North Korea. This ideological construction of the nation enabled the modernizing state to deploy disciplinary techniques of surveillance and normalization, as well as institutionalized violence, in its remolding of individuals and social groups. It also resulted in the ascendance of militarized national security over any other sociopolitical issues and justified the construction of the strong modern military and the integration of men's military service into the organization of the economy" (*Militarized Modernity and Gendered Citizenship in South Korea*, 24).

6. Cumings connects Korea's sanitized memory of the Korean War with its sanitized memory of its role in this war in his article "The Korean War."

7. See Lee's "Surrogate Military, Subimperialism, and Masculinity," 657, for the characterization of South Korea as a subempire. The idea of East Asian nations, particularly Japan, Korea, and Taiwan, as subempires who have a neocolonial relationship with the United States comes from Chen's *Asia as Method*.

8. The book was first translated into English in 1994 and then again in 2014, both with the same translator. I cite from the later edition. For more on the significance of this novel, see Hughes's "Locating the Revolutionary Subject."

9. Korean names have been romanized in different ways. Hwang Suk-Yong, for example, also appears in different editions or critical discussions as Hwang Suk-Young and Hwang Seok-young. I follow the romanization of author, director, and character names according to the way they appear in the editions of the texts, covers, and movies I cite.

10. Hwang, *The Shadow of Arms*, 65.

11. Ibid., 66.

12. Park, "Narratives of the Vietnam War by Korean and American Writers," 76.

13. Hwang, *The Shadow of Arms*, 137.

14. As both Moon (*Militarized Modernity and Gendered Citizenship in South Korea*) and Choi ("The Discourse of Decolonization and Popular Memory") argue in different ways, South Koreans have an am-

bivalent relationship to the West and what it represents. For Moon, the South Korean embrace of Western modernity is tinged with an awareness that Western modernity is a legacy of colonialism. Choi argues that South Korea still suffers from a neocolonial relationship with the United States. This ambivalence about being formerly colonized, but implicated in helping the United States colonize or dominate other countries, helps shape Korean attitudes toward the Vietnamese.

15. Hwang, *The Shadow of Arms*, 41.
16. Ibid., 399.
17. Ibid., 46.
18. See Ryu ("Korea's Vietnam," 106) for the full lyrics and for an account of the song's popularity and the eventual movie based on it. Kwon (*After the Massacre*, vii) affirms the song's popularity, recounting how he sang the song as a youngster during wartime. In popular cultural accounts circulating within Korea after the war, the Korean veteran of the war is featured in "proud, boastful reproductions of the legendary ROK," or Republic of Korean soldier (Ryu, "Korea's Vietnam," 102). Perhaps this is not surprising, given how the Korean public did not oppose the war and, according to Moon, did not participate in the global movement against the war that was strong even in nearby Japan. Instead, that public was subject to the Korean state's efforts at "mass mobilization and propaganda," whereby "students were exhorted to send comfort letters and comfort goods to Korean soldiers serving in Vietnam. The mass media produced a plethora of images and stories supporting the everyday mythology of brave and ferocious Korean soldiers fighting in the war" (*Militarized Modernity and Gendered Citizenship in South Korea*, 26).
19. Hwang, *The Shadow of Arms*, 67.
20. The presence of soldier and prostitute are evidence of what Lee calls "sexual proletarianization," where Korea encouraged poor rural men to volunteer for Vietnam as "military labor" and poor women to export themselves as sexual labor ("Surrogate Military, Subimperialism, and Masculinity," 656). Hwang mentions Korean soldiers sending appliances home on p. 239 of *The Shadow of Arms*.
21. On Korean attitudes toward whiteness and blackness, and how those have been shaped by the United States and its military presence in South Korea, see Kim, *Imperial Citizens*.

22. Armstrong accounts for the movie's Korean title of *White War* (*Hayan chonjaeng*) in "America's Korea, Korea's Vietnam," 539n22.

23. Ahn, *White Badge*, 289.

24. Ibid., 40.

25. See Cumings ("The Northeast Asian Political Economy"), Woo (*Race to the Swift*, 45–117), and Woo-Cumings ("Market Dependency in U.S.–East Asian Relations") for the details of the Korean economy's relationship to the Republic of Vietnam during the war and the consequences of the relationship for Korea's rise.

26. Ahn, *White Badge*, 40.

27. Ibid., 155.

28. Ibid., 69. "Hungry and poor, they were eager to prove their masculinity," says Lee. The Korean soldiers became miniaturized versions of Americans, "vengefully mimetic and reiterative" ("Surrogate Military, Subimperialism, and Masculinity," 663–64).

29. Ahn, *White Badge*, 154.

30. Ibid., 155.

31. Ibid., 78.

32. Ibid., 278.

33. Ibid., 314.

34. Ibid., 155.

35. Cumings, "The Northeast Asian Political Economy," 129.

36. For a detailed reading of the novel and its film adaptation, see Williams, "From Novel to Film."

37. See the essays in Stringer's *New Korean Cinema* for more on this topic.

38. Jeffords, *The Remasculinization of America*, and Kim, *The Remasculinization of Korean Cinema*.

39. As Ryu argues, the vengeful female ghost exists as a sign of what Koreans continue to find unthinkable, the fact that Korean soldiers, as implied in the movie, carried out "unspeakable tales of gendered violence" that included "an entire range of sexual activity from rape to prostitution to abandonment of Vietnamese common-law wives and children that formed the off-the-battlefield reality for so many soldiers" ("Korea's Vietnam," 111).

40. The theme of ghosts, haunting, and trauma surface also in a South Korean musical about the Vietnam War, *Blue Saigon*, which was performed in 2002 at the National Theater in Seoul and was presum-

ably known by the makers of *R-Point*. The musical follows the sole survivor of a Korean unit, Sergeant Kim, as he lies dying in contemporary Korea of illness brought on by American-sprayed Agent Orange (another reference to the black-faced Sergeant Kim of popular song). Sergeant Kim's daughter is also disabled by the effects of Agent Orange on her father, while his half-son from a Vietnamese bar hostess and Viet Cong agent has finally come to visit Korea, where he is disillusioned by what he finds. As Sergeant Kim lies dying, a ghostly woman appears by his bedside, singing "Blue Saigon." In many ways, then, *Blue Saigon* occupies the same territory of memory as the other works mentioned here. For the summary of the musical and the intentions of its producers, see Kirk, "Confronting Korea's Agony in Vietnam."

41. The motif of "friendly fire" is prevalent in American memories of the war, as Kinney shows in *Friendly Fire*. Korean movies about the war evoke these Hollywood themes for the same purpose, to make the war about Koreans rather than Vietnamese.

42. Jager and Jiyul in "The Korean War after the Cold War," 234, describe this claim.

43. In Vietnamese, the part about Korean soldiers calls them "Park Chung Hee's mercenaries" (*bọn lính dánh thuê Pắc Chung Hy*).

44. Ky writes that "many South Korean and Thai volunteers . . . bought cheap appliances in American PXes and either shipped them home to be sold on the black market or sold them to a Vietnamese for triple their cost. But these men . . . were poor and underpaid, and I understood from personal experience why they did wrong" (*Buddha's Child*, 164).

45. Brigham, *ARVN: Life and Death in the South Vietnamese Army*, 60.

46. Michèle Ray's segment from the omnibus antiwar film *Loin du Vietnam* (Far from Vietnam, directed by Joris Ivens et al.) discusses how the "Vietnamese don't like and fear these Koreans" (at the 1 hour and 11 minute mark).

47. Hayslip, *When Heaven and Earth Changed Places*, 198.

48. Kwon, *After the Massacre*, 29.

49. Ryu calls the song a "mega-hit" ("Korea's Vietnam," 104).

50. On how memories of Korean soldiers and their actions affect postwar relations between Vietnamese civilians and the Vietnamese state, see Kwon's *After the Massacre*.

51. King, "Address at the Fourth Annual Institute of Nonviolence and Social Change at Bethel Baptist Church," 338.

52. Ibid., 339.

53. For the Korean American perspective on the Los Angeles rebellion, and an account of the death of the lone Korean American, see the documentary *Sa-I-Gu*.

54. I owe great thanks to Heonik Kwon for providing me with the directions to the memorial. His work on the memorial in *After the Massacre* informs much of my discussion of the memorial, as does Kim's "Korea's 'Vietnam Question.'"

6. ON ASYMMETRY

1. Yamashita, *The I-Hotel*, 2.

2. Gustafsson, *War and Shadows*, xiii.

3. See Taylor's *Vietnamese Women at War* and Turner and Phan's *Even the Women Must Fight* for studies of Vietnamese women during the war.

4. Comments made at the event "Dreaming of Peace."

5. For a collection of images of these lighters, see Buchanan's *Vietnam Zippos*.

6. The paragraphs on the Zippo lighter are adapted from my article "The Authenticity of the Anonymous."

7. Mbembe, "Necropolitics," 29.

8. Kundera, *The Book of Laughter and Forgetting*, 30–31.

9. The description of the photograph's physical condition comes from a private correspondence by email from Horst Faas, June 2, 2003.

10. Faas and Page, *Requiem*, 315.

11. Ricoeur, *Memory, History, Forgetting*, 15–19.

12. Young, *The Texture of Memory*, 5.

13. On the research that says the dead far outnumber the living, at about fifteen to one, see Stephenson, "Do the Dead Outnumber the Living?"

14. Ricoeur, *Memory, History, Forgetting*, 166.

7. ON VICTIMS AND VOICES

1. The first six paragraphs of this chapter are adapted from my essay "Speak of the Dead, Speak of Viet Nam."

2. Bao Phi, "You Bring Out the Vietnamese in Me," from *Sông I Sing* (11). Of course, my thinking here on photographs and their relation to the dead is influenced by Sontag (*On Photography*, *Regarding the Pain of Others*), Barthes (*Camera Lucida*), and Sebald (*Austerlitz*, among many of his works).

3. thuy, *The Gangster We Are All Looking For*, 99.

4. Nguyen-Vo, "Forking Paths," 159.

5. Kingston, *The Woman Warrior*, 3.

6. Ibid., 19.

7. Hayslip, *When Heaven and Earth Changed Places*, 15.

8. Gordon, *Ghostly Matters*, 187.

9. Espiritu, *Body Counts*, 23.

10. Sollors, *Multilingual America*.

11. On the distinction between race and ethnicity, see Takaki, ed., *From Different Shores: Perspectives on Race and Ethnicity in America*, and Omi and Winant, *Racial Formation in the United States*.

12. The academic and journalistic accounts of the divisions within American culture about the meaning of the war are many. Here is just a sampling, their titles perhaps enough to indicate some of these meanings: Anderson and Ernst, eds., *The War that Never Ends*; Appy, *American Reckoning*; Bates, *The Wars We Took to Vietnam*; Christopher, *The Viet Nam War/The American War*; Hellman, *American Myth and the Legacy of Vietnam*; Rowe and Berg, *The Vietnam War and American Memory*; Turner, *Echoes of Combat*.

13. Pelaud, *this is all i choose to tell*.

14. Some sample articles in the popular press evoking this war in relation to contemporary wars, published during the writing of this chapter, include: Friedman, "ISIS and Vietnam"; Logevall and Goldstein, "Will Syria Be Obama's Vietnam?"; Packer, "Obama and the Fall of Saigon."

15. For an historical account of Vietnamese American literature, see Janette's *Mỹ Việt*.

16. Waters, *Ethnic Options*.

17. Le, *The Boat*.

18. On the theme of betrayal in ethnic literature, see Bow, *Betrayal and Other Acts of Subversion*, and Parikh, *An Ethics of Betrayal*.

19. C. Wong, "Sugar Sisterhood."

20. Cao, *The Lotus and the Storm*, Kindle edition, loc. 80.

21. Nguyen, *The People of the Fall*. Critic Mimi Thi Nguyen calls this bind of gratitude and betrayal "the gift of freedom," from her book of the same title.

22. Wittgenstein, *Tractatus Logico-Philosophicus*, 89.

23. Espiritu, *Body Counts*, 101.

24. See Wang's "The Politics of Return" for a study of this return in Vietnamese American literature.

25. O'Connor, *Mystery and Manners*, 86.

26. McGurl, *The Program Era*.

27. Truong, "Vietnamese American Literature," 235.

28. Palumbo-Liu, *The Deliverance of Others*, 1.

29. Duong, *Treacherous Subjects*, 1–22.

30. Nguyen, *Pioneer Girl*.

31. Kinnell, "The Dead Shall Be Raised Incorruptible," from *The Book of Nightmares*.

32. thuy, *The Gangster We Are All Looking For*, 160.

33. Trinh, *Woman Native Other*, 7.

34. Ibid., 98.

35. Dinh, *Love like Hate*, Kindle edition, loc. 113.

36. Hong, "Delusions of Whiteness in the Avant-Garde."

37. Dinh, *Postcards from the End of America*, http://linhdinhphotos.blogspot.com/.

38. Martin Luther King Jr. in a 1966 interview with Mike Wallace for *CBS Reports*. http://www.cbsnews.com/news/mlk-a-riot-is-the-language-of-the-unheard/.

39. Phi, *Sông I Sing*, 9.

40. Ibid., 39.

41. Ibid., 78.

42. Baldwin, *No Name on the Street*, 167.

43. Sontag, *Regarding the Pain of Others*, 112.

44. Ibid., 113.

45. Acosta, *Revolt of the Cockroach People*, 201.

46. Díaz, *The Brief Wondrous Life of Oscar Wao*, 4. Judy Tzu-Chun Wu provides historical context for American minority radicals who sought to build international connections with Chinese and Vietnamese communists in *Radicals on the Road: Internationalism, Orientalism, and Feminism during the Vietnam Era*.

8. ON TRUE WAR STORIES

1. Kingston, *China Men*, 284.
2. O'Brien, *The Things They Carried*, 76–77.
3. Hayslip, *When Heaven and Earth Changed Places*, 97.
4. Ibid.
5. Ibid., 15.
6. James, *The Moral Equivalent of War*, 3.
7. Miles and Roth, *From Vietnam to Hollywood*, 20.
8. O'Brien, *Journey from the Fall*, 226.
9. Žižek, *How to Read Lacan*, 47.
10. Hinton et al., "Assessment of Posttraumatic Stress Disorder in Cambodian Refugees Using the Clinician-Administered PTSD Scale," and Marshall et al., "Mental Health of Cambodian Refugees 2 Decades after Resettlement in the United States."
11. Žižek, *How to Read Lacan*, 47.
12. Chang, *Inhuman Citizenship*, 14.
13. Heinemann, *Paco's Story*, 195.
14. Ibid., 209.
15. "The Latehomecomers," *Entertainment Weekly*.
16. Artist's talk at the "Southeast Asians in the Diaspora" Conference, University of Illinois, Urbana-Champaign, April 16, 2008.
17. Thiep, *The General Retires*, 102.
18. Ibid., 104.
19. Ibid., 113.
20. These paragraphs on "Cun" have been adapted from my essay on "What Is the Political? American Culture and the Example of Viet Nam."
21. Mishra, "Why Salman Rushdie Should Pause Before Condemning Mo Yan on Censorship."
22. Said, *Culture and Imperialism*.
23. Mishra, "Why Salman Rushdie Should Pause Before Condemning Mo Yan on Censorship."
24. Yang, *The Latehomecomer*, 46
25. Ibid., 4.
26. Ibid., 46.
27. Ibid., 93.

28. See also Cargill and Huynh's *Voices of Vietnamese Boat People*, Kindle edition, loc. 1341 and 1798 for the unsanitary conditions of refugee camps.
29. O'Brien, *The Things They Carried*, 161.
30. Jin, *The Writer as Migrant*, 4.
31. Moua, *Bamboo among the Oaks*, 10.
32. Bhabha, *The Location of Culture*, 87.

9. ON POWERFUL MEMORY

1. Kipling, *Kipling*, 97–98.
2. Trinh, *Woman Native Other*, 10–11.
3. In her valuable work on *War, Genocide, and Justice*, Schlund-Vials argues that S-21 encourages visitors to see its history through the eyes of the prison's administration and guards (43). If so, this is one possible reason why the Khmer may not be interested in visiting.
4. Um, "Exiled Memory," 832.
5. Ricoeur, *Memory, History, Forgetting*, 457.
6. Hayslip, *When Heaven and Earth Changed Places*, xiv.
7. Ibid., 365.
8. Ibid.
9. Ibid., xv.
10. Ibid., 365.
11. Storr, *Dislocations*, 28.
12. Ibid., xv.
13. Scarry, *The Body in Pain*, 131.
14. Utley, "12 Reasons Why America Doesn't Win Its Wars."
15. Some of the sources that inform this discussion on sympathy, empathy, and compassion are Berlant, "Introduction"; Edelman, *No Future*, 67–100; Garber, "Compassion"; Keen, *Empathy and the Novel*; Song, *Strange Future*, 87–90; and Yui, "Perception Gaps between Asia and the United States of America," 71.
16. Sontag, *Regarding the Pain of Others*, 101.
17. Hirsch, "From 'The Generation of Postmemory,'" 347. See also Hirsch, *Family Frames*.
18. Ollman, "Dinh Q. Le at Shoshana Wayne."

19. Cotter, "Two Sides' Viewpoints on the War in Vietnam."
20. Sontag, *Regarding the Pain of Others*, 70.
21. The analysis of Lê is adapted from my essay "Impossible to Forget, Difficult to Remember: Vietnam and the Art of Dinh Q. Lê."
22. Morrison, *Beloved*, 44.
23. The commentary on cosmopolitanism is extensive. For a few sources, see Appiah, *Cosmopolitanism*; Archibugi, "Cosmopolitical Democracy"; Brennan, *At Home in the World* and "Cosmopolitanism and Internationalism"; Cheah and Robbins, *Cosmopolitics*; Clifford, *Routes*; Derrida, *On Cosmopolitanism and Forgiveness*; Douzinas, *Human Rights and Empire*; Gilroy, *Against Race* and *Postcolonial Melancholia*; Hollinger, "Not Universalists, Not Pluralists"; Kant, *To Perpetual Peace*; Kaplan, *Questions of Travel*; Nussbaum, "Patriotism and Cosmopolitanism"; Srikanth, *The World Next Door*; and Vertovec and Cohen, *Conceiving Cosmopolitanism*.
24. Appiah, *Cosmopolitanism*, 85.
25. Ibid., 144.
26. Gilroy, *Postcolonial Melancholia*, 59–60.
27. Scarry, "The Difficulty of Imagining Other People," 105.
28. Ibid., 103.
29. Kingsolver, "A Pure, High Note of Anguish."
30. King, "Beyond Vietnam," 151.
31. For accounts of the book's impact and popularity, see the essays by Fox, "Fire, Spirit, Love, Story"; Vo, "Memories That Bind"; and Vuong, "*The Diary of Dang Thuy Tram* and the Postwar Vietnamese Mentality."
32. Tram, *Last Night I Dreamed of Peace*, 27 and 111.
33. Ibid, 114. The quotations are drawn from the English edition of the diary, although I have cross-checked these translations with the original Vietnamese edition.
34. Ibid., 158.
35. Ibid., 83 and 47, respectively.
36. Ibid., 96.
37. Ibid., 83.
38. Ibid., 86.
39. Ibid., 104.
40. Nussbaum, "Patriotism and Cosmopolitanism," 6.

41. Kingston, *Fifth Book of Peace*, 227.
42. The arguments about compassion, cosmopolitanism, and peace in this chapter have been adapted from my article "Remembering War, Dreaming Peace."
43. Kingston, *Fifth Book of Peace*, 61.

JUST FORGETTING

1. Thiep, "Don't Cry in California," 602, italics in original, my translation from his story "Khong Khoc O California."
2. Ibid., 599 and 600, italics in original.
3. Hanh, *Fragrant Palm Leaves*, Kindle edition, loc. 1837.
4. Vang, "Heirs of the 'Secret War' in Laos."
5. For insightful accounts of the genre of the Hmong story cloth, see Conquergood, "Fabricating Culture," and Chiu, "'I Salute the Spirit of My Communities.'"
6. The Chas' story cloth can be found in Cha, *Dia's Story Cloth*.
7. This paragraph is adapted from my article on "Refugee Memories and Asian American Critique."
8. Walcott, "The Schooner Flight," *Collected Poems*, 330.
9. UN News Centre, "UN Warns of 'Record High' 60 Million Displaced amid Expanding Global Conflicts."
10. Walcott, "The Schooner Flight," *Collected Poems*, 334.
11. Davies, "Vietnam 40 Years On."
12. Among many such articles, Pincus' "In Iraq, Lessons of Vietnam Still Resonate" was published as I wrote the last few chapters of this book.
13. O'Reilly, "Q&A: Doris Lessing Talks to Sarah O'Reilly about *The Golden Notebook*," loc. 11316.
14. Derrida, *On Cosmopolitanism and Forgiveness*, 31–32.
15. Ibid., 27.
16. Ibid., 31.
17. Ibid., 33–34.
18. Ibid., 39.
19. Hanh, *The Miracle of Mindfulness*, Kindle edition, loc. 741.
20. Griswold, *Forgiveness*, 29.
21. Ibid., 30.
22. Margalit, *The Ethics of Memory*, 193.

23. "Forgive," Oxford English Dictionary.
24. Connerton in *How Modernity Forgets* discusses how forgetting is an integral part of capitalism and modernity, which the gift is supposed to counteract through compelling memory (53).
25. Ricoeur, *Memory, History, Forgetting*, 481.
26. Ehrhart, "The Invasion of Grenada."
27. Hyde, *The Gift*, 258.
28. Short's *Pol Pot* was a helpful source in studying the life of the Khmer Rouge leader.
29. Dunlop, *The Lost Executioner*, 22.

EPILOGUE

1. Marker, *Sans Soleil*.
2. Ibid.
3. Spiegelman, *Metamaus*, 60.
4. Parts of this epilogue are adapted from my article "War, Memory and the Future."

Works Cited

Abelmann, Nancy, and John Lie. *Blue Dreams: Korean Americans and the Los Angeles Riots*. Cambridge, MA: Harvard University Press, 1997.

Acosta, Oscar Zeta. *Revolt of the Cockroach People*. New York: Vintage, 1989.

Aguilar-San Juan, Karin. *Little Saigons: Staying Vietnamese in America*. Minneapolis: University of Minnesota Press, 2009.

Ahn, Junghyo. *White Badge: A Novel of Korea*. New York: Soho Press, 1989.

Anderson, David L., and John Ernst. *The War that Never Ends: New Perspectives on the Vietnam War*. Lexington: University Press of Kentucky, 2007.

Apostol, Gina. *The Gun Dealers' Daughter*. New York: W. W. Norton, 2012. Kindle edition.

Appiah, Kwame Anthony. *Cosmopolitanism: Ethics in a World of Strangers*. New York: W. W. Norton, 2006.

Appy, Christian G. *American Reckoning: The Vietnam War and Our National Identity*. New York: Viking, 2015. Kindle edition.

———. *Patriots: The Vietnam War Remembered from All Sides*. New York: Viking, 2003.

Aptheker, Herbert. *Dr. Martin Luther King, Vietnam, and Civil Rights*. New York: New Outlook Publishers, 1967.

Archibugi, Daniele. "Cosmopolitical Democracy." In *Debating Cosmopolitics*, edited by Daniele Archibugi, 1–15. New York: Verso, 2003.

Arendt, Hannah. *Eichmann in Jerusalem: A Report on the Banality of Evil*. New York: Viking, 1963.

Armstrong, Charles K. "America's Korea, Korea's Vietnam." *Critical Asian Studies* 33, no. 4 (2001): 527–39.

Ashabranner, Brent. *Always to Remember: The Story of the Vietnam Veterans Memorial*. New York: G. P. Putnam's Sons, 1988.

Ashplant, T. G., Graham Dawson, and Michael Roper. "The Politics of War Memory and Commemoration: Contexts, Structures and Dynamics." In *The Politics of War Memory and Commemoration*, edited by T. G. Ashplant, Graham Dawson, and Michael Roper, 3–85. London: Routledge, 2000.

Assman, Jan. "From *Moses the Egyptian: The Memory of Egypt in Western Monotheism*." In *The Collective Memory Reader*, edited by Jeffrey K. Olick, Vered Vinitzky-Seroussi, and Daniel Levy, 209–15. New York: Oxford University Press, 2011.

Augé, Marc. "From *Oblivion*." In *The Collective Memory Reader*, edited by Jeffrey K. Olick, Vered Vinitzky-Seroussi, and Daniel Levy, 473–74. New York: Oxford University Press, 2011.

Balaban, John. *Remembering Heaven's Face: A Story of Wartime Rescue in Vietnam*. Athens: University of Georgia Press, 2002.

Baldwin, James. *No Name in the Street*. New York: Dell, 1972.

Bao Ninh, *The Sorrow of War*. New York: River head, 1996.

Barthes, Roland. *Camera Lucida: Reflections on Photography*. Translated by Richard Howard. New York: Hill and Wang, 1981.

Bates, Milton J. *The Wars We Took to Vietnam: Cultural Conflict and Storytelling*. Berkeley: University of California Press, 1996.

Baudrillard, Jean. *Simulacra and Simulation*. Translated by Sheila Faria Glaser. Ann Arbor: University of Michigan Press, 1994.

Becker, Carol. "Pilgrimage to My Lai: Social Memory and the Making of Art." *Art Journal* 62, no. 4 (2003): 50–65.

Becker, Elizabeth. *When the War Was Over: Cambodia and the Khmer Rouge Revolution*. New York: PublicAffairs, 1998.

Behdad, Ali. *A Forgetful Nation: On Immigration and Cultural Identity in the United States*. Durham, NC: Duke University Press, 2005.

Bennett, Jill. *Empathic Vision: Affect, Trauma, and Contemporary Art*. Stanford, CA: Stanford University Press, 2005.

Bercovitch, Sacvan. *The Rites of Assent: Transformations in the Symbolic Construction of America*. New York: Routledge, 1993.

Bergson, Henri. *Matter and Memory*. New York: Cosimo Classics, 2007.

Berlant, Lauren. "Introduction: Compassion (and Withholding)." In *Compassion: The Culture and Politics of an Emotion*, edited by Lauren Berlant, 1–13. New York: Routledge, 2004.

Bhabha, Homi. *The Location of Culture*. New York: Routledge, 1994.

Blackburn, Robert M. *Mercenaries and Lyndon Johnson's "More Flags."* Jefferson, NC: McFarland and Company, 1994.

Bleakney, Julia. *Revisiting Vietnam: Memoirs, Memorials, Museums*. New York: Routledge, 2006.

Blustein, Jeffrey. *The Moral Demands of Memory*. Cambridge: Cambridge University Press, 2008.

Borges, Jorge Luis. *Ficciones*. New York: Grove Press, 1994.

Bow, Leslie. *Betrayal and Other Acts of Subversion: Feminism, Sexual Politics, Asian American Women's Literature*. Princeton, NJ: Princeton University Press, 2001.

Boym, Svetlana. *The Future of Nostalgia*. New York: Basic Books, 2001.

Bradley, Mark. *Vietnam at War*. New York: Oxford University Press, 2009.

Bradley, Mark, and Marilyn B. Young, eds. *Making Sense of the Vietnam Wars: Local, National, and Transnational Perspectives*. New York: Oxford University Press, 2008.

Brennan, Timothy. *At Home in the World: Cosmopolitanism Now*. Cambridge, MA: Harvard University Press, 1997.

———. "Cosmopolitanism and Internationalism." In *Debating Cosmopolitics*, edited by Daniele Archibugi, 40–50. New York: Verso, 2003.

Brigham, Robert K. *ARVN: Life and Death in the South Vietnamese Army*. Lawrence: University Press of Kansas, 2006.

Brochure for War Memorial of Korea. Seoul, Korea: np.

Buchanan, Sherry. *Vietnam Zippos: American Soldiers' Engravings and Stories, 1965–1973*. Chicago: University of Chicago Press, 2007.

Bui Thac Chuyen. *Living in Fear*. Hanoi: Vietnam Feature Film Studio, 2006.

Butler, Judith. *Frames of War: When Is Life Grievable?* New York: Verso, 2009.

———. *Precarious Life: The Powers of Mourning and Violence*. New York: Verso, 2004.

Butler, Robert Olen. *A Good Scent from a Strange Mountain*. New York: Henry Holt, 1992.

Cao, Lan. *The Lotus and the Storm*. New York: Viking, 2014.

Calverley, Bob. "Next Generation War Games." *USC Trojan Family Magazine*, Spring 2002. http://tfm.usc.edu/spring-2002/next-generation -war-games.

Cargill, Mary Terrell, and Jade Ngoc Quang Huynh, eds. *Voices of Vietnamese Boat People: Nineteen Narratives of Escape and Survival*. Jefferson, NC: McFarland, 2001. Kindle edition.

Caruth, Cathy. *Unclaimed Experience: Trauma, Narrative, and History*. Baltimore: Johns Hopkins University Press, 1996.

Cha, Dia. *Dia's Story Cloth*. Denver: Denver Museum of Natural History, 1996.

Chandler, David. *Voices from S-21: Terror and History in Pol Pot's Secret Prison*. Berkeley: University of California Press, 2000.

Chang, Juliana. *Inhuman Citizenship: Traumatic Enjoyment and Asian American Literature*. Minneapolis: University of Minnesota Press, 2012.

Cheah, Pheng. *Inhuman Conditions: On Cosmopolitanism and Human Rights*. Cambridge, MA: Harvard University Press, 2006.

Cheah, Pheng, and Bruce Robbins, eds. *Cosmopolitics: Thinking and Feeling Beyond the Nation*. Minneapolis: University of Minnesota Press, 1998.

Chen, Kuan-Hsing. *Asia as Method: Toward Deimperialization*. Durham: Duke University Press, 2010.

Ch'ien, Evelyn. *Weird English*. Cambridge, MA: Harvard University Press, 2005. Kindle edition.

Chin, Frank, and Jeffery Paul Chan. "Racist Love." In *Seeing through Shuck*, edited by Richard Kostelanetz, 65–79. New York: Ballantine Books, 1972.

Chiu, Jeannie. "'I Salute the Spirit of My Communities': Autoethno- graphic Innovations in Hmong American Literature." *College Literature* 31, no. 3 (2004): 43–69.

Cho, Grace. *Haunting the Korean Diaspora: Shame, Secrecy, and the Forgotten War*. Minneapolis: University of Minnesota Press, 2008.

Choi, Chungmoo. "The Discourse of Decolonization and Popular Memory: South Korea." *positions: east asia cultures critique* 1, no. 1 (1993): 77–102.

Chong, Denise. *The Girl in the Picture: The Story of Kim Phuc, Whose Image Altered the Course of the Vietnam War*. New York: Viking Adult, 2000.

Chong, Sylvia Shin Huey. *The Oriental Obscene: Violence and Racial Fantasies in the Vietnam Era*. Durham, NC: Duke University Press, 2011.

Chow, Rey. *Ethics after Idealism: Theory-Culture-Ethnicity-Reading*. Bloomington: Indiana University Press, 1998.

Choy, Christine, and Dai Sil Kim-Gibson. *Sa-I-Gu*. San Francisco: CrossCurrent Media: Distributed by National Asian American Telecommunications Association, 1993.

Christopher, Renny. *The Viet Nam War/the American War: Images and Representations in Euro-American and Vietnamese Exile Narratives*. Amherst: University of Massachusetts Press, 1995.

Clifford, James. *Routes: Travel and Translation in the Late Twentieth Century*. Cambridge, MA: Harvard University Press, 1997.

Connerton, Paul. *How Modernity Forgets*. Cambridge: Cambridge University Press, 2009.

———. "Seven Types of Forgetting." *Memory Studies* 1, no. 1 (2008): 59–71.

Conquergood, Dwight. "Fabricating Culture: The Textile Art of Hmong Refugee Women." In *Performance, Culture, and Identity*, edited by Elizabeth C. Fine and Jean Haskell Speer, 207–48. Westport, CT: Praeger, 1992.

Coppola, Eleanor. *Hearts of Darkness*. Hollywood: Paramount Home Entertainment, 1991.

Coppola, Francis Ford. *Apocalypse Now*. Santa Monica: Lionsgate, 1978.

Cotter, Hollan. "Two Sides' Viewpoints on the War in Vietnam." *New York Times*, December 9, 2005, E35.

Cumings, Bruce. *The Korean War: A History*. New York: Modern Library, 2010.

———. "The Korean War: What Is It that We Are Remembering to Forget?" In *Ruptured Histories: War, Memory, and the Post-Cold War in Asia*, edited by Sheila Miyoshi Jager and Rana Mitter, 266–90. Cambridge, MA: Harvard University Press, 2007.

———. "The Northeast Asian Political Economy." In *What Is in a Rim? Critical Perspectives on the Pacific Region Idea*, edited by Arif Dirlik, 99–141. Lanham, MD: Rowman and Littlefield, 1998.

Dang Nhat Minh. Speech given at "Dreaming of Peace: Vietnamese Filmmakers Move from War to Reconciliation," University of Southern California, January 23, 2010.

Dang Thuy Tram. *Last Night I Dreamed of Peace*. New York: Harmony Books, 2007.

———. *Nhat Ky Dang Thuy Tram* [The Diary of Dang Thuy Tram]. Hanoi: Nha Xuat Ban Hoi Nha Van, 2005.

Davey, Monica. "In Kansas, Proposed Monument to a Wartime Friendship Tests the Bond." *New York Times*, August 2, 2009.

Davies, Nick. "Vietnam 40 Years On: How a Communist Victory Gave Way to Capitalist Corruption." *The Guardian*, April 22, 2015.

de Palma, Brian. *Casualties of War*. Burbank, CA: Columbia Pictures, 1989.

———. *Redacted*. Los Angeles: Magnolia Home Entertainment, 2008.

Debord, Guy. *Society of the Spectacle*. Detroit: Black and Red, 1983.

Derrida, Jacques. *On Cosmopolitanism and Forgiveness*. New York: Routledge, 2002.

Díaz, Junot. *The Brief Wondrous Life of Oscar Wao*. New York: Riverhead Books, 2007.

Dick, Kirby, and Amy Ziering Kofman. *Derrida*. New York: Zeitgeist Films: Jane Doe Films, 2002.

Didion, Joan. *Blue Nights*. New York: Knopf, 2012.

Dinh, Linh. *Love like Hate*. New York: Seven Stories Press, 2010. Kindle edition.

Douzinas, Costas. *Human Rights and Empire: The Political Philosophy of Cosmopolitanism*. New York: Routledge-Cavendish, 2007.

Dowd, Maureen. "After the War: White House Memo; War Introduces a Tougher Bush to Nation." *New York Times*, March 1, 1991.

DuBois, W. E. B. *The Souls of Black Folk*. New Haven, CT: Yale University Press, 2015.

Dudziak, Mary L. *War Time: An Idea, Its History, Its Consequences*. New York: Oxford University Press, 2013.

Duiker, William J. *Ho Chi Minh: A Life*. New York: Hyperion, 2000.

Dumbrell, John, and David Ryan, eds. *Vietnam in Iraq: Tactics, Lessons, Legacies and Ghosts*. New York: Routledge, 2006.

Dunlop, Nic. *The Lost Executioner: A Journey to the Heart of the Killing Fields*. New York: Walker and Company, 2005.

Duong, Lan. *Treacherous Subjects: Gender, Culture, and Trans-Vietnamese Feminism*. Philadelphia: Temple University Press, 2012.

Duong Thu Huong. *Novel without a Name*. New York: Penguin, 1996.

Eastwood, Clint. *Gran Torino*. Burbank, CA: Warner Home Video, 2008.

Edelman, Lee. *No Future: Queer Theory and the Death Drive*. Durham, NC: Duke University Press, 2004.

Edkins, Jenny. *Trauma and the Memory of Politics*. Cambridge: Cambridge University Press, 2003.

Ehrhart, W. D. *Going Back: An Ex-Marine Returns to Vietnam*. Jefferson, NC: McFarland, 1987.

———. "The Invasion of Grenada." http://www.wdehrhart.com/poem-invasion-of-grenada.html.

Ellison, Ralph. *Invisible Man*. New York: Vintage, 1995.

Espiritu, Yen Le. *Body Counts: The Vietnam War and Militarized Refugees*. Berkeley: University of California Press, 2014. Kindle edition.

Faas, Horst, and Tim Page, eds. *Requiem: By the Photographers Who Died in Vietnam and Indochina*. New York: Random House, 1997.

Farocki, Harun. *Inextinguishable Fire*. Berlin: Deutsche Film- und Fernsehakademie Berlin (DFFB), 1969.

Fitzgerald, Frances. *Fire in the Lake: The Vietnamese and the Americans in Vietnam*. Boston: Back Bay Books, 2002.

Forster, E. M. *Aspects of the Novel*. New York: Harcourt, Brace, 1956. Kindle edition.

Foucault, Michel. *The History of Sexuality: An Introduction*. Translated by Robert Hurley. 3 vols. New York: Vintage, 1990.

Fox, Diane Niblack. "Fire, Spirit, Love, Story." *Journal of Vietnamese Studies* 3, no. 2 (Summer 2008): 218–21.

Freud, Sigmund. "Remembering, Repeating, and Working-Through." In *The Standard Edition of the Complete Works of Sigmund Freud*, 147–56. London: Hogarth Press, 1958.

Friedman, Thomas. "Isis and Vietnam." *New York Times*, October 28, 2014.

Fuller, Samuel. *China Gate*. Los Angeles: Twentieth Century-Fox Film Corporation, 1957 (Theatrical): Republic Pictures Home Video, 1998 (VHS).

Fussell, Paul. *The Great War and Modern Memory*. New York: Oxford University Press, 1975.

Garber, Marjorie. "Compassion." In *Compassion: The Culture and Politics of an Emotion*, edited by Lauren Berlant, 15–27. New York: Routledge, 2004.

Gardner, Lloyd C., and Marilyn Blatt Young. *Iraq and the Lessons of Vietnam, or, How Not to Learn from the Past*. New York: W. W. Norton, 2007.

Gilroy, Paul. *Against Race: Imagining Political Culture beyond the Color Line*. Cambridge, MA: Belknap Press of Harvard University Press, 2000.

———. *Postcolonial Melancholia*. New York: Columbia University Press, 2006.

Ginzburg, Natalia. *A Place to Live*. Translated by Lynne Sharon Schwartz. New York: Seven Stories Press, 2002.

Goldstein, Gordon M., and Frederick Logevall. "Will Syria Be Obama's Vietnam?" *New York Times*, October 7, 2014.

Gómez-Barris, Macarena. *Where Memory Dwells: Culture and State Violence in Chile*. Berkeley: University of California Press, 2009.

Gooding-Williams, Robert, ed. *Reading Rodney King, Reading Urban Uprising*. New York: Routledge, 1993.

Gordon, Avery F. *Ghostly Matters: Haunting and the Sociological Imagination*. Minneapolis: University of Minnesota Press, 1997.

Greene, Graham. *The Quiet American*. New York: Penguin, 2004.

Griswold, Charles L. *Forgiveness: A Philosophical Exploration*. New York: Cambridge University Press, 2007.

Grossman, David. *On Killing: The Psychological Cost of Learning to Kill in War and Society*. Boston: Back Bay Books, 2009.

Guevara, Che. *On Vietnam and World Revolution*. New York, Merit Publishers, 1967.

Gustafsson, Mai Lan. *War and Shadows: The Haunting of Vietnam*. Ithaca, NY: Cornell University Press, 2009.

Hagopian, Patrick. *The Vietnam War in American Memory: Veterans, Memorials, and the Politics of Healing*. Amherst: University of Massachusetts Press, 2009.

Halbwachs, Maurice. *On Collective Memory*. Chicago: University of Chicago Press, 1992.

Hass, Kristen. *Carried to the Wall: American Memory and the Vietnam Veterans Memorial*. Berkeley: University of California Press, 1998.

Hayslip, Le Ly, with James Wurts. *When Heaven and Earth Changed Places*. New York: Doubleday, 1989.

Heinemann, Larry. *Black Virgin Mountain: A Return to Vietnam*. New York: Vintage, 2005.

———. *Close Quarters*. New York: Vintage, 2005.

———. *Paco's Story*. New York: Vintage Contemporaries, 1986.

Hellman, John. *American Myth and the Legacy of Vietnam*. New York: Columbia University Press, 1986.

Herman, Judith Lewis. *Trauma and Recovery*. London: Pandora, 2001.

Herr, Michael. *Dispatches*. New York: Vintage, 1991.

Hinton, Devon E., Dara Chhean, and Vuth Pich, M. H. Pollack, Scott P. Orr, and Roger K. Pitman. "Assessment of Posttraumatic Stress Disorder in Cambodian Refugees Using the Clinician-Administered PTSD Scale: Psychometric Properties and Symptom Severity." *Journal of Traumatic Stress* 19, no. 3 (2006): 405–9.

Hirsch, Marianne. *Family Frames: Photography, Narrative, and Postmemory*. Cambridge, MA: Harvard University Press, 1997.

———. "From 'the Generation of Postmemory.'" In *The Collective Memory Reader*, edited by Jeffrey K. Olick, Vered Vinitzky-Seroussi, and Daniel Levy, 346–47. New York: Oxford University Press, 2011.

Hollinger, David. "Not Universalists, Not Pluralists: The New Cosmopolitans Find Their Own Way." In *Conceiving Cosmopolitanism: Theory, Context, and Practice*, edited by Steven Vertovec and Robin Cohen, 227–39. New York: Oxford University Press, 2002.

Hong, Cathy Park. "Delusions of Whitenss in the Avant-Garde." *Lana Turner* 7 (2015).http://arcade.stanford.edu/content/delusions -whiteness-avant-garde.

Hughes, Theodore. "Locating the Revolutionary Subject: Hwang Suk-Young's *The Shadow of Arms*." Munbal-ri, Korea: Changbi Publishers, 2003.

Huong, Duong Thu. *Paradise of the Blind*. New York: William Morrow, 1993.

Huyssen, Andreas. *Present Pasts: Urban Palimpsests and the Politics of Memory*. Stanford, CA: Stanford University Press, 2003.

Hwang, Sok-Yong. *The Shadow of Arms*. Translated by Chun Kyung-Ja. New York: Seven Stories Press, 2014.

Hyde, Lewis. *The Gift: Creativity and the Artist in the Modern World*. New York: Vintage, 2007.

Irwin, Don. "Viet Reparations Ruled Out." *Los Angeles Times*, March 25, 1977, 1.

Isaacs, Arnold R. *Vietnam Shadows: The War, Its Ghosts, and Its Legacy*. Baltimore: The Johns Hopkins University Press, 1997.

Ivens, Joris, William Klein, Claude Lelouch, Agnès Varda, Jean-Luc Godard, Chris Marker, Michèle Ray, and Alain Resnais. *Loin du Vietnam*. Paris: Société pour le Lancement des Oeuvres Nouvelles (SLON), 1967.

Iyer, Pico. *Video Night in Kathmandu*. New York: Vintage, 1989.

Jager, Sheila Miyoshi. "Monumental Histories: Manliness, the Military, and the War Memorial." *Public Culture* 14, no. 2 (2002): 387–409.

Jager, Sheila Miyoshi, and Jiyul Kim. "The Korean War after the Cold War." In *Ruptured Histories: War, Memory, and the Post-Cold War in Asia*, edited by Sheila Miyoshi Jager and Rana Mitter, 233–65. Cambridge, MA: Harvard University Press, 2007.

James, William. *The Moral Equivalent of War, and Other Essays: And Selections from Some Problems of Philosophy*. New York: Harper and Row, 1971.

Janette, Michelle. *Mỹ Việt: Vietnamese American Literature in English, 1962–Present*. Honolulu: University of Hawaii Press, 2011.

Jeffords, Susan. *The Remasculinization of America: Gender and the Vietnam War*. Bloomington: University of Indiana Press, 1989.

Jeong, Ji-Yeong. *White Badge*. Costa Mesa, CA: Distributed by Vanguard Cinema, 1994.

Jin, Ha. *The Writer as Migrant*. Chicago: University of Chicago Press, 2008.

Johnson, Chalmers. *The Sorrows of Empire: Militarism, Secrecy, and the End of the American Republic*. New York: Metropolitan Books, 2004.

Kant, Immanuel. *To Perpetual Peace: A Philosophical Sketch*. Translated by Ted Humphrey. Indianapolis: Hackett Publishing, 2003.

Kaplan, Caren. *Questions of Travel: Postmodern Discourses of Displacement*. Durham, NC: Duke University Press, 1996.

Karlin, Wayne. *Wandering Souls: Journeys with the Dead and the Living in Viet Nam*. New York: Nation Books, 2009.

———. *War Movies: Journeys to Viet Nam: Scenes and Out-Takes*. Willimantic, CT: Curbstone Press, 2005.

Karlin, Wayne, Lê Minh Khuê, and Truong Vu, eds. *The Other Side of Heaven: Post-War Fiction by Vietnamese and American Writers*. Willimantic, CT: Curbstone Press, 1995.

Keen, Suzanne. *Empathy and the Novel*. Oxford: Oxford University Press, 2007.

Kellogg, Ray, and John Wayne. *The Green Berets*. Burbank, CA: Warner Home Video, 1968.

Kennedy, John F. "Remarks of Senator John F. Kennedy at the Conference on Vietnam Luncheon in the Hotel Willard, Washington, D.C." http://www.jfklibrary.org/Research/Research-Aids/JFK-Speeches /Vietnam-Conference-Washington-DC_19560601.aspx.

Kim, Hyun Sook. "Korea's 'Vietnam Question': War Atrocities, National Identity, and Reconciliation in Asia." *positions: east asia cultures critique* 9, no. 3 (2001): 621–34.

Kim, Jodi. *Ends of Empire: Asian American Critique and the Cold War.* Minneapolis: University of Minnesota Press, 2010.

Kim, Kyung Hyun. *The Remasculinization of Korean Cinema.* Durham, NC: Duke University Press, 2004.

Kim, Nadia Y. *Imperial Citizens: Koreans and Race from Seoul to LA.* Stanford, CA: Stanford University Press, 2008.

King, Martin Luther, Jr. "Address at the Fourth Annual Institute on Nonviolence and Social Change at Bethel Baptist Church." In *The Martin Luther King, Jr. Papers Project,* edited by Clayborne Carson. https://swap.stanford.edu/20141218225548/http://mlk-kpp01 .stanford.edu/primarydocuments/Vol5/3Dec1959_AddressattheFourt hAnnualInstituteonNonviolenceandSo.pdf.

———. "Beyond Vietnam." In *A Call to Conscience: The Landmark Speeches of Dr. Martin Luther King, Jr.,* edited by Clayborne Carson, and Kris Shepard, 133–64. New York: Warner Books, 2001.

Kingsolver, Barbara. "A Pure, High Note of Anguish." *Los Angeles Times,* September 23, 2001. http://articles.latimes.com/2001/sep/23/opinion /op-48850.

Kingston, Maxine Hong. *China Men.* New York: Knopf, 1980.

———. *The Fifth Book of Peace.* New York: Knopf, 2003.

———. *The Woman Warrior.* New York: Vintage International, 1989.

Kinnell, Galway. *The Book of Nightmares.* New York: Mariner Books, 1973.

Kinney, Katherine. *Friendly Fire: American Images of the Vietnam War.* New York: Oxford University Press, 2000.

Kipling, Rudyard. *Kipling: Poems (Everyman's Library).* New York: Knopf, 2007.

Kirk, Don. "Confronting Korea's Agony in Vietnam." *New York Times,* September 28, 2002.

Kong, Su-chang. *R-Point.* Seoul: CJ Entertainment, 2004.

Kwon, Heonik. *After the Massacre: Commemoration and Consolation in Ha My and My Lai.* Berkeley: University of California Press, 2006.

Kundera, Milan. *The Book of Laughter and Forgetting.* New York: HarperPerennial, 1996.

Kuras, Ellen, and Thavisouk Phrasavath. *The Betrayal (Nerakhoon).* Rockland, NY: Pandinlao Films, 2008.

Laderman, Scott. *Tours of Vietnam: War, Travel Guides, and Memory.* Durham, NC: Duke University Press, 2009.

Lam, Andrew. *Perfume Dreams: Reflections on the Vietnamese Diaspora.* Berkeley, CA: Heyday Books, 2005.

Larsen, Wendy Wilder, and Tran Thi Nga. *Shallow Graves: Two Women and Vietnam.* New York: Random House, 1986.

"The Latehomecomers." *Entertainment Weekly*, April 11, 2008.

Lawrence, Mark Atwood. *The Vietnam War: A Concise International History.* New York: Oxford University Press, 2008.

Le, Nam. *The Boat.* New York: Alfred A. Knopf, 2008.

le thi diem thuy. *The Gangster We Are All Looking For.* New York: Anchor Books, 2004.

Lee, Jin-kyung. "Surrogate Military, Subimperialism, and Masculinity: South Korea in the Vietnam War, 1965–1973." *positions: east asia cultures critique* 17, no. 3 (2009): 655–82.

Lee, Jun-ik. *Sunny.* Seoul: Tiger Pictures, 2008.

Lesser, William. "Presence of Mind: The Photographs of Philip Jones Griffiths." *Aperture* no. 190 (2008). http://www.aperture.org /jonesgriffiths/.

Levinas, Emmanuel. *Totality and Infinity: An Essay on Exteriority.* Translated by Alphonso Lingis. Pittsburgh: Duquesne University Press, 1969.

Leys, Ruth. *Trauma: A Genealogy.* Chicago: University of Chicago Press, 2000.

Lieu, Nhi T. *The American Dream in Vietnamese.* Minneapolis: University of Minnesota Press, 2011.

Lin, Maya. *Boundaries.* New York: Simon and Schuster, 2000.

Lipsitz, George. *Time Passages: Collective Memory and American Popular Culture.* Minneapolis: Minnesota University Press, 1990.

Logevall, Fredrik. *Embers of War: The Fall of an Empire and the Making of America's Vietnam.* New York: Random House, 2012.

Maguire, Peter. *Facing Death in Cambodia.* New York: Columbia University Press, 2005.

Maier, Charles. "From 'A Surfeit of Memory? Reflections on History, Melancholy, and Denial.'" In *The Collective Memory Reader*, edited by Jeffrey K. Olick, Vered Vinitzky-Seroussi, and Daniel Levy, 442–45. New York: Oxford University Press, 2011.

Makuch, Eddie. "Destiny Reaches 16 Million Registered Users, Call of Duty Franchise Hits $11 Billion." *Gamespot* (2015). Published

electronically February 5. http://www.gamespot.com/articles/destiny-reaches-16-million-registered-users-call-o/1100-6425136/.

Malarney, Shaun. *Culture, Ritual and Revolution in Vietnam*. London: Routledge-Curzon Press, 2002.

Malarney, Shaun Kingsley. "'The Fatherland Remembers Your Sacrifice.'" In *The Country of Memory: Remaking the Past in Late Socialist Vietnam*, edited by Hue-Tam Ho Tai, 46–76. Berkeley: University of California Press, 2001.

Margalit, Avishai. *The Ethics of Memory*. Cambridge, MA: Harvard University Press, 2002.

Marker, Chris. *Sans Soleil*. Paris: Argos Films, 1983.

Marling, Karal Ann, and Robert Silberman. "The Statue at the Wall: The Vietnam Veterans Memorial and the Art of Remembering." In *The United States and the Vietnam War: Historical Memory and Representation of the Vietnam War*, edited by Walter Hixson, 122–48. New York: Garland Publishing, 2000.

Marshall, Grant N., Terry L. Schell, Marc N. Elliott, S. Megan Berthold, and Chi-Ah Chun. "Mental Health of Cambodian Refugees 2 Decades after Resettlement in the United States." *JAMA* 294, no. 5 (2005): 571–79.

Martini, Edwin A. *Invisible Enemies: The American War on Vietnam, 1975–2000*. Amherst: University of Massachusetts Press, 2007.

Marx, Karl, and Friedrich Engels. *The German Ideology*. New York: International Publishers, 1970.

Mbembe, Achille. "Necropolitics." *Public Culture* 15, no. 1 (2003): 11–40.

McCarthy, Mary. *The Seventeenth Degree*. New York: Harcourt Brace Jovanovich, 1974.

McGurl, Mark. *The Program Era: Postwar Fiction and the Rise of Creative Writing*. Cambridge, MA: Harvard University Press, 2011.

McMahon, Robert J. "Contested Memory: The Vietnam War and American Society, 1975–2001." *Diplomatic History* 26, no. 2 (Spring 2002): 159–84.

Menand, Louis. *American Studies*. New York: Farrar, Straus and Giroux, 2002.

Merridale, Catherine. "War, Death, and Remembrance in Soviet Russia." In *War and Remembrance in the Twentieth Century*, edited by Jay Winter and Emmanuel Sivan, 61–83. Cambridge: Cambridge University Press, 1999.

Michaels, Walter Benn. *The Trouble with Diversity: How We Learned to Love Identity and Ignore Inequality*. New York: Henry Holt, 2006.

Miles, Christopher, and Moira Roth. *From Vietnam to Hollywood: Dinh Q. Lê*. Seattle: Marquand Books, 2003.

Milliot, Jim. "The PW Publishing Industry Salary Survey 2015: A Younger Workforce, Still Predominantly White." *Publishers Weekly*, October 16, 2015. http://www.publishersweekly.com/pw/by-topic/industry-news/publisher-news/article/68405-publishing-industry-salary-survey-2015-a-younger-workforce-still-predominantly-white.html.

Mishra, Pankaj. "Why Salman Rushdie Should Pause before Condemning Mo Yan on Censorship." *The Guardian*, December 13, 2012.

"MLK: A Riot Is the Language of the Unheard." *CBS Reports*, 2013. http://www.cbsnews.com/news/mlk-a-riot-is-the-language-of-the-unheard/.

Mo Jo Sung. *Do You Know?*, 2000. http://www.youtube.com/watch?v=dOhAT45KZHk.

Moon, Seungsook. *Militarized Modernity and Gendered Citizenship in South Korea*. Durham, NC: Duke University Press, 2005.

Morris, Errol. *The Fog of War*. New York: Sony Pictures Classics, 2003.

Morrison, Toni. *Beloved*. New York: Knopf, 2007.

Moua, Mai Neng. *Bamboo among the Oaks: Contemporary Writing by Hmong Americans*. St. Paul: Minnesota Historical Society Press, 2002.

Nguyen, Bich Minh. *Pioneer Girl*. New York: Viking, 2014.

Nguyen Cao Ky. *Buddha's Child: My Fight to Save Vietnam*. New York: St. Martin's Griffin, 2002.

Nguyen Huy Thiep. *The General Retires and Other Stories*. New York: Oxford University Press, 1993.

———. "Khong Khoc O California." In *Tuyen Tap Truyen Ngan Nguyen Huy Thiep*. Hanoi: Nha xuat ban Phu nu, 2001.

Nguyen, Mimi Thi. *The Gift of Freedom: War, Debt, and Other Refugee Passages*. Durham, NC: Duke University Press, 2012.

Nguyen, Nathalie Huynh Chau. *Memory Is Another Country: Women of the Vietnamese Diaspora*. Santa Barbara, CA: Praeger, 2009.

Nguyen, Phuong. "The People of the Fall: Refugee Nationalism in Little Saigon since 1975–2005." PhD dissertation, University of Southern California, 2009.

Nguyen Qui Duc. *Where the Ashes Are*. Reading, MA: Addison-Wesley, 1994.

Nguyen, Viet Thanh. "The Authenticity of the Anonymous: Popular Culture and the Art of War." In *Transpop: Korea Vietnam Remix*, edited by Viet Le and Yong Soon Min, 58–67. Seoul: Arko Arts Center, 2008.

———. "Impossible to Forget, Difficult to Remember: Vietnam and the Art of Dinh Q. Lê." *A Tapestry of Memories: The Art of Dinh Q. Lê*. Bellevue, WA: Bellevue Arts Museum, 2007: 19–29.

———. "Just Memory: War and the Ethics of Remembrance." *American Literary History* 25, no. 1 (2013): 144–63.

———. "Refugee Memories and Asian American Critique." *positions: asia critique* 20, no. 3 (2012): 911–42.

———. "Remembering War, Dreaming Peace: On Cosmopolitanism, Compassion and Literature," *Japanese Journal of American Studies*, no. 20 (2009): 1–26.

———. "Speak of the Dead, Speak of Viet Nam: The Ethics and Aesthetics of Minority Discourse." *New Centennial Review* 6, no. 2 (2007): 7–37.

———. "War, Memory and the Future." *The Asian American Literary Review* 1, no. 2 (2010): 279–90.

———. "What Is the Political? American Culture and the Example of Viet Nam." In *Asian American Studies after Critical Mass*, edited by Kent A. Ono, 19–39. Massachusetts: Blackwell Publishing, 2005.

Nguyen-Vo Thu-Huong. "Forking Paths: How Shall We Mourn the Dead?" *Amerasia Journal* 31, no. 2 (2005): 157–75.

Nietzsche, Friedrich. *On the Advantage and Disadvantage of History for Life*. Translated by Peter Preuss. Indianapolis: Hackett Publishing, 1980.

———. "On the Genealogy of Morals." Translated by Walter Kaufmann. In *Basic Writings of Nietzsche*, 437–600. New York: Modern Library, 2000.

Nora, Pierre. "Between Memory and History: *Les Lieux De Mémoire*." *Representations* 26 (Spring 1989): 7–24.

———. "From 'Reasons for the Current Upsurge in Memory.'" In *The Collective Memory Reader*, edited by Jeffrey K. Olick, Vered Vinitzky-Seroussi, and Daniel Levy, 437–41. New York: Oxford University Press, 2011.

Nussbaum, Martha. "Patriotism and Cosmopolitanism." In *For Love of Country?*, edited by Martha Nussbaum, 3–17. Boston: Beacon Press, 1996.

Obama, Barack. "Presidential Proclamation—Veterans Day." March 29, 2012. http://www.whitehouse.gov/the-press-office/2012/03/29 /presidential-proclamation-vietnam-veterans-day.

O'Brien, Tim. *The Things They Carried*. New York: Mariner Books, 2009.

O'Connor, Flannery. *Mystery and Manners: Occasional Prose*. New York: Farrar, Straus and Giroux, 1969.

Olick, Jeffrey K. *The Politics of Regret: On Collective Memory and Historical Responsibility*. New York: Routledge, 2007.

Olick, Jeffrey K., Vered Vinitzky-Seroussi, and Daniel Levy. "Introduction." In *The Collective Memory Reader*, edited by Jeffrey K. Olick, Vered Vinitzky-Seroussi, and Daniel Levy, 3–62. New York: Oxford University Press, 2011.

Ollman, Leah. "Dinh Q. Le at Shoshana Wayne." *Art in America* 88, no. 2 (February 2000): 136.

Omi, Michael, and Howard Winant. *Racial Formation in the United States*. 2nd ed. New York: Routledge, 1994.

Ondaatje, Michael. *The English Patient*. New York: Vintage, 1993.

O'Reilly, Sarah. "Q&A: Doris Lessing Talks to Sarah O'Reilly about *The Golden Notebook*." In Doris Lessing, *The Golden Notebook*. New York: Harper Perennial, 2013. Kindle edition.

Packer, George. "Obama and the Fall of Saigon." *New Yorker*, September 10, 2014.

Palumbo-Liu, David. *The Deliverance of Others: Reading Literature in a Global Age*. Durham, NC: Duke University Press, 2012.

Panh, Rithy. *The Missing Picture*. Paris: Arte France Cinema, 2013.

———. *S-21: The Khmer Rouge Killing Machine*. Paris: Arte France Cinema, 2003.

Panh, Rithy, and Christophe Bataille. *The Elimination*. Translated by John Cullen. New York: The Other Press, 2013. Kindle edition.

Papageorge, Tod. *American Sports, 1970: Or How We Spent the War in Vietnam*. New York: Aperture, 2007.

Parikh, Crystal. *An Ethics of Betrayal: The Politics of Otherness in Emergent U.S. Literature and Culture*. New York: Fordham University Press, 2009.

Park, Jinim. *Narratives of the Vietnam War by Korean and American Writers*. New York: Peter Lang, 2007.

Paterniti, Michael. "Never Forget." *GQ*, July 2009. http://www.gq.com /news-politics/big-issues/200907/cambodia-khmer-rouge-michael -paterniti.

Pelaud, Isabelle Thuy. *This Is All I Choose to Tell: History and Hybridity in Vietnamese American Literature*. Philadelphia: Temple University Press, 2011.

Pham, Andrew X. *Catfish and Mandala: A Two-Wheeled Voyage through the Landscape and Memory of Vietnam*. New York: Picador, 2000.

———. *The Eaves of Heaven*. New York: Broadway Books, 2009.

Phan, Aimee. *We Should Never Meet*. New York: Picador, 2005.

Phi, Bao. *Sông I Sing*. Minneapolis: Coffee House Press, 2011.

Pincus, Walter. "In Iraq, Lessons of Vietnam Still Resonate." *Washington Post*, May 25, 2015.

Poeuv, Socheata. *New Year Baby*. San Francisco: Center for Asian American Media, 2006.

Ratner, Vaddey. *In the Shadow of the Banyan*. New York: Simon and Schuster, 2012.

Renan, Ernst. "From 'What Is a Nation?.'" In *The Collective Memory Reader*, edited by Jeffrey K. Olick, Vered Vinitzky-Seroussi, and Daniel Levy, 80–83. New York: Oxford University Press, 2011.

Ricoeur, Paul. *Memory, History, Forgetting*. Chicago: Chicago University Press, 2004.

Robson, Mark. *The Bridges at Toko-Ri*. Los Angeles: Paramount Pictures, 1954.

Rosenfeld, Gavriel D. "A Looming Crash or a Soft Landing? Forecasting the Future of the Memory 'Industry'." *Journal of Modern History* 81 (March 2009): 122–58.

Rowe, John Carlos. "'Bringing It All Back Home': American Recyclings of the Vietnam War." In *The Violence of Representation*, edited by Nancy Armstrong and Leonard Tennenhouse, 197–218. London: Routledge, 1989.

Rowe, John Carlos, and Rick Berg. "The Vietnam War and American Memory." In *The Vietnam War and American Culture*, edited by John Carlos Rowe and Rick Berg, 1–18. New York: Columbia University Press, 1991.

Russ, Martin. *The Last Parallel: A Marine's War Journal*. New York: Rinehart, 1957.

Ryu, Youngju. "Korea's Vietnam: Popular Culture, Patriarchy, Intertextuality." *The Review of Korean Studies* 12, no. 3 (2009): 101–23.

Said, Edward. *Culture and Imperialism*. New York: Vintage, 1994.

———. *Orientalism*. New York: Vintage Books, 1979.

Scarry, Elaine. *The Body in Pain*. New York: Oxford University Press, 1985.
———. "The Difficulty of Imagining Other People." In *For Love of Country?*, edited by Martha Nussbaum, 98–110. Boston: Beacon Press, 1996.

Schacter, Daniel L. *The Seven Sins of Memory: How the Mind Forgets and Remembers*. Boston: Houghton Mifflin, 2001.

Schlesinger, Arthur M., Jr. *The Disuniting of America: Reflections on a Multicultural Society*. New York: W. W. Norton, 1998.

Schlund-Vials, Cathy. *War, Genocide, and Justice: Cambodian American Memory Work*. Minneapolis: University of Minnesota Press, 2012.

Schwartz, Lynne Sharon. *The Emergence of Memory: Conversations with W. G. Sebald*. New York: Seven Stories Press, 2007. Kindle edition.

Schwenkel, Christina. *The American War in Contemporary Vietnam: Transnational Remembrance and Representation*. Bloomington: Indiana University Press, 2009.

Sebald, W. G. *Austerlitz*. New York: Modern Library, 2001.
———. *On the Natural History of Destruction*. New York: Modern Library 2004.

Shacochis, Bob. *The Woman Who Lost Her Soul*. New York: Atlantic Monthly Press, 2013. Kindle edition.

Shan, Te-hsing. "Trauma, Re(-)Membering, and Reconciliation—on Maya Lin's Vietnam Veterans Memorial." In *Landmarks in American Literature: History in the Making*, edited by Isaac Sequeira, Manju Jaidka, and Anil Raina, 161–77. New Delhi: Prestige Books, 2007.

Shawcross, William. *Sideshow: Kissinger, Nixon, and the Destruction of Cambodia*. New York: Cooper Square Press, 2002.

Short, Philip. *Pol Pot: Anatomy of a Nightmare*. New York: Henry Holt and Co., 2007.

Sirk, Douglas. *Battle Hymn*. Los Angeles: Universal International Pictures, 1957.

Sollors, Werner. *Multilingual America: Transnationalism, Ethnicity, and the Languages of American Literature*. New York: New York University Press, 1998.

Solzhenitsyn, Aleksandr. *The Gulag Archipelago 1918–1956*. New York: Harper and Row, 1973.

Song, Min Hyoung. *Strange Future: Pessimism and the 1992 Los Angeles Riots*. Durham, NC: Duke University Press, 2005.

Sontag, Susan. *On Photography*. New York: Picador, 2001.

———. *Regarding the Pain of Others*. New York: Farrar, Straus and Giroux, 2003.

Spanos, William. *American Exceptionalism in the Age of Globalization: The Specter of Vietnam*. Albany, NY: SUNY Press, 2008.

———. *America's Shadow: An Anatomy of Empire*. Minneapolis: University of Minnesota Press, 2000.

Spiegelman, Art. *Metamaus*. New York: Pantheon, 2011.

Srikanth, Rajini. *The World Next Door: South Asian American Literature and the Idea of America*. Philadelphia: Temple University Press, 2004.

Stephenson, Wesley. "Do the Dead Outnumber the Living?" *BBC News Magazine*, February 3, 2012.

Storr, Robert. *Dislocations*. New York: The Museum of Modern Art, 1991.

Stringer, Julian, ed. *New Korean Cinema*. New York: New York University Press, 2005.

Stur, Heather Marie. *Beyond Combat: Women and Gender in the Vietnam War Era*. New York: Cambridge University Press, 2011.

Sturken, Marita. *Tangled Memories: The Vietnam War, the Aids Epidemic, and the Politics of Remembering*. Berkeley: University of California Press, 1997.

———. *Tourists of History: Memory, Kitsch, and Consumerism from Oklahoma City to Ground Zero*. Durham, NC: Duke University Press, 2007.

Swofford, Anthony. *Jarhead: A Marine's Chronicle of the Gulf War and Other Battles*. New York: Scribner, 2003.

Tai, Hue-Tam Ho, ed. *The Country of Memory: Remaking the Past in Late Socialist Vietnam*. Berkeley: University of California Press, 2001.

Takaki, Ronald, ed. *From Different Shores: Perspectives on Race and Ethnicity in America*. 2nd ed. New York: Oxford University Press, 1994.

Tatum, James. *The Mourner's Song: War and Remembrance from the Iliad to Vietnam*. Chicago: University of Chicago Press, 2003.

Taylor, Sandra C. *Vietnamese Women at War: Fighting for Ho Chi Minh and the Revolution*. Lawrence: University Press of Kansas, 1999.

Thich Nhat Hanh. *Fragrant Palm Leaves: Journals, 1962–1966*. New York: Riverhead, 1999. Kindle edition.

———. *The Miracle of Mindfulness: An Introduction to the Practice of Meditation*. Boston: Beacon Press, 1999. Kindle edition.

Tran, GB. *Vietnamerica: A Family's Journey*. New York: Villard, 2011.

Tran, Ham. *Journey from the Fall*. Orange County, CA: Old Photo Film, 2006.

Tran, John. *The Vietnam War and the Theologies of Memory: Time and Eternity in the Far Country*. Malden, MA: Wiley-Blackwell, 2010.

Trinh, T. Minh-ha. "All-Owning Spectatorship." In *When the Moon Waxes Red: Representation, Gender, and Cultural Politics*, 81–105. New York: Routledge, 1991.

———. *Surname Viet, Given Name Nam*. New York: Women Make Movies, 1989.

———. *Woman Native Other*. Bloomington: Indiana University Press, 1989.

Truong, Monique. *The Book of Salt*. New York: Houghton Mifflin Harcourt, 2003.

Truong, Monique T. D. "Vietnamese American Literature." In *An Interethnic Companion to Asian American Literature*, edited by King-Kok Cheung, 219–46. New York: Cambridge University Press, 1997.

Turley, William S. *The Second Indochina War: A Concise Political and Military History*. Lanham, MD: Rowman and Littlefield, 2008.

Turner, Fred. *Echoes of Combat: The Viet Nam War in American Memory*. New York: Doubleday, 1992.

Turner, Karen Gottschang, and Thanh Hao Phan. *Even the Women Must Fight: Memories of War from North Vietnam*. New York: John Wiley and Sons, 1998.

Turse, Nick. *Kill Anything That Moves: The Real American War in Vietnam*. New York: Metropolitan Books, 2013.

Um, Khatharya. "Exiled Memory: History, Identity, and Remembering in Southeast Asia and Southeast Asian Diaspora." *positions: asia critique* 20, no. 3 (2012): 831–50.

———. "The 'Vietnam War': What's in a Name?" *Amerasia Journal* 31, no. 2 (2005): 134–39.

UN News Centre. "UN Warns of 'Record High' 60 Million Displaced Amid Expanding Global Conflicts." (2015). Published electronically June 18. http://www.un.org/apps/news/story.asp?NewsID=51185 -.VZBiO-1Vikp.

Utley, Jon Basil. "12 Reasons America Doesn't Win Its Wars." *The American Conservative*, June 12, 2015. http://www.theamericanconservative.com/articles/12-reasons-america-doesnt-win-its-wars/.

Vang, Ma. "The Refugee Soldier: A Critique of Recognition and Citizenship in the Hmong Veterans' Naturalization Act of 1997." *positions: asia critique* 20, no. 3 (2012): 685–712.

Vang, Mai Der. "Heirs of the 'Secret War' in Laos." *New York Times*, May 27, 2015.

Vertovec, Steven, and Robin Cohen, eds. *Conceiving Cosmopolitanism: Theory, Context, and Practice.* New York: Oxford University Press, 2002.

Virilio, Paul. *War and Cinema: The Logistics of Perception.* New York: Verso, 1989.

"Virtual Reality Exposure Therapy." http://ict.usc.edu/prototypes/pts/.

Viswanathan, Gauri, ed. *Power, Politics and Culture: Interviews with Edward W. Said.* New York: Random House, 2001.

Vo, Hong Chuong-Dai. "Memories That Bind: Dang Thuy Tram's Diaries as Agent of Reconciliation." *Journal of Vietnamese Studies* 3, no. 2 (Summer 2008): 196–207.

Vo, Nghia M. *The Bamboo Gulag: Political Imprisonment in Communist Vietnam.* Jefferson, NC: McFarland, 2004.

Vuong, Tri Nhan. "*The Diary of Dang Thuy Tram* and the Postwar Vietnamese Mentality." *Journal of Vietnamese Studies* 3, no. 2 (Summer 2008): 180–95.

Wagner-Pacifici, Robin, and Barry Schwartz. "The Vietnam Veterans Memorial: Commemorating a Difficult Past." *American Journal of Sociology* 97, no. 2 (September 1991): 376–420.

Walcott, Derek. *Collected Poems: 1948–1984.* New York: Farrar, Straus and Giroux, 1987.

Wang, Chih-ming. "Politics of Return: Homecoming Stories of the Vietnamese Diaspora." *positions: asia critique* 21, no. 1 (2013): 161–87.

Waters, Mary C. *Ethnic Options: Choosing Identities in America.* Berkeley: University of California Press, 1990.

Weaver, Gina. *Ideologies of Forgetting: Rape in the Vietnam War.* Albany, NY: SUNY Press, 2010.

Weigl, Bruce. *The Circle of Hanh: A Memoir.* New York: Grove Press, 2000.

Williams, Raymond. *Marxism and Literature.* Oxford: Oxford University Press, 1977.

Williams, Tony. "From Novel to Film: *White Badge.*" *Asian Cinema* 13, no. 2 (2002): 39–53.

Winter, Jay. "Forms of Kinship and Remembrance in the Aftermath of the Great War." In *War and Remembrance in the Twentieth Century*, edited by Jay Winter and Emmanuel Sivan, 40–60. Cambridge: Cambridge University Press, 1999.

———. "From *Remembering War: The Great War between Memory and History in the Twentieth Century*." In *The Collective Memory Reader*, edited by Jeffrey K. Olick, Vered Vinitzky-Seroussi, and Daniel Levy, 426–29. New York: Oxford University Press, 2011.

Winter, Jay, and Emmanuel Sivan. "Introduction." In *War and Remembrance in the Twentieth Century*, edited by Jay Winter and Emmanuel Sivan, 1–5. Cambridge: Cambridge University Press, 1999.

———. "Setting the Framework." In *War and Remembrance in the Twentieth Century*, edited by Jay Winter and Emmanuel Sivan, 6–39. Cambridge: Cambridge University Press, 1999.

———. *War and Remembrance in the Twentieth Century*. Cambridge: Cambridge University Press, 1999.

Wittgenstein, Ludwig. *Tractatus Logico-Philosophicus*. Translated by D. F. Pears and B. F. McGuinness. New York: Routledge.

Wong, Sau-ling Cynthia. "'Sugar Sisterhood': Situating the Amy Tan Phenomenon." In *The Ethnic Canon: Histories, Institutions, and Interventions*, edited by David Palumbo-Liu, 174–210. Minneapolis: University of Minneapolis Press, 1995.

Woo, Jung-en. *Race to the Swift: State and Finance in Korean Industrialization*. New York: Columbia University Press, 1991.

Woo-Cumings, Meredith. "Market Dependency in U.S.–East Asian Relations." In *What Is in a Rim? Critical Perspectives on the Pacific Region Idea*, edited by Arif Dirlik, 163–86. Lanham, MD: Rowman and Littlefield, 1998.

Woodward, Kathleen. "Calculating Compassion." In *Compassion: The Culture and Politics of an Emotion*, edited by Lauren Berlant, 59–86. New York: Routledge, 2004.

Wu, Judy Tzu-Chun. *Radicals on the Road: Internationalism, Orientalism, and Feminism during the Vietnam Era*. Ithaca, NY: Cornell University Press, 2013.

Yamashita, Karen Tei. *The I-Hotel*. Minneapolis: Coffee House Press, 2010.

Yang, Kao Kalia. Artist's talk at the "Southeast Asians in the Diaspora" Conference, University of Illinois, Urbana-Champaign, April 16, 2008.

———. *The Latehomecomer: A Hmong Family Memoir*. Minneapolis: Coffee House Press, 2008.

Yoneyama, Lisa. *Hiroshima Traces: Time, Space, and the Dialectics of Memory*. Berkeley: University of California Press, 1999.

Yoon Je-kyoon, *Ode to My Father*. Seoul: JK Film, 2014.

Young, James. *The Texture of Memory*. New Haven, CT: Yale University Press, 1993.

Young, Marilyn Blatt. *The Vietnam Wars*. New York: HarperCollins, 1991.

Yui, Daizaburo. "Perception Gaps between Asia and the United States of America: Lessons from 12/7 and 9/11." In *Crossed Memories: Perspectives on 9/11 and American Power*, edited by Laura Hein and Daizaburo Yui, 54–79. Tokyo: Center for Pacific and American Studies, The University of Tokyo, 2003.

Zelizer, Barbie. *Remembering to Forget: Holocaust Memory through the Camera's Eye*. Chicago: University of Chicago Press, 1998.

Žižek, Slavoj. *How to Read Lacan*. New York: W. W. Norton, 2007.

Acknowledgments

After writing a book about being haunted by memory, it is a pleasure to conclude with remembering what I owe to others. To begin with, various institutions granted significant financial assistance that allowed me time to research and write, starting with the University of Southern California and its consistent support for my travel and sabbaticals. A Suzanne Young Murray Fellowship from the Radcliffe Institute for Advanced Study, and another fellowship from the American Council of Learned Societies, gave me the opportunity to think through difficult problems. The Southeast Asian Summer Studies Institute funded my study of Vietnamese at the University of Wisconsin at Madison, an experience that I furthered through trips to Southeast Asia that were supported by a Luce Foundation Fellowship from the Asian Cultural Council, a Grant for Artistic Innovation from the Center for Cultural Innovation, and a grant from the Center for International Studies at USC. An Arts Writers Grant from Creative Capital and the Warhol Foundation encouraged me to write about the role that visual culture played in memories of the war, while the Japan–United States Friendship Commission afforded me the chance to present early arguments before Japanese

audiences. Many years later, I returned to Asia as a fellow of the Asia Research Institute at the National University of Singapore, which provided a stimulating environment for sharing the final version of this book.

Unlike the audience at ARI, most people who heard me talk about this book listened to my ideas in more nascent form. I appreciate their generosity and intellectual engagement. From the most recent to the earliest, the individuals and institutions who invited me to discuss my work are: Eliza Noh, Tu-Uyen Nguyen, and California State University, Fullerton; Wafa Azeem, Kent Baxter, and California State University, Northridge; Prasenjit Duara, Chua Beng Huat, and the Asia Research Institute; Bruce Solheim and Citrus College; Mayumo Inoue and Hitotsubashi University; Elaine Kim and the Chinese American Literature Research Center at Beijing Foreign Studies University; Akitoshi Nagahata and Nagoya University; Otto Heim, Kendall Johnson, and the University of Hong Kong; Hyungji Park and Yonsei University; Youngmin Kim and the English Language and Literature Association of Korea; Kent Ono, Gordon Hutner, Mimi Thi Nguyen, Fiona I. B. Ngo, and the University of Illinois at Urbana-Champaign; Hsinya Huang and National Sun Yat-Sen University; Chih-Ming Wang and the Institute of European and American Studies at Academia Sinica; Guy Beauregard and National Taiwan University; Lawrence Buell and Harvard University; Yuan Shu and Texas Tech University; Viet Le, Yong Soon Min, and the Arko Art Center of Seoul; Edward Park and Loyola Marymount University; Frederick Aldama and Project Narrative at The Ohio State University; Stefano Catalani and the Bellevue Arts Museum; Yasuo Endo and the Center for Pacific and American Studies at the University of Tokyo; Satoshi Nakano and the Center for the Study of Peace and Reconciliation at Hitotsubashi University; Juri Abe, the Japanese Association of American Studies, and Rikkyo University; Celine Parreñas Shimizu and UC Santa Barbara; Lan T. Chu and Occidental College; Iris Schmeisser, Heike Paul, and the

University of Erlangen-Nuremberg; the Center for Black Studies and UC Santa Barbara; Charlie Bertsch and the University of Arizona; Ruth Mayer, Vanessa Künnemann, and the University of Hannover; and Rachel Lee and UCLA.

Although I traveled far and wide to discuss the book in progress, much of it was shaped at my home campus of USC, where the graduate students of my two seminars on War and Memory challenged me to sharpen my thinking on that topic. My research assistants, Tiffany Babb, Yvette Marie Chua, Ninalenn Ibrahim, and Cam Vu (as well as Kathleen Hale at Harvard), proved invaluable as they took care of things small and large. In the English Department, Joseph Boone has been a great friend and supportive department chair, while Emily Anderson gave me a space to share my work with colleagues. Two of them, John Carlos Rowe and Rick Berg, pushed me to think more radically. At the book's completion, my dean, Peter Mancall, provided a subvention that paid for many of the images. And while I took a long time to write this book, it would have taken even longer without Heather James and Dorinne Kondo, whose generous advice helped me greatly in winning fellowships. Finally, I am delighted to have worked with Janet Hoskins to develop our concepts about transpacific studies, many of which inform this book.

In Phnom Penh, Kok-Thay Eng of the Documentation Center of Cambodia was generous with his time. So was Chuck Searcy of Project RENEW in Hanoi, and his colleague Ngo Xuan Hien in Dong Ha. My travels through Vietnam were enriched by the assistance of Tran Minh Duc and through my collaboration with photographer Sam Sweezy, who took several of the photos for this book. I am grateful to him for their use, as I am to all the other artists, photographers, and institutions who are listed in the credits. I am especially thankful to Andrew Kinney and the staff at Harvard University Press for ushering this book to publication, as well as to Zoë Ruiz, whose editing was crucial.

If these acknowledgments have run on for a considerable length, that reflects the thirteen years I spent accruing debts as I worked on this book, and the many years before that during which I engaged with war, memory, and art-making. Through more than two decades, I have benefited immeasurably from a community of like-minded scholars and artists devoted to Southeast Asia and its diasporas, including Chuong Chung, Tiffany Chung, Yến Lê Espiritu, Dinh Q. Lê, Viet Lê, Nguyen Qui Duc, Isabelle Thuy Pelaud, Thy Phu, and Cathy Schlund-Vials. Among these scholars and artists, the most important interlocutor and collaborator has been my partner, Lan Duong. Without her patience and support, this book would not exist. Neither would our son, Ellison, whose life has left its subtle imprint on all that I do and write. While he will not grow up in a world without war, I hope that he will work for peace.

His grandparents, my father and mother, have known too many years of war. Their sacrifices for my brother Tung and me, as well as for our partners and children, have been enormous. Born in the 1930s in a poor northern village, they have traveled an immense distance in space and time from their homeland. My father and mother are the ones to whom I owe the most, and I dedicate this book, insufficient as it might be, to them.

Credits

P. 24. Truong Son Martyrs Cemetery. Photo by Sam Sweezy

P. 34. Ho Chi Minh City Martyrs Cemetery. Photo by Sam Sweezy

P. 35. Mourning soldier, statue, Ho Chi Minh City. Photo by Gregory Farris

P. 38. Defaced tombstone, National Cemetery of the Army of the Republic of Vietnam. Photo by Sam Sweezy

P. 54. *Vietnam Veterans Memorial Wall,* Maya Lin. Washington, DC. Photo by Viet Thanh Nguyen

P. 57. *The Three Soldiers,* Frederick Hart. Washington, DC. Photo by Viet Thanh Nguyen

P. 58. *Vietnam Women's Memorial,* Glenna Goodacre. Washington, DC. Photo by Viet Thanh Nguyen

P. 91. Photographs of faces, S-21, Phnom Penh. Photo by Viet Thanh Nguyen

P. 94. "No laughing" sign. S-21, Phnom Penh. Photo by Viet Thanh Nguyen

P. 98. Defaced photograph of Duch. S-21, Phnom Penh. Photo by Viet Thanh Nguyen

P. 99. *The Missing Picture,* film still, dir. Rithy Panh. © CDP/Bophana Center

P. 106. Pens and necklaces supposedly made from American bullets. Photo by Viet Thanh Nguyen

P. 128. Rusted tank, Doc Mieu firebase, near the demilitarized zone. Photo by Sam Sweezy

P. 137. Helicopter diorama, War Memorial of Korea, Seoul. Photo by Viet Thanh Nguyen

P. 146. *R-Point,* film still, dir. Gong Su-chang. 2004 CJ Entertainment / Cinema Service

P. 147. *Sunny,* film still, dir. Joon-ik Lee. 2008 Tiger Pictures / Achim Pictures

P. 154. Ha My Memorial, near Hoi An. Photo by Sam Sweezy

P. 161. Dien Bien Phu Martyrs Cemetery Memorial. Photo by Viet Thanh Nguyen

P. 162. Mosaic, Cu Chi tunnels. Photo by Viet Thanh Nguyen

P. 163. Russian jet, B-52 Victory Museum, Hanoi. Photo by Viet Thanh Nguyen

P. 165. Thich Quang Duc's car. Photo by Sam Sweezy

P. 166. *Dien Bien Phu of the Air,* Military History Museum, Hanoi. Photo by Sam Sweezy

P. 167. Nancy Rubins, *Chas' Stainless Steel, Mark Thomson's Airplane Parts, about 1,000 lbs. of Stainless Steel Wire & Gagosian's Beverly Hills Space at MOCA,* 2002. Airplane parts, stainless steel armature, stainless

steel wire cable, 25 x 54 x 33 feet. Collection of the Museum of Contemporary Art, Los Angeles, purchased in honor of Beatrice Gersh with funds provided by the Acquisition and Collection Committee; the Broad Art Foundation; Linda and Bob Gersh; David, Susan, Steven, and Laura Gersh; and Eugenio López. © Nancy Rubins. Photo by Brian Forrest

P. 170. Frieze, Dien Bien Phu Martyrs Cemetery, 2009. Photo by Viet Thanh Nguyen

P. 173. Diorama, Con Son Island Prison Complex, Con Dao Islands. Photo by Viet Thanh Nguyen

P. 175. *In Every Neighborhood,* Dang Duc Sinh. Photo by Sam Sweezy

P. 176. *Commemoration,* Nguyen Phu Cuong. Photo by Sam Sweezy

P. 178. Zippo lighters, Ho Chi Minh City Museum. Photo by Viet Thanh Nguyen

P. 182. Vinh Moc tunnels, 2009. Photo by Viet Thanh Nguyen

P. 184. The Dinh's only surviving photo. Courtesy Viet Nam News Agency (VNA) Photo Department. F.8420

P. 188. Tham Phiu Cave, Plain of Jars, Laos. Photo by Viet Thanh Nguyen

P. 213. Graphic novel excerpt from *Vietnamerica: A Family's Journey* by G. B. Tran, copyright © 2011 by Gia-Bao Tran. Used by permission of Villard Books, an imprint of Random House, a division of Penguin Random House LLC. All rights reserved.

P. 216. Homeless man, Philadelphia. Photo by Linh Dinh

P. 226. "Cleaning the Drapes," from the series *House Beautiful: Bringing the War Home*, c. 1967–1972. Martha Rosler

P. 231. Photo, in *American Sports, 1970: Or How We Spent the War in Vietnam* (Aperture Press, 2008), Tod Papageorge. Yale University Art Gallery.

Index